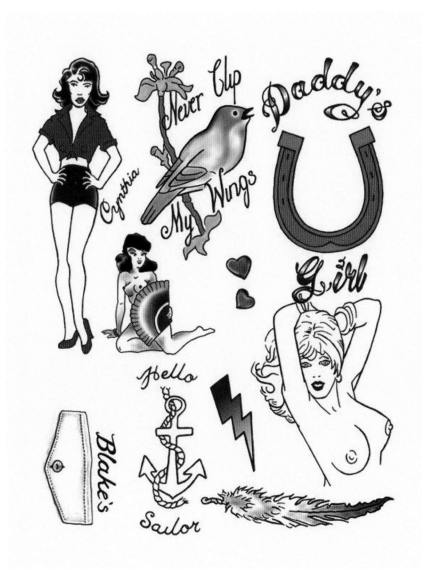

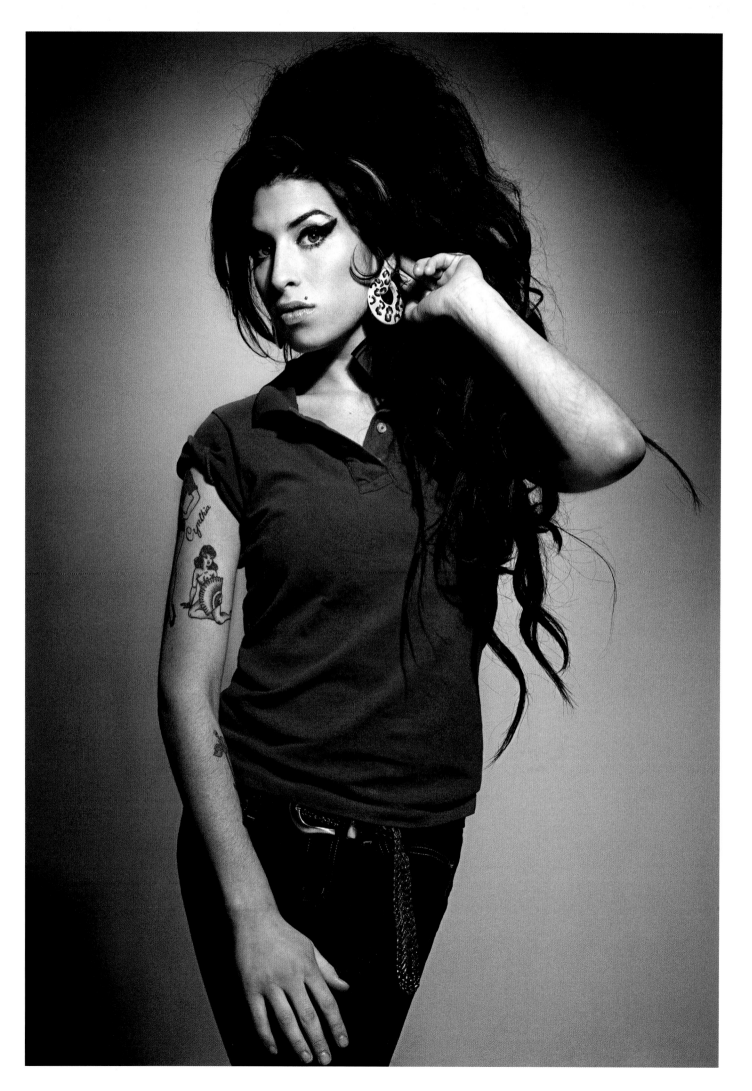

Amy Winehouse
Beyond Black

curated by
NAOMI PARRY

with additional contributions

Abrams, New York

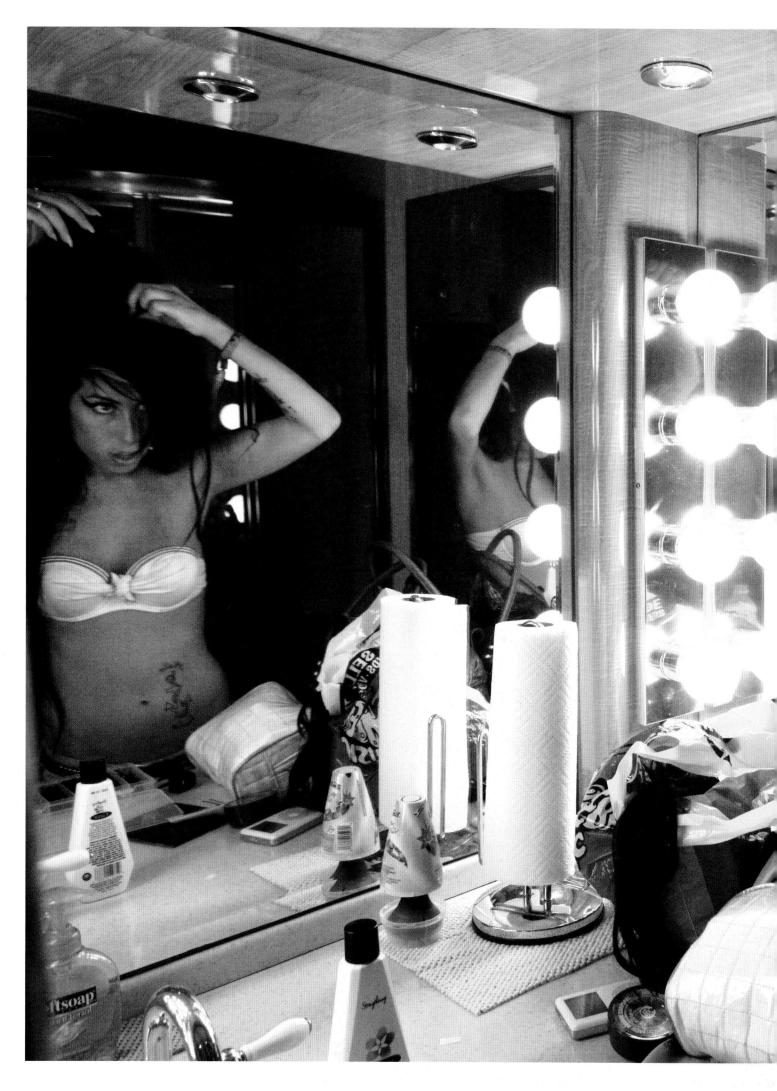

Contents

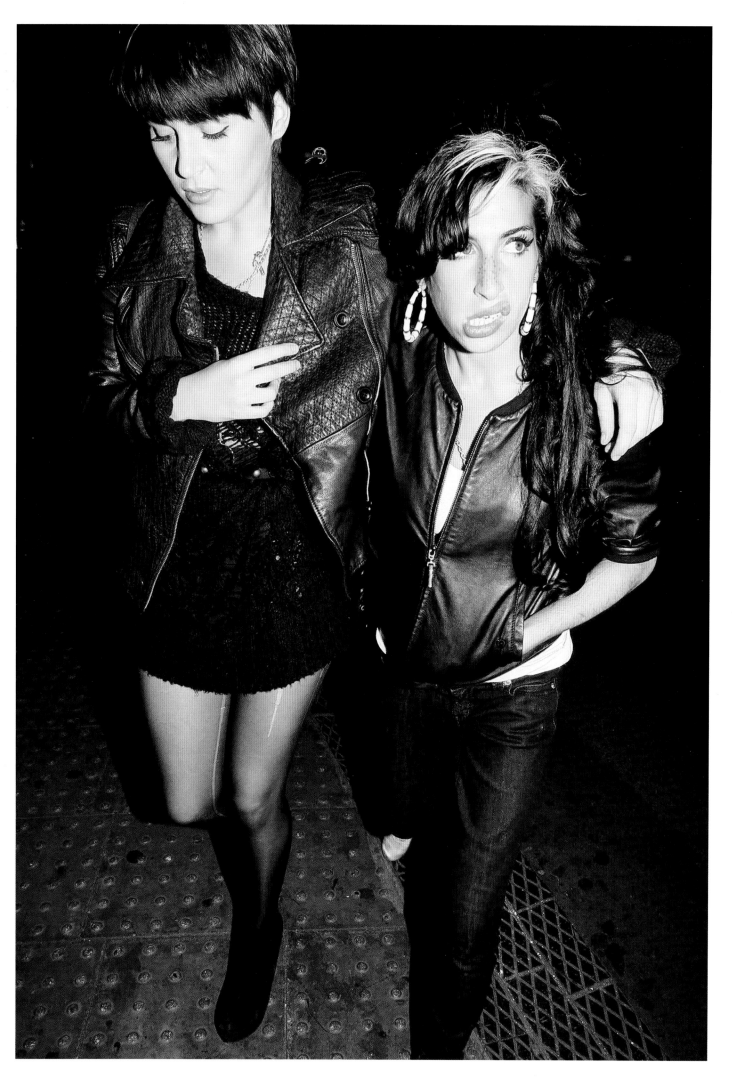

PREFACE
by Naomi Parry
Stylist & Friend

After Amy died in 2011, I didn't have a moment to reflect or absorb what had happened. Even in death she was still on stage. Her whole life, warts and all, was splashed across the papers. She became a byword for tragedy rather than talent.

With this book I wanted to redress the balance and shift the focus to her enormous achievements, ensuring that the person I knew wasn't lost in the myth.

Amy's beloved Camden was my starting point. She drew so much inspiration from here and I felt it should be celebrated. Photographer Andrew Hobbs and I set about shooting places she frequented - the streets, the market, the pubs and restaurants - in an attempt to capture the character and spirit of Amy's Camden.

I also wanted to shoot her archive of clothing and memorabilia, which had been stored away for 10 years. Sadly, all but one of the dresses that we created together for her final tour were unworn. They were the only pieces ever created specially for Amy and, for me, they symbolized the life she never got to live. I really didn't want to present another stark mannequin display so I decided to create styled and dressed sets, using many of Amy's things, to encapsulate different aspects of her character, taste, interests and inspiration, and to evoke the memories I have of her.

Amy's approach to her style was irreverent, spontaneous and unique. She would ask me to hack off the bottom of a dress before she went on stage, having suddenly decided it wasn't short enough, and she often insisted on wearing two bras to house her double stuffing of chicken fillets (breast enhancers). It was all so unpolished and wonderful. She taught me so much about style, about seeing beauty in the 'flaws'. I also learned a lot from her about humility and kindness.

Every single part of this book has been created with Amy in mind, from the choice of writer and photographer, sets and locations, design and imagery, to the selection of personal recollections. Always I asked the question: 'Would Amy approve this?'

I hope you will agree that within these pages her life is presented with balance, honesty and empathy. Ultimately, it is a love letter to a friend - an extraordinary person who had a huge impact on so many and whose legacy will outlive us all.

←
Nighthawks
LEAVING THE DINER,
JAMESTOWN ROAD, CAMDEN, LONDON,
7 SEPTEMBER 2009
PHOTO Agency

→
Amy's Things
REIMAGINED INTERIOR CONTAINING
SOME OF AMY'S CLOTHES, ACCESSORIES,
RECORDS, BOOKS AND LES PAUL GIBSON
PHOTO Andrew Hobbs

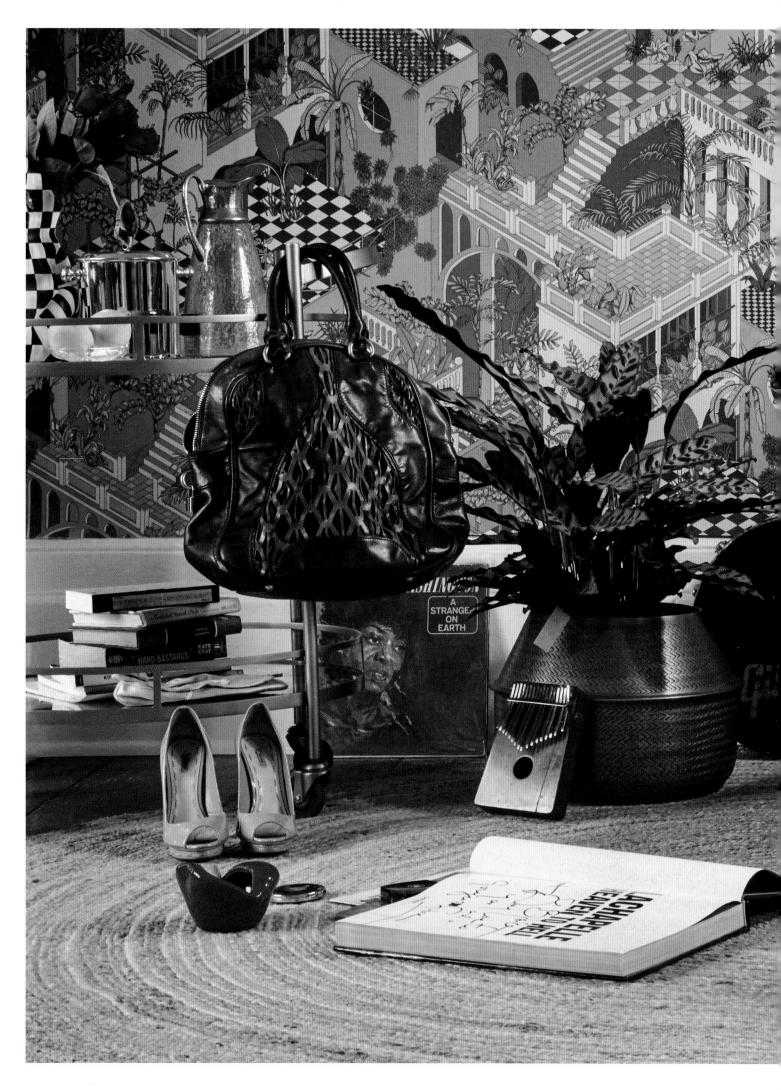

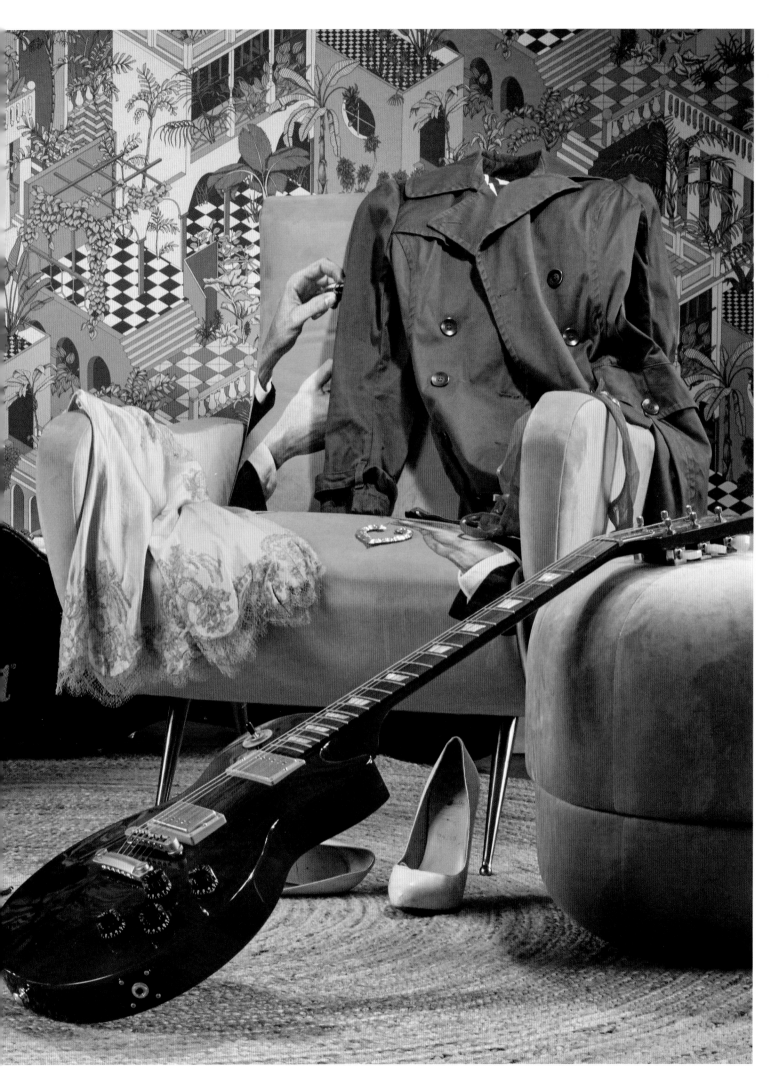

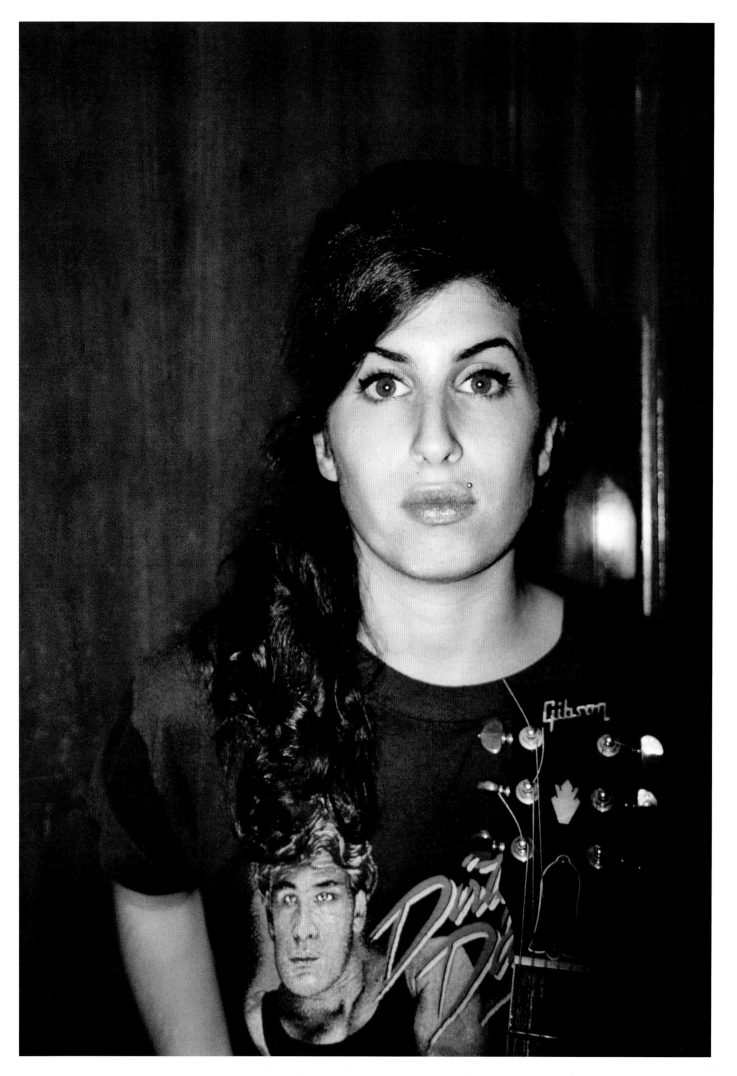

INTRODUCING
Amy
by Emma Garland
VICE Magazine

There was nothing typical about Amy Winehouse. A rowdy jazz singer armed with big, unruly hair and a mouth to match, she was an incongruous addition to the early-noughties landscape of genteel singer-songwriters, *Mickey Mouse Club* alumni and *X Factor* contestants. Her very presence in the music industry felt like a provocation. The veneer of perfection and humourlessness, intrinsic to mainstream pop at the time, felt trite compared to this twenty-something old soul from north London, who seemed to be almost painfully in love with music but entirely disinterested in celebrity.

Amy visibly sighed her way through tedious interviews, said she'd 'rather have cat AIDS' than collaborate with Katie Melua, and performed with what the *New York Times* critic Jon Pareles once described as a 'British layer of detachment', switching 'between confession and indifference' on stage. Ahead of the 2004 BRIT Awards, where she received two nominations for her

debut album *Frank*, she drove around London with comedian Simon Amstell, sticking her head out the window and shouting at pedestrians through a loudspeaker to 'PLEASE SUPPORT AMY WINEHOUSE' before hurling something at a promotional billboard of Dido.

Amy didn't win any BRIT Awards that year, but points were made. Amy Winehouse became a national treasure in the UK, beloved for her down-to-earth charm and humour as much as her music. 'A lot of the stuff that's out, it's not heartfelt,' Amy says with a shrug in one of her earliest TV interviews, a 2004 appearance on the talk show *Friday Night with Jonathan Ross*. She was responding to his remark about the 'trend' of young jazz singers at the time, wearing a bold patterned bandeau dress, hot pink plastic earrings and a wide smile – the one you can sense is masking something else – while doing so. Although the Amy we see in this interview radiates promise, wrapping

Dirty Dancing
ELEVATOR, RITZ TOWER,
PARK AVENUE, NEW YORK,
JULY 2003
PHOTO Charles Moriarty

up her spot on the show with a solo acoustic performance of 'I Heard Love Is Blind', which lays bare her extraordinary talent as a singer in particular, there was little to suggest she wouldn't continue along the path of precocious but easily digestible jazz. Two years later, she released *Back To Black*.

A timeless collection of torch songs written from the depths of heartbreak and addiction, *Back To Black* transformed Amy Winehouse from a British household name into an international superstar overnight. Amy had transformed as well. Weight had been noticeably lost, traditional tattoos collected over her arms and torso, and dark hair back-combed and piled on top of her head - a look that was deliberately pulled together from a wide range of reference points, but one that also became an emblem for the turbulence of her life at the time.

Back To Black was written during a period of separation from her then ex-boyfriend and future husband, Blake Fielder-Civil, who temporarily left her to pursue his previous ex-girlfriend. The full impact of this betrayal can be felt most keenly on the title track, whose laboured pace, prominent bell tolls and mournful strings are almost theatrical in conveying grief, although her sense of loss can be felt just as poignantly on more sedate tracks such as 'Love Is A Losing Game', 'Wake Up Alone' and 'He Can Only Hold Her'.

A dark current runs through *Back To Black*, bar a brief interlude of optimism with 'Tears Dry On Their Own' - a song of defiance that feels exactly like waking up to find things hurt a little less, enough to bother doing your make-up for the first time in weeks. Shifting between acute pain and bleary-eyed emptiness, the album has a fatalistic energy that can only come from someone in the process of documenting their own downward spiral. Knowing what we know now, Amy Winehouse leaves a complicated legacy as an artist whose most recognizable song is an account of her refusal to go to rehab, and who can be seen leading a funeral procession in the music video for a single accepting the 'odds stacked' against her. Though none of that changes the fact that, at just 23 years of age, Amy Winehouse had written a genuine masterpiece that solidified her place in music history.

Produced by Salaam Remi and Mark Ronson, *Back To Black* successfully ushered the sensibilities of sixties pop and soul into a modern setting; combining the bone-deep yearning of girl groups such as The Shangri-Las, The Ronettes and The Shirelles with a blunt, hip-hop-influenced approach to lyricism. The album's lush arrangements and retro metallic sound came courtesy of Sharon Jones' band the Dap-Kings, setting the seedy scene for a record that name checks more alcohol brands than people. Critics at the time compared Amy to influential American singers like Dinah Washington, Martha Reeves and Carla Thomas, with Dorian Lynskey of *The Guardian* coining the album 'a twenty-first-century soul classic'.

Back To Black tore through pop culture like a wildfire, dominating charts all over the world and continuing to break records for years after its release. It was the bestselling album of 2007 in the UK and topped the European Top 100 Albums chart for 13 consecutive weeks. It entered the US Billboard 200 at number seven, becoming the highest debut entry for an album by a British female solo artist. It was named one of the best albums of 2006 and 2007 by several publications, including *Time* (No. 1), *Entertainment Weekly* (No. 2), *Billboard* (No. 3) and the *New York Times* (No. 3). In 2007 the single 'Rehab' earned Amy her second Ivor Novello Award, and in 2008 she became the first British woman to win five Grammys. Today, *Back To Black* has sold over 16 million copies worldwide. In the UK, it's one of the bestselling albums of all time. But sales figures and trophies only tell a part of the story of this incredible young talent, whose career-defining album would also be her last.

At the height of her fame in the mid-to-late-noughties, Amy Winehouse was one of the most recognizable people in the world; beloved by fans, celebrated by the music press and respected by everyone from Nas to Tony Bennett to Prince (who took to covering 'Love Is A Losing Game' live with his backing singer Shelby J on lead vocals). To this day, when you hear the name 'Amy' – one of the most popular in the Western world – it naturally gives way to 'Winehouse', conjuring up her signature silhouette of a mini cocktail dress and towering beehive, as if she were the only Amy ever to have lived. This endurance isn't just down to her influence as a singer-songwriter, which paved the way for the wider commercial success of British soul artists such as Estelle, Duffy, Leona Lewis and Adele (though her retro inspirations and lyrical fixation on tragic romance endure most faithfully in Lana Del Rey). It's also down to Amy as a person. Atypical Amy, whose epochal songs, unique style and larger-than-life character have all had a long-lasting impact not only on pop music, but on pop culture at large.

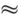

Amy Jade Winehouse was born on 14 September, 1983, to upwardly mobile parents of Russian Jewish and Polish Jewish descent. They lived in the suburb of Southgate, north London, where she was raised with her older brother Alex. Their father Mitchell 'Mitch' Winehouse earned his money in double glazing before going into cab driving, and their mother Janis worked as a pharmacist before being diagnosed with multiple sclerosis. They separated when Amy was nine years old. She takes after them both – getting her mouthiness and big personality from her dad, and her striking features and quiet resolve from her mother. According to Janis' 2014 memoir, *Loving Amy*, the joke on her side of the family was, 'We were so poor we could only afford one face.'

Many of her maternal uncles were professional jazz musicians, and so

Amy's introduction to jazz came young. Her grandmother, Cynthia - a major presence in Amy's and Alex's lives - loved music and dated the legendary jazz club owner Ronnie Scott in the forties. Amy later had the name 'Cynthia' tattooed on her right arm next to a pin-up girl resembling her grandmother who, in her heyday, would likely have been described as a 'knockout'.

If you buy into pop astrology, you might peg Amy for a classic Virgo - loud but withholding; strong willed but rarely keen to open up except in close relationships. According to those who knew her best, that isn't far off. Her childhood nickname was 'Hurricane Amy' - a fitting moniker for a bright spark who knew what she wanted and wasn't afraid to get into trouble about it. She carried this with her into adulthood, in character if not in name. When remembering her in interviews, close friends often recall her loyalty above all else, describing Amy as the type to drop everything - no matter how much of a crisis she was in herself - to show up for one of her inner circle. She came alive in social settings, telling jokes and doing voices and impressions with a hyper-focused energy that made whoever she was with feel special. She also had an incredible flair for flirting, with no reservations at all about walking over to a stranger at a bar and introducing herself by sitting on his lap.

There was also a spikiness to Amy sometimes; the sharp tongue that delivered barbs like '*You're just a little boy underneath that hat / You need the nerve to hide your ego, don't come with that*' in her lyrics also pulled no punches in real life. There were fights with friends and tabloid-documented bust-ups with partners, both of which were compounded if the other person was as fiery as she was. As an artist, Amy was both determined and blasé. She had no time for music that didn't feel honest, and treated the suits and schmoozing side of the music industry with caution - both of which were stances that were made clear through bluntness and humour, more than anything else. Reflecting on the experience of making *Back To Black*, Mark Ronson said Amy was direct with her feedback. If she didn't like a song, she'd say so, he explains in a 2010 interview with *The Guardian*. If he offered to rework it, 'She'd say "Nah, don't bother, it's shit".' Her former manager, Nick Shymansky, claims that when he first approached her about working together, 'She flicked my ego away like it was a pea on my shoulder.'

Much of this behaviour was an armour for her tremendous sensitivity. The same Amy who knocked back her future manager with jokes, insisting that she had no interest in making music, also sent him a two-song demo tape in a Jiffy bag covered in stickers of hearts and kisses with 'Amy' scribbled over it. 'It didn't fit with the girl who didn't want to be noticed,' Shymansky says, identifying the love-hate relationship Amy would continue to have with the spotlight. Her own biggest critic, Amy set the bar

↗
School Fête
OSIDGE PRIMARY SCHOOL,
CHASE SIDE, SOUTHGATE,
LONDON, *c.* 1992
PHOTO Janis Winehouse

↘
Band Rehearsal
AMY WITH FRIEND JULIETTE ASHBY
(AND FENDER STRATOCASTER)
REHEARSING AS SWEET 'N' SOUR, *c.* 1994
FOOTAGE STILL Juliette Ashby

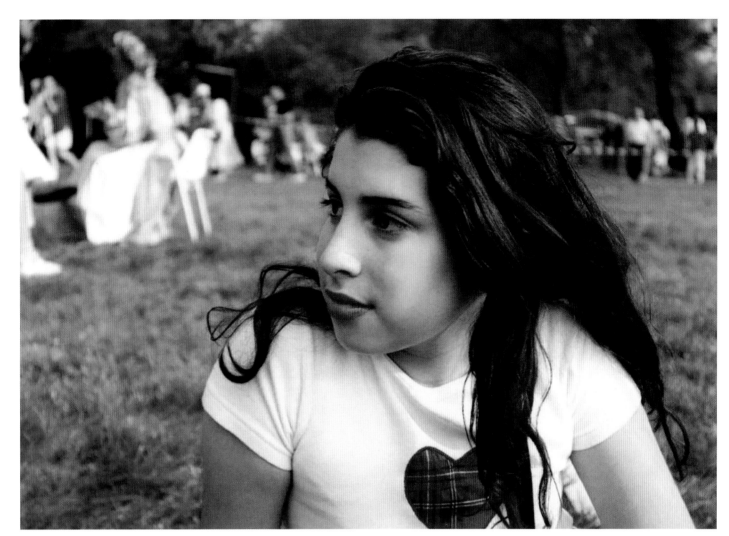

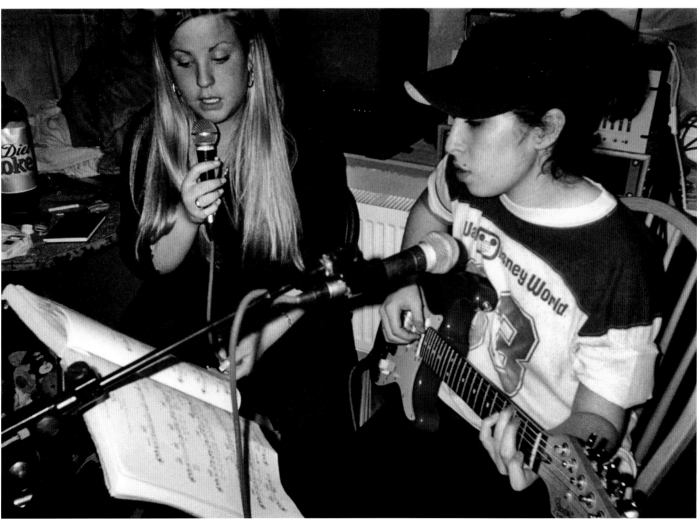

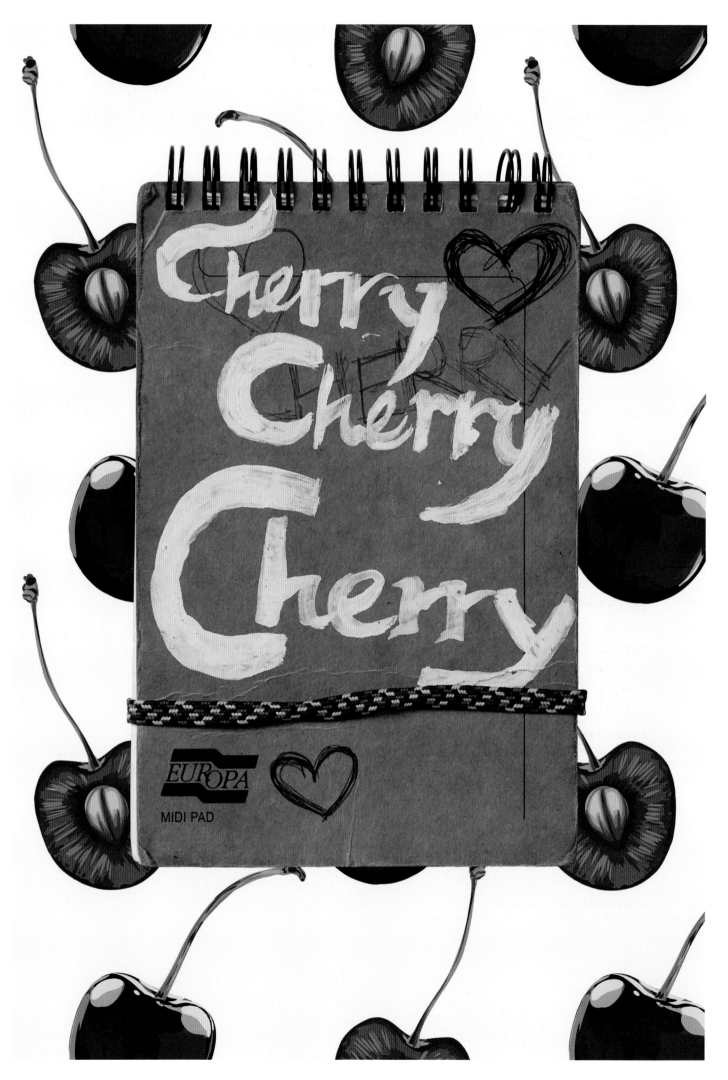

for herself incredibly high. If she didn't pull off what she wanted to do in her head, it was like jabbing hot coals with a poker. This fear or feeling of falling short often manifested as public outbursts of anger, fierce bouts of self-criticism and periods of depression that were often misread as diva-like sulkiness. She always fought nerves before a performance and alcohol became a crutch, until the line between the real Amy and Amy under the influence became increasingly blurred.

In her final interview, which appeared in *The Telegraph*, Amy is quoted as saying: 'I'm not a natural born performer. I'm a natural singer, but I'm quite shy, really.' The interview was conducted during a recording session with Tony Bennett, four months before her death. Music critic Neil McCormick describes her as nervous, worrying at her clothes and doing take after take of extraordinary vocal performances after which she'd apologise for being 'terrible'. It was Amy's first time back in the studio for a while: getting her to work on her own material, the follow-up album to *Back To Black*, had been a struggle, but the opportunity to join one of her heroes was one she couldn't refuse. 'It's good to be in the studio with Tony,' she says. 'That's the only reason I'm here.'

The result of that session is a particularly rich rendition of the thirties jazz standard 'Body And Soul', which appears on Bennett's 2011 album *Duets II: The Great Performances*. It was released as a single on 14 September 2011, on what would have been Amy's 28th birthday. Listening back now, it feels untethered from time and place, like lowering a stylus on a record unearthed from your grandparents' attic. Amy's straightforward delivery and liquor-smooth melismas show how at home she was with golden age material, her performance evoking a smile-filled supper club, filled with cigarette smoke and clinking cocktail glasses that she was born half a century too late to experience. No one else her age could sing like that, resonant and with a sense of eternity about it, as if rising up to greet you from the past.

Considering the headlines of disappointing live sets and 'binges' that had gathered around Amy like storm clouds, obfuscating her talent, the recording is a bittersweet reminder of what she was capable of. Having already proven that her songs could stand confidently alongside those sung by the sixties soul groups she admired, 'Body And Soul' is final and undeniable proof Amy Winehouse could also stand confidently among the greatest jazz singers of all time.

Though Amy was an unorthodox star, her journey to fame was fairly typical. In 1992, she attended the Susi Earnshaw Theatre School on Saturdays, where she furthered her vocal education and learned to tap dance. In 1996 she attended Sylvia Young Theatre School

'Cherry' Notepad
GUITAR CHORDS, SONG IDEAS & LYRICS,
2001–2002
COURTESY Amy Winehouse Foundation

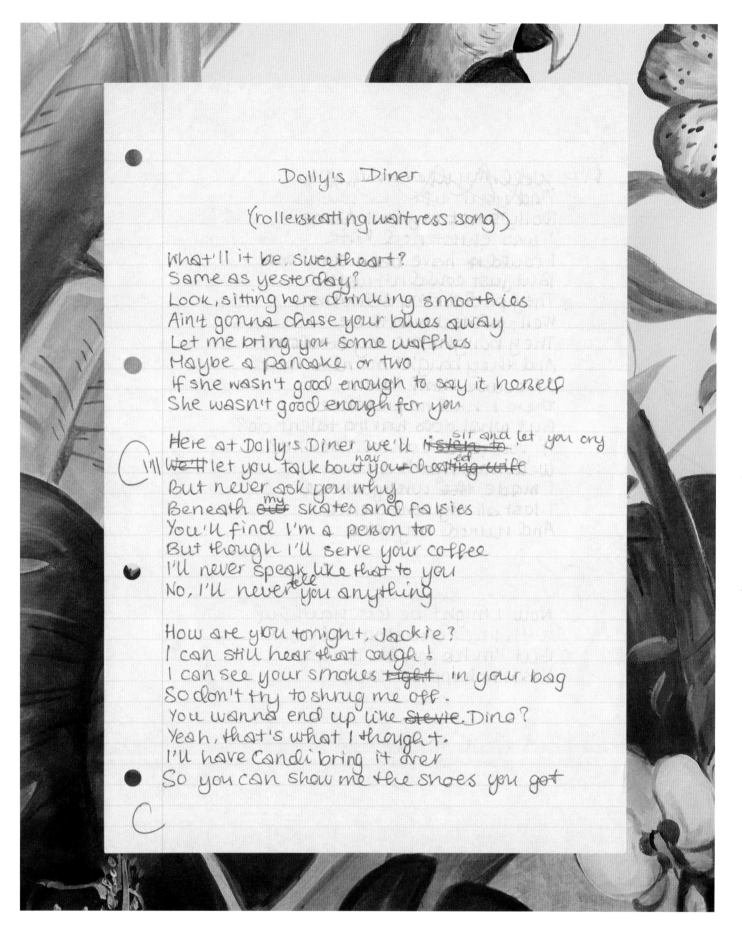

Dolly's Diner

(rollerskating waitress song)

What'll it be, sweetheart?
Same as yesterday?
Look, sitting here drinking smoothies
Ain't gonna chase your blues away
Let me bring you some waffles
Maybe a pancake, or two
If she wasn't good enough to say it herself
She wasn't good enough for you

Here at Dolly's Diner we'll ~~listen to~~ sit and let you cry
I'll ~~We'll~~ let you talk bout your ~~cheating wife~~ now ed
But never ask you why
Beneath ~~my~~ my skates and falsies
You'll find I'm a person too
But though I'll serve your coffee
I'll never speak like ~~that~~ to you
No, I'll never ~~tell~~ you anything

How are you tonight, Jackie?
I can still hear ~~that~~ cough!
I can see your smokes ~~tight~~ in your bag
So don't try to shrug me off.
You wanna end up like ~~Stevie~~. Dino?
Yeah, that's what I thought.
I'll have Candi bring it over
So you can show me ~~the~~ shoes you got

'Dolly's Diner' (Rollerskating waitress song)
UNRECORDED/UNRELEASED LYRICS, 2001,
SET AGAINST COTTONS RESTAURANT MURAL, CAMDEN, LONDON
COURTESY Amy Winehouse Foundation / Sony Music Publishing Ltd

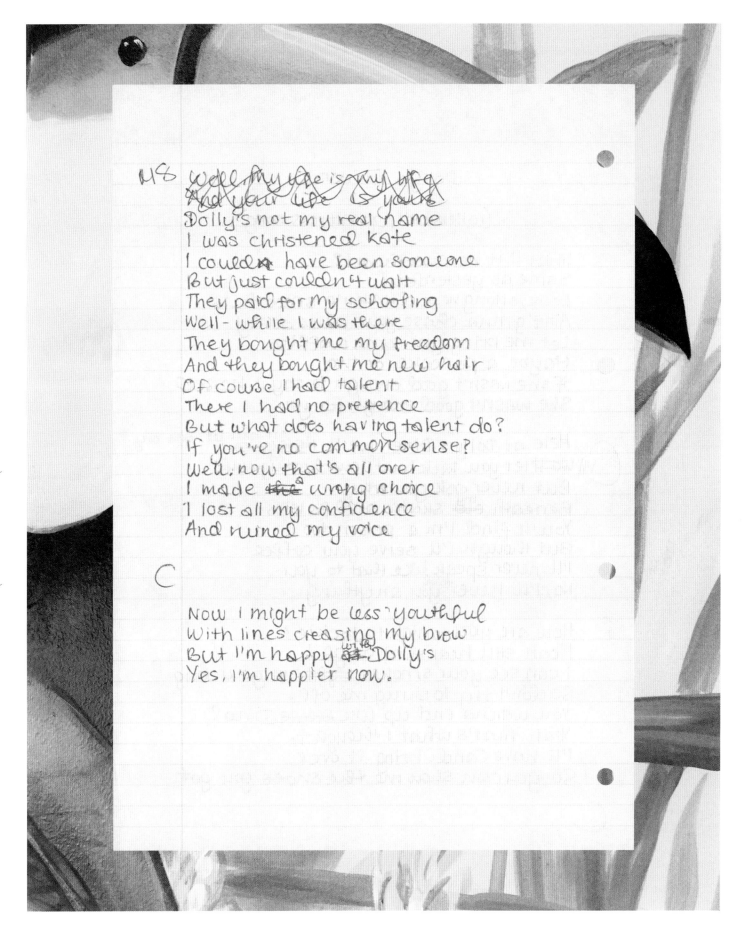

MS ~~Well my life is my life~~
~~And your life is yours~~
Dolly's not my real name
I was christened Kate
I couldn't have been someone
But just couldn't wait
They paid for my schooling
Well - while I was there
They bought me my freedom
And they bought me new hair
Of course I had talent
There I had no pretence
But what does having talent do?
If you've no common sense?
Well, now that's all over
I made ~~the~~ wrong choice
I lost all my confidence
And ruined my voice

C

Now I might be less youthful
With lines creasing my brow
But I'm happy ~~as~~ Dolly's
Yes, I'm happier now.

"Amy always dreamt of opening a diner
and being a roller-skating waitress."

MITCH WINEHOUSE FATHER

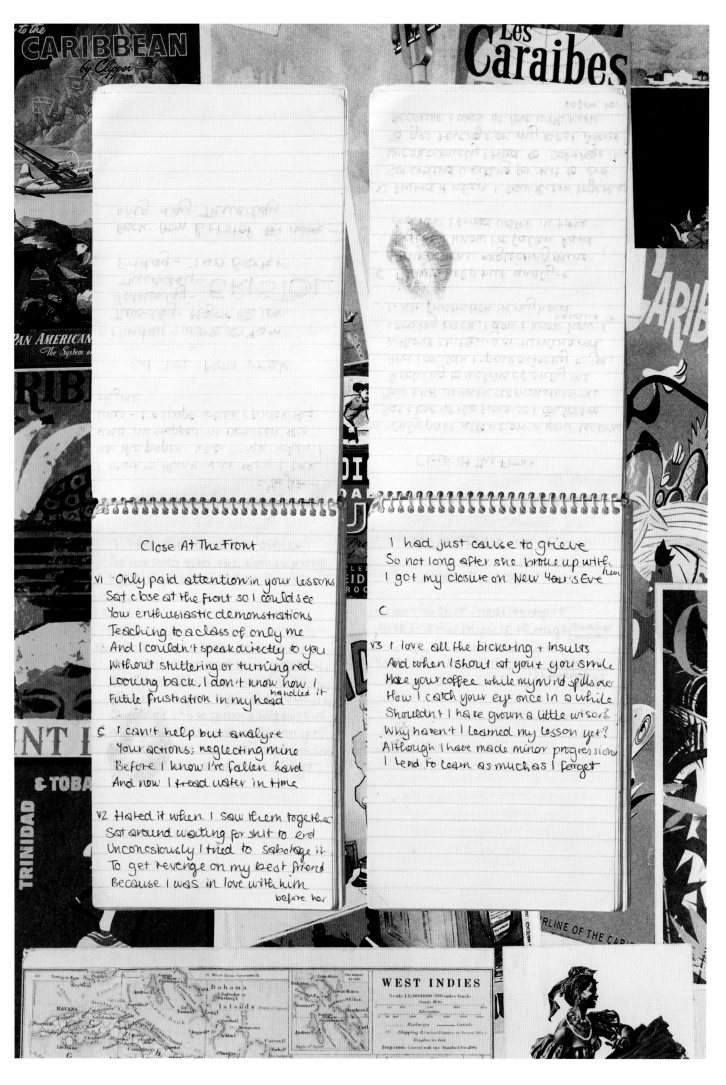

Close At The Front

V1 Only paid attention in your lessons
Sat close at the front so I could see
Your enthusiastic demonstrations
Teaching to a class of only me
And I couldn't speak directly to you
Without stuttering or turning red
Looking back, I don't know how I handled it
Futile frustration in my head

C I can't help but analyse
Your actions; neglecting mine
Before I know I've fallen hard
And now I tread water in time

V2 Hated it when I saw them together
Sat around waiting for shit to end
Unconsciously I tried to sabotage it
To get revenge on my best friend
Because I was in love with him
before her

I had just cause to grieve
So not long after she broke up with him
I got my closure on New Year's Eve

C

V3 I love all the bickering + insults
And when I shout at you + you smile
Make your coffee while my mind spills over
How I catch your eye once in a while
Shouldn't I have grown a little wiser?
Why haven't I learned my lesson yet?
Although I have made minor progressions
I tend to learn as much as I forget

(a specialist performing arts school in central London) on a scholarship, but was later expelled and transferred to The Mount School, Mill Hill. She also did a brief stint at the BRIT School around the same time as Leona Lewis, Jessie J and Adele. Though she certainly had the chops for it, formal training didn't chime with Amy's rebellious nature and disdain for convention. She thrived in her bedroom and on the stage, where she could do things her own way, and where she could 'feel' without thinking, as she would often describe her process in interviews later on.

After toying around with Alex's guitar at home, Amy bought her own at the age of 13 and taught herself to play (she later wrote the song 'Cherry' as an ode to her beloved Westfield Cherry Red guitar). As a performer she cut her teeth playing in clubs with a local jazz and blues covers group called the Bolsha Band. She also became the featured female vocalist with the National Youth Jazz Orchestra, and did her first gig with them at the Rayners Hotel in Harrow (now a Christ the Redeemer training college) at the age of 16. She has been quoted as saying she began her career in that spot 'singing for old people in the back room of a pub in Rayners Lane'.

In 2002 a then 19-year-old Amy signed to 19 Management by Simon Fuller, the mastermind behind *Pop Idol* and manager of the Spice Girls, Annie Lennox and Cathy Dennis among others. It quickly led to a publishing deal with EMI and a record deal with Island, which released her debut studio album *Frank* in 2003. With that, a star was born.

Though its legacy is overshadowed by *Back To Black*, when *Frank* dropped it was like someone shattered all the windows of a room that hadn't been ventilated in a decade. The noughties was an explosive time for music, with the indie rock revival and burgeoning grime scene bubbling up through London around the same time, but everything outside mainstream pop was decidedly male-dominated. As a solo female artist with a nostalgic sound, Amy was peerless. Her husky contralto voice said 'Depression-era jazz bar', but her look – those two thick wings of eyeliner and a Monroe piercing, with her from the very start – said 'Mutya Buena eat your heart out'.

Frank was well received by critics, who admired Amy's originality as a songwriter and gift as a vocalist. *The Times* regarded it as both 'commercial and eclectic, accessible and uncompromising', while *The Guardian* put her sound as 'somewhere between Nina Simone and Erykah Badu [...] at once innocent and sleazy'. A string of awards followed: nominations for British Female Solo Artist and British Urban Act at the 2004 BRIT Awards, a Mercury Music Prize shortlist place and an Ivor Novello Award for the single 'Stronger Than Me'. Though it wasn't released in America until 2007, it received positive reviews in retrospect, with the *New York Times* complimenting its 'glossy admixture of breezy funk, dub and jazz-

←
'Close At The Front'
WORKING LYRICS, 2001. SET AGAINST COTTONS RESTAURANT WALL COLLAGE COURTESY Amy Winehouse Foundation / Sony Music Publishing Ltd

→
Support Act
FOR FINLEY QUAYE, SHEPHERD'S BUSH EMPIRE, LONDON, 13 NOVEMBER 2003
PHOTO David Butler

"An artist I was looking after, Tyler James, said he knew a girl called Amy Winehouse who'd dropped out of school, and things weren't happening for her. I called her and pretended I was this big manager who could make things happen, giving it all the showbiz talk, and obviously she thought I was a wanker.

Nick Shymansky Manager

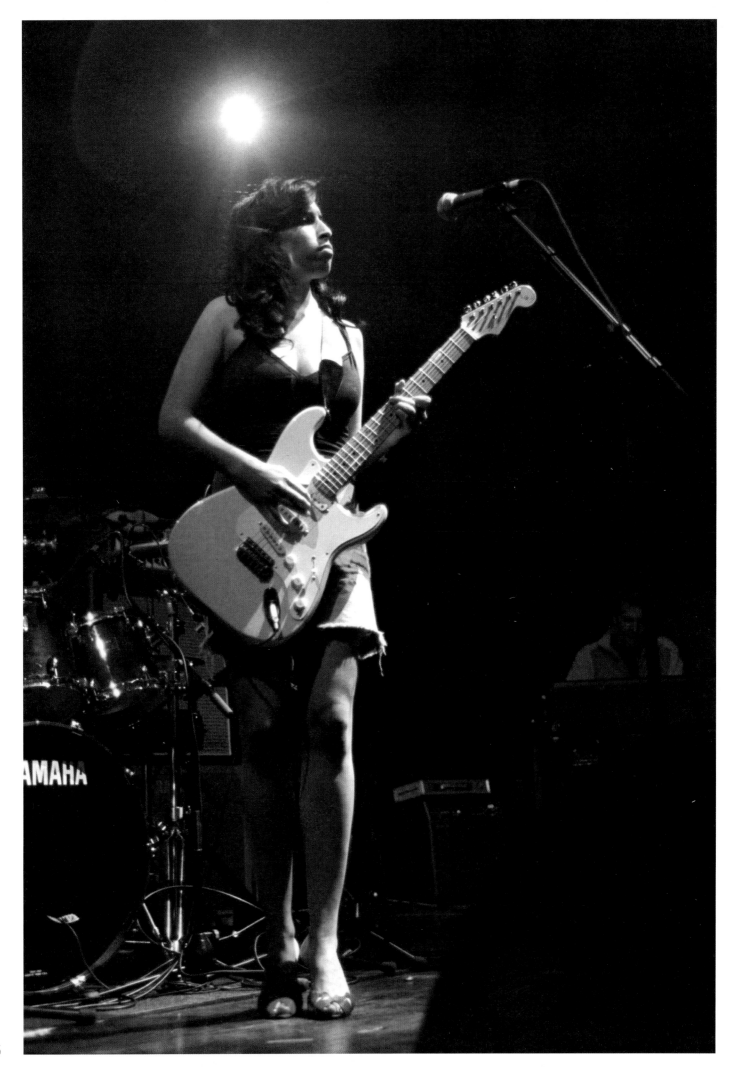

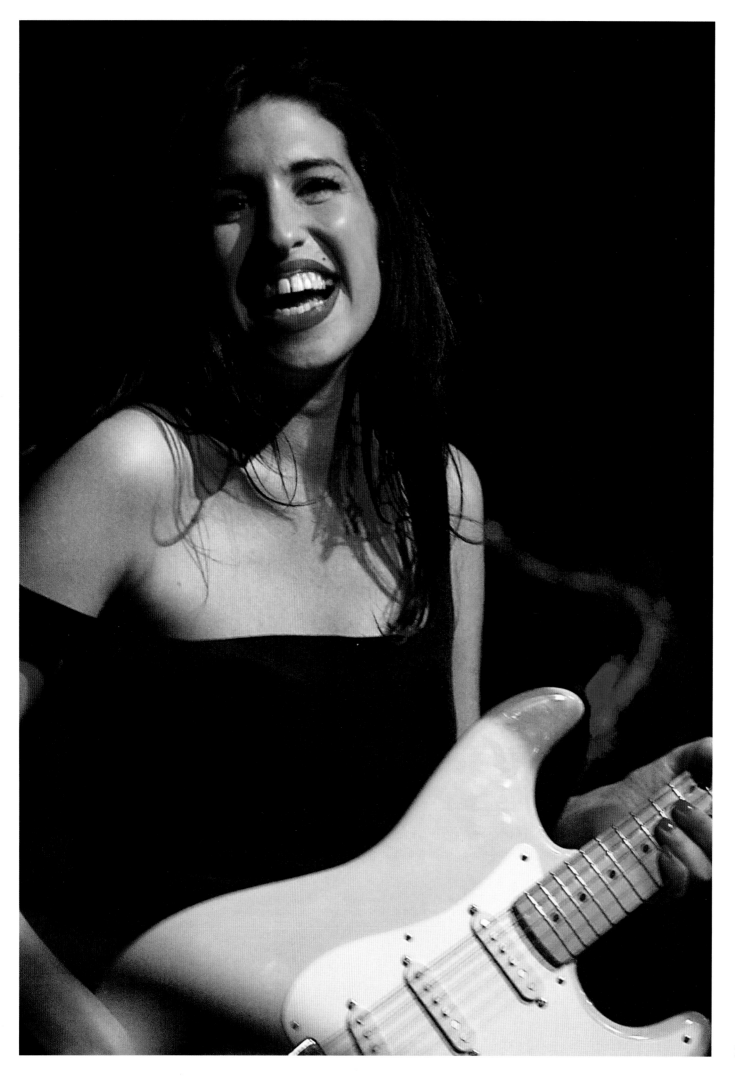

inflected soul' while noting that Amy's style wasn't yet 'fully evolved'.

Amy did well in America, where black history and music history are one and the same. As Jon Pareles notes, 'British soul singing has always been at least once removed from its African-American sources. It doesn't have the foundation that American singers often get by singing in church, since British singers are more likely to learn soul style from their record collections.' In the UK, where the baseline understanding of jazz, soul and blues begins and ends with Jools Holland, Amy was treated initially as a curiosity. Impressive, but different. Who was this vulnerable yet determined young woman who spoke like she ran a market stall on Portobello Road but sang like Billie Holiday?

Themes of love, lack and loneliness were a defining feature of Amy's lyrics. As sixties girl groups like The Shirelles and The Supremes sang of their desire to be desired, pining after men to wash away their tears and love them tomorrow, so too did Amy. *Frank* was a mix of introspective and observational songwriting, balancing tracks that dug deep into her own feelings with those that dug deep into the characters around her. And she filtered it all through her funny, conversational London slang. For Amy, everything was significant but nothing was serious. In an early 2004 performance at New Pop Festival in Baden-Baden, she introduces the graceful, lovesick tune 'You Sent Me Flying' by saying – in that Southgate

drawl, almost as distinctive as her singing voice – that she 'wrote it about a guy I used to like who didn't like me back'.

Again, this was pretty unusual for the time. With the exception of Britney Spears, female vocalists in the early noughties were primarily celebrated for singing about empowerment (think: Christina Aguilera, P!nk, Beyoncé) and teenage angst (think: Avril Lavigne, Vanessa Carlton, Kelly Clarkson). In the UK the scenery was decidedly more muted, with the rise of soulful but gentle singers like Dido, Norah Jones and Estelle. After the 'girl power' message peddled by pop artists in the nineties, admitting that you wanted, let alone needed, a man to take care of you was basically a taboo subject. Amy, never one to adhere to conventions or expectations, didn't care. She sang candidly about men from the get go, with lines such as 'I'll take the wrong man as naturally as I sing' draped over a groovy instrumental like one of her staple off-the-shoulder tops.

This in itself gave Amy an air of tragedy, as it does all women who sing about their devotion to men. From Etta James to Lana Del Rey, there's usually a sense of hopelessness or at least naivety ascribed to heterosexual women who give themselves over to emotion, speaking freely about their desire to be loved and their disappointment when things don't work out. Though it would become the lowest charting single of her career, 'Stronger Than Me' is, in hindsight, a revealing introduction to Amy's inner world – a song that finds her frustrated

←

Jazz Café
PARKWAY, CAMDEN, LONDON
27 JANUARY 2004
PHOTO John Alex Maguire

→

Jeffrey's Place / Prowse Place
HOME FOR FIVE YEARS IN HOUSES ON
THESE ADJACENT STREETS IN CAMDEN
PHOTO Andrew Hobbs

27

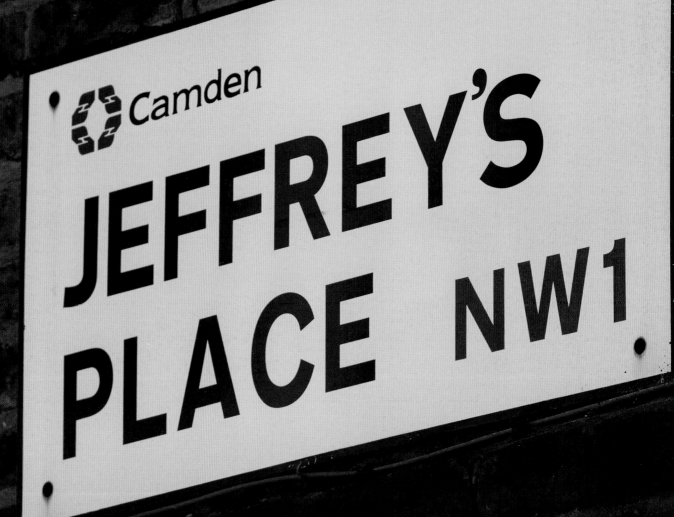

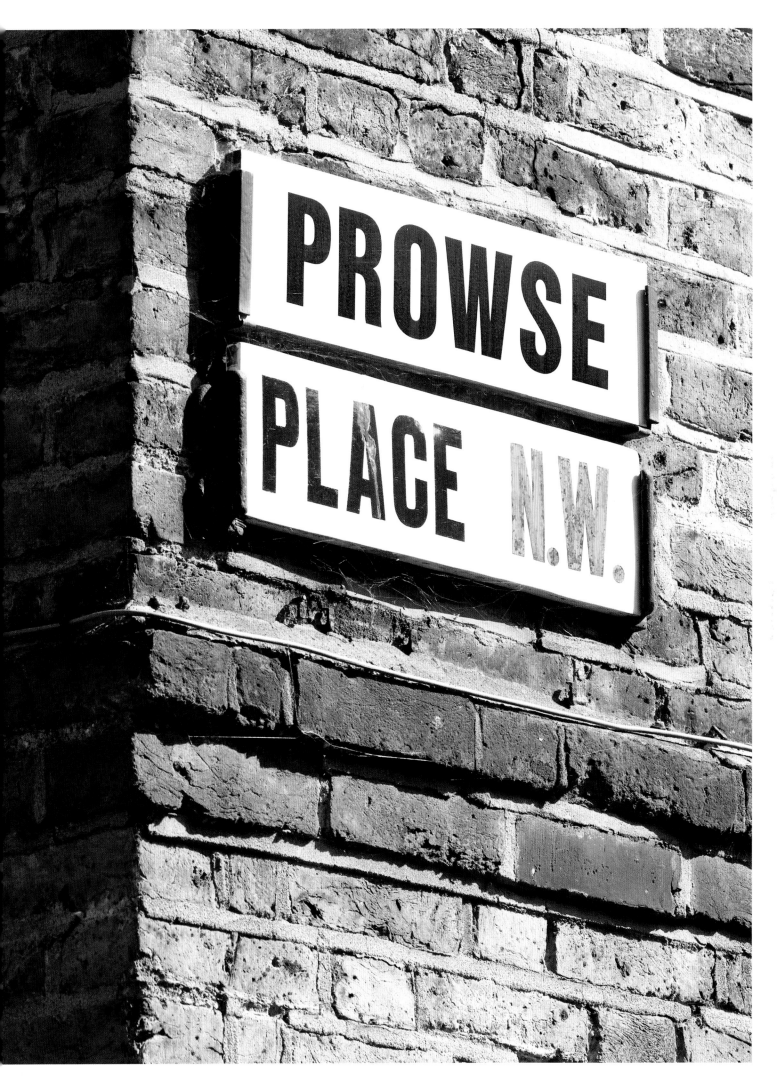

to find no space for her own weakness in a relationship because she spends all her time supporting men ('*You want to talk it through, I'm okay / I always have to comfort you every day*'). In the music video she finds her partner drunk in a bar, tries to take him home and then dumps him on the pavement after he throws up in the taxi. Another uncomfortable case of foreshadowing.

Unfortunately, Amy's relationships were more than a lyrical theme. They became a major part of her story, bound up with alcohol and substance abuse. After *Frank* the British tabloids hounded Amy mercilessly and relentlessly, responding to and fuelling a cultural obsession that reached a fever pitch in the years surrounding *Black To Black*. Sensing a superstar – better yet, a wreck – every messy night out was documented, every tearful moment captured and splashed back in her face in the papers the next day, turning her private battles with drugs, alcohol and men into a form of public entertainment. Amy wasn't the first woman to suffer this treatment, and she wouldn't be the last. There came a point where the number of paparazzi shots in which she was visibly crying, lashing out in self-defence or literally running away by far outweighed the rest.

≈

In the three years between *Frank* and *Back To Black*, Amy overhauled everything – her life, her sound, her image. She moved to Camden, the cultural capital of the UK throughout most of the noughties, which she described as her 'playground' and treated it like one. She was a regular at The Hawley Arms, a go-to haunt for indie darlings and hipster celebrities at the time, as well as The Good Mixer, which was home to two infamous drinks – the 'Rickstasy' (a mixture of Southern Comfort, vodka, Baileys and banana liqueur, Amy's favourite) and the 'Illusion' (which was blue but tasted like pineapple juice), both of which were completely lethal and probably technically illegal.

She liked to shoot pool wherever she could, and was frequently spotted performing, pulling pints or chatting with regulars at The Dublin Castle. After a huge fire destroyed a large section of Camden market in 2008, including The Hawley Arms, Amy signed off her Grammy acceptance speech for Album of the Year by saying: 'This is for London, because Camden Town ain't burning down.'

A ramshackle sprawl of alternative music history, vintage clothes shops, old man boozers and general squalor, Camden became key to Amy's artistic identity. Billed as something of a spiritual home for the reckless and bohemian, it influenced her music and her sense of style, which had developed over time into an amalgamation of all the cultural references she had absorbed like a sponge. Fifties head scarves, waist belts, Capri pants, leather jackets, big nineties-style hoop earrings, mesh vests, bold clashing prints, her ballet pumps from

Camden Crawl
THE DUBLIN CASTLE, CAMDEN, LONDON,
19 APRIL 2007
PHOTO **Samir Hussein**

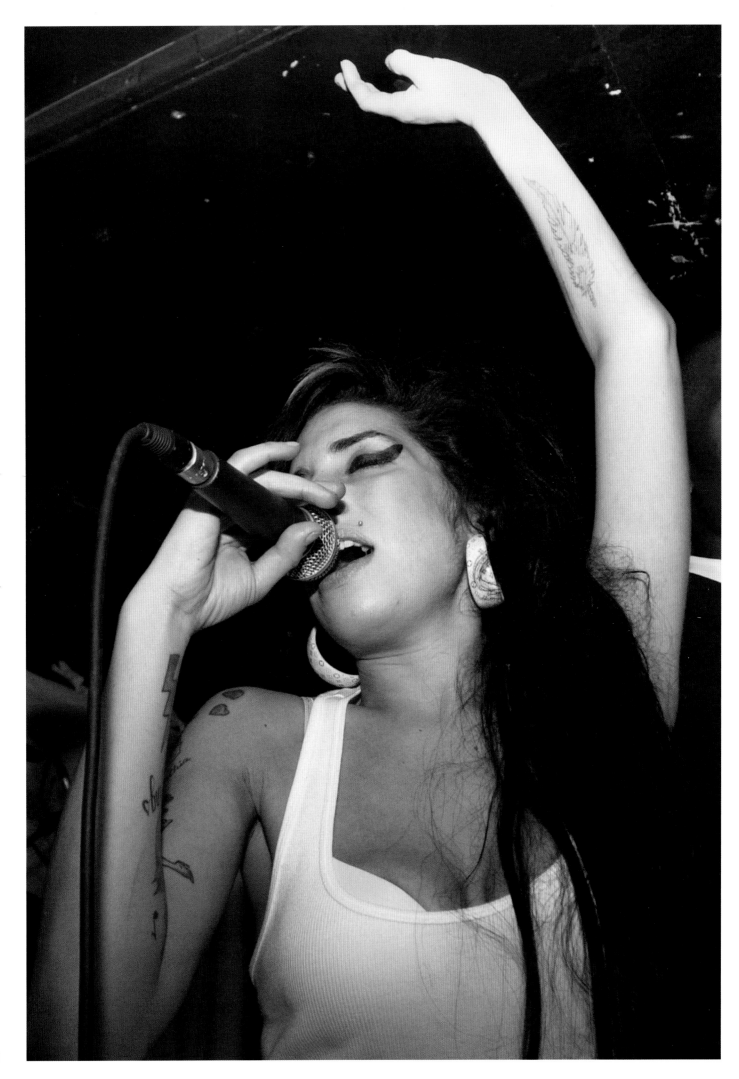

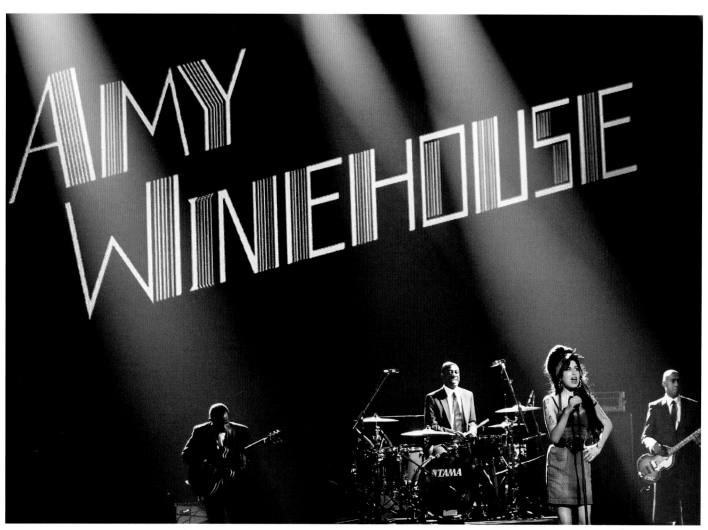

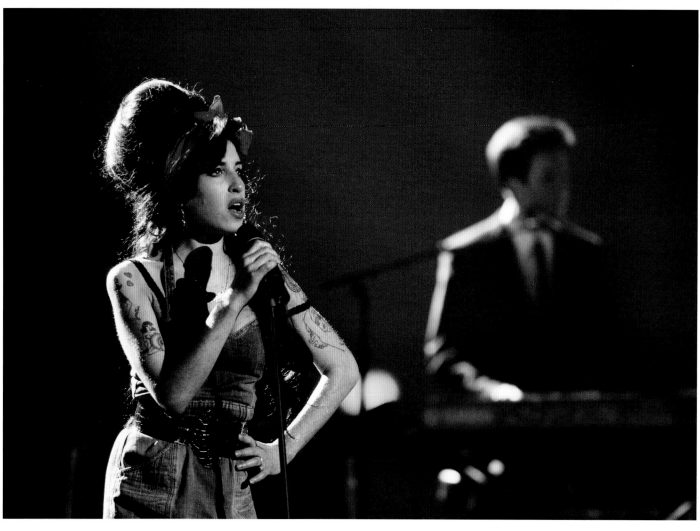

childhood – she was like a sentient stall at Camden Stables, a fifties starlet and her greaser boyfriend rolled into one. *New York Times* style reporter, Guy Trebay, described her as a '5-foot 3 almanac of visual reference', but for Amy it was pure punk rebellion; another way in which she rejected the squeaky clean pop star image at the time. She had a statement, and the statement was imperfection.

It was around this time that Naomi Parry became Amy's close friend and personal stylist. The pair met on a night out, where they clocked each other while backcombing their hair in the toilets. Parry pulled Amy deeper into the world of fashion, introducing her to up-and-coming designers like Preen and mixing high-end names with high street finds in a way that was both accessible and inventive. Though it split the fashion world itself down the middle – one half thinking 'this is a mess' and the other thinking 'this is amazing' – her style became iconic because it made no sense, but was undeniably her own. Though the cobbled together vintage look was already popular in London at the time, Amy took it to the next level, and she took it mainstream.

Once the look had been established, it became increasingly hyperbolic. The dresses got shorter, the cleavage more exaggerated. After her make-up artist, Talia Shobrook, moved to the US, Amy started doing all her make-up herself, and so the winged eyeliner got bolder. (If you make a mistake while doing a cat eye, you have two choices: wipe

it all off, or make it even bigger.) After being introduced to the 'hair baby' – a load of fake hair backcombed and then put into hair nets – by a stylist hired by David LaChapelle for the 'Tears Dry On Their Own' video, the beehive got bigger too, until eventually it was held up by hairspray and sheer will. This, combined with her savage wit and underdog status, made Amy a natural queer icon. 'It's hard to look that cheap and pull it off,' John Waters said after her death – an enormous compliment from the Pope of Trash himself, and one Amy would have enjoyed. It brings to mind an earlier video interview with Kelly Osbourne, who asks if Amy considers herself to be a 'sex symbol'. Amy – who's in the middle of a game of pool at the time, wielding the cue like a weapon – says, without a moment's pause, 'only to gays'.

The move to Camden coincided with a seemingly endless streak of bad news. Amy spent most of her time cutting about Camden with Blake, a former video production assistant she had met in 2005. The relationship was turbulent from the start, always on and off, and they were rarely seen doing anything besides drinking and playing pool. During one period of separation, she began dating the musician Alex Clare after meeting him at The Hawley Arms. In a pattern that Fielder-Civil would later repeat, Clare sold intimate stories about their relationship to the *News of the World*. In 2006, her grandmother Cynthia died of lung cancer, and the loss hit Amy hard.

2007 MTV Europe Awards
OLYMPIAHALLE, MUNICH, GERMANY, WITH HAWI, FRANK AND DALE, 1 NOVEMBER 2007
PHOTO Kevin Mazur

Amy & Sam
2007 MTV Europe Awards
AMY WITH SAM ON KEYBOARDS, DENIM DRESS BY D&G, 1 NOVEMBER 2007
PHOTO Sean Gallup

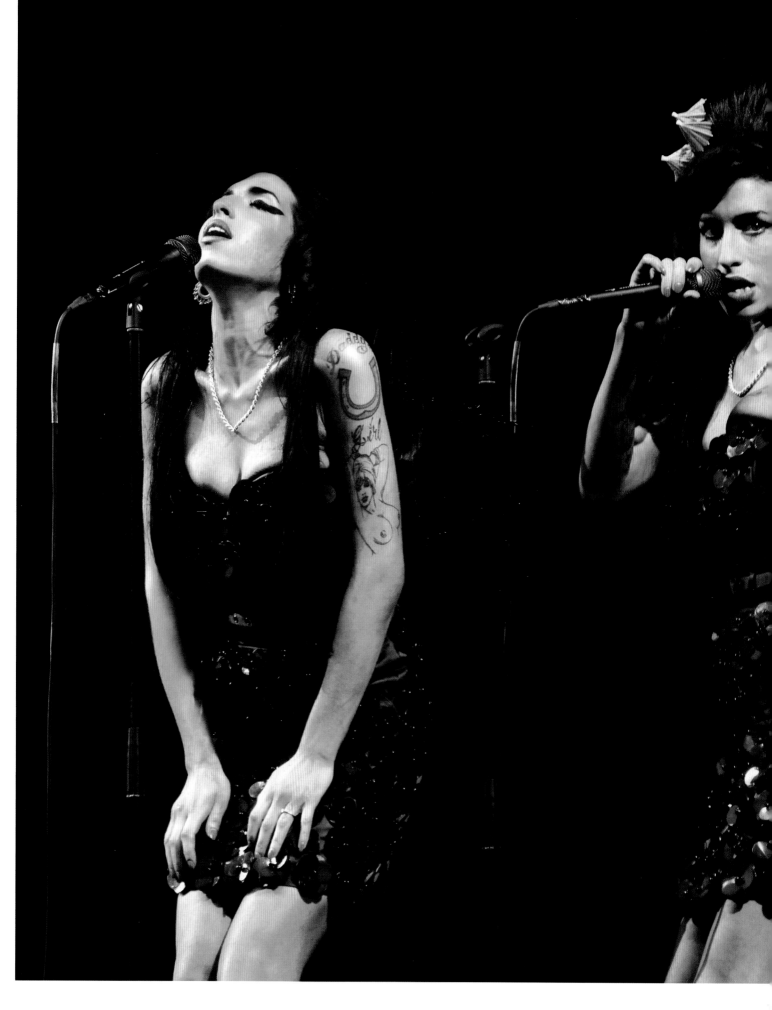

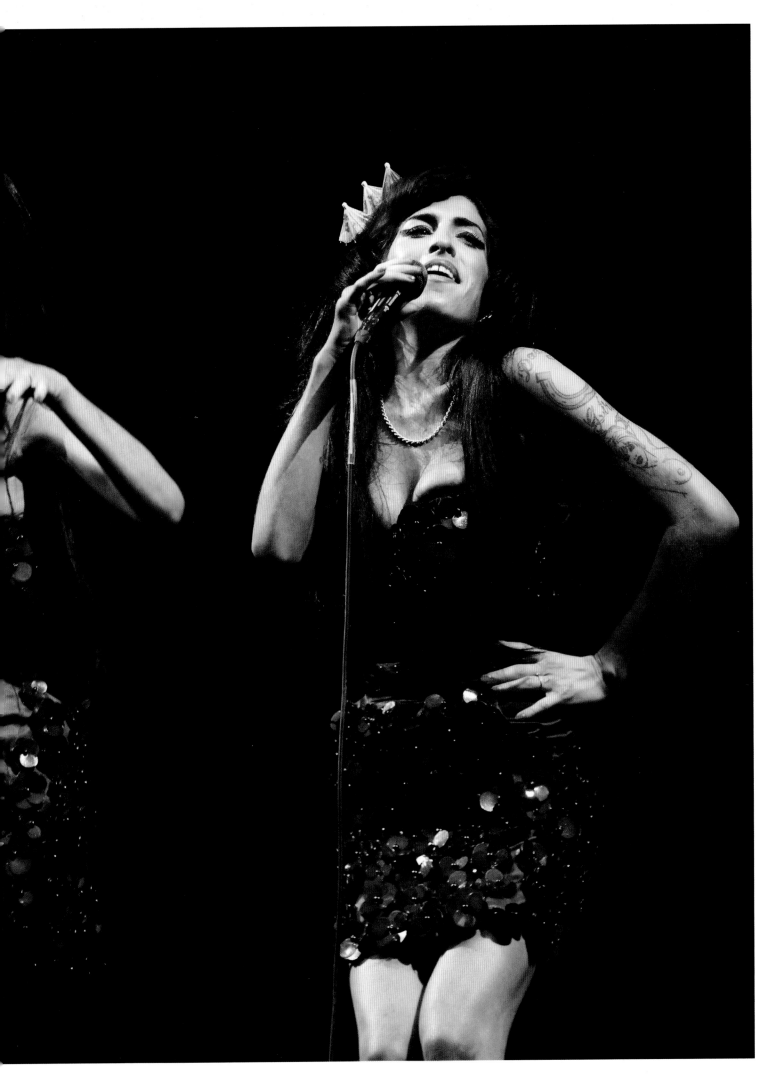

Amy and Blake eventually married in Miami-Dade County on 18 May 2007, and the years that followed were marked by even more troubling events. In June 2007, Fielder-Civil was involved in an assault on pub manager James King outside The Macbeth, for which he was sentenced to 27 months in prison for trial fixing and grievous bodily harm. There were physical fights - between Amy and Blake, this time - and a hospital admission for a suspected overdose. On 24 January 2008, Amy entered rehab for two weeks of treatment. Their divorce was finalized in July 2009. Though the tabloids focused on scandal, Amy was at the height of her commercial success. During this period, and in spite of the mess of it all, she performed on some of the biggest stages in the world: Glastonbury, Lollapalooza, Rock in Rio Lisboa. In 2008, her summer was filled with back to back festival slots at Oxegen, T in the Park, V Festival and Bestival. She opened a Fendi boutique in Paris and performed at Nelson Mandela's 90th birthday concert in Hyde Park. Though hiccups arrived in the form of late arrivals and problems with her voice, she attracted huge crowds and captivated them - for the most part - regardless, with most reviews ringing positive, if a little concerned for her well-being.

Things never calmed down, but Amy kept pushing. In January 2009 she launched her own record label, Lioness Records - a title that feels like her own imprint of Hurricane Amy - and signed goddaughter Dionne Bromfield as her first act. She began working on new music with Salaam Remi and sang with The Specials at V Festival. She designed a collection with Fred Perry - 17 pieces overall, a mix of polo shirts, dresses, sweatshirts and bomber jackets, each emblazoned with two cartoon red hearts, just like the Jiffy bag containing the demo tape she'd given to her manager as a teenager. In 2010 she started a relationship with the English film director and writer Reg Traviss, who was with her until the end.

Though she was said to be working on new material, none came. Speaking to BBC News in late 2009, Island co-president Darcus Beese said, 'I've heard a couple of song demos that have absolutely floored me.' Amy promised the third album - 'very much the same' as the second, 'a lot of jukebox stuff' - would be released no later than January 2011, but it was never finished. It was as if a light, of sorts, had gone out. The dynamic, bright-eyed Amy in her early twenties, who always had a compliment or an insult to hand, had withdrawn. The media storm, fuelled in part by obsessive fandom, put a total stop to her ability to live life like a normal human being. She turned inward, losing some of her natural humour and confidence through nerves - though when she was around people she was comfortable with, it would start to come out again. On 20 July 2011, Amy joined Dionne Bromfield on stage at The Roundhouse for a cover of The Shirelles' 1961 hit 'Mama Said'. She mostly dances throughout the performance, staring up into the rafters and declining to sing

←

Cocktail Umbrellas
PERFORMING AT GLASTONBURY FESTIVAL,
28 JUNE 2008,
DRESS BY LUELLA
PHOTOS Jimmy James

into the mic set up in front of her. She died three days later in her home at 30 Camden Square.

The outpouring of devastation when the news broke was overwhelming. Fans flocked to Amy's address, leaving tributes of flowers, candles, bottles of wine, cans of lager, stuffed toys and hand-written messages on the ground outside. They cluttered the pavement for weeks. One card read: 'You will not be forgotten by Camden. We all love you and will continue to love you. Your legend lives on.'

Meanwhile, celebrities paid their respects online. Sir Elton John described Amy as 'one of the most seminal artists this country has ever produced', while Lady Gaga said she 'changed pop music forever'. In a series of tweets, the late George Michael, who would receive his own tributes under similarly tragic circumstances seven years later, wrote: 'Amy was, in my opinion, the most soulful vocalist this country has ever seen.' The comedian Russell Brand published an emotional essay on his website, recalling his friendship with Amy and their shared struggles with substance abuse and addiction. Adele also published a heartfelt statement on her blog, writing 'Amy paved the way for artists like me and made people excited about British music again whilst being fearlessly hilarious and blasé about the whole thing. I don't think she ever realized just how brilliant she was and how important she is, but that just makes her even more charming.'

A bronze statue was erected in Stables Market in Camden Town on 14 September 2014 – what would have been her 31st birthday. Designed by the artist Scott Eaton, it depicts Amy at her most iconic: strapless dress, beehive and heels. Small, mighty and with a bright red English rose tucked into her hairdo, it represents Amy as she lived and died: a permanent fixture of Camden, for better or worse. Her ashes are buried at Edgwarebury Cemetery, alongside her grandmother's.

Amy Winehouse will be remembered not for her troubles, but for the way she dealt with them. She was a storyteller, and hers were not happy ones. She sang of love and loss as if they were fixed states, and perhaps for Amy they were. Her music is a coping mechanism, in many cases a physical expression of anguish as she digs deep into the very bowels of herself and stays there howling. There's more feeling contained within her delivery of the line *Life is like a pipe / And I'm a tiny penny rolling up the walls inside* on *Back To Black* than there is across most singers' entire discographies. Who else would perform live at The BRITs, then cut off Denise Van Outen's gushing about it with 'it was a piece of shit; you look fit though'? Who else could pull off opening a devastating break-up song with the lyric '*He left no time to regret / Kept his dick wet, with his safe oh safe bet*'? She told tales as old as time, in a voice from another era, in a way that was unmistakably hers. The world had never seen a star like Amy Winehouse before, and it will not see another. She was one of a kind. •

→
Backstreet Stroll
WALKING DOWN GRIMSBY STREET,
SHOREDITCH, LONDON,
JUNE 2003
PHOTO Charles Moriarty

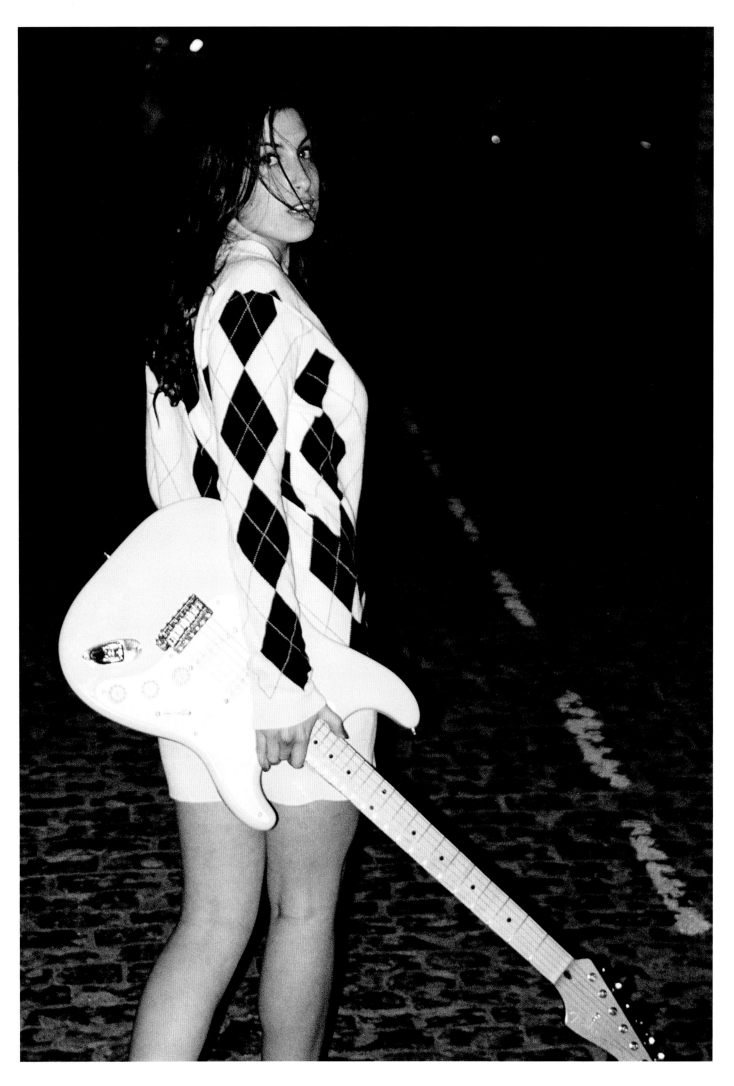

AMY WINEHOUSE \ *FRANK* \ 2002–2004

1

Frank

2002–2004

Amy Winehouse was just 16 years old when she walked into Nick Godwyn's office in 1999. A bright-eyed teenager with a passion for jazz - Dinah Washington, Frank Sinatra, Billie Holiday - and ideas of becoming a roller waitress or a housewife, she was invited to sing for Godwyn and Nick Shymansky after Tyler James (a friend she met when they both trained at the Sylvia Young Theatre School) passed them her demo tape. Godwyn and Shymansky were A&R men at Simon Fuller's 19 Management and had recently signed James as their first artist. Amy's voice blew them away.

During the visit she broke a guitar string and couldn't perform, but she came back again a week later and they knew instantly that there was something special about her. Shymansky, who was only 19 himself at the time, became her manager from 1999 to 2006, and she officially signed to 19 Management in 2002. It was unusual for a company to spend so long developing an artist, and Amy was kept an industry secret during the process. However, she had joined the National Youth Jazz Orchestra in 2000, and regularly performed live at the Cobden Club with the Bolsha Band where she first met her long-time backing singer, Ade Omotayo.

Meanwhile, Darcus Beese, then Head of A&R at Island Records, stumbled across Amy by chance. John Campbell, manager of brothers Pete and Steve Lewinson (producers/musicians who have worked with Joss Stone and others) showed him some productions of his

clients, which featured Amy as a key vocalist. Beese knew then and there that he wanted to sign her - but he had to find out who she was first. He continually asked around to no avail. He called 19 Management, who wouldn't get back to him. Six months later, he ran into Sugababes songwriter Felix Howard, who played him some tracks he'd been working on, and Beese recognized one voice immediately. He asked who it was, and Howard said 'Amy Winehouse'.

By the time Beese managed to track Amy down, interest in her had started to build. She had recorded a number of songs and signed a publishing deal with EMI, where she formed a working relationship with producer Salaam Remi. Representatives of EMI and Virgin were making moves for a record contract based solely on the strength of her demos, but in December 2002, Amy signed with Island/Universal, which released her debut album *Frank* on 20 October 2003.

Frank was recorded between 2002 and 2003, with Salaam Remi acting as the main producer alongside 'Commissioner Gordon' Williams, Jimmy Hogarth, Matt Rowe and Amy. The album includes several songs from her original demos, including 'I Heard Love Is Blind', 'In My Bed' and 'Take The Box'. Apart from two covers - Eddie Jefferson's 'Moody's Mood For Love' and the Isham Jones-composed thirties jazz standard '(There Is) No Greater Love' - every song was written by Amy, though a glance at

Lipstick
RITZ TOWER, PARK AVENUE, NEW YORK,
JULY 2003
PHOTO Charles Moriarty

Phone Booth
SOHO, NEW YORK,
JULY 2003
PHOTO Charles Moriarty

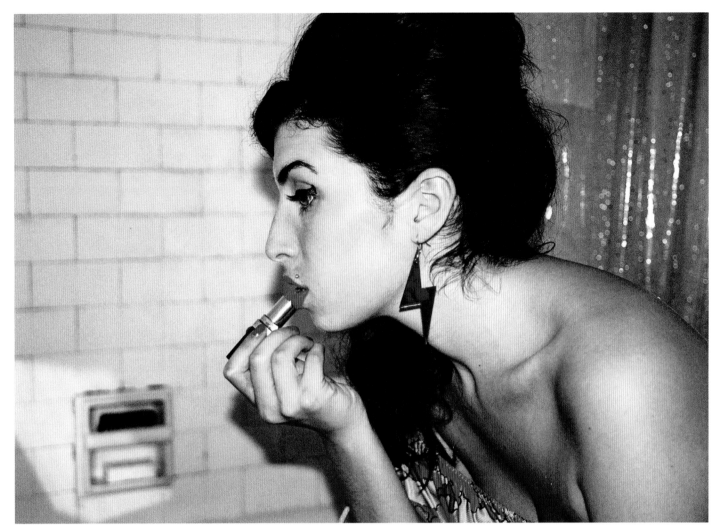

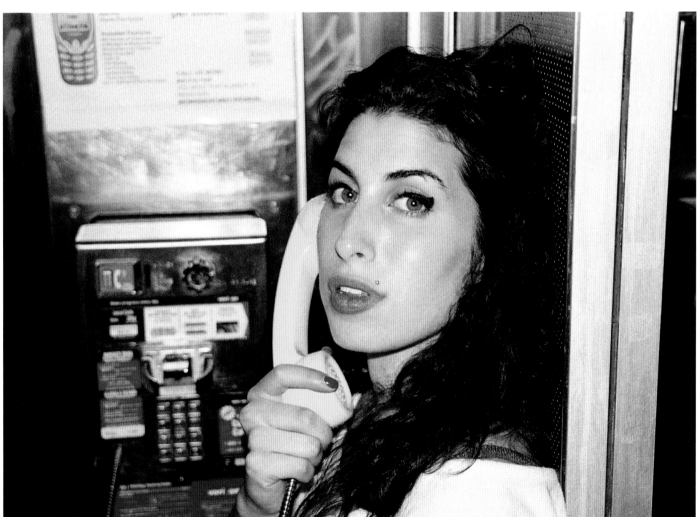

♡ Frank

1. Stronger Than Me - Salaam
2. Fuck Me Pumps - Salaam
3. Take The Box - Gordon (fast)
4. You Sent Me Flying - salaam
5. Do Me Good - Gordon
6. What Is It Bout Men? - Gordon
7. October Song - Gordon
8. Best Friends - acoustic - also fast
9. What It Is - acoustic BSIDE with new end.
10. Close ~~the Front Door~~
11. Take The Box slow (original) (slow)
12. I Heard Love Is Blind - Salaam
13. Round Midnight - Salaam
14. Moody's Mood for Love - Salaam
15. Fool's Gold
16. Mr Magic
17. In My Bed
18. Know You Now

♡

double a-side 1st :

Fuck Me Pumps / Take The Box
2nd In My Bed
3rd Stronger Than Me

'Help yourself!'

MONDAY 21st July.

priorities:
* get films, good prints and all negatives
 (plus clothes I do not want + shoes) to
 Naomi. Speak about contact sheet
* get to Torrington practically ready by 6pm
* get pink paper lyrics to Kate (find ones
 you already did).
* deposit cheque from Shepherd's.

CALL:
* Orange to cancel account.
* TV license people to say Mama paid
* ~~BT~~ Zurich to make the claim, but get
 yo facts right first.

house:
* clear garden out
* get in loft + put suitcases there
* paint bedroom 2 just emulsion
* ~~get~~ ~~out~~ to A4 picture frames

other:
* laundry ⎱ breakfast
* sunbed ⎰

D+G skirt, pink Moschino vest + Stella
vest. Marc Jacobs pumps, cute scarf in
hair + jewellry.

OUTFIT 1 - inside or on steps outside
blue bikini top, coral bedjacket, yellow
shorts + black Paste Mistress wedges. SOME WITH GUITAR
hair in curlers + scarf. no jewellry.

OUTFIT 3 - night location
white towel space dress + red dotty wedges
red lips + guitar + jewellry.

OUTFIT 4 - night location
Miss 60 leaf dress, DKNY laceups + big
earrings, def. guitar.
[bighair] OUTFIT 5 - night location
Beyoncé dress, pink Louboutins, nice
earrings, big hair, smoky eyes pink lips

Outfit 6
Dirty Dancing tee, red ankle straps
big hair + plastic jewellry.

Album Preparation Notes
TRACKLIST, PRODUCTION, PHOTO SHOOT WARDROBE
& OTHER ESSENTIALS
JULY 2003
COURTESY Amy Winehouse Foundation

3/7/03

I had just finished university – with an idea to move into the
film industry. I enjoyed taking pictures of my friends when we went
out, and one of my friends who knew this asked if I would take
some of Amy and see what I could capture.

CHARLES MORIARTY PHOTOGRAPHER

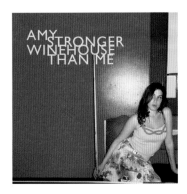

'Stronger Than Me'
ISLAND RECORDS
6 OCTOBER 2003

'Take The Box'
ISLAND RECORDS
12 JANUARY 2004

'In My Bed' /
'You Sent Me Flying'
ISLAND RECORDS
5 APRIL 2004

'Pumps' / 'Help Yourself'
ISLAND RECORDS
23 AUGUST 2004

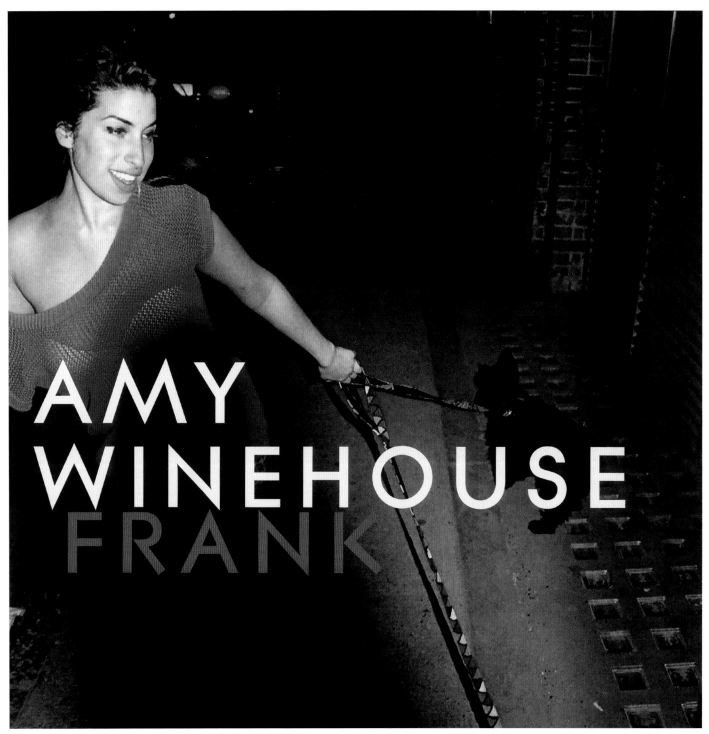

Frank
ISLAND RECORDS, 20 OCTOBER 2003

the liner notes will show that *Frank* is the result of many cooks and many kitchens. A selection of co-writers, including Felix Howard ('You Sent Me Flying', 'What Is It About Men'), were brought in to work on the album during its creation across five different studios in Miami, London, New York City and New Jersey.

Loose in sound and languid in nature, with a distinct streak of hip-hop and modern R&B throughout, *Frank* had a stripped-back feel that allowed Amy's lyrics - and therefore, her personality - to occupy the foreground. Although she was just 19 when she wrote the songs, she dug deep, tapping into a universal wisdom that evades most artists even in their winter years. In one breath she'd be chiding desperate groupies and lousy men, and in the next she'd be revealing her wounded heart in almost photographic detail. The artwork is just as candid: a flash photo of Amy taken on the streets of east London at night, looking away from the camera and smirking. It was shot by then-amateur photographer Charles Moriarty on Princelet Street in Spitalfields. Moriarty and then-flatmate Catriona Gourlay and other friends were walking around, drinking wine, when a man walked past with two black Scottish terriers on a rainbow lead. Catriona asked if they could borrow them for a photo; Moriarty took the photo and it was chosen as the cover.

You couldn't get much further from the bright, glossy, studio shots that graced most solo artist album covers at the time, but Amy's rise aligned with the early-noughties emergence of young jazz singer-songwriters like Norah Jones, Katie Melua and Joss Stone, and she was initially considered part of the same wave. However, it became clearer with every interview in which she spoke with even less of a filter than she had on the album, that Amy was a different kettle of fish. Her voice, in every respect, commanded attention. Critics compared her vocals to jazz greats like Nina Simone and Sarah Vaughan, with *The Times* journalist Dan Cairns admiring her 'refreshingly outspoken' nature. 'It is no exaggeration', he writes, 'to state that the voice with which Winehouse articulates this mental warfare is one of the most extraordinary to be heard in pop music for years.'

Frank entered the UK Albums Chart at No. 60 before climbing to No. 13 in late January 2004. It debuted at No. 61 on the Billboard 200 in the US, selling 22,000 copies in its opening week. However, Amy expressed ambivalence towards the album. She wasn't a fan of the 'fake' strings that were put on 'Take The Box', and felt frustrated with the marketing and the promotion. As an emerging artist sharing credit with five other producers and a shopping list of co-writers, Amy perhaps felt as though some creative control had been wrestled away from her, but ultimately *Frank* was a captivating debut that did its job. It introduced Amy to the world. •

"I've never heard the album from start to finish. I don't have it in my house. Well, the marketing was fucked, the promotion was terrible. Everything was a shambles."

"When I heard her demos I wasn't sure cos I thought it was kinda maybe a fake Erykah Badu-ish type vibe. When she sat in a room with me and opened her mouth and played her guitar I was clear that she had something special — from that moment onward we just started working. She inspired me to tap

back into an area of jazz that I hadn't really heard since I was a kid... and to really make a very jazz, very hip hop album — drums underneath an organ with a trumpet, staying on both sides of it. When I saw her, I thought, OK, you're 18 now, what are you gonna be by the time you're 25 and that was big for me."

Salaam Remi Producer

Her name is Cherry
We just met
But already she knows me better than you ~~do~~
She understands me
~~Fifteen~~ Twenty is ~~years~~
And you still ~~don't like me~~ don't see me, like you ought to do
She's with me always
~~Side by side, Hand in~~ Hand ~~in handle~~

tune - moon, loon, croon, dune, immune,
june, balloon
tune you up - cup,

Maybe we could talk bout things
If you was made of wood and strings
Hand in handle, side by side
~~couldn't~~ Couldn't leave her if I tried

brown ~~down~~ browned
tune you down - town, round, around,
sound ground, hound, mound.

☆ You know me well enough to ask me what I want
for my birthday. You shouldn't have to ask - and
sometimes you forget on purpose.
☆ ~~Maybe you shoul~~ Maybe we could talk bout
things/
If you was made/of wood +
Strings.
Hand in But you're only human
handle

Hand in handle, by my side
side - ride, lied
confide, cried,
denied, tried

'Cherry'
WORKING LYRIC SHEET, 2002
COURTESY Amy Winehouse Foundation /
Sony Music Publishing Ltd

Launderette
PARKWAY, CAMDEN, LONDON.
1 FEBRUARY 2003
PHOTO Rick Smee

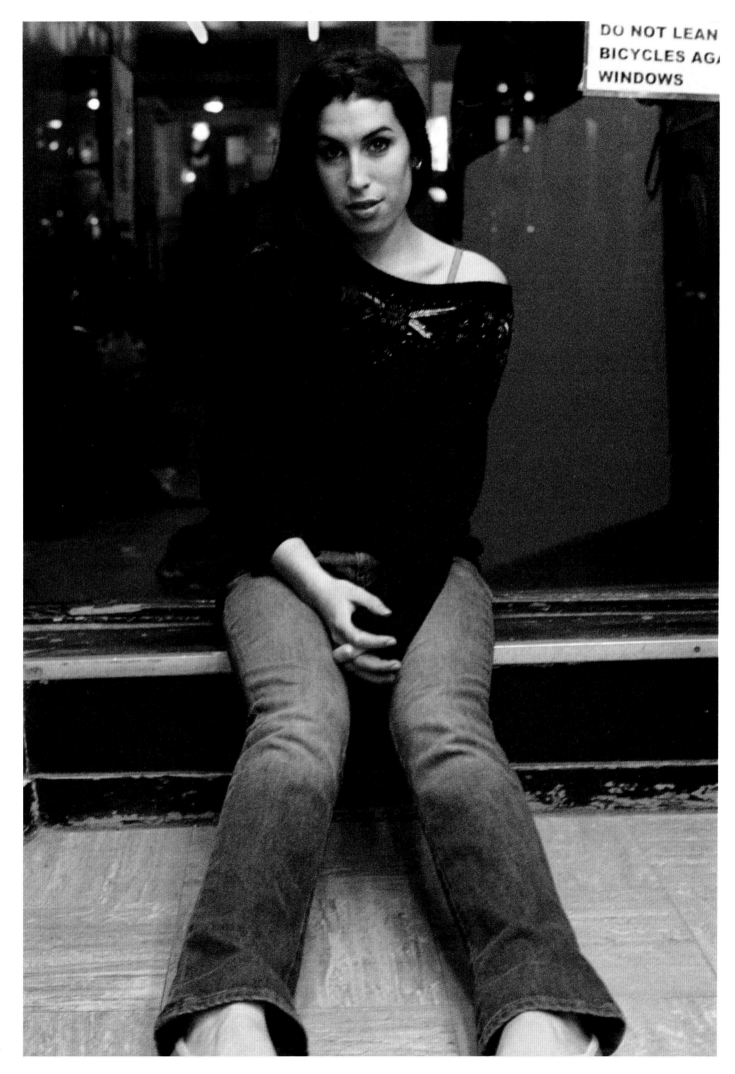

DO NOT LEAN
BICYCLES AGA
WINDOWS

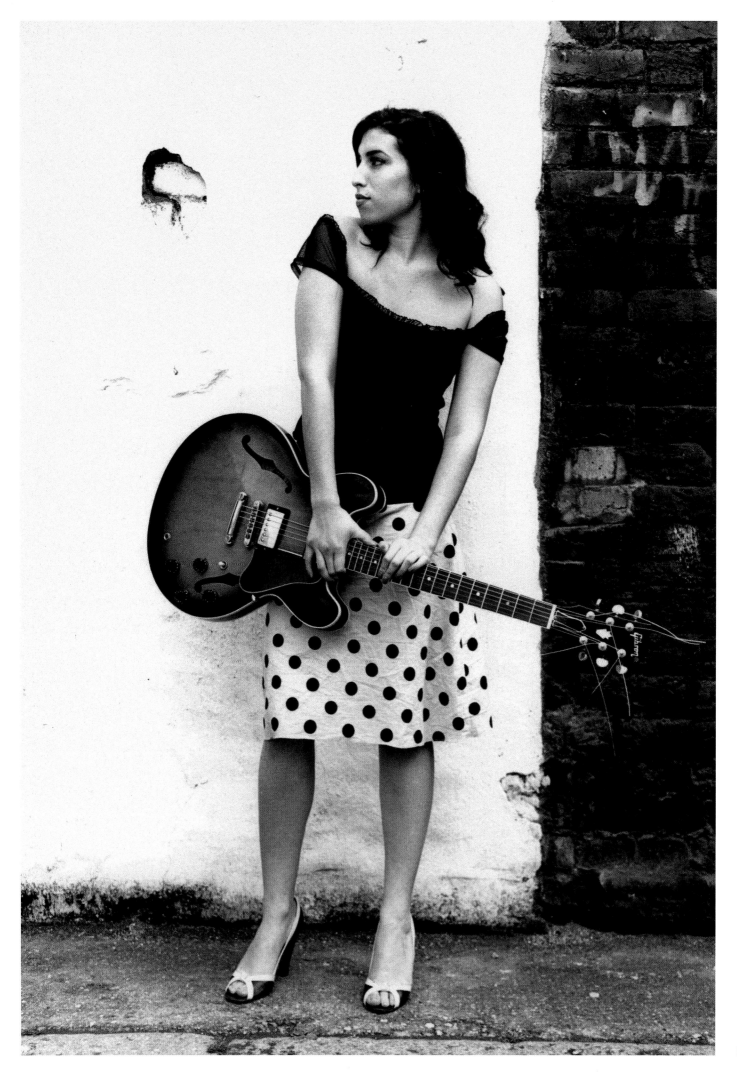

ALBUM REVIEW
Frank

Greg Boraman,
BBC Music, 2003

It is rare for such a young performer to debut with such assurance, confidence and to such instant acclaim, but north London sensation Amy Winehouse already has a reputation that many far more seasoned artists would swap their gold discs for. Winehouse combines a distinctive '20-a-day' voice with a serious appreciation of female jazz and soul heroes (Sarah Vaughan's scatting style seeps through Amy's vocal ad-libs as well as getting a name check). She combines considerable jazz guitar ability with a classic approach, which produces contemporary, quirky, upfront, tongue-in-cheek and risqué lyrics. Her version of the eternally hip jazz track 'Moody's Mood For Love', which rides over a dub reggae rhythm, demonstrates this attitude: it looks back in order to know where it's going and, although in print this idea might raise a musical eyebrow, in reality it sounds like a perfect partnership.

The first single, 'Stronger Than Me', contains all of these qualities and proves that jazz-influenced contemporary soul needn't be safe or sullied by the dinner or 'smooth' prefixes. Lyrically fresh and uncompromising, the only occasional weakness across the collection are the sometimes obtrusive programmed beats, but recent radio and television appearances confirm that Winehouse live has a wonderfully organic sound that supports her approach well. Amy's influences (Vaughan, Dinah Washington and the more contemporary Badu et al.) are obvious but not overpowering, and Winehouse has enough attitude, talent and chutzpah to make any comparisons fleeting and pointless. In fact, on the delicious, lush and soulful 'Put It In The Box', she out-Badus Erykah brilliantly, using a similar female perspective on broken relationships to get her point across very directly. This is Amy's first release and augurs well for her future. If this is what the young lady is capable of at such an early stage, it must be pretty certain that this will be the first in a long line of well crafted, funky and feisty releases. •

Amy with Gibson ES-335 Sunburst
Semi-Acoustic Guitar
CAMDEN, LONDON, JUNE 2003
PHOTO Alexis Maryon

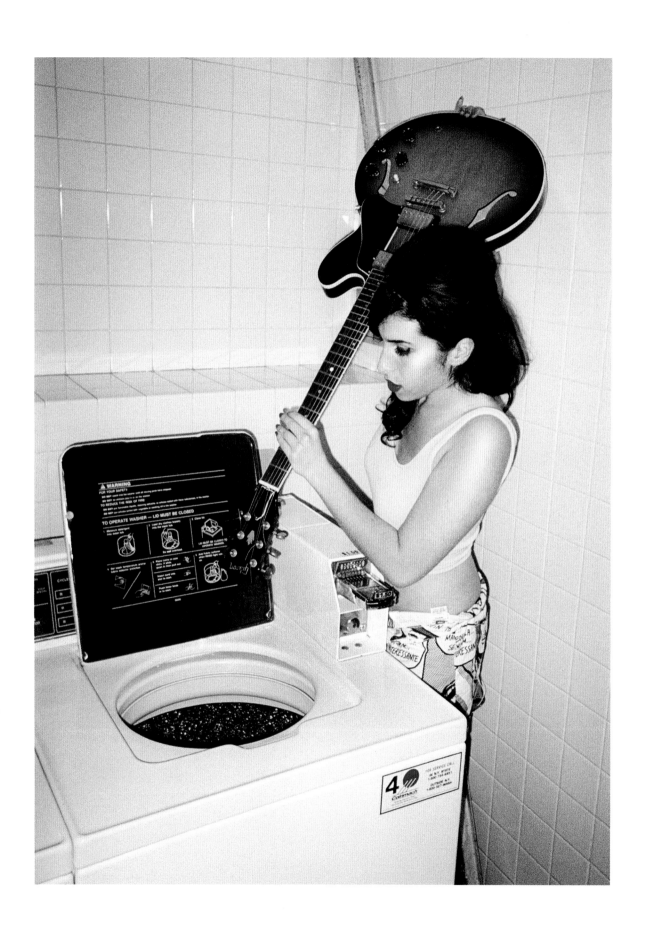

↑
Laundry Room
RITZ TOWER, PARK AVENUE, NEW YORK,
JULY 2003
PHOTO **Charles Moriarty**

→
Rollers
RITZ TOWER, PARK AVENUE, NEW YORK,
JULY 2003
PHOTO **Charles Moriarty**

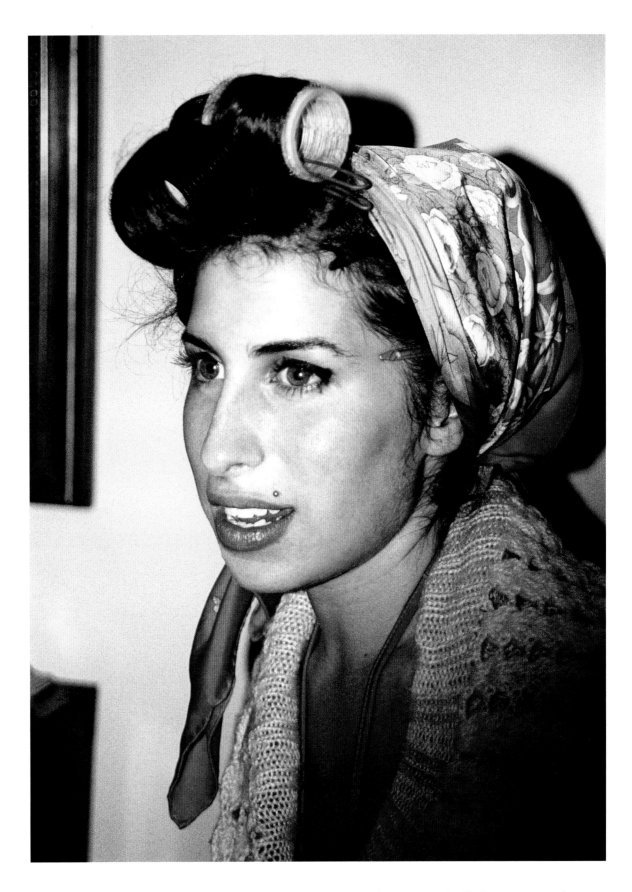

"Amy started getting ready, putting on make-up and all that. Even the curlers she used seemed to be from another time - but that was very Amy, and it seemed appropriate for her. And who knew that what she came up with right there would become her quintessential style trademark."

CHARLES MORIARTY PHOTOGRAPHER

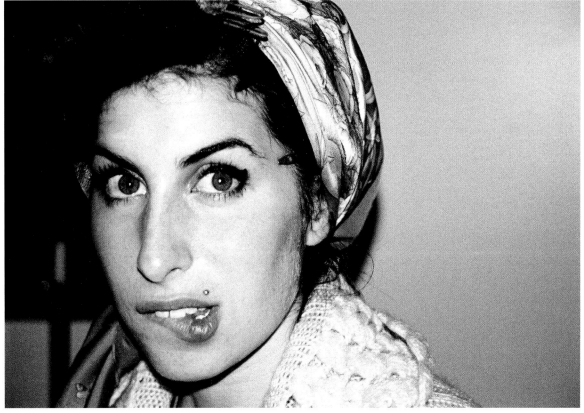

Make-up & Hair
RITZ TOWER, PARK AVENUE, NEW YORK,
JULY 2003
PHOTOS Charles Moriarty

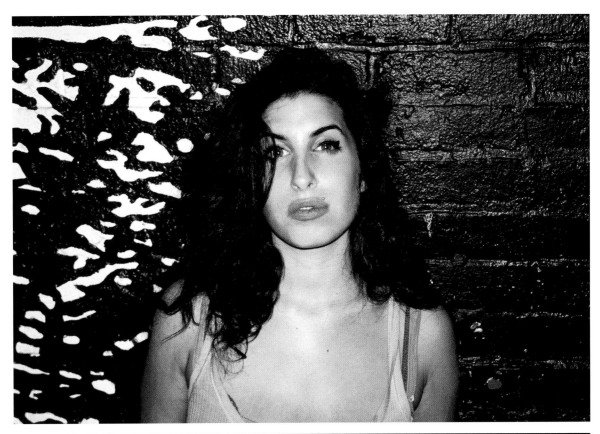

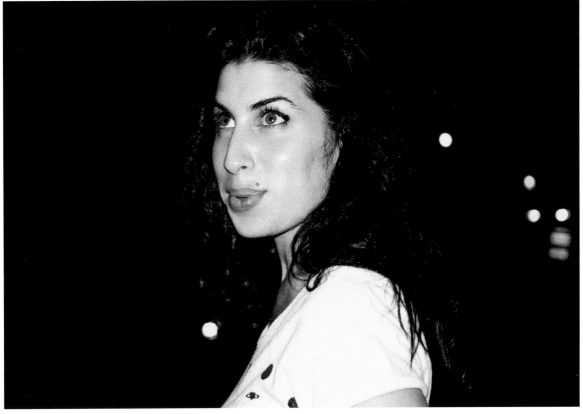

Downtown
NOHO & SOHO, NEW YORK,
JULY 2003
PHOTOS Charles Moriarty

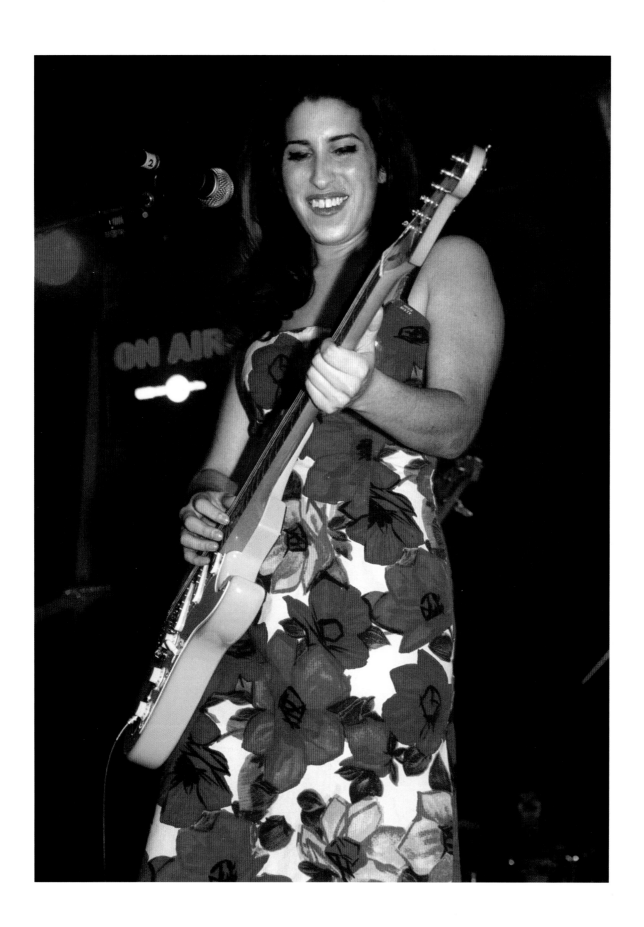

↑
Live at The Stables
THE STABLES THEATRE, WAVENDON,
BUCKINGHAMSHIRE, 14 NOVEMBER 2003;
BROADCAST BBC RADIO 2, 29 MARCH 2004
PHOTO Ian Dickson

→
Backstage at The Stables
THE STABLES THEATRE, WAVENDON,
BUCKINGHAMSHIRE, WITH AMY ARE (L–R)
IAN, STUART, BEN AND DALE
PHOTOS Ian Dickson

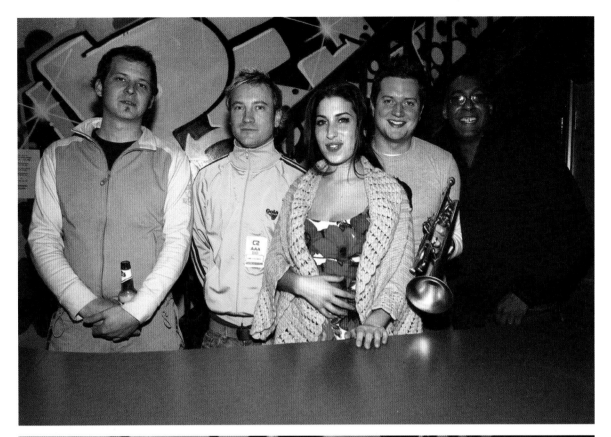

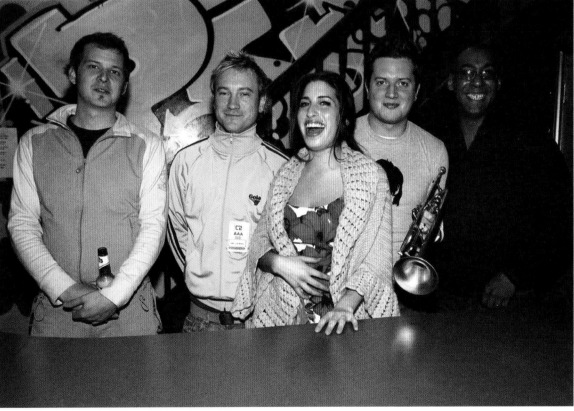

"Her first album, *Frank* really changed my life. I went to music school when I was 14, and when I was like 15 and a half, *Frank* came out. I used to see her on TV or in magazine shoots with a pink electric guitar, and I used to think she was the coolest motherfucker on the face of the earth."

ADELE ARTIST

"She seemed really quiet and shy when I met her. We arranged a shoot date and a location. The location we decided upon was Portobello Road and Golborne Road, in the west London area. So we spent a fantastic day; she was up for ideas, a great subject. She was pretty funny, in a London way."

Phil Knott Photographer

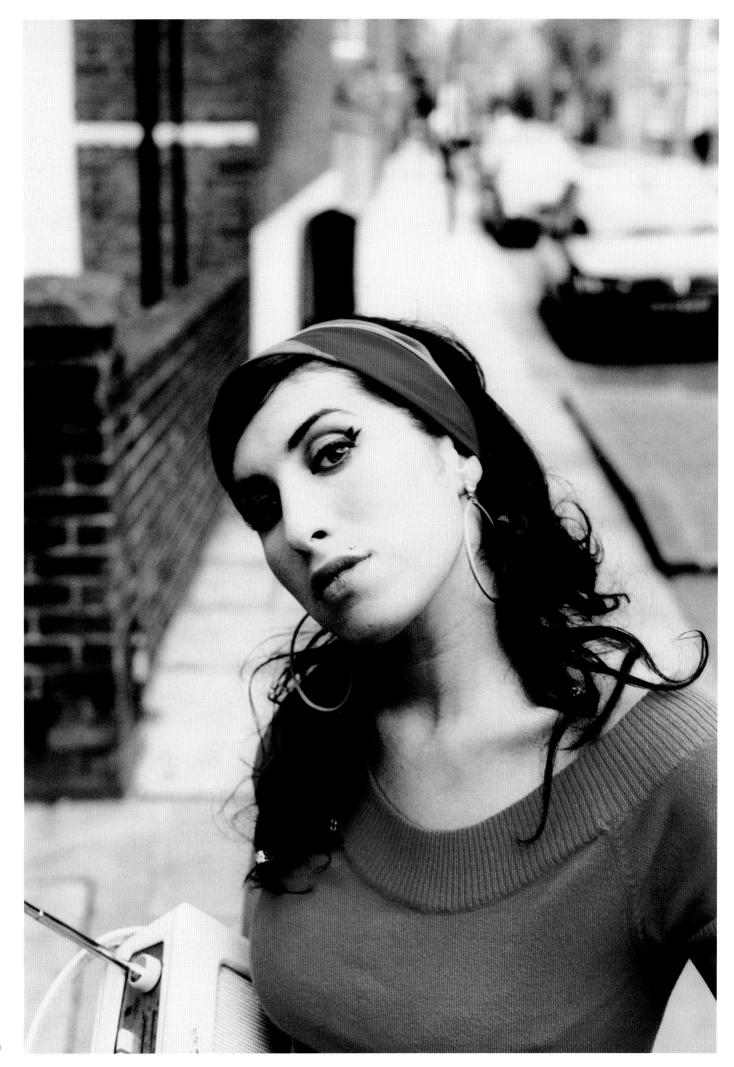

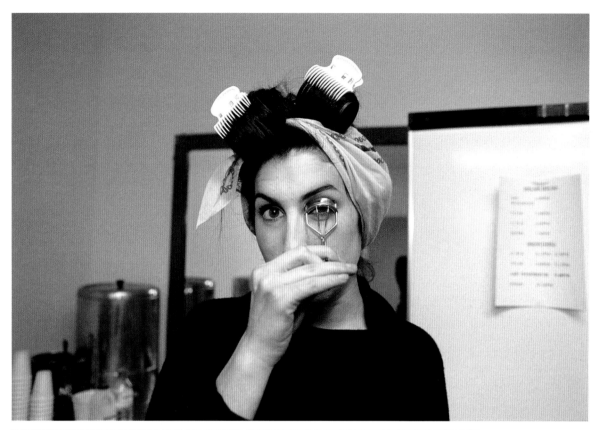

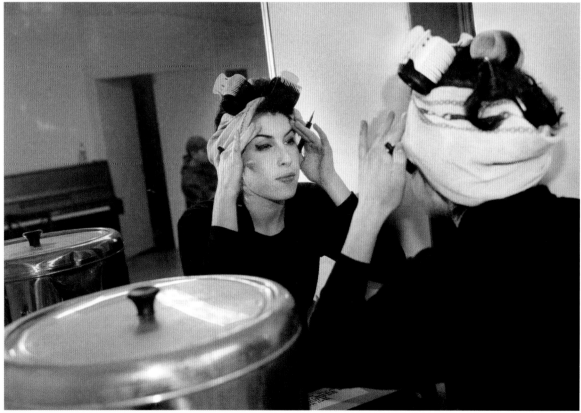

←

West London Strut
AMY WITH PINK ROBERTS RADIO
OFF HARROW ROAD, LONDON,
SEPTEMBER 2003
PHOTO Phil Knott

↑ / →

Backstage, Onstage
BUSH HALL, SHEPHERD'S BUSH,
LONDON,
2 DECEMBER 2003
PHOTOS Karen Robinson

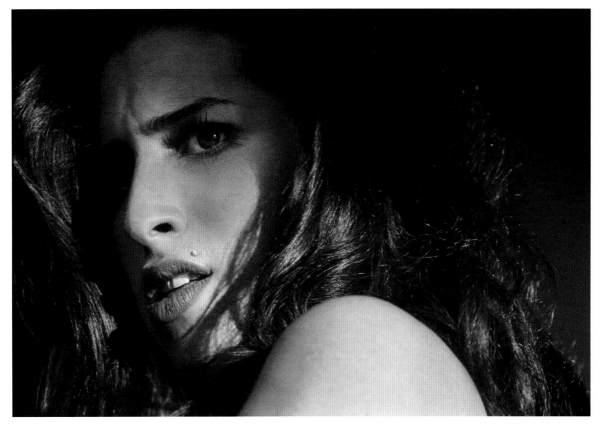

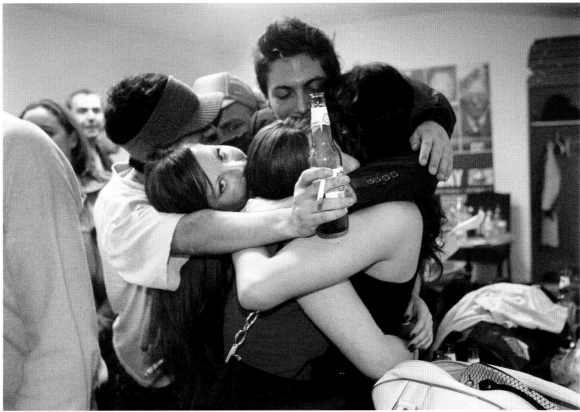

"The first time I met Amy she was wearing rollers backstage at the Bush theatre, preparing for her gig. She was friendly, smart, cool, utterly sober and alone. Backstage, after her amazing gig, her friends swarmed around giving her a huge group hug. They were just excited school kids."

KAREN ROBINSON PHOTOGRAPHER

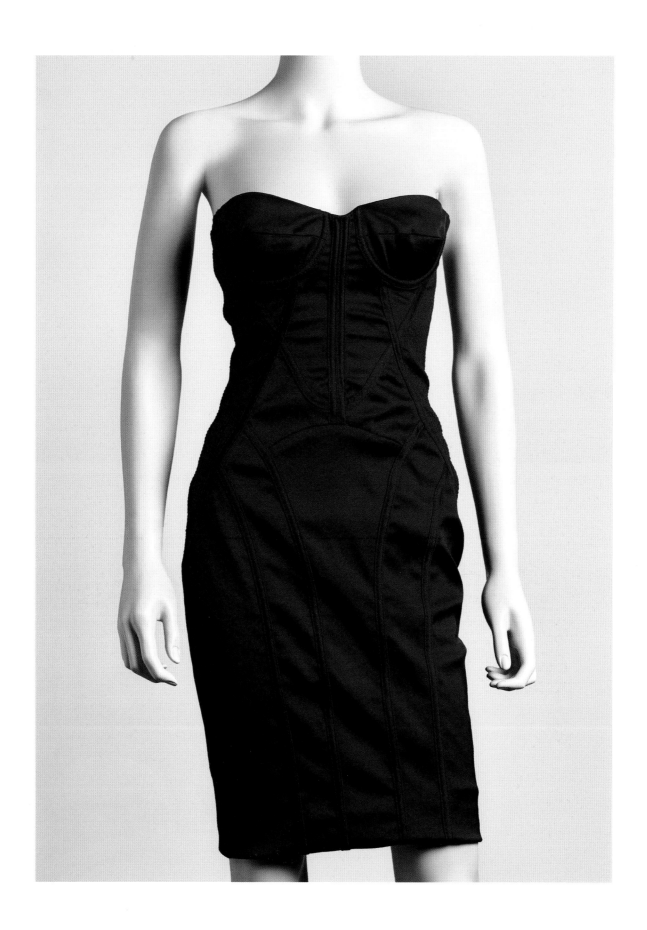

2004 BRIT Awards Nominations
Stage Dress
DRESS BY KAREN MILLEN,
2004

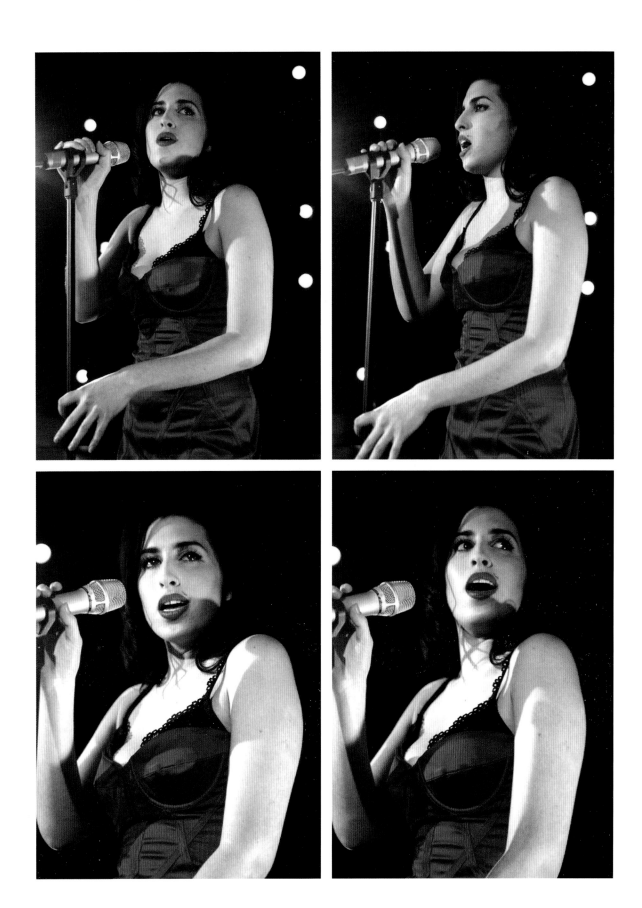

2004 BRIT Awards Nominations
Performance
LONDON, 12 JANUARY 2004
PHOTOS Brian Rašić

↑
At the Launderette
PARKWAY, CAMDEN, LONDON,
4 FEBRUARY 2004
PHOTOS Diane Patrice

→
Pool Hall
COUSINS, SEVEN SISTERS ROAD, LONDON,
4 FEBRUARY 2004
PHOTOS Diane Patrice

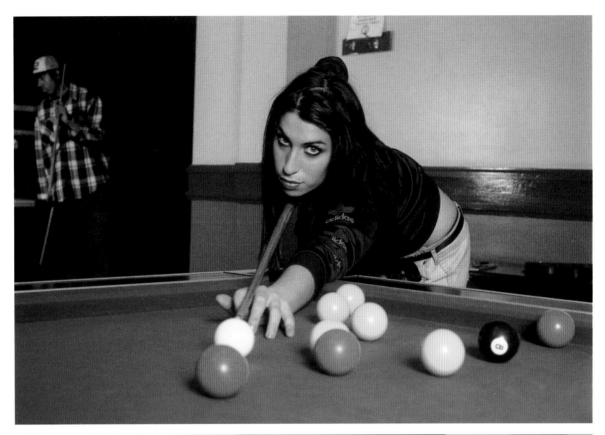

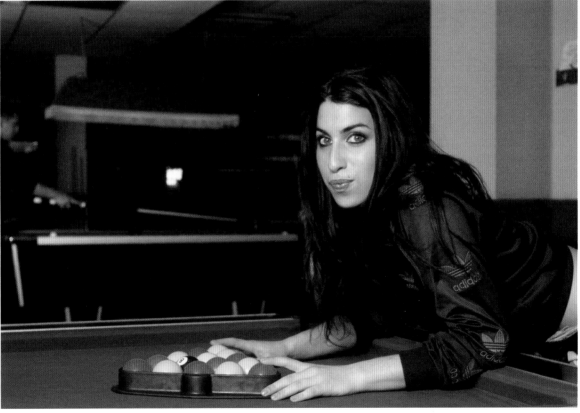

"She was perfectly unpolished. Kind with a potty mouth. A powerful, confident presence yet understated – quite a raw and authentic soul, unlike anyone I had photographed before. Amy styled herself with a look that was timeless; I sensed she was a rebel with a huge heart and a filthy laugh."

DIANE PATRICE PHOTOGRAPHER

Douglas Charles-Ridler
Owner, The Hawley Arms, Camden

I first met Amy in 2003 when I was working at the Lockside Lounge in Camden. She strolled in with Tyler James one Sunday afternoon, wearing an Adidas zip-up top, big hair and big eyes. I asked her what she did and she said she was a jazz singer. From that moment I was hooked. After that I was always bumping into her around Camden, mostly in The Good Mixer by the pool table. We would talk about our shared love of soul, funk and jazz while she went about the business of thrashing me at pool. She was a very good pool player.

By December 2004 I had acquired the lease on an old boozer just below Camden Lock railway bridge – The Hawley Arms. The first thing I did was install a jukebox. Amy loved it. We could rarely get her off it, in fact. It was always 'One more song!' or 'Tune! Turn it up!' The pub became a post work spot for MTV staff and presenters who were based just round the corner. Musicians had the run of the place – Pete, Carl Barât and Gary Powell from the Libertines and Jonny Borrell and Razorlight were regulars.

One evening Dave McCabe was in. I introduced him to Amy and they bonded at the jukebox. They put on the Zutons' 2006 hit 'Valerie', and Amy loved it. She covered it the next year for Mark Ronson's album *Version* and it was released as a single in October 2007. It was a huge hit, spending 39 consecutive weeks in the UK singles chart. McCabe later commented, 'I love it. Amy absolutely nailed it.'

Amy loved to jump behind the bar and help. It made her happy to be one of the bar crew. She always had time to chat to the customers too. The Hawley was both her playground and her safe space. In the early days she gave me her passport and weekly record company money to keep in the pub safe, and she used to hang out upstairs sometimes on her own, playing the guitar and writing in her diary. It was also to The Hawley that she invited everyone back for a completely unplanned aftershow party following her incredible performance at Shepherd's Bush Empire in November 2007. And she would frequently steal food from the kitchen to make Blake special dinners at 1 a.m.

After the Camden fire damaged the building in February 2008, we refurbished the pub and created a room specially for Amy on the top floor. We painted it black and installed a vintage jukebox. Sadly, there wasn't room for a pool table. It became a hideaway for her and her close friends, and she liked to sit in the window and wave to people in the street below. •

Barfly, Live
THE BARFLY, CHALK FARM ROAD,
CAMDEN, LONDON,
2 MARCH 2004
PHOTO Rob Watkins

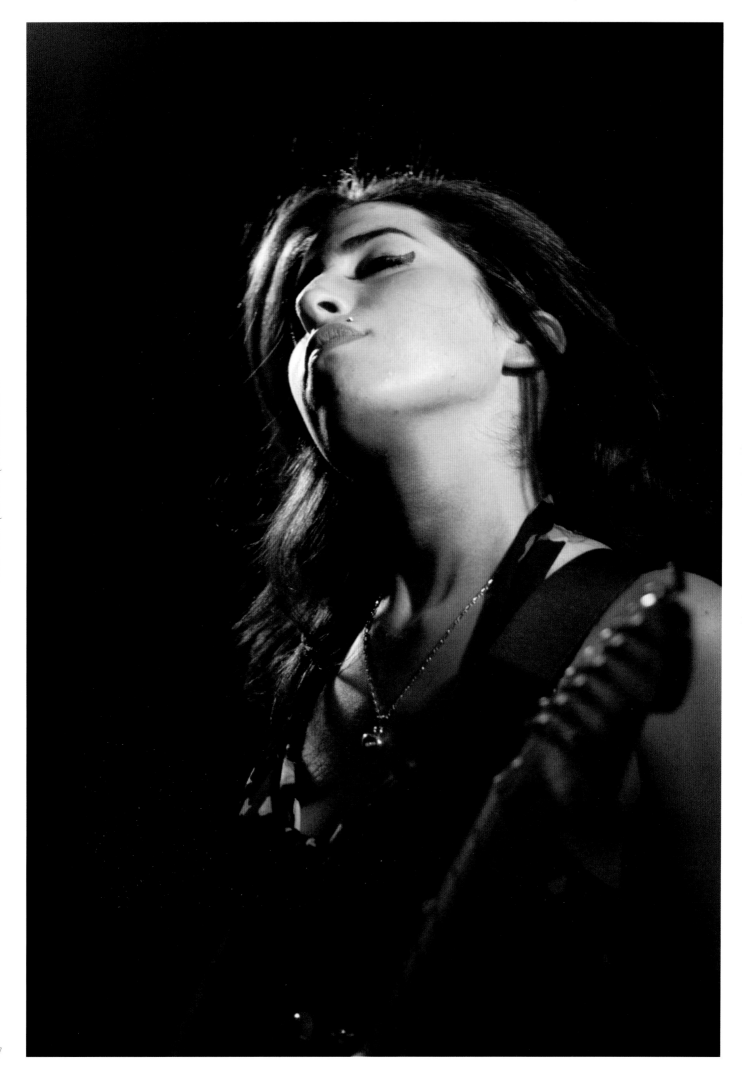

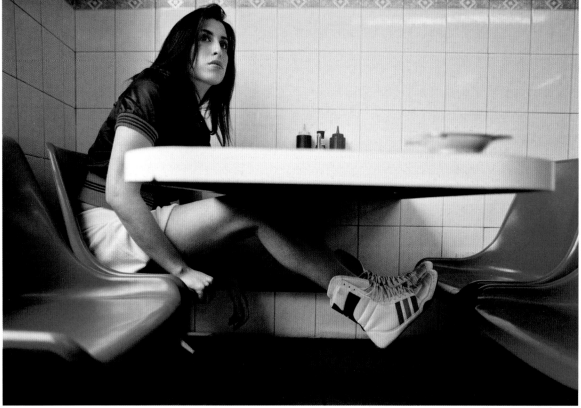

Greasy Spoon in Hi-Tops
KENTISH TOWN ROAD, LONDON,
FEBRUARY 2004
PHOTOS Jake Chessum

"She was hesitant about wearing more make-up than she normally would and about changing outfits for the photos. She was conscious that it wasn't 'her'. I wondered years later when her look was much more exaggerated whether that image was a barricade against the pressures of her life and career."

Jake Chessum Photographer

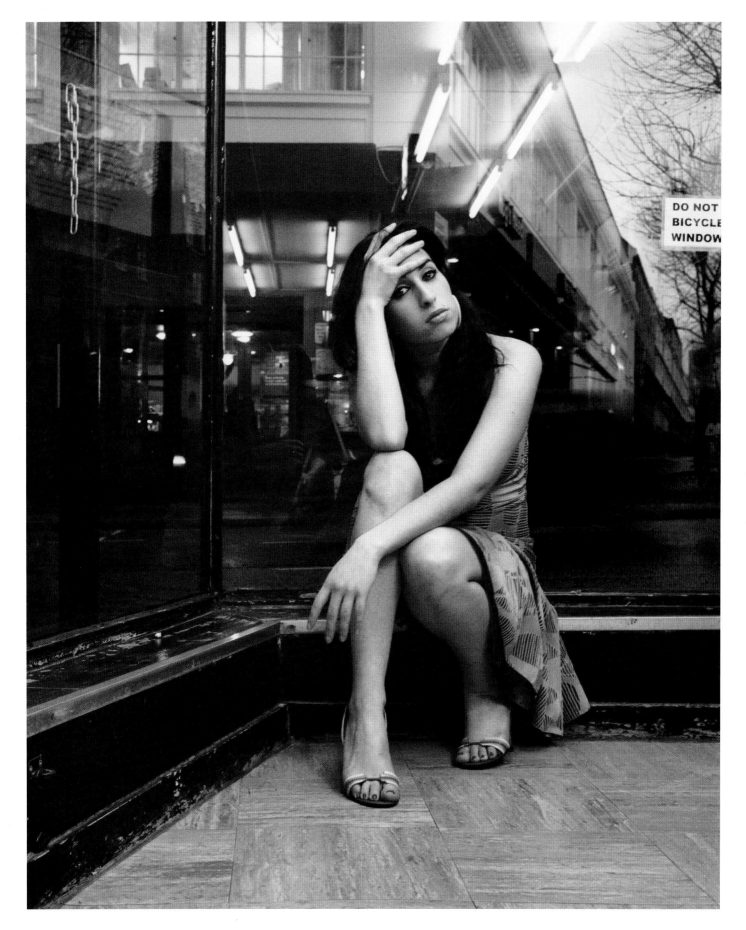

"We went to a few of her local haunts: a cafe, a launderette, Primrose Hill. The record company were very hands off and didn't pressure us to do any particular set ups. We just went with the flow. She was really entertaining: funny, smart and cooly indiscreet. As she was, I am a huge jazz fan and I remember we talked about music that we loved."

JAKE CHESSUM PHOTOGRAPHER

←

Cover Shot
'In My Bed' / 'You Sent Me Flying'
LAUNDERETTE, PARKWAY, CAMDEN, LONDON,
FEBRUARY 2004
PHOTO Jake Chessum

↑ / →

Contact Sheet (outtakes) & Cover Image
'Pumps' / 'Help Yourself'
LAUNDERETTE, PARKWAY, CAMDEN, LONDON,
FEBRUARY 2004
PHOTOS Jake Chessum

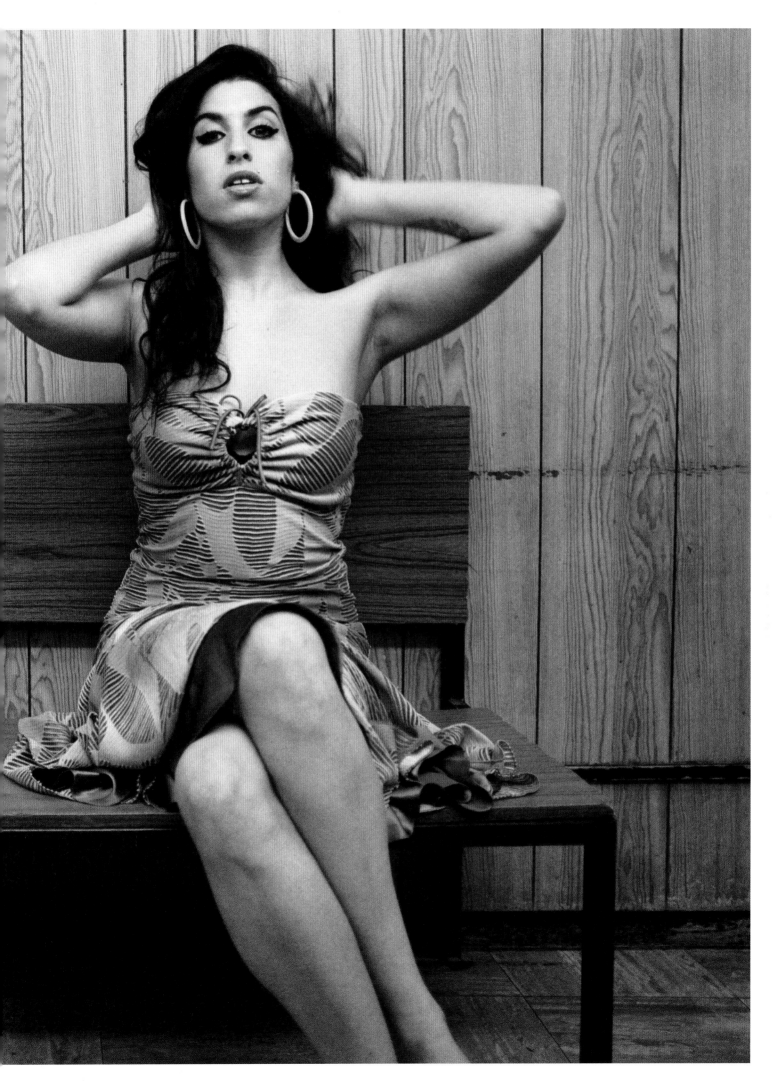

☆ Mr Amy ☆

I can't work like this
With you next to me
With your battered jeans } ?
And your Beasties tee

Did you know that tan
Brings out your blue eyes
Staring at your hands
Cos they're oversized.. I fantasise ✓

Dressing every day
Keep your taste in mind
With you in my head
Keep you in mind
When I dress every day } rephrase
Are my feelings returned? somehow
It's too hard to say
I can't get a feeli vibe back
And before I move in
I need the all-clear
I can't

you just write your features } change
And ent watch various sports
You're rude + obnoxious } ✓
But you enter my thoughts
Tough set to sort files
With your voice in my head ✓
So I bribe you downstairs
With a Marlboro Red
Lent you Outsidaz
And my new Badu ✓
So isn't it obvious?
You ain't got a clue

*"Music is something in my life where I can be
completely honest, and sometimes I don't want to sing
some of the songs 'cos they're so raw."*

AMY WINEHOUSE

Can't keep my mouth shut
Everybody knows
That I'm into you—
Shit, it really shows.
Haven't you noticed
Me laughing at all your jokes?
Or how it don't matter
That you steal all my smokes?
Now I'm looking for a sign
But I search in vain
Shouldn't Maybe I should
Save myself the pain
Or work extra hard
To appear more mature change to 'immature'
But your presence beside me
Is too much to endure
I could follow advice
And just ask you straight
But that's too embarrassing
To contemplate
I know you're a person
Who would let me down lightly
But I won't take chances
If doubt is there slightly
I know you're impressed
By my musical shit
But otherwise, I feel
You're disinterested
You know how I feel —
About office romance
But see, I've been told
That you won't take the chance

re-word

'You Sent Me Flying'
WORKING LYRICS, EARLY VERSION, 2002
COURTESY Amy Winehouse Foundation /
Sony Music Publishing Ltd

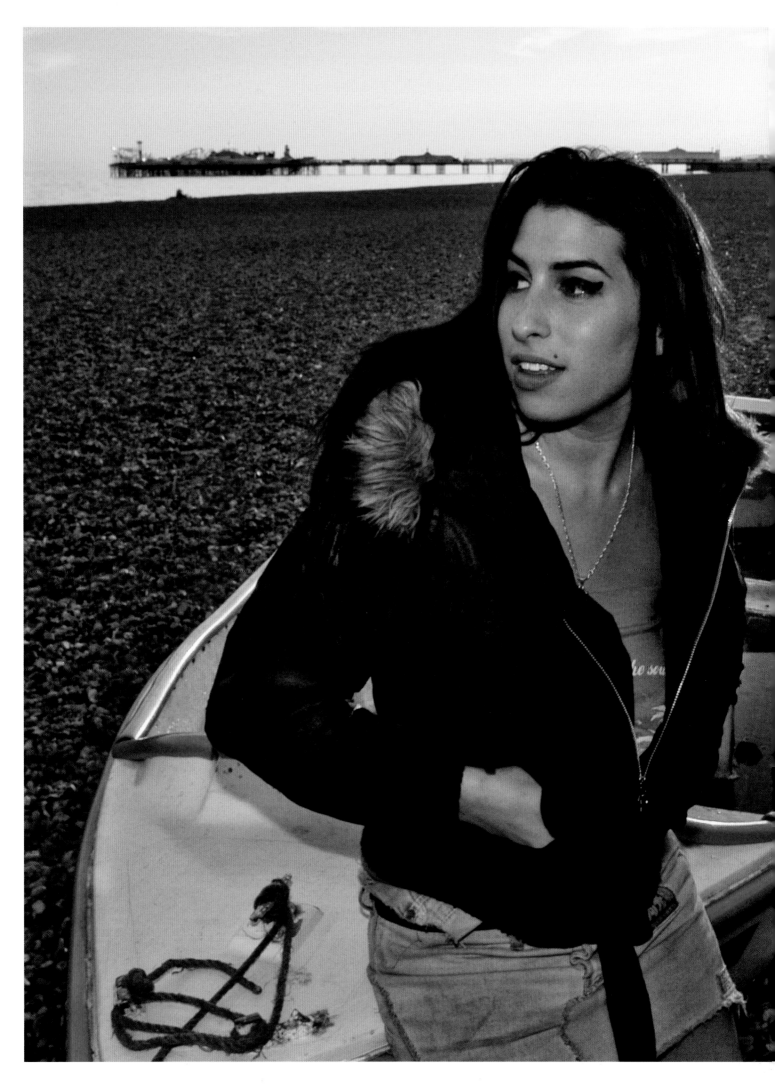

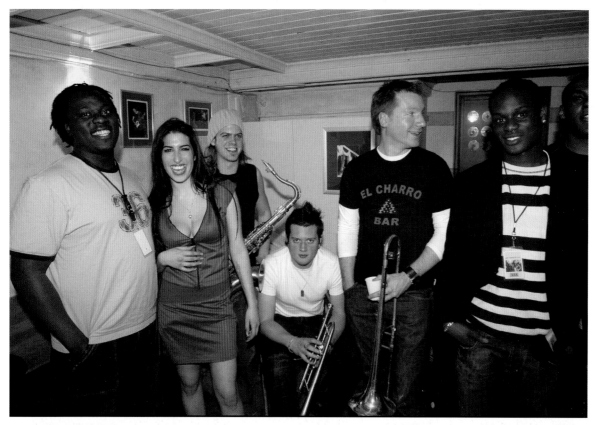

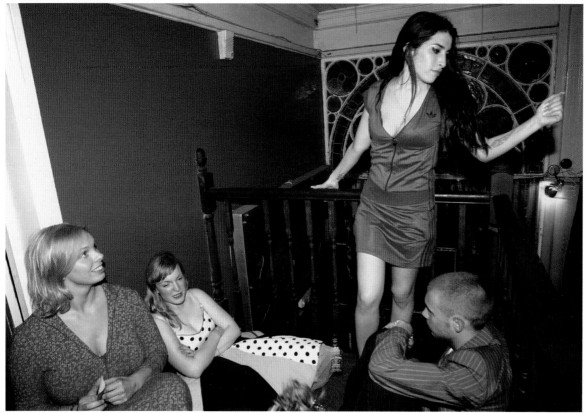

←

Brighton Beach
BY PALACE PIER, BRIGHTON, BEFORE THE
GIG AT BRIGHTON CONCORDE 2,
1 MAY 2004
PHOTO Roger Sargent

↑

Before the Brighton Gig
AMY WITH FEMI, DAVE, BEN, MIKE AND
NATHAN (TOP), AND WITH CLAIRE AND
CATRIONA GOURLAY (BOTTOM), 1 MAY 2004
PHOTOS Roger Sargent

"She had that effortless common touch. Some people might think possessing a common touch makes you less than, but thinking back, it was the sign of a proper mensch. Amy was a mensch."

Emory Ruegg Friend

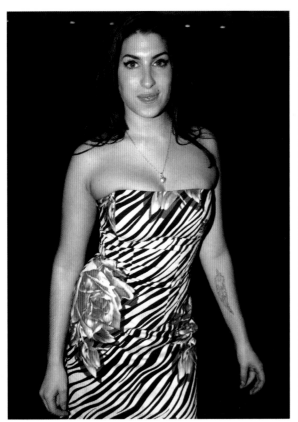

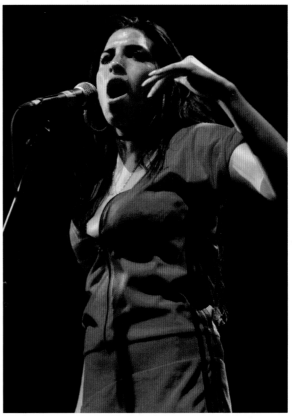

↑
Roses & Zebra Stripe Dress
BY BETSEY JOHNSON
IVOR NOVELLO AWARDS, LONDON,
27 MAY 2004
PHOTO (TOP) Richard Young

↑ / →
Adidas Zip Dress
SHEPHERD'S BUSH, LONDON,
3 MAY 2004
PHOTOS (BOTTOM) Carey Brandon,
(OPPOSITE) Agency

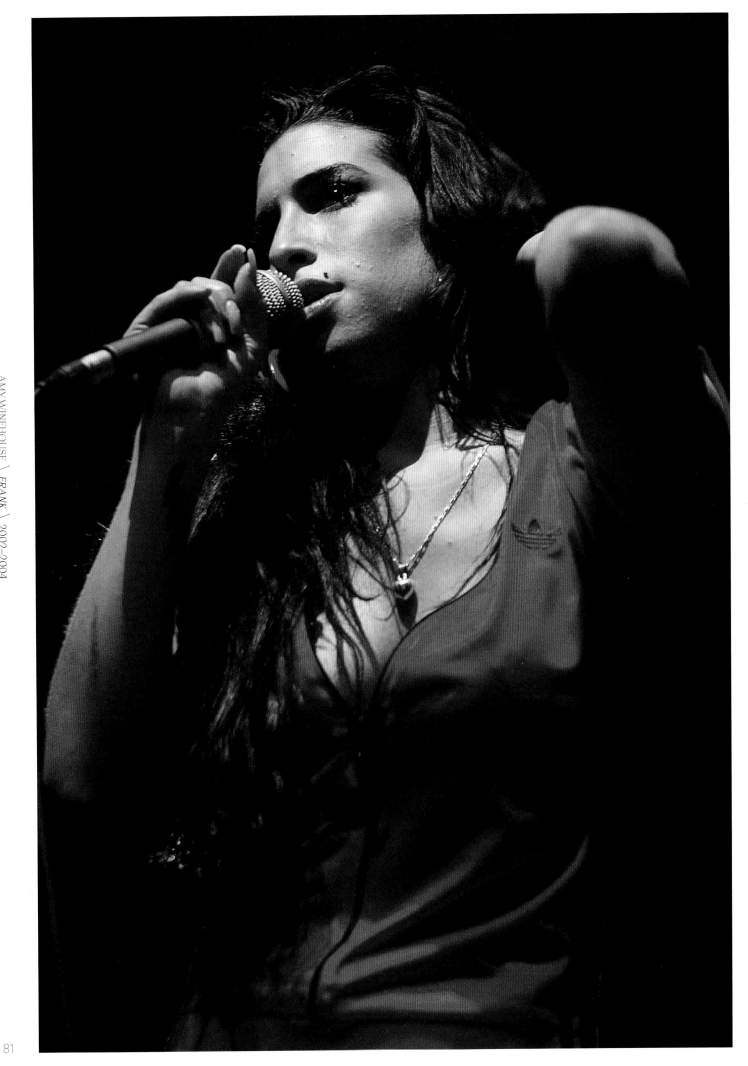

Thórunn Magnúsdóttir
Artist

As I let memories of Amy flood into my mind I feel such a deep sadness and so much gratitude and love. I have never liked the idea of publicly speaking about Amy. The world had painted her picture with such sharp edges and bright vivid colours and who am I to share my warm, fuzzy watercolours of this gentle soul and funny, funny girl? But I think she would want us to tell you who she was, and still is in my mind; those who knew her before the world's crooked teeth started chewing her up. Warm, smiley, friendly and fucking hilarious Amy.

I moved to London when I was about 18 years old and working as a musician. I had signed a record deal with BMG as part of a band called The Honeymoon and for the first few months had stayed at Courtyard Studios in Oxfordshire. I remember hearing that Camden was the place to be, so I took a bus alone to Camden to see it in all its glory. I remember getting lost and holding a map up like an ignorant tourist. My band mate Wayne Murray introduced me to many people and one of them was this dude called Simon White who worked at a shoe shop in the market selling sneakers. He was looking for a flatmate and I moved in.

Simon used to be in a band called Menswear and later became manager of bands such as Fields, Bloc Party and many more. I met a lot of people through him, one of whom was this amazing, funny and beautiful girl called Catriona. Soon after we became close friends, I started to work with her at this second-hand vintage store called Rokit in Camden. Her amazing friend Amy would come in all the time and I just loved her. She was so funny - one of the most hilarious people you could meet. Amy was a jazz singer and I hated jazz but we got on and talked about boys mostly. Love, unrequited love, mad love. And we got drunk. This was way before she became famous.

The thing about Amy is she would make you feel like you were the funniest person on earth, laughing so hard when I said something naive or stupid, which was all the time. I can still hear her laughter. I hope I always will. LOUD, CRAZY, BEAUTIFUL LAUGHTER. I remember a really funny thing. It was 2006 and I was in the indie band Fields. The *NME* came out with its 'Cool' list: I was ranked at number 49 and Amy at number 50. She called me up and was like, 'You fucking bitch!' She laughed so hard and loud that I had beaten her by one place.

Amy started seeing this guy we knew and I just remember the heartbreak she

Rotterdam Import Festival 2004
ROTTERDAM, 19 JUNE 2004
PHOTO Rob Verhorst

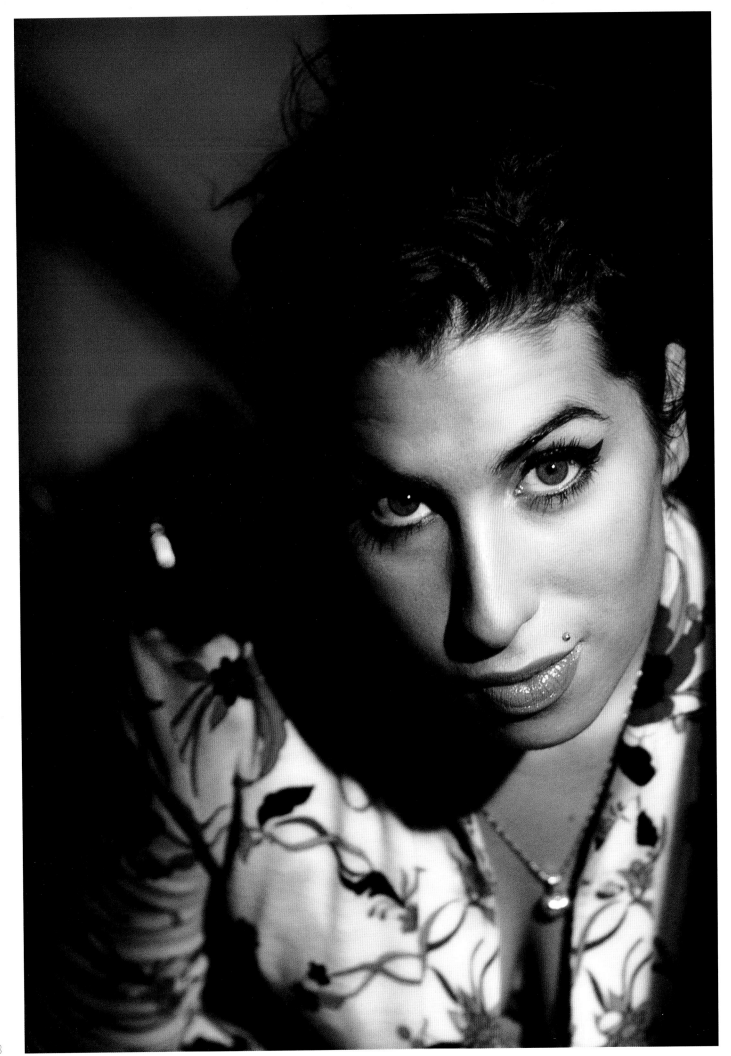

felt almost instantly with him. He had a girlfriend but kept seeing Amy on the side, leading her on. One day she came into Rokit all starry eyed and in love and had tattoed his name across her chest. Cat and I were laughing so hard and calling her crazy. My heart broke for her - such a fool in love.

Somewhere during those years she started working with new people on new songs and her fame increased. I remember me, Cat, Naomi, Kelly Osbourne and some of her other friends thinking it was crazy. Good crazy. Hilarious crazy. We were so proud but we didn't really take it seriously at all! But as she became more famous - as the world had more and more of her - she got skinnier and more fragile. More vultures started to circle around her. It makes me cry to think of it. As a young Icelandic singer who naively thought fame would lead to all things great, boy did I find out I was wrong. Witnessing the world eating Amy alive was so utterly heartbreaking. She was pursued by the paparazzi and surrounded by people only wanting to hang out with her because of her status. Her house was suddenly full of designer clothes people sent her, although she was always so down to earth about it all - she didn't care at all. She threw me a dress once with the words, 'Hey, Sexy you can have this.' That was her nickname for me. Fucking loved that. I still have that beautiful Dolce & Gabbana dress. She became famous almost overnight. There were wigs in her hairstyle in party outfit shops. It

was just wild. And that's when I stopped wanting fame. As more people loved her, she loved herself less and less. That was the true heartbreak of it all.

For those of you who love her songs you should have heard her true laughter, her banter at The Good Mixer, playing pool in a crop top; throwing things when she got too wasted; her humming when she cooked for others - she loved caring for others - her open heart and her kindness.

I will never forget the surreal moment when I heard the news of her death. I had just sung at a friend's wedding in Iceland, and came out of the church surrounded by joyful friends and family of the bride and groom. I still can't believe she is gone. I have avoided all documentaries, news, videos of her wasted for years as it was all too much being her close friend to the end and not being able to do or say anything to save her. I will forever be grateful for her big, beautiful lesson of love and friendship and for teaching me the utter heartbreak and cruelty of fame. And I'm not afraid to point the finger at those who followed her into the darkness, flashing cameras in her face. They did wrong, together with all of the people who made money from her agony. The heartbreak that we hear so clearly in her songs was her biggest gift to the world. Sharing that takes guts and listening to it is pure magic.

Amy, I will cherish your version of yourself forever. The version I knew and loved. The one I've held close to my heart and always will. •

Rokit
VINTAGE CLOTHING STORE
DAY & EVENING (TOP),
BY THE FITTING ROOMS (BOTTOM),
CAMDEN HIGH STREET, CAMDEN, LONDON

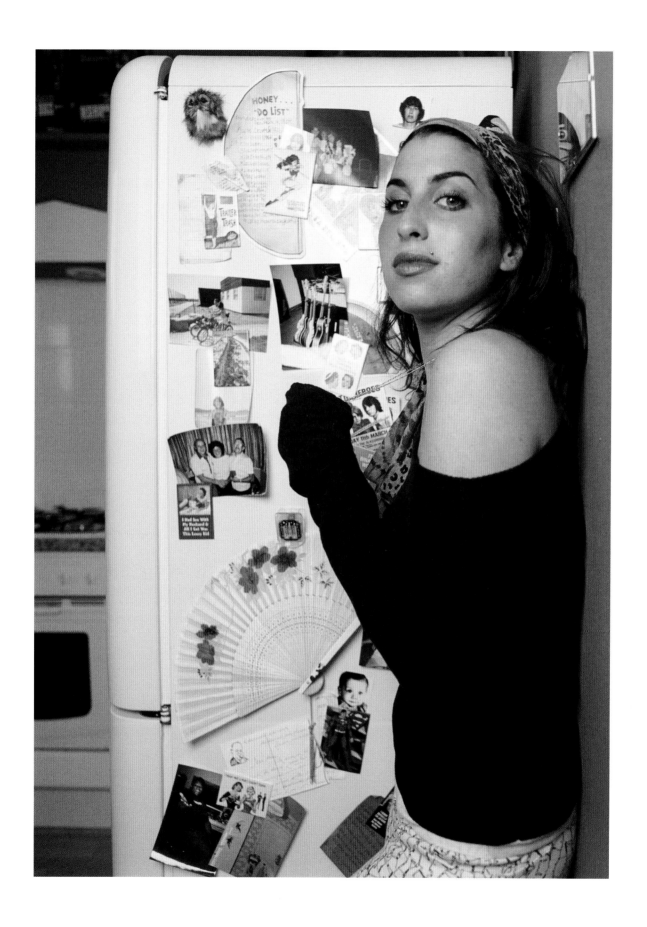

"Amy loved shoes in a Carrie Bradshaw kind of way."

NAOMI PARRY STYLIST

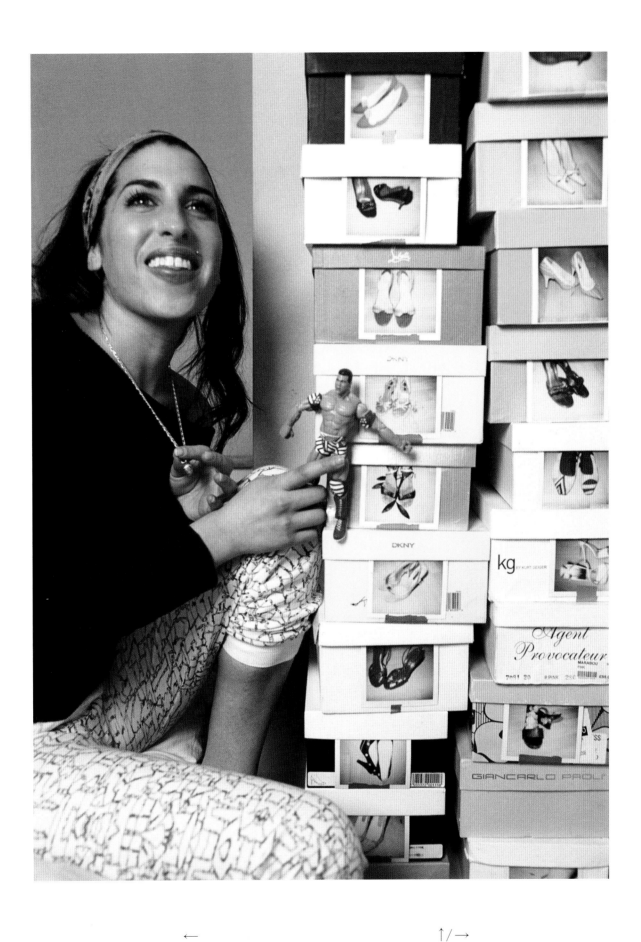

←
Customized Smeg Fridge
KITCHEN, JEFFREY'S PLACE,
CAMDEN, LONDON,
JULY 2004
PHOTO Mark Okoh

↑ / →
Shoe Collection
INCLUDING DESIGNS BY CHRISTIAN
LOUBOUTIN, MIU MIU & AGENT
PROVOCATEUR
PHOTO (ABOVE) Mark Okoh

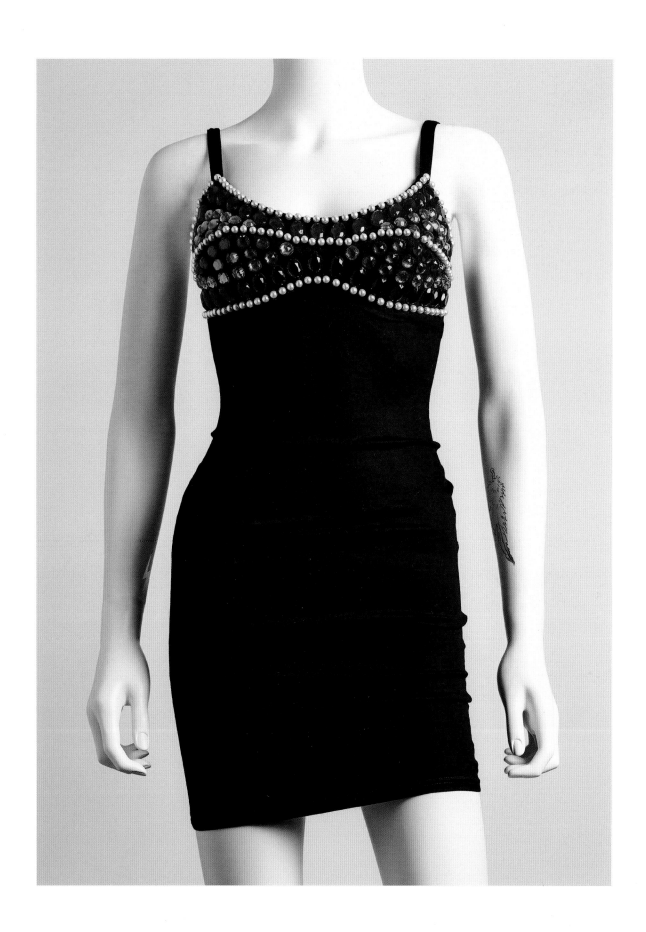

↑
2004 Nationwide Mercury Prize
Awards Dress
VINTAGE DRESS, WORN TO PHOTO
CALL AT RED CARPET ARRIVALS

→
2004 Nationwide Mercury Prize Awards
GROVESNOR HOUSE HOTEL, LONDON,
7 SEPTEMBER 2004
PHOTO David Lodge

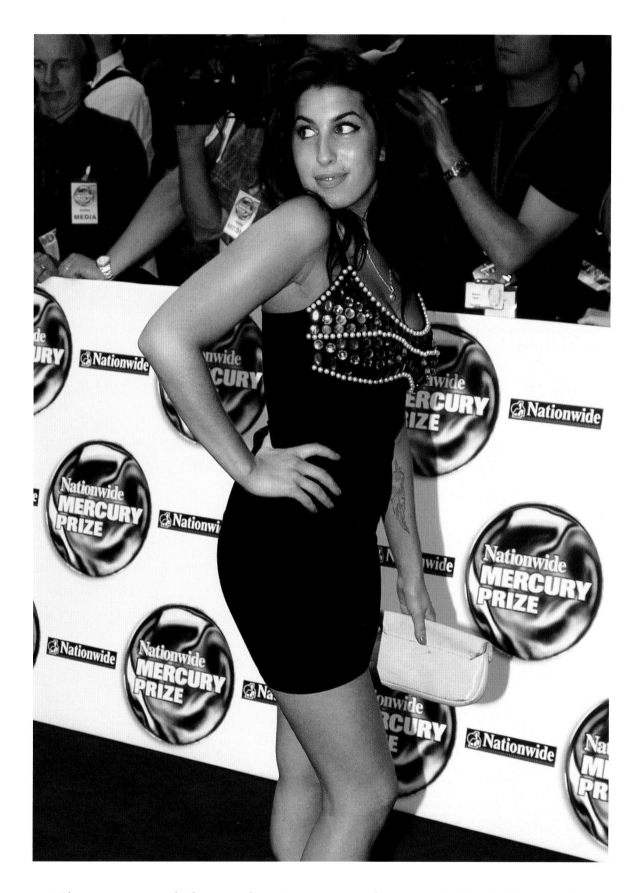

"She was my only hope when I was up and coming. Nobody knew who I was and I had no fans, no record label and everybody said I wasn't pretty enough or that my voice was too low or strange. They had nowhere to put me. I just remember thinking 'Well, they found somewhere to put Amy....'"

LADY GAGA ARTIST

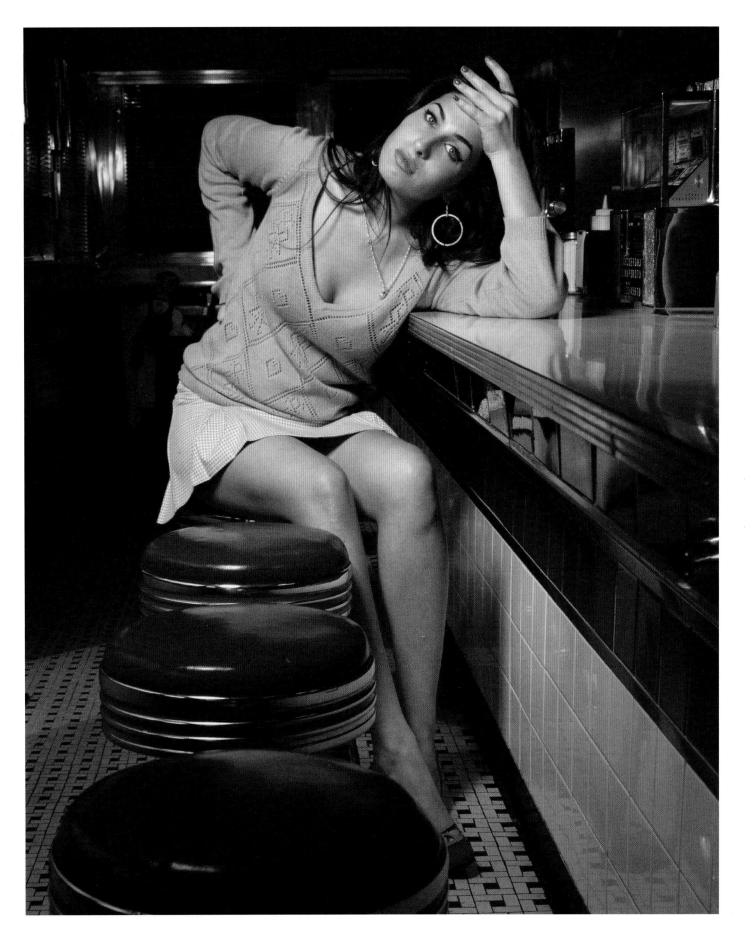

"She didn't give a fuck at a time when the majority of female acts were groomed by the pop industry. In 2004's Top 20 singles, there are only four songs by women – Beyoncé, Destiny's Child and the other two are by Kelis."

HANNA HANRA WRITER

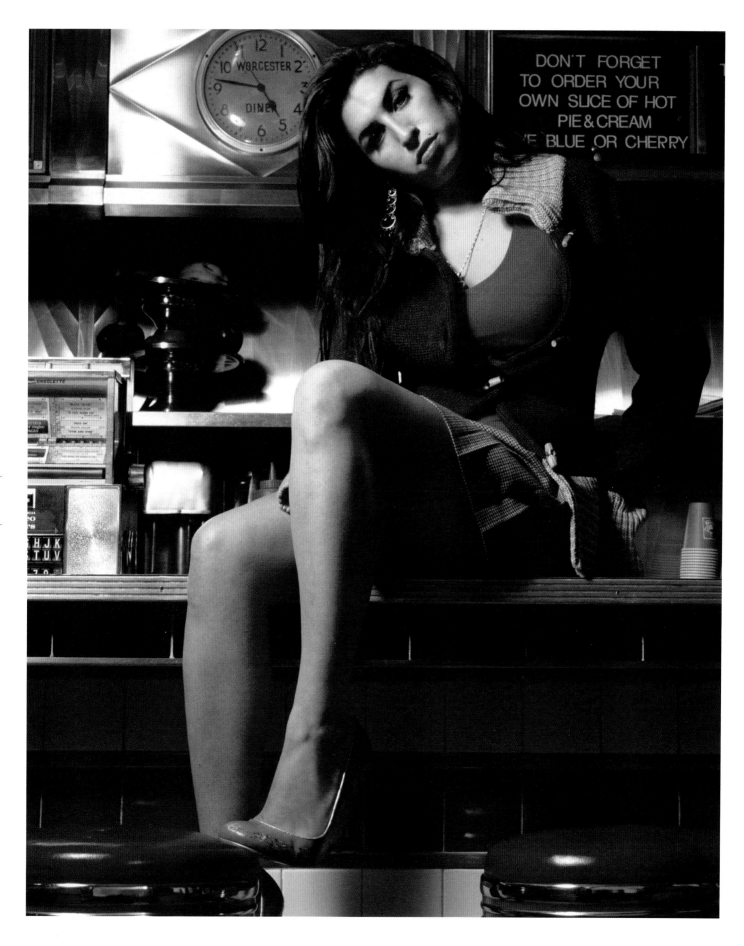

DON'T FORGET
TO ORDER YOUR
OWN SLICE OF HOT
PIE & CREAM
E BLUE OR CHERRY

←/↑
Fatboy's Diner
TRINITY BUOY WHARF,
AUTUMN 2004
PHOTOS Ram Shergill

→
East India Dock Studio Shoot
LONDON,
AUTUMN 2004
PHOTO Ram Shergill

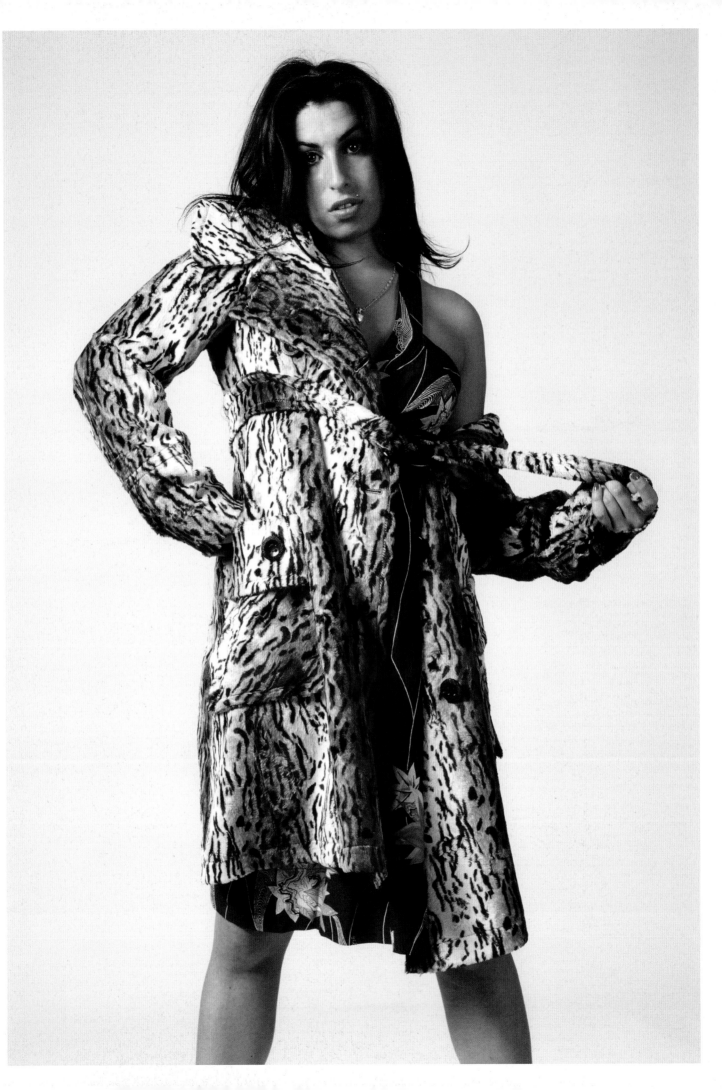

"She picked out a leopard coat – she loved this coat and 'styled it' with her own clothes. On the photoshoot she was happiest in her own 'look'. Amy insisted on doing her own hair and make-up, adding more eyeliner throughout the day, asking me whether I liked it or not – which, of course, I loved."

Ram Shergill Photographer

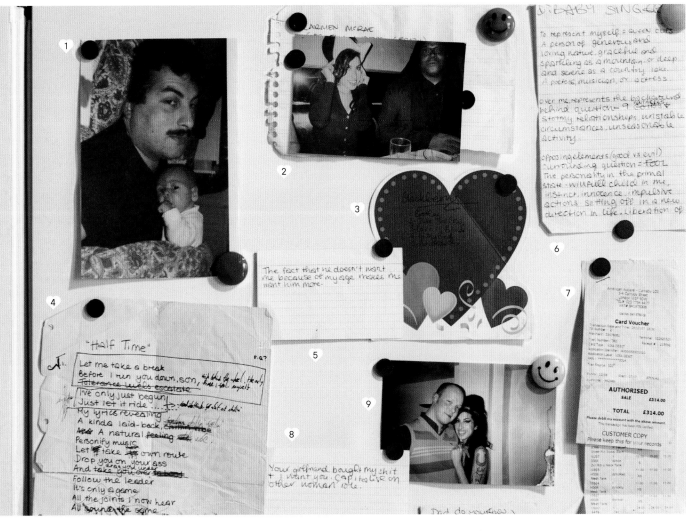

Knowing Amy

By Catriona Gourlay

There are few friendships or, indeed, relationships that one can say with confidence will last a lifetime. However, when someone is taken from you abruptly while the friendship is still strong, it is unbelievably cruel.

I met Amy when we were both teenagers, sometime in 2002. She was a healthy, confident girl with killer curves, rapier sharp humour and searingly intelligent to boot. So quick witted you would not believe. Never mind the fact she sang like nothing I had ever heard. People are often labelled talented but this was something else. I miss hearing her voice travelling down the stairs in the flat we shared in Jeffrey's Place in Camden. She would interpolate a song differently every time she sang it.

The bulk of *Back To Black* was written while I was living there and it is actually about four different relationships. Amy would later go on to attribute a few well-known songs to her most publicised relationship. In fact, they were written some time before he came on the scene, but this was quite typical of the tendency of both of us to revel in the drama of it all. It was our way.

It is hard to know what she would want me to say now, after everything that happened; how she would feel. Jolly pissed off about how things turned out, I would imagine. I have waited the best part of a decade to even contemplate talking about our relationship because it feels like some kind of betrayal. I would defend her with my last dying breath and always wanted to act in her best interests.

I wonder where she would be now and what she would be doing. In my mind she has her own record label (she had started this endeavour), writes songs for other people and mentors younger artists – I think she would have liked that.

Would we be mothers together boring our children to death about the glory days? Regaling them with tales of the

Amy's Things #1

❶ MITCH HOLDING AMY AS A BABY / ❷ AMY & RAYE / ❸ SETLIST FOR BLACKBERRY LAUNCH EVENT AT SANDERSON HOTEL, LONDON, 7 OCTOBER 2004 / ❹ 'HALF TIME' WORKING LYRICS / ❺ NOTE, POTENTIAL LYRIC / ❻ TAROT READING NOTE / ❼ AMERICAN APPAREL RECEIPT FOR £314.00, JULY 2007 / ❽ NOTE, POTENTIAL LYRIC / ❾ THOM STONE & AMY

things we used to do, the high jinks and the inevitable trouble that ensued?

I often find myself half asleep and thinking she is next to me, the scratch (sorry, Amy!) of her hair on my neck and the smell of chocolate body cream and hot couture combined. We may be separated physically but these memories cannot be taken away.

I know she would be proud of the book and see it as legacy building, an opportunity for people to get to know the real her. It shows a side to her that was not decimated by the press, which focused on her foibles rather than her achievements. I believe today the language used to describe her would be different. It was certainly a very unforgiving time to be the focus of media attention.

There are some items pictured within these pages that are synonymous with Amy - her gold woven belt, the black arrogant cat belt which she wore on so many occasions, her head scarves, ballet shoes and the aforementioned perfume and body cream. Her red Adidas zipper dress is very *Frank* era, the 'Amy' Jonathan Kelsey shoes which she adored, the boots she wore on the *Frank* album cover all littered with nail polish. She used to keep so many polishes in our fridge - all organized by colour, of course. Every item has a memory of a night out, a particular period in our lives or a shared secret - of which we had many.

It is interesting to see the progression of her style: in the early days she wore Karen Millen dresses and had relatively conventional looks, then she started to become more like the girls I worked with in Camden Market. The hair got bigger, the thick eyeliner got thicker and she began to wear vintage bowling shirts, head scarves and ballet pumps, which was an everyday Camden uniform to us but over time it became a silhouette that was recognizable across the world as *her*.

We had identical clutch bags (matching most things, in fact, including hairstyles - we must have looked ridiculous!) with bus passes, lip glosses and drinks tokens for KOKO in them. We had an unsurpassable knack for being able to go out with a fiver and come home with more money than we left with. Not through theft, I might add, but successful pool hustling.

In the mid-noughties I was a budding presenter and I interviewed Amy about her process writing *Back To Black*. She replied, 'Every song I've ever written is about a bad time or a raw deal.' We had a mutual understanding about that kitchen sink drama mentality; often painful trauma was something we thrived off in a way, I suppose. Healthy? Perhaps not. Certainly, we always followed our gut and our emotions above all else. The 'star-crossed lovers' concept validated some undesirable relationships in our eyes, at least. It is, of course, just a part of being young. Often I forget we were VERY young to be dealing with the Narnia of what was going on.

In 2007, when we were living in the same complex of flats in Hackney Wick, I bought her a pack of Vivienne

Amy's Things #2

❤ DONNY HATHAWAY *EXTENSION OF A MAN*, THE VELVETTES *THE MOTOWN ANTHOLOGY* / ❷ THELONIOUS MONK *IT'S MONK TIME*, RAY CHARLES *GENIUS LOVES COMPANY* / ❸ ADIDAS DRESS / ❹ MERCURY MUSIC PRIZE AWARDS 2004 DRESS / ❺ *MARILYN SINGS!* SONGBOOK / ❻ SUPREMES BOX SET / ❼ ROBERTS REVIVAL RADIO IN DUSKY PINK / ❽ HIGHEST HEEL PATENT, RED STILETTOS / ❾ THE BELMONTS *THE LAURIE, SABINA & UNITED ARTISTS SIDES*, VOLUME I

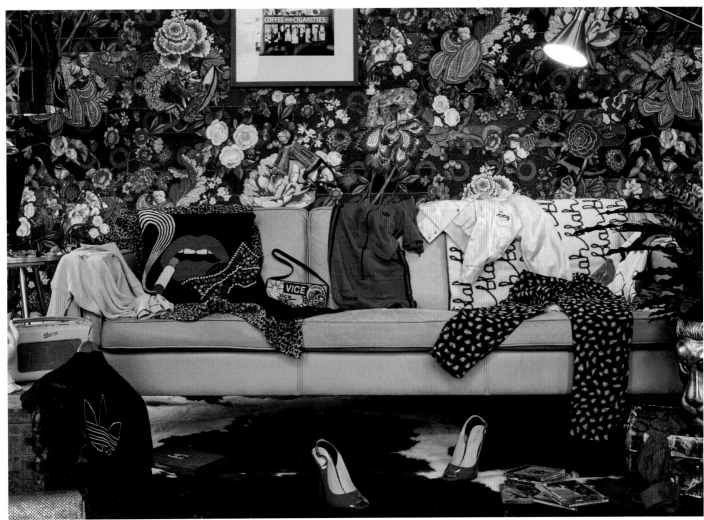

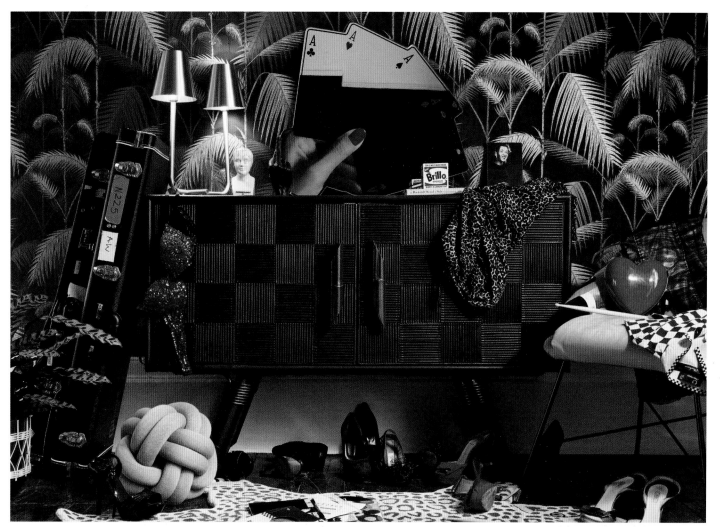

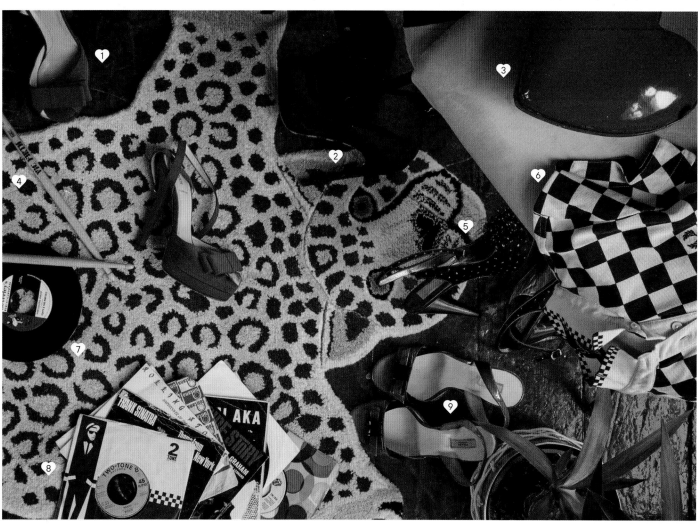

Westwood playing cards as a present – quite a financial commitment given I had just been made redundant from my minimum wage job. Amy was in a funny mood and was quite dismissive of the cards, so I left her flat and went upstairs to mine. By the time I'd come back Amy had clearly ascertained I was unimpressed by her lack of gratitude and a wee bit offended, quite frankly. In typical Amy fashion rather than apologising she had turned the deck of playing cards into a collage with an airmail letter that read something like a telegram: 'To Catriona Go Go Gourlay. Stop. You're so thoughtful. Stop. Mittens forever. Stop. Slapping. Stop. Is the nuts. Stop.' It's an item that I cherish so much, especially as I can hear her saying the words when I read it.

'Mitten' was our nickname for each other. She used to get mittens from the vintage shop I worked in on Camden High Street. We would refer to each other as 'Mitts'. We had our own secret language, childish as it sounds. 'Mamacita' became 'Ceets' and so on.

We had an imaginary band called Slapping Mitten Fight. The plan was to hire out a few venues during the Camden crawl – get a bit of a buzz going ('Have you not heard of Slapping Mitten Fight?') and our act, such as it was, would be to get up on stage and slap each other round the face with mittens. We found the idea hysterical but perhaps it was just as well it never came to fruition.

We fought like sisters but acted like we had been married for years. No one was ever good enough for the other. We were so protective of each other, inhabiting our own world that was so often impenetrable to others. She used to call me her dreamer friend and we made believe together quite happily for years. I was incredibly proud of her achievements, absolutely, but our private world felt like it had been invaded by the time *Back To Black* was making its mark globally.

That being said, standing on the side of the stage at Glastonbury, or Isle of Wight, V Festival or wherever we were, it was impossible not to feel a sense of pride at a sea of faces appreciating the wonder of her ability, which I was fortunate enough to experience in private every day. One day we would be sitting on the floor outside KFC on Camden High Street (something that never changed despite her growing fame), the next I might be watching her sing with the Rolling Stones and be given a lift back on their hovercraft afterwards. The 2008 Grammys was odd, but amazing. I cried my eyes out as Tony Bennett announced that she had won record of the year. That was the only part of the awards where she was live streamed; we knew that she had won other awards but it did not seem real or tangible until I saw all the other artists... and Amy. My Amy. It was bizarre.

Some of my favourite shows and memories are actually pre *Back To Black*, when she was touring the *Frank* album in 2004. My sister and I went down to Brighton to see Amy at Concorde 2

Amy's Things #3

❶ FENDI RED SHOES / ❷ GEORGINA GOODMAN PURPLE SHOES / ❸ MOSCHINO HEART BAG / ❹ VIC FIRTH DRUMSTICKS / ❺ BETSEY JOHNSON SHOES / ❻ FRED PERRY AMY COLLECTION TOP / ❼ TOOTS & THE MAYTALS 'PRESSURE DROP' / ❽ 45S, INCLUDING THE SPECIALS, FRANK SINATRA, *WEST SIDE STORY* & GLADYS KNIGHT & THE PIPS / ❾ PRADA BOW SLINGBACKS

and took some pictures on the pier. Now I live in Brighton and whenever I go to a show there I see her doing her 'Amy shuffle' on the stage. Shepherd's Bush Empire at the end of that tour was a highlight. By the time we got there I knew every joke she was going to say between songs and still I revelled in seeing audiences respond to her witticisms for the first time.

She played in a church in Glasgow on the first night of the first tour. Her baggage had been lost by the airline, so Amy was reliant on me to pick something of mine for her to wear. As she was getting ready backstage (I am making it sound far more glamorous than it was), her then A&R Darcus (who would go on to become global president of Island) came to check in.

Amy was trying to do her hair and sort out the extensions she had but was making rather a meal of it. 'Don't tell a SOUL,' said Darcus, 'but I used to be a hairdresser.' He sorted out her hair and ensured it was blow dried properly (bear in mind this was pre beehive).

As she was introducing her band and saying her thank yous (including to yours truly for providing a lemon-coloured dress which barely concealed her modesty), she quipped, 'And I'd like to thank Darcus for doing my hair - did you know he used to be a hairdresser?' Being the first night of the tour, the world and their wife were there, including half of the label, who all fell about laughing. CLASSIC Amy. Never ever tell her not to do something

- red rag to a bull. So it was with her relationships too, but that is not something I am keen to dwell on here. Had she made what I considered to be better decisions in that regard I still do not think I would have thought her partners worthy of her.

I cannot say Amy's full name. Amy Winehouse is someone that I knew, someone I would see around in a boozer in Camden, but she is not my Amy. The two are inextricably linked, of course, but my Amy is a different person. Amy is the girl I played dollies with, which meant doing each other's hair and make-up. The girl I watched *Sin City* and *Planet Terror* with. The girl I cuddled on the kitchen floor and danced naked with. The girl I sat in the bath with until we both resembled prunes. The girl I played pool with. The girl I found curled up on a bag of belts, shoes or something else dreadfully uncomfortable in the stockroom at work. The girl who watched me sleep and left me notes saying how beautiful I looked (slightly creepy, I know, but flattering nonetheless). The girl who fed me home-made chicken soup or meatballs so salty they should have come with a cardiogram. The girl who played me Donny Hathaway tracks at night as we fell asleep.

Every decision I make and every life choice is informed by her in some small way - so it shall be until the end of my days. I suppose that is how I have started to learn to live with her death and to be thankful for a life that enriched my own beyond measure. I have much to thank

Amy's Things #4

❶ CUSTOMIZED FAITH EVANS *FAITHFULLY* CD / ❷ NAS *STREET'S DISCIPLE* CD / ❸ NEOM RESTORE ORGANIC BATH OIL / ❹ ORANGE NAIL VARNISH / ❺ FENDI RED SHOES / ❻ *STANDING IN THE SHADOWS OF MOTOWN: THE LIFE AND MUSIC OF LEGENDARY BASSIST JAMES JAMERSON* BY DR. LICKS, 1989 / ❼ VHS TAPE RECORDING OF *DUMBO* AND *GULLIVER'S TRAVELS*

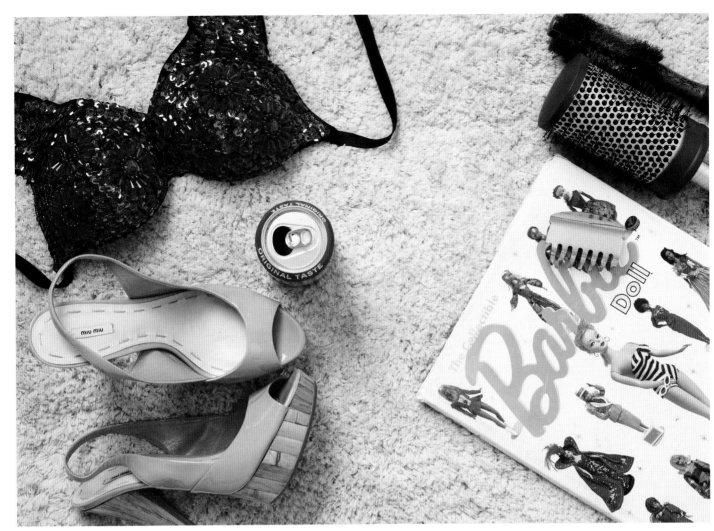

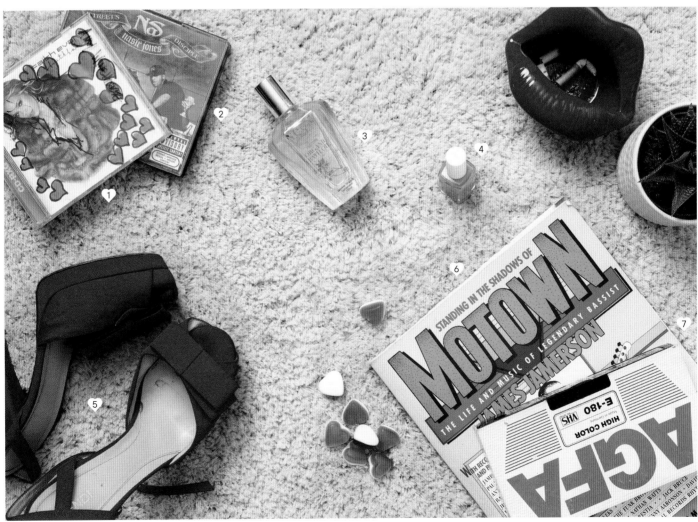

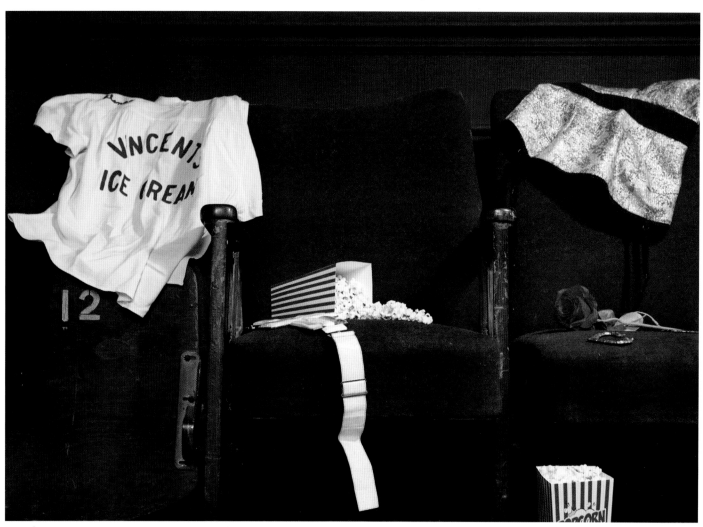

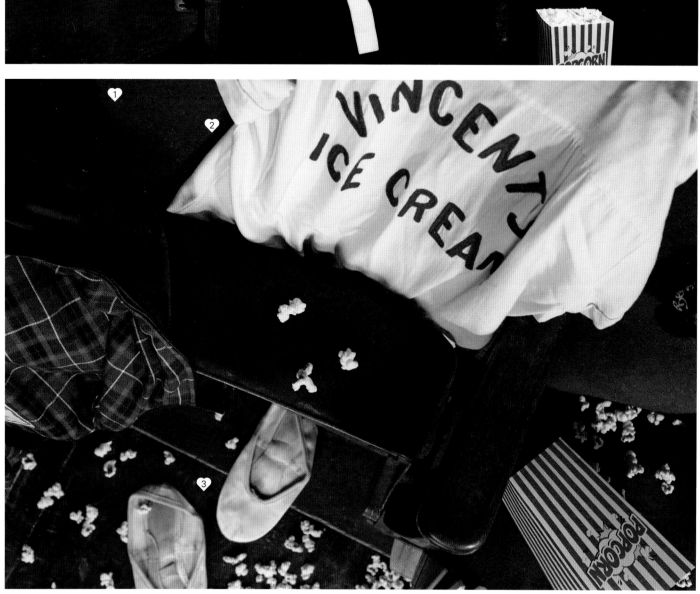

her for. She changed my outlook on life, what I value, what I prioritize. In some ways I feel like I have reconnected with her during this past year by working on this project. Our old haunts, which I have avoided since Amy left, are now happier places; I see her on every street corner and on every road we used to walk down. I smile to myself recalling special times with her. I spent years harbouring frustration about the way things ended given how much progress she had made – particularly in overcoming her reliance on substances, which was no mean feat. She was so nearly there.

The last day we spent together was during the week before her passing. We were keeping very different schedules – practically in different time zones. I had an office job then and she would often want to Skype late at night while I was asleep. I decided to book a day of annual leave to spend some time with her. Had I known it was to be our last ever meal together we might have indulged in something a bit more frivolous than chicken nuggets but perhaps that was rather in keeping with the unpretentious relationship we maintained throughout the years. We watched films in her bedroom and talked about the strides she had made with overcoming her alcohol addiction. (I had been sober for some time by this point and she knew we could talk about this honestly without any judgement on my part.) We made plans to go to the cinema to see the last instalment of the Harry Potter films the following week.

We chatted on Skype the following Friday afternoon. I was getting ready to leave the office and head down to my mother's for the weekend. I introduced Amy, virtually, to my newly adopted toy poodle Lily. 'Has no one noticed her in the office?' she asked. 'Well, she's not wearing an invisibility cloak... so yes.'

On Saturday afternoon, after returning from a food shopping trip, I looked at my phone and saw a huge volume of messages and missed calls. One message flashed up: 'Please tell me the rumours aren't true.' My mother said she had never heard a noise like it in her life after I took the first call. Something not human. I remember very little else after that. The next time I saw Amy I was getting her ready for her funeral. One last time of playing dollies, if you will. Except that this was not something either of us had ever planned for. A pastime that had previously been such a happy one – it was the very last thing I could give her; a final act of love.

It may have seemed a very obvious conclusion to her life to the outside observer who knew only the tabloid version of events, or perhaps to someone who had not seen her for a long while. To me it came as a shock. I thought, wrongly, that she was almost out of the woods, that she was invincible in a way. She had conquered the worst of it, or so I thought. A future lay ahead of her, free of the gaze and vitriol of the tabloid media.

My darling girl is frozen in time.

Forever my love, my Mitts. To know her was to love her. •

Amy's Things #5

❶ BARACUTA BLACK BOMBER JACKET / ❷ 'VINCENT'S ICE CREAM' VINTAGE ALOHA SHIRT / ❸ FREED OF LONDON BALLET PUMPS

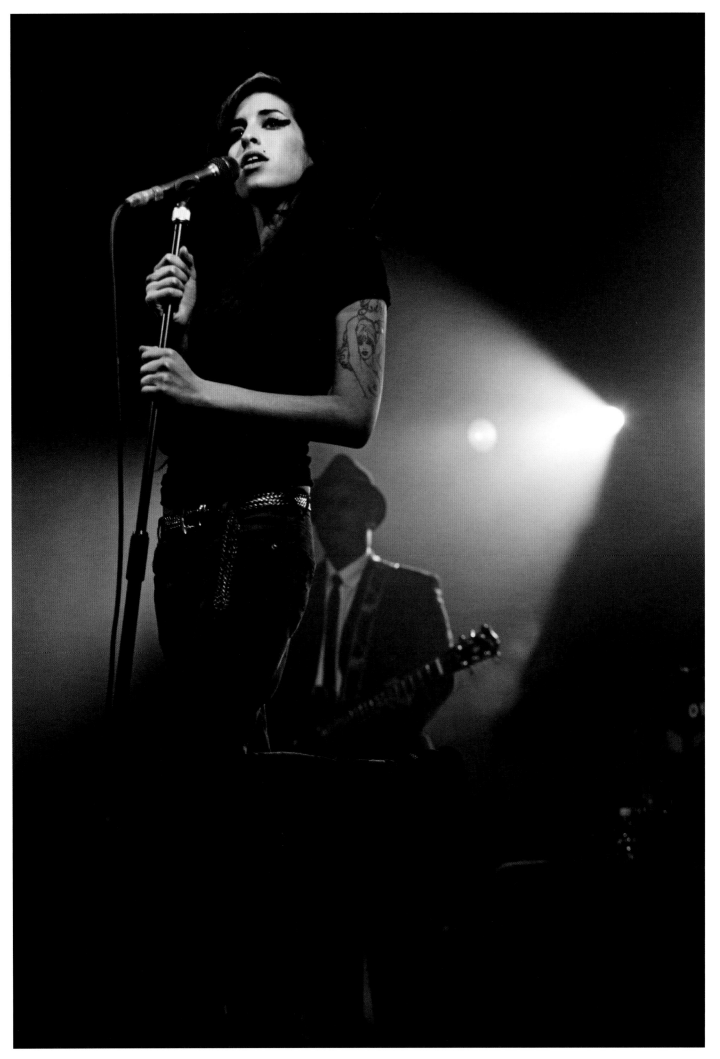

2

Back To Black

2005–2008

Recording sessions for *Back To Black* began in November 2005, though its genesis came much earlier. Each song on the album is the culmination of ups and downs that occupied the years after *Frank*; drinking, drugs, loves lost and found and then lost again. Or, as Amy often referred to it: life experience.

In some ways *Back To Black* was a continuation of *Frank*. It involved many of the same collaborators, including producer Salaam Remi, mix engineer Tom Elmhirst and instrumentalists such as Vincent Henry and Bruce Purse, but it almost felt like the work of a completely different artist. Amy overhauled her sound, leaning into her jukebox favourites - doo-wop, Motown and fifties and sixties girl groups such as The Ronettes and The Shangri-Las - with an image to match. Aware of the parallels between them, Ronnie Spector noted in an Eagle Vision-produced 2018 documentary that Amy took what The Ronettes did 'to a whole other level'. The songwriting - that unique blend of darkness and humour, blunt lyricism and idiosyncratic phrasing - was fundamentally unchanged, however, save for a slight lurch towards melodrama.

The foundations of *Back To Black* were laid at Remi's Instrument Zoo Studios in Miami, where demos for 'Tears Dry On Their Own', 'Some Unholy War', 'Me & Mr Jones', 'Just Friends' and 'Addicted' were recorded over the course of ten days. Amy and Remi had an intuitive creative relationship. She would write the songs, and he would rearrange them afterwards. While the initial arrangements picked up where *Frank* left off - mid-tempo soul jams, but with more of a Latin jazz influence this time - Amy had done away with the songwriting help that had been brought in for her debut. Instead, most were written the way she had learned to write as a teenager: just Amy, her voice and a guitar.

According to Frank Socorro, the engineer on the five songs Remi produced, Amy's vocals were 'effortless and honest'; done in a few takes. Far from the all-nighters typically expected, the sessions were done and dusted in daylight, lasting from around midday to 9 p.m. Even though there was little downtime around that, she cooked dinner for everyone every night. The sessions were intimate in general, with Amy playing guitar and singing, and Remi adding instruments played mostly by himself (piano, drums, upright bass, main and bass guitars), Vincent Henry (saxophone, flute, clarinet) and Bruce Purse (bass trumpet, flugelhorn, trumpet). It wasn't until five months later, though, that *Back To Black* really found its sound.

In March 2006, Amy visited Mark Ronson at his studio in Manhattan after their shared publishing company encouraged them to meet. As he tried to establish what sort of album she wanted to make, she played him all those jukebox favourites, and ideas began to percolate. The piano chords for 'Back To Black' came first, swiftly followed by the idea to enlist funk and soul revivalist group the Dap-Kings, whose

At the Octagon
OCTAGON CENTRE, SHEFFIELD,
3 MARCH 2007
PHOTO Grenville Charles

Sash Window
JEFFREY'S PLACE, CAMDEN, LONDON,
24 JUNE 2005
PHOTO Jay Brooks

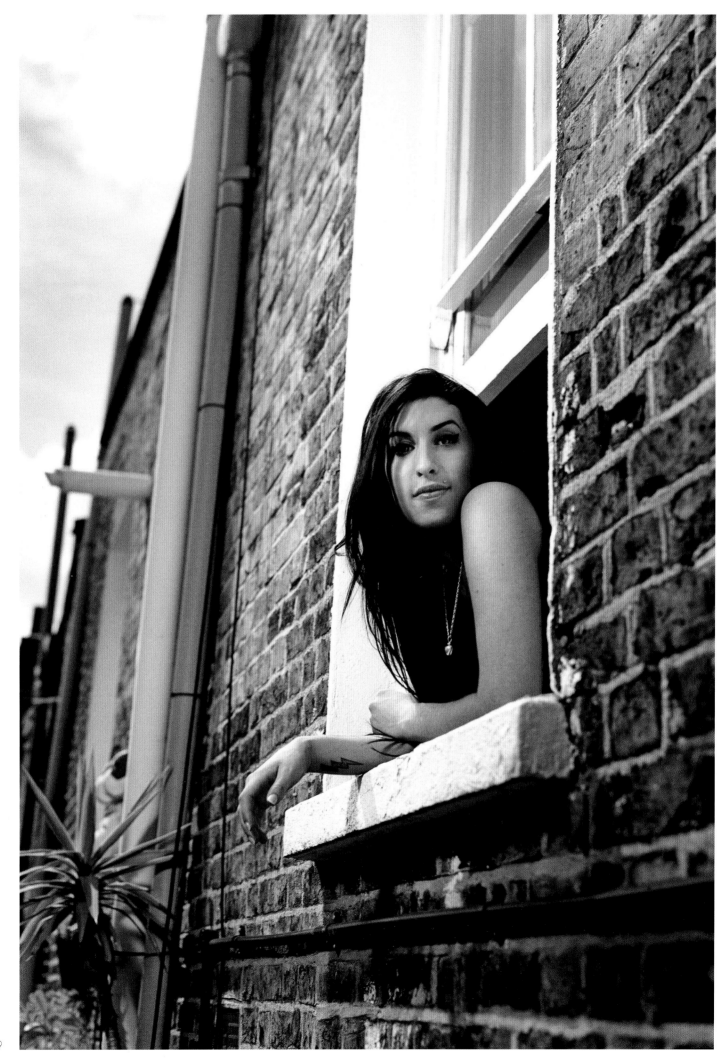

'Rehab'
ISLAND RECORDS
23 OCTOBER 2006

Back To Black
ISLAND RECORDS
27 OCTOBER 2006

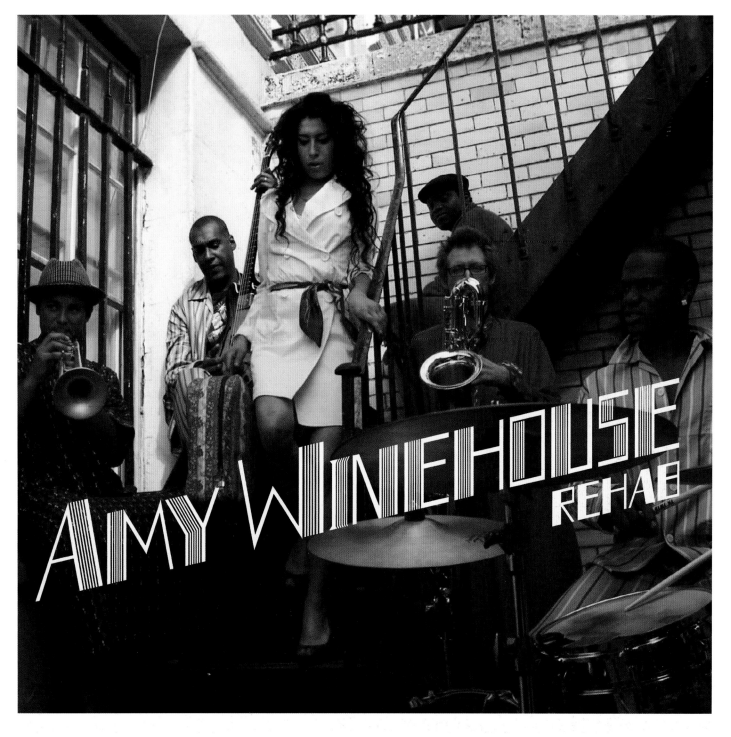

'You Know I'm No Good'
ISLAND RECORDS
8 JANUARY 2007

'Back To Black'
ISLAND RECORDS
30 APRIL 2007

'Tears Dry On Their Own'
ISLAND RECORDS
13 AUGUST 2007

'Love Is A Losing Game'
ISLAND RECORDS
10 DECEMBER 2007

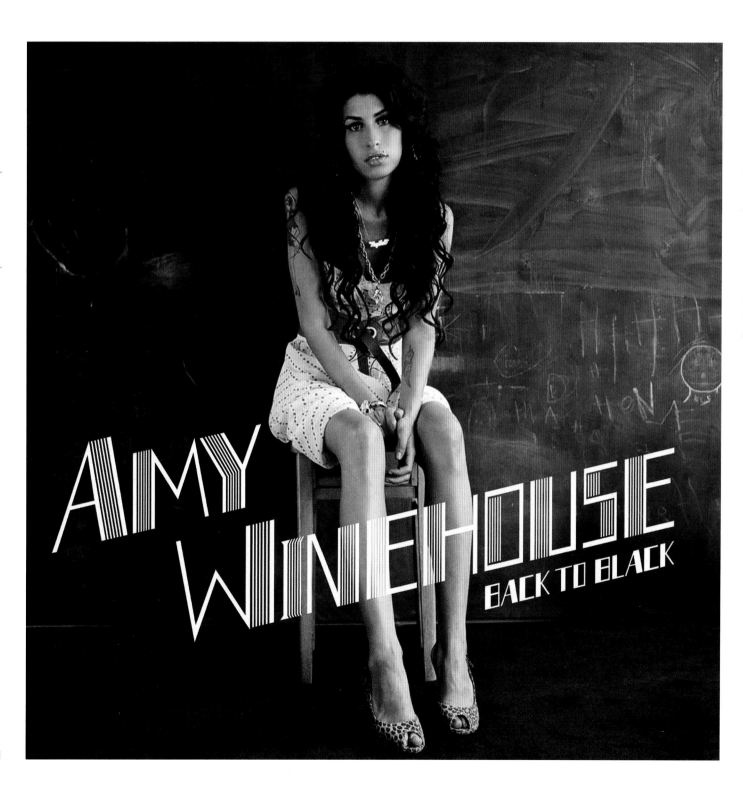

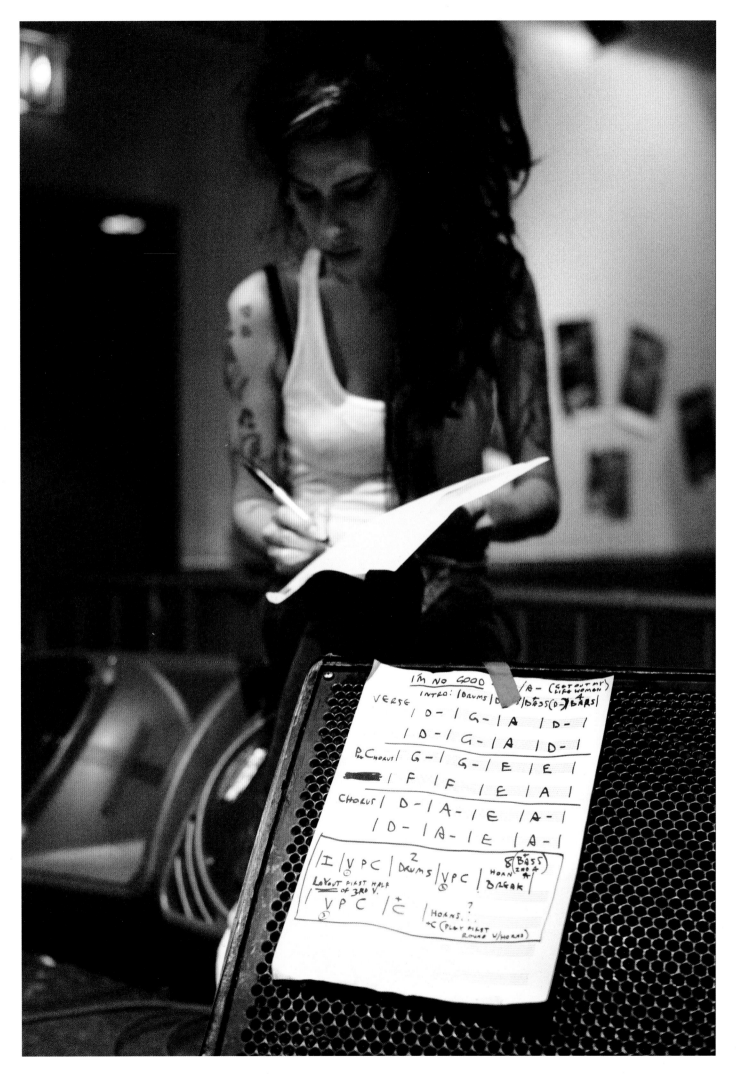

arrangements added urgency, life and texture under Amy's voice.

'Back To Black' was the first instrumental recorded, with Ronson integrating the Dap-Kings' tightly honed movements into a modern pop sound. They played it to Amy the next day, and she loved it so much she went away and wrote the lyrics in an hour. The rest of the songs poured out – 'Rehab' 'You Know I'm No Good', 'Love Is A Losing Game', 'Wake Up Alone', 'He Can Only Hold Her' – all recorded between Chung King Studios and Daptone Records in New York. Ronson later commented that it was the fastest process of any record he'd ever worked on, with four of the songs done in just five days.

Like the sessions with Remi, the sessions with Ronson were fuelled by their environment. The hook for 'Rehab' struck like lightning one day when Amy and Ronson were wandering around the neighbourhood, looking to buy a present for her then-partner Alex Clare. As she told the true story of how she'd been encouraged to go to rehab, she used the phrase 'I said no, no, no'. Ronson instantly heard it as a lyric and suggested heading back to the studio to give it a go. Amy flippantly agreed, thinking it was a fun gimmick song they could smash out in an hour, and it did start out that way – the initial version was more of a 12-bar blues track – but once they put a beat behind it, upped the tempo and added the all-important hand claps, it became the decade-defining lead single we know today.

Once the direction and style of the album had been established, Salaam Remi began to rearrange the tracks from their earlier sessions into more of a sixties space. After re-discovering Marvin Gaye and Tammi Terrell's 'Ain't No Mountain High Enough' around the same time, he interpolated it on 'Tears Dry On Their Own' and had Amy re-record the vocals at a much faster tempo. He also interpolated The Icemen's 1966 track 'My Girl (She's a Fox)' on 'He Can Only Hold Her' and added mournful flugelhorns to 'Unholy War' – a rare case of the brassy, upbeat sound of *Back To Black* reflecting the sadness of Amy's lyrics and melodies. The album was then mixed at Metropolis Studios in London by Tom Elmhirst, who dipped it in reverb-heavy nostalgia and helped it to feel tougher and more robust. All swagger and sadness, *Back To Black* isn't just a love letter to the sixties, but a modern evolution of the sound.

Both Remi and Ronson were central in the making of *Back To Black*, with each producer bringing their own sound, energy and relationship with Amy that was intrinsic to the project as a whole. The lynchpin, of course, was Amy herself. She wasn't just the voice of the album, she was its creator.

Back To Black was released on 27 October 2006, by Island Records. Over the next two years it would top album charts around the world, collect five Grammys and turn Amy Winehouse into one of the most significant artists of the twenty-first century. •

Coachella Rehearsal
('You Know I'm No Good')
COACHELLA, INDO, CALIFORNIA,
26 APRIL 2007
PHOTO Jennifer Rocholl

"On 'Rehab', she wrote those lyrics in two hours and they're so honest. Whoever thought there'd be a pop record about preferring to listen to Donny Hathaway than going to rehab, in 2006? Hers were the most open, honest lyrics you're ever going to hear on pop radio."

Mark Ronson Producer

"Working on 'Back To Black', when she first sang the chorus – *We only said goodbye in words / I died a hundred times* – I said, 'Hey, sorry, it's got to rhyme. That's weird. Can you fix that?' And she just looked at me like I was crazy – 'Why would I fix that? That's what came out.'"

Mark Ronson Producer

ALBUM REVIEW
Back To Black

John Murphy
musicOMH, 2006

Partly produced by man of the moment Mark Ronson, it's an amazingly confident second album, which shows Winehouse moving on leaps and bounds from *Frank*. The main difference is the sound and feel of the album - whereas *Frank* was all jazzy smoky ballads, *Back To Black* goes for a more commercial, poppy, yet still retro sound. 'Rehab' itself is a great example - horns parp and blaze, strings classily swing and smoulder while Winehouse's extraordinary voice purrs and growls about old Ray Charles records being better for her than the Priory. It's Motown rewritten for the 21st century, and it's quite brilliant.

The old school soul references keep up throughout the album. The title track deftly steals its introduction from Jimmy Mack before spiralling off into a much darker place, while 'You Know I'm No Good' has a classy Philadelphia soul feel and some wonderful horn work. Ronson's influence is unmistakable - it's a long time since a producer and artiste felt this right together. Yet this is still Winehouse's album all over. Her voice is still incredible - every so often, you get a shiver down the spine as you realize that she's still only 23 with the voice of a woman two or three times her age - but her lyrics have matured now as well. Apparently written while she was nursing a broken heart, the spectre of failed relationships looms large, especially during the gently skanking 'Just Friends' or the aching 'Love Is A Losing Game'.

She can still swear like a trouper too. 'Me And Mr Jones' could almost be an old soul hit from the late fifties until you hear Winehouse purring the quite magnificent opening line of "What kind of fuckery is this? You made me miss the Slick Rick gig". The exuberant 'Tears Dry On Their Own' is another highlight, marrying a glorious rush of a chorus with Winehouse's husky vocals.

It's a superb comeback and one of the best albums of the year. •

'Rehab' Performance
2007 MTV MUSIC AWARDS,
GIBSON AMPHITHEATRE, UNIVERSAL CITY,
LOS ANGELES, 3 JUNE 2007
—
PHOTO Kevin Winter

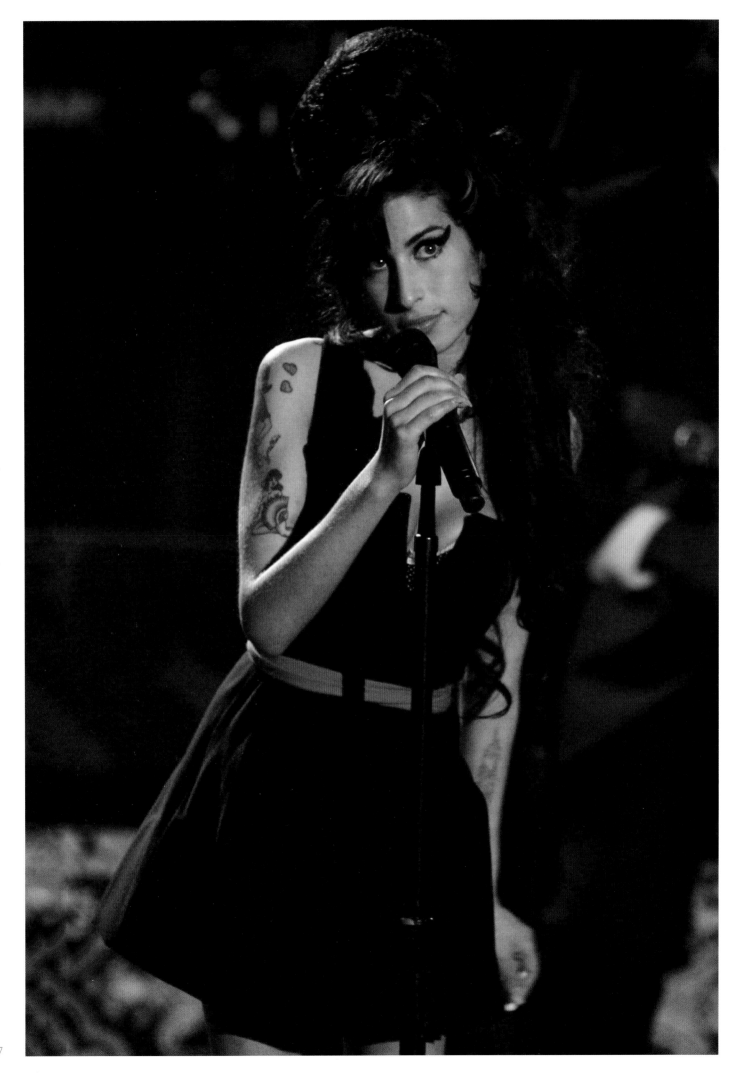

"Sitting in front of me was this tiny petite girl with straight hair and big green eyes that were striking. She wanted a tattoo of her nan, Cynthia, to pay tribute to her. She spoke very highly of her nan and in a loving way. She wanted a tattoo that looked aged, a bit worn, in the style of the traditional tattoos of the

fifties and sixties when they only used four colours plus black. She was very specific about what she wanted. She ripped out some pages showing pin ups from that era from a book I owned and handed them to me for reference. I drew a sketch in under ten minutes, and Amy refused to let me redraw it.

Henry Hate Tattooist

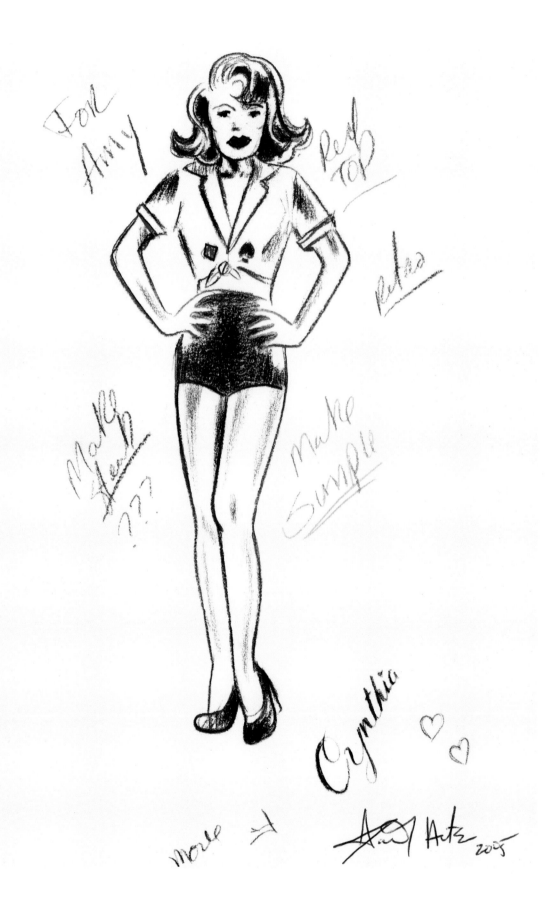

Cynthia Design
DESIGNED AND INKED BY HENRY HATE
AT PRICK, OLD STREET, LONDON,
2004

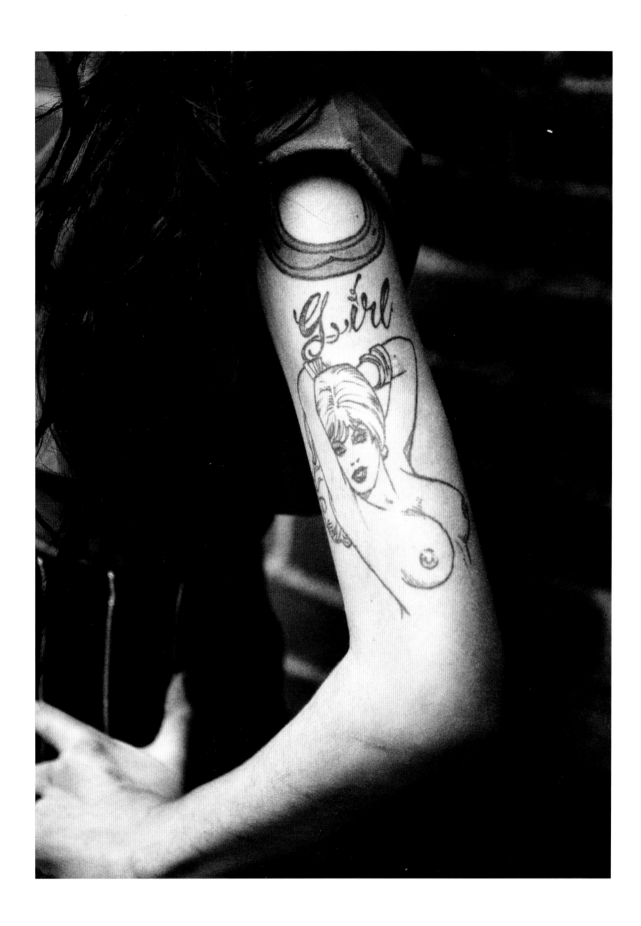

Daddy's Girl Tattoo
DESIGNED AND INKED BY HENRY HATE,
PHOTOGRAPHED IN CAMDEN, LONDON
PHOTO Bryan Adams

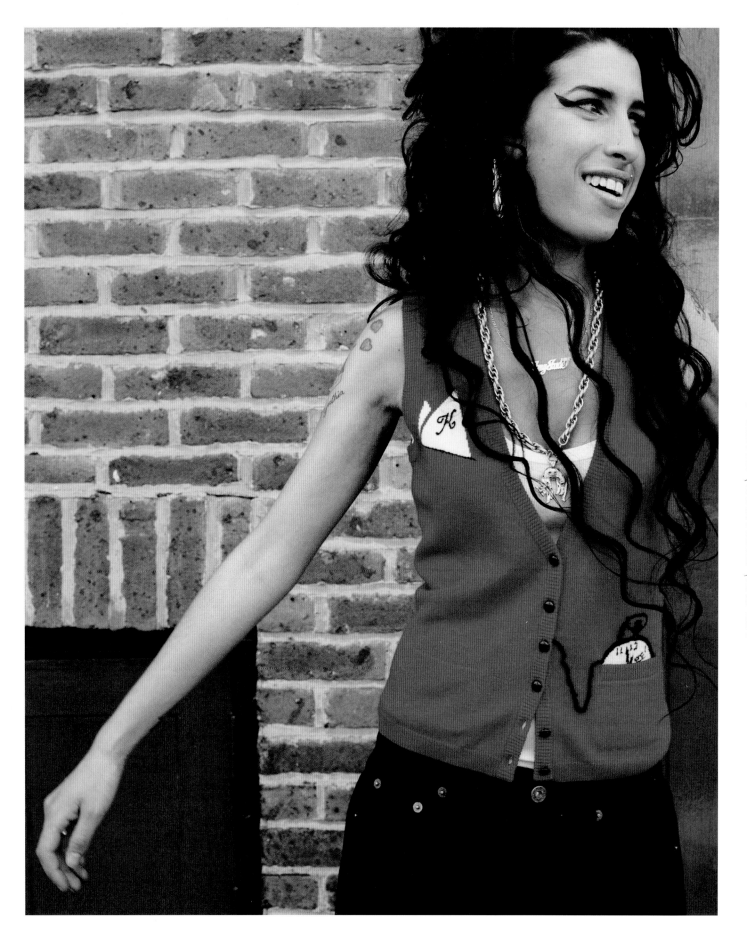

↑ / →
Cover Shoot
KENSAL RISE, LONDON, DRESS BY DISAYA,
24 JULY 2006
PHOTO Mischa Richter

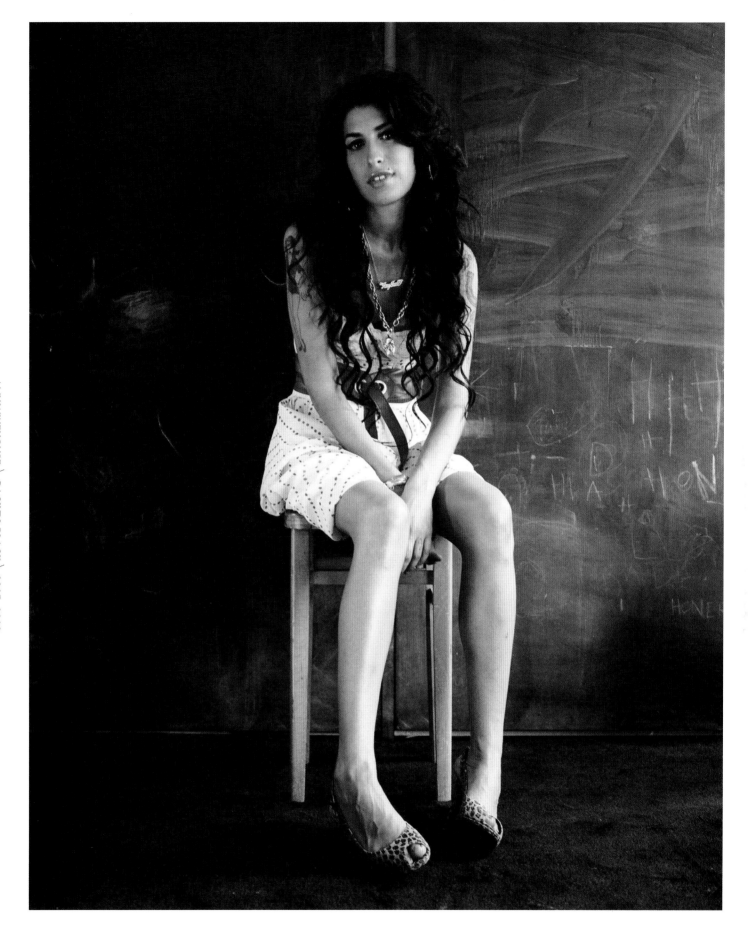

"There was a room I called the black room – I stored negatives and contact sheets in there. I took the last shot of the day there. The record company decided they wanted it for the album cover – and when they told me they were going to call it *Back To Black*, it all made sense. Serendipity, I guess."

MISCHA RICHTER PHOTOGRAPHER

"Amy was more than just a client. Our first meeting she walked into the Kensal Rise location house for the *Back To Black* album cover shoot, a larger-than-life tiny lady. Wow, what a presence Amy had! She told me she didn't like people touching her face or doing her make-up, to which I answered, 'Well

that's great, we gonna get on just fine.' It was at that moment we mutually agreed that we were going to be more than work colleagues to each other. Over the years of working with Amy I experienced so many loving and funny moments; she was definitely a carer not a taker.

Talia Sparrow Make-up Artist

Phil Griffin
Director & Photographer

It is early, we are still waking up, and Amy asks me to tell her jokes while the team prepare the studio. I make her laugh, and this unforgettable smile appears; it's the smile she always gave when she was being her truest self. The Amy I knew – the girl with the most generous spirit, the woman with the most trusting, honest, driven heart and the friend with the kind of unconditional love that happens only a few times in a lifetime.

Amy changed everything for me. There was life before her, and then there was our time with her and now of course, sadly, unjustly, unremittingly, there is life without her. I've heard it said that loss is hardest on the left behind. With Amy this is a both true and false. For many years I could not listen to her nor look at her without pain, regret, anger. How could we lose her? How did this happen? What could we have done differently? But then as time passes and clouds drift over the pain, my memory resurrects the joy of knowing and loving this tiny giant.

My soul re-collects and re-connects to the power of her music, the truth of her love, the real story of her life. Even in bearing her loss, Amy teaches us to be curious enough to listen hard to the lessons of how the heart works. Even in missing her raucous laugh, she encourages us to be unfailingly, unpredictably and unapologetically human. And I am grateful. And somewhere in there – in that aching absence of her presence, quietly, almost like the whisper of a shadow and the faint smell of hairspray and humour hanging in the air just like her smile – I am able to re-hear, re-listen, re-laugh and re-set.

For me Amy was a saviour, someone whose demons helped me find angels as I searched for my own way of seeing the world. And now? More time, more clouds and our Amy is a rainbow in those clouds; a lesson in and of the rain. I no longer reach out to turn down the radio whenever she comes on. Instead, I lean in to turn it up. I re-learn to celebrate and I am re-grateful daily for our friendship.

She called me 'My Phil'. This young, ferocious, audacious spirit, restrained only by the flesh of that petite north London body and expressed always by the voice that torc through bone, soul and sorrow, is still with us, and she will always be 'My Amy'. She understood completely the need for authenticity – no matter the cost – she recognized intuitively the value of truth no matter the price paid. And like the passing of all those clouds she always, always showed me that with honesty all things re-up.

In the end and most of all, I think, she taught me how to make our shared space a safe place to be dangerous.

I miss her every day. •

'Rehab' Video Shoot Test Shot
32 PORTLAND PLACE, LONDON,
MARCH 2006 (FIRST AIRED SEPTEMBER)
PHOTO Phil Griffin

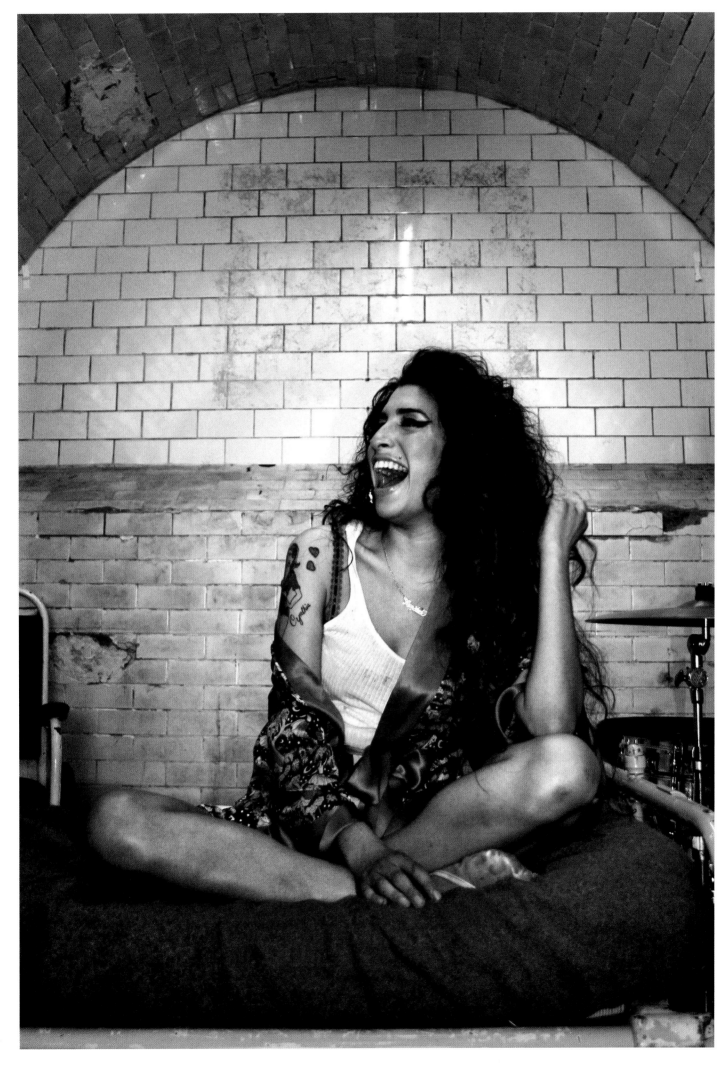

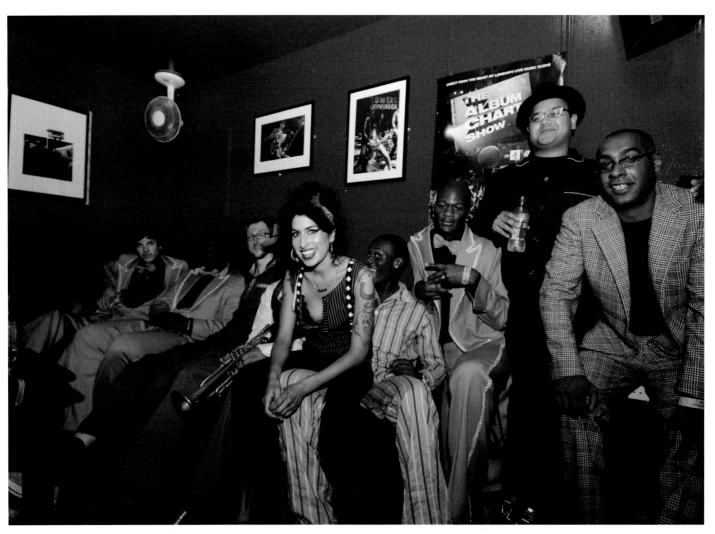

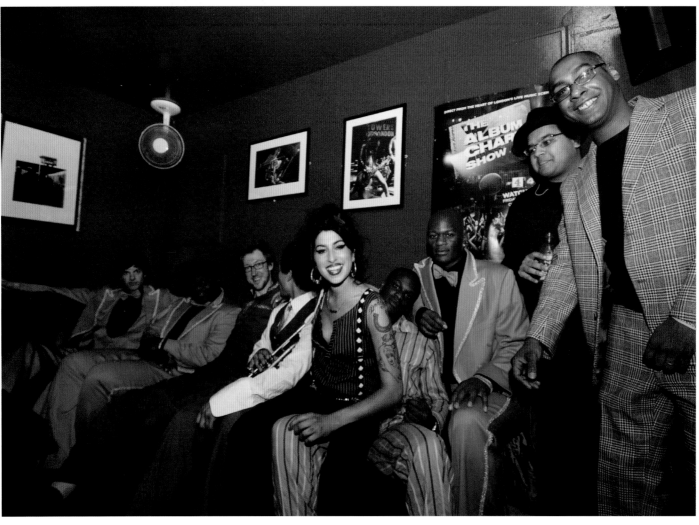

Adeleye Omotayo
Backing Singer

I will never forget our first encounter. It was 2002 and I was trying out for a band Amy sang with called The Bolsha Band. She came through the door looking suave in a top coat, trilby worn to the side Sinatra style and an upper lip piercing. She looked like a beautiful alien to me and I really hoped she sang as good as she looked. Of course, her voice was even more out of this world than her attire. I basked in the sheer glorious resonance of it. It was like nothing I had ever heard before. Afterwards, I rushed straight home to tell everyone that I had just encountered the best singer I had ever heard and her name was Amy Winehouse.

We played gigs for cool kids with fake IDs in north London pubs. I learnt so much from her in the process. Then, inevitably, she signed a record deal and for a while I only saw her at a few signings at the HMV store in Oxford Street and on TV. Then one day, years later, she sought me out to sing backing vocals on tracks from the *Black To Black* album. I really had very little experience but she assured me that I could do it - that's why she had chosen me. In no time at all I was involved in music videos and rehearsals. I never imagined that this could happen to me. Amy was always like that. She saw things in people they couldn't see in themselves. Fiercely protective of her friends, she wouldn't let anyone, no matter how big, pronounce my name wrong. I really didn't mind but it moved me to know that she did. She had recorded the bulk of the album with the Dap Kings in America but she wanted the live band to be resident in the UK. Being on the road at the time was such a humbling and fresh experience. Sometimes all nine of us would get dressed under a staircase or in a broom cupboard. It really didn't matter to us as the music was just so damn good. After a gig we would listen to jazz and watch music documentaries. I couldn't believe some of the people who came to see us play. Once Stephen Marley brought an entourage of Rastafarians to see her perform. I had never seen so much red gold and green in my life!

In the midst of all the madness Amy never lost sight of who she was. She could be funny, feisty, frivolous, but she was always kind, always trying to take care of us all. She loved watching Eddie Murphy's *Daddy Day Care* and we would often argue over whether Nas or Jay Z was the best. (She loved Mr Jones obviously.) I don't think I'll ever get over her passing. It's tough listening to her music, so I don't. I can't believe it's been 10 years. I'll never forget you Amy.

Backstage at KOKO
CAMDEN HIGH ST, CAMDEN, LONDON,
AMY WITH (L–R) SAM, ADE, AARON, JAY, NATHAN,
ZALON, ROBIN AND DALE,
25 SEPTEMBER 2006
PHOTOS Scarlet Page

NME *Photoshoot*
28 OCTOBER 2006 ISSUE
PHOTOS Dean Chalkley

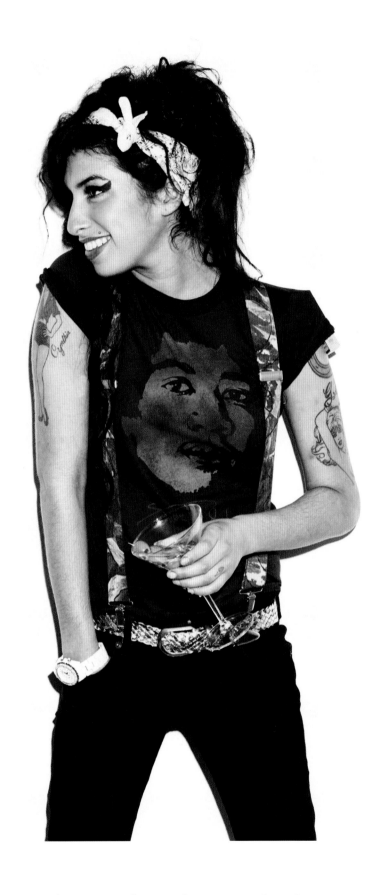

"Amy was such a crucial artist but more than her pure
musical genius she captured a special power and energy,
she was the real deal…. Genuine!"

DEAN CHALKLEY PHOTOGRAPHER

Kristian Marr
Actor & Musician

It's 2006. We spent the evening in The Good Mixer, then made our way down to Tommy Flynn's on Camden High Street where my friend Alex Clare and I played an acoustic show. After the show we ended up at The Dublin Castle, one of our favourite bars at the time. We would dance and drink till the last bell in the back room. She loved being around people, laughing and dancing and playing pool. Her song-writing definitely took a lot of inspiration from her day-to-day life, her friends and relationships.

Amy was successful at this point but nowhere near the heights that were to come. She was the beautiful, innocent, happy young Amy who could enjoy just being herself without the pressures that were to come later. I remember Camden back then as the best place in the world. Nothing could come close. There was so much energy and the whole place was thriving. So many characters – it was almost like living in a cartoon. We felt safe and surrounded by everything we loved. It was a good place for a young musician to live and showcase their music. So many live music venues.

Still to this day I have never witnessed another voice like Amy's. I remember her singing while cleaning or making a cup of tea and I'd be like fucking hell,

she's good! Her voice would fill the whole room and the hairs on my arms would be trying to join her. It really was something that grabbed a hold of you and lifted you off your feet.

We used to have great fun in Amy's apartment with guitars or records, fighting over blues and jazz! Often she would pull the guitar off me to show me a new jazz chord she had learned. In fact, every time I picked up the guitar she had a new chord to show me. She kept putting her fingers in crazy patterns on the strings and we would start laughing. I swear most of the chords were made up on the spot just to get me off the guitar.

I had such a great dynamic with Amy! She was very clever and witty. We were constantly winding each other up and in tears of laughter. I remember her laugh and smile so much. It's a rare thing to find and I know I really had something special there.

Amy cared so much about the people around her, which was so lovely to witness. People were very attracted to her not just for her music but for her kindness and charm. She loved to cook or order takeaway for everyone wherever we were. I look back and cherish who she was and how much love she gave to others. Amy gave 110 per cent with everything she did. •

Night Out
TOMMY FLYNN'S PUB, CAMDEN, LONDON,
OCTOBER 2006
PHOTOS Kristian Marr

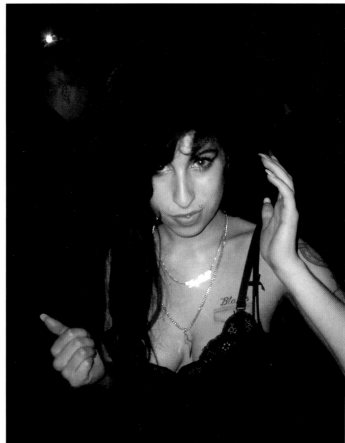
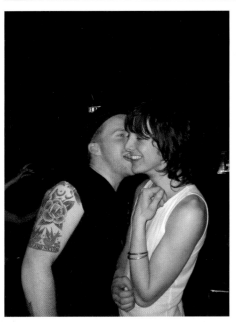
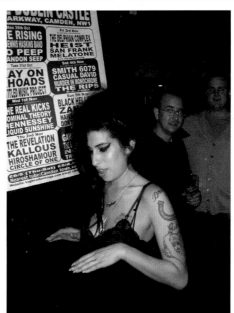
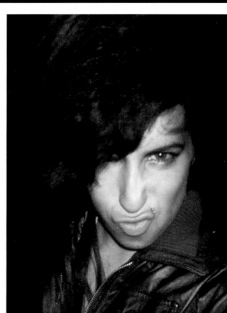

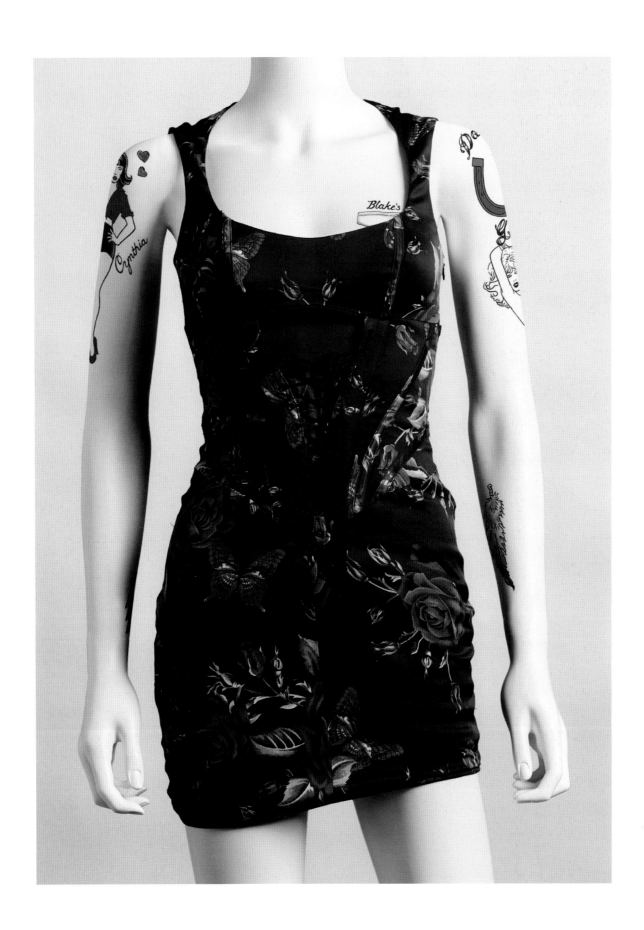

↑
KOKO *Stage Dress*
BY KAREN MILLEN,
WORN ONSTAGE AT KOKO,
14 NOVEMBER 2006

→
Onstage at KOKO
KOKO, CAMDEN, LONDON,
14 NOVEMBER 2006
PHOTOS **Simone Joyner**

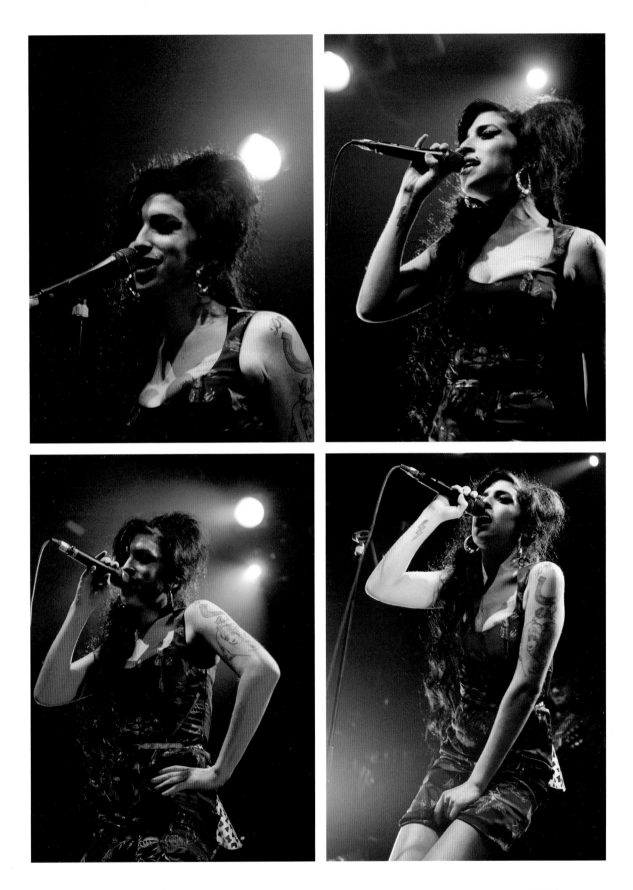

"Amy played an amazing live show at the venue in 2006. Unlike
99 per cent of the Camden scene, Amy obviously had a huge talent. She
always had time for everyone working there. It was like she felt safe and
comfortable hanging out at KOKO; she was real friend of the venue."

DAVEID PHILLIPS HEAD OF MUSIC, KOKO

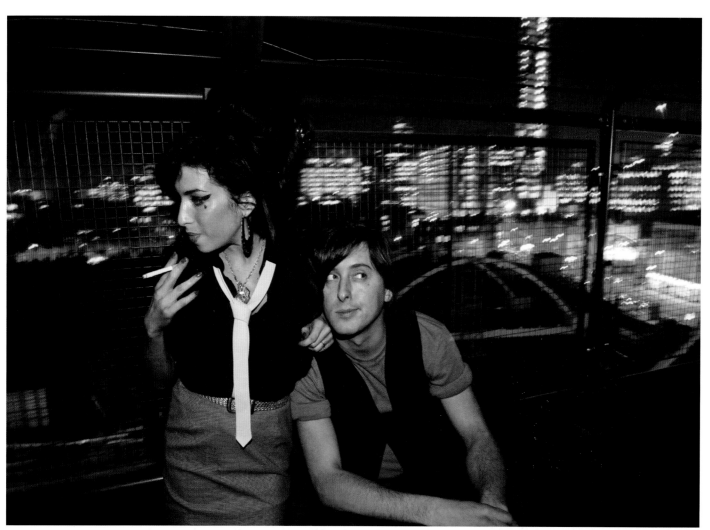

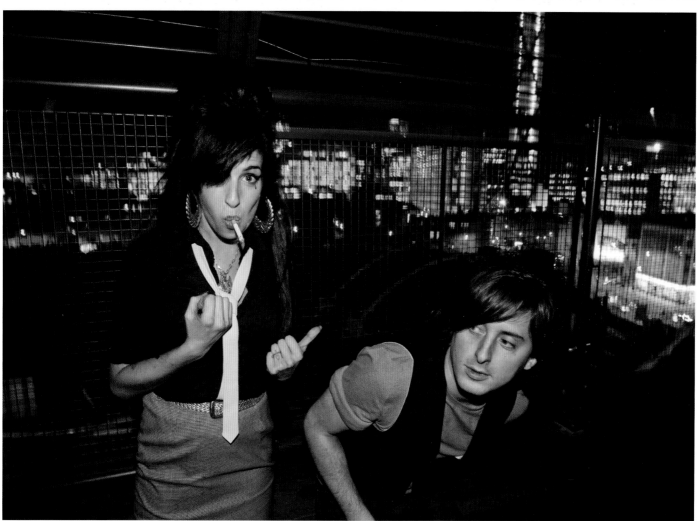

Carl Barât
Artist

Losing a friend is a world-shaking thing. We become lost to a mental maelstrom of love and mortality, loss and reality. I believe that with each and every relationship between two people, a third entity is born, an incarnation existing only to the two people involved. (Amy might say this was bollocks!) I believe it is this entity that we mourn most of all. But when you lose a friend, who is also a friend to the whole world, all your personal moments and memories begin to conflate with the media coverage, and it's hard to hold on to what was ever real.

I first met Amy on the set of *Friday Night with Jonathan Ross* when she was promoting *Frank* and we were doing 'Can't Stand Stand Me Now'. She was charming, mysterious, exotic and timeless with her thick London accent and her ukulele. We had already moved around the same circles for some time, with many friends in common, and from this point onwards, Amy became one of our gang back in the day in Camden. The majority of our nights ended up in situations probably unmentionable here, but in short, we shared a lot of good times.

One thing that always stays with me about Amy, besides her quick wit and world-beating talent, is her incongruous mix of kindness and fire. I was putting on a night at Proud Galleries – this was a short time after the release of *Back To Black* – and despite Amy being well into her meteoric rise by then, without hesitation, she agreed to play a show for me. There was no money in it, and it totally conflicted with her touring schedule, but she did it anyway and fucking nailed it of course. The performance was complete with the spirit of the best Camden gigs – beer raining down, dodgy sound and bacchanalian fervour abounding. She even brought her whole brass section. Looking back, not only was it just such a magical moment, but I'm struck by how she really pulled out all the stops for me.

After a set which was played with as much passion and intent as an arena show, she jumped off the front of the stage to leave through the scrum. People were grabbing at her as Raye ushered her out of the barriers through the sea of hands. She was clearly getting frustrated and began to see red as drinks were flying on her. Someone grabbed at one of the straps on her tops, stretching it. Rather than crumble or freak out, she spun round like Sugar Ray Leonard and smacked this fella square on the jaw. He disappeared under the waves of the melee. She didn't bat an eyelid as she carried on out to the bar. She was kind and tough in equal measure, and complex and full of beauty and pain.

Only the good die young. Amy forever. •

←
On the Balcony
SHOREDITCH HOUSE, LONDON,
NOVEMBER 2006
PHOTO Roger Sargent

→
'Back To Black' Video Shoot
GIBSON GARDENS, LONDON, DRESS BY
WHEELS & DOLLBABY, NOVEMBER 2006
PHOTO Alex Lake

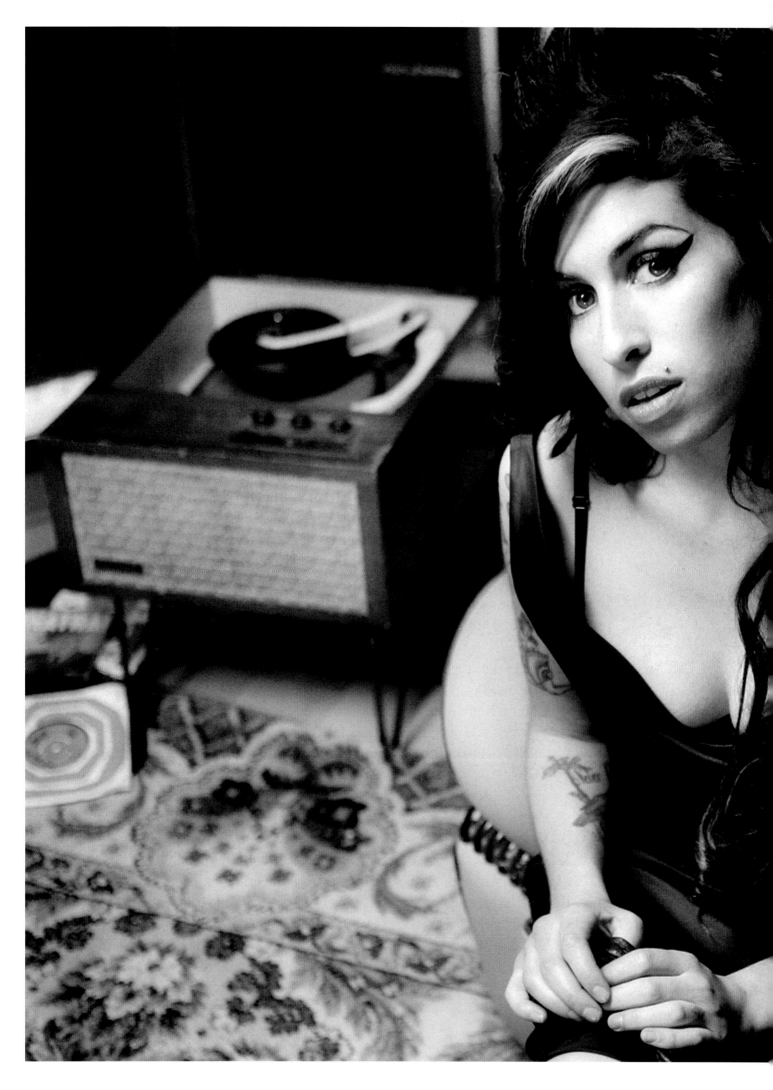

"I remember first meeting Amy at the Southbank Awards, she stood out with her beehive and her tattoos, and her make-up. I didn't know who the hell she was, I just thought she looked a character and we had a drink and a laugh together, and then she got dragged off one way and I got dragged off another."

Ronnie Wood Artist

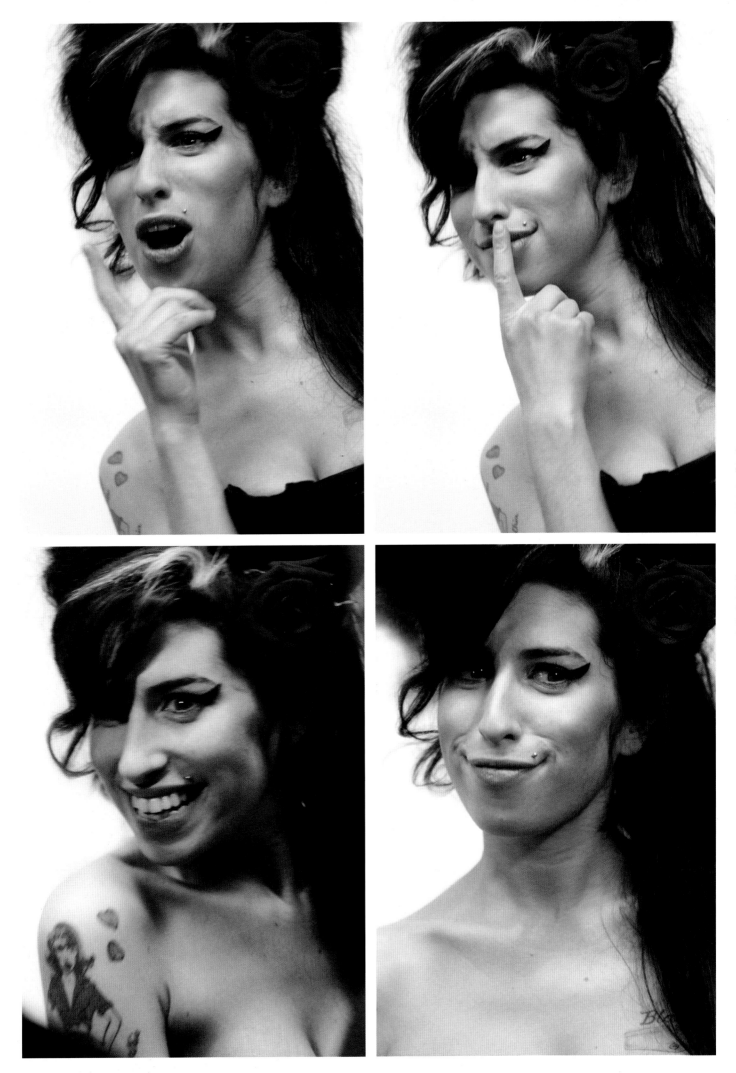

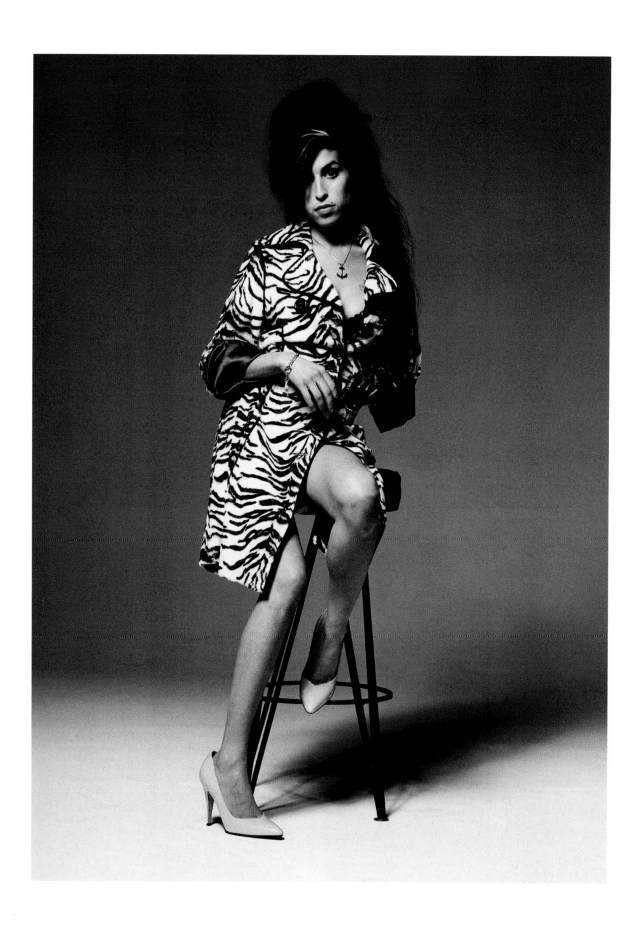

←
One of a Kind (×4)
SOUTHBANK SHOW AWARDS, LONDON,
23 JANUARY 2007
PHOTOS James Veysey

↑ / →
Zebra Stripe
MISSBEHAVE SHOOT, NEW YORK,
2 FEBRUARY 2007
PHOTOS Brooke Nipar

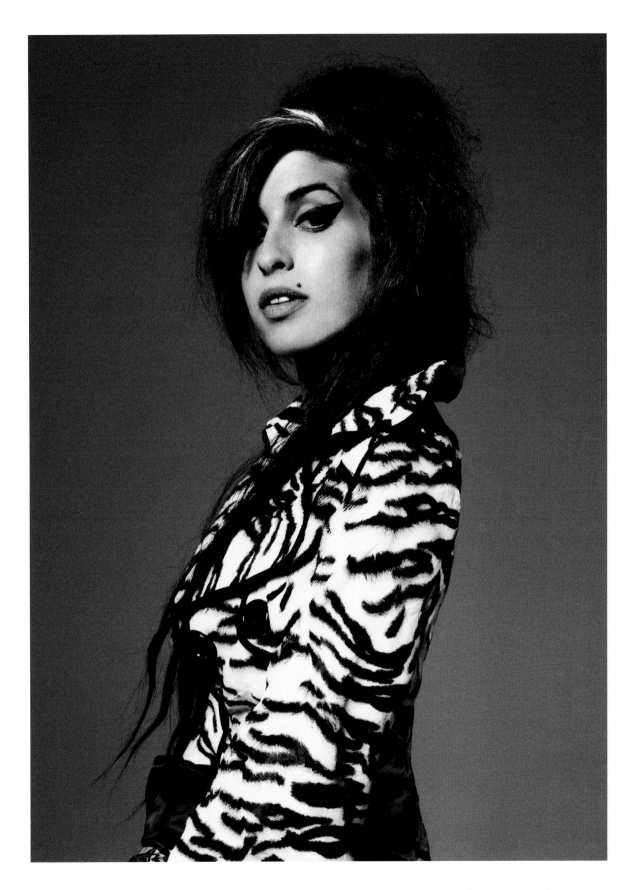

"When I showed up to the studio, she had locked herself in the bathroom with a bottle of champagne and refused to come out. Her manager... promised me my own studio day with her, which ended up being awesome. When she arrived on set she was so sweet and apologetic."

BROOKE NIPAR PHOTOGRAPHER

"I love that Amy didn't look like a make-up artist had done her make-up, and that her look made such a simple but impactful statement. It was a minimal approach to a dramatic make-up. Many elements of her look were just left undone. That's what real make-up is about; it moves. She was definitely a pioneer

of casual glamour – she's the one who brought back liquid liner, and for good. All make-up artists now know the 'Amy liner' – that incredibly thick black flick. Like a 'Linda eyebrow' or 'Bardot hair' it became a trademark. I remember her style was completely new at the time – no one looked like her.

Pablo Rodriguez ILLAMASQUA

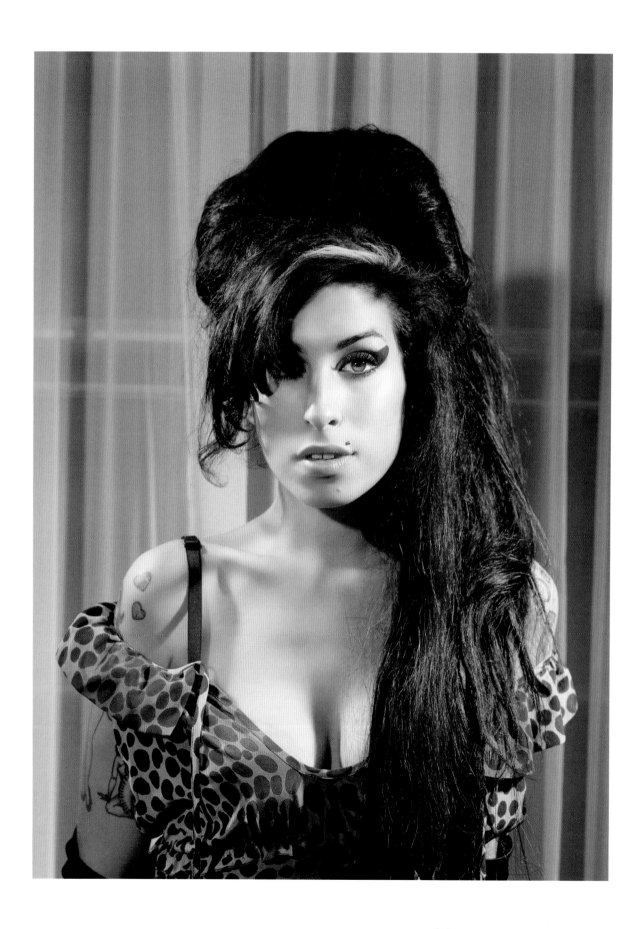

←

Amy's Make-up
CHANEL FOUNDATION, MASCARA,
BLACK LINER, RED LIPSTICK, BLUSHER
& NAIL VARNISH
PHOTO Andrew Hobbs

↑ / →

Leopard Print
PORTRAIT SHOOT FOR *WALLPAPER**
MAGAZINE, LONDON,
10 FEBRUARY 2007
PHOTOS Daniel Stier

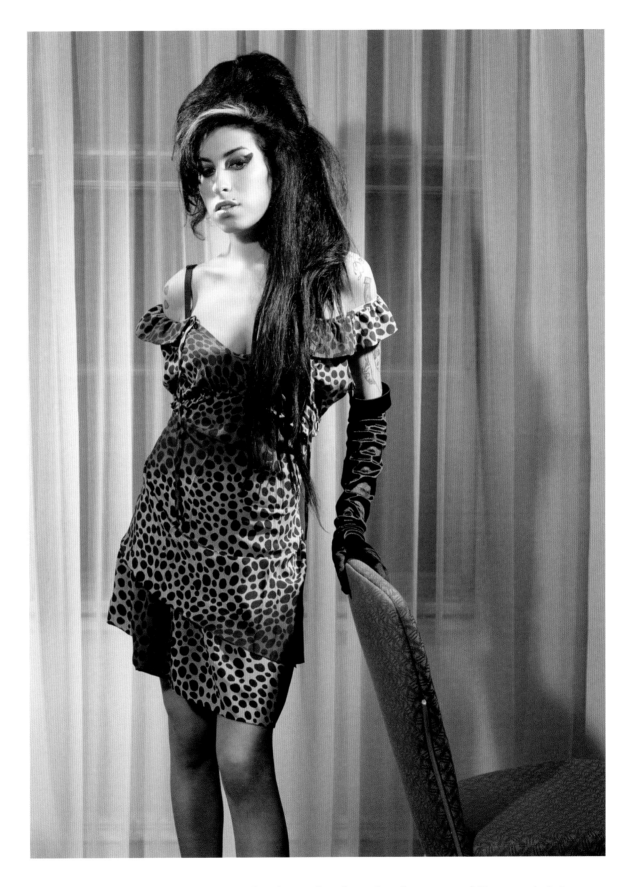

"Amy looked further back, to the heartbroken hit factory of Detroit's Motown girl groups. To the Rat Pack's long croony notes and heavy drinking. And truth be told, there just weren't many independent women around. Not only did Amy introduce a whole new sound, she also introduced a whole new attitude."

HANNA HANRA WRITER

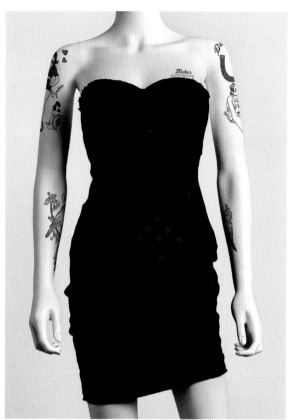

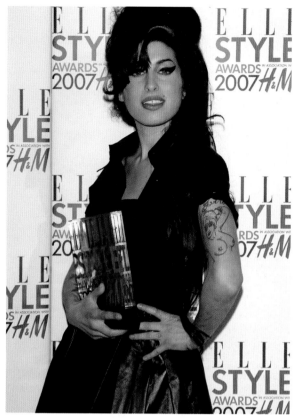

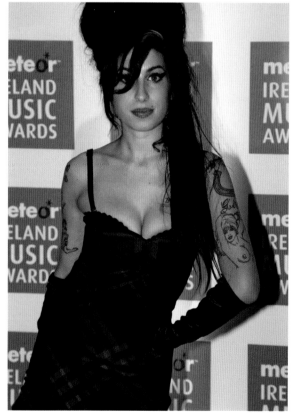

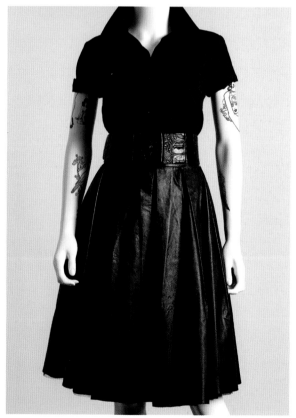

↑

2007 Meteor Music Awards,
Ireland
POINT THEATRE, DUBLIN,
1 FEBRUARY 2007,
DRESS BY JULIEN MACDONALD
PHOTO (BOTTOM) Joe Fox

↑ / →

ELLE *Style Awards 2007*
(Winner: Best Music Act)
ROUNDHOUSE, CHALK FARM ROAD, CAMDEN,
LONDON, 12 FEBRUARY 2007,
OUTFIT BY TINA KALIVAS
PHOTO (TOP) Ian West

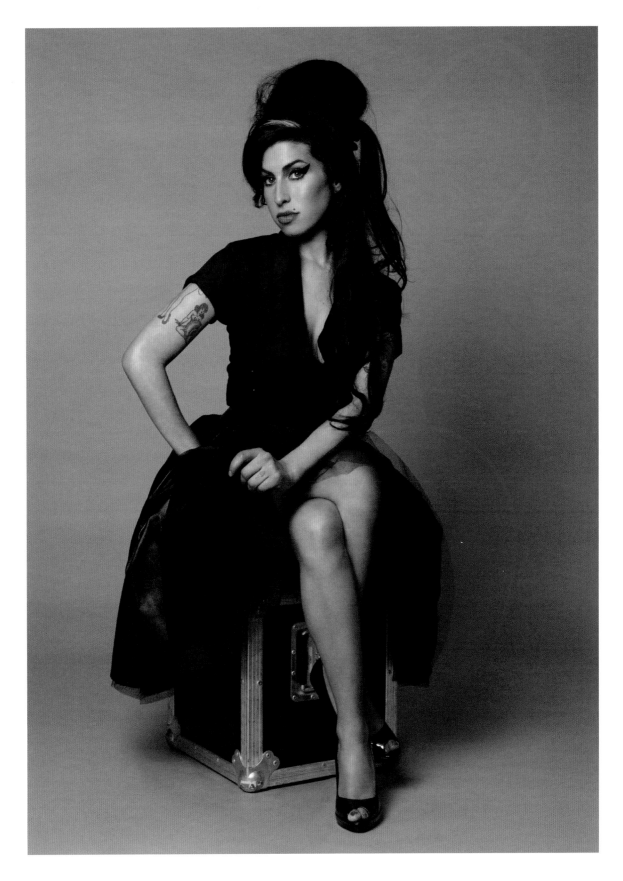

"This leather rock 'n' roll skirt and shirt I actually made for Amy with my own hands. She took this outfit to a whole new level when she wore it to the *Elle* Style Awards. Amy made everything feel so personal and authentic with her voice and with her style."

TINA KALIVAS COSTUME DESIGNER

↑
Heart-shaped Bag
BY MOSCHINO
VANITY FAIR 10TH ANNIVERARY
LIMITED EDITION,
2007

→
2007 BRIT Awards
(Winner: British Female Solo Artist)
WEARING PREEN DRESS AT EARL'S COURT,
LONDON, 14 FEBRUARY 2007
PHOTO David Fisher

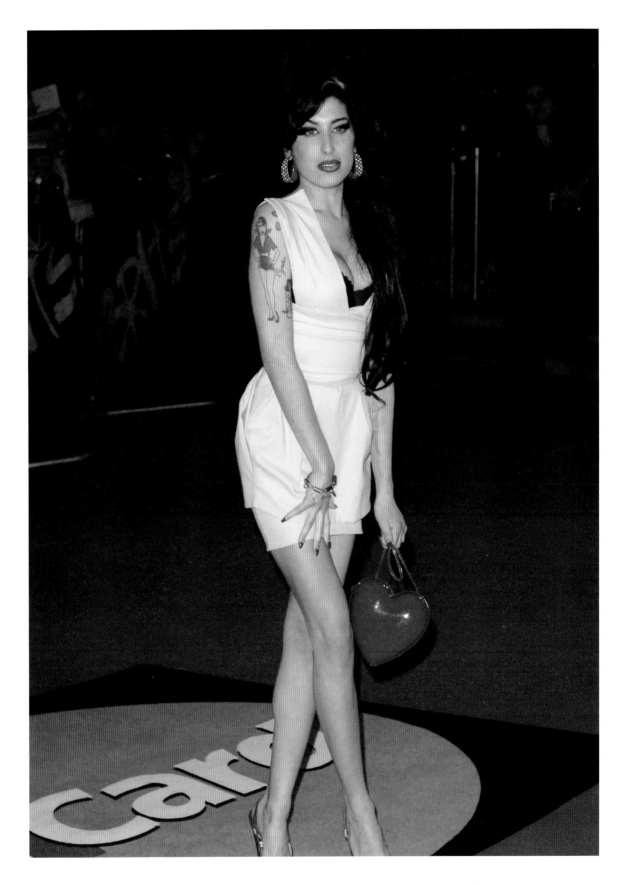

"The BRITS 2007 fell on Valentine's day, and when Moschino sent over
this unbelievably kitsch heart bag, Amy got really excited and we built
the outfit around it. To me, this was the moment that she really found
her signature style. It was the most comfortable I had seen her."

NAOMI PARRY STYLIST

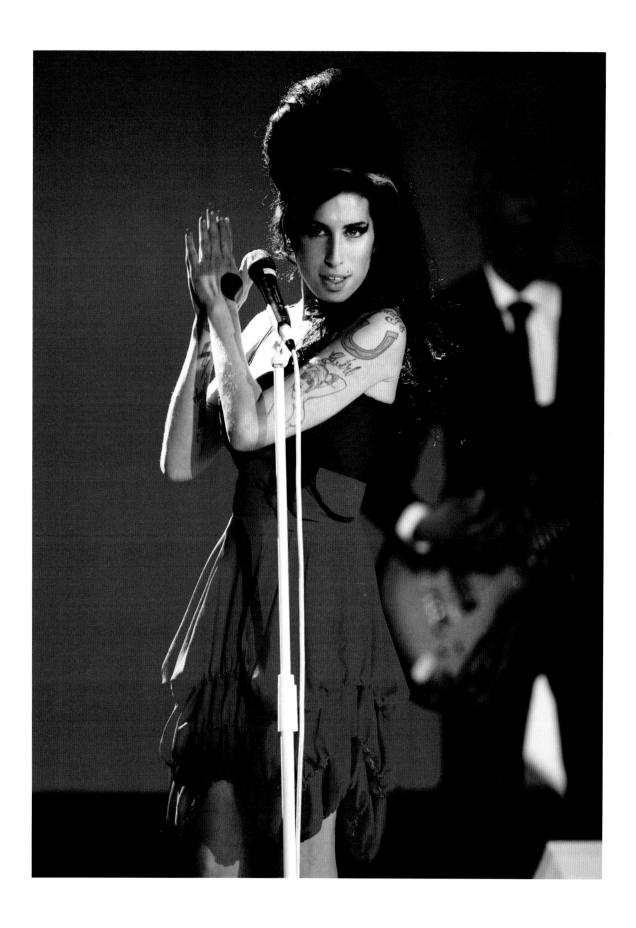

2007 BRIT Awards Performance
AMY IN ARMANI TULIP-SKIRTED DRESS
WITH DALE ON BASS GUITAR,
14 FEBRUARY 2007
PHOTO Dave Hogan

"She was such a great singer. You could play literally anything and she would sing over the top: she had amazing rhythm and an ability to glue things together. She was a true artist, very generous and courageous. It was great to be a part of that history, but it will always be tinged with sadness."

Dale Davis Bassist

"Whenever I listen to her music, I can imagine being in a room with her and her band playing, and I really love that. That's what I like [to do] with my music: to make it sound like you're in a room with me and I'm playing live."

Jorja Smith Artist

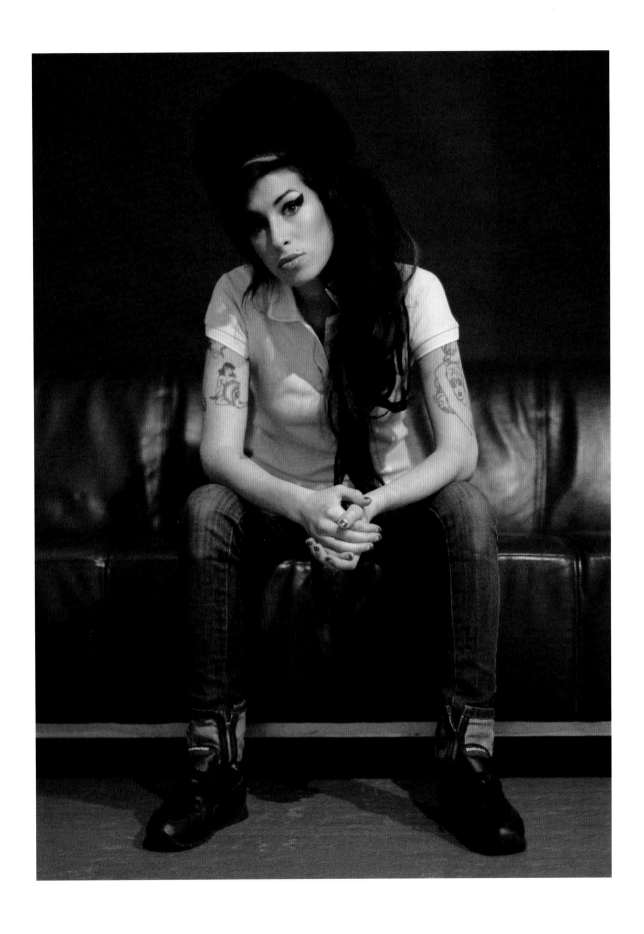

Astoria Backstage
LONDON ASTORIA,
CHARING CROSS ROAD, LONDON,
19 FEBRUARY 2007
PHOTO Matt Dunham

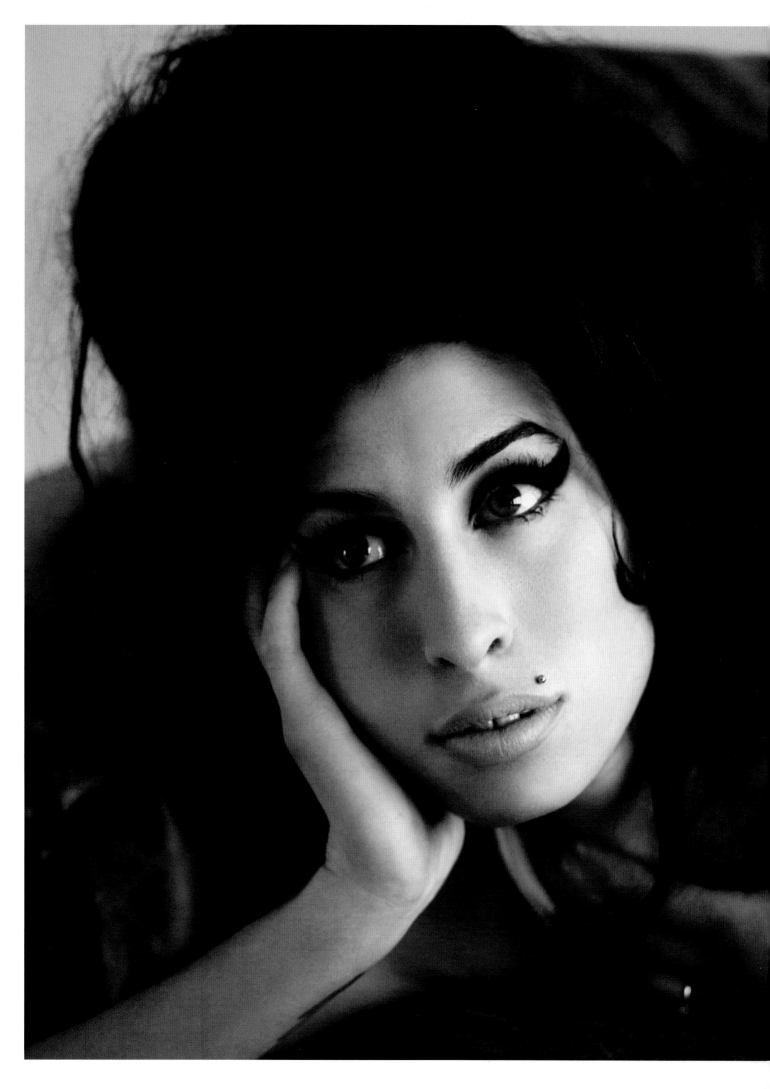

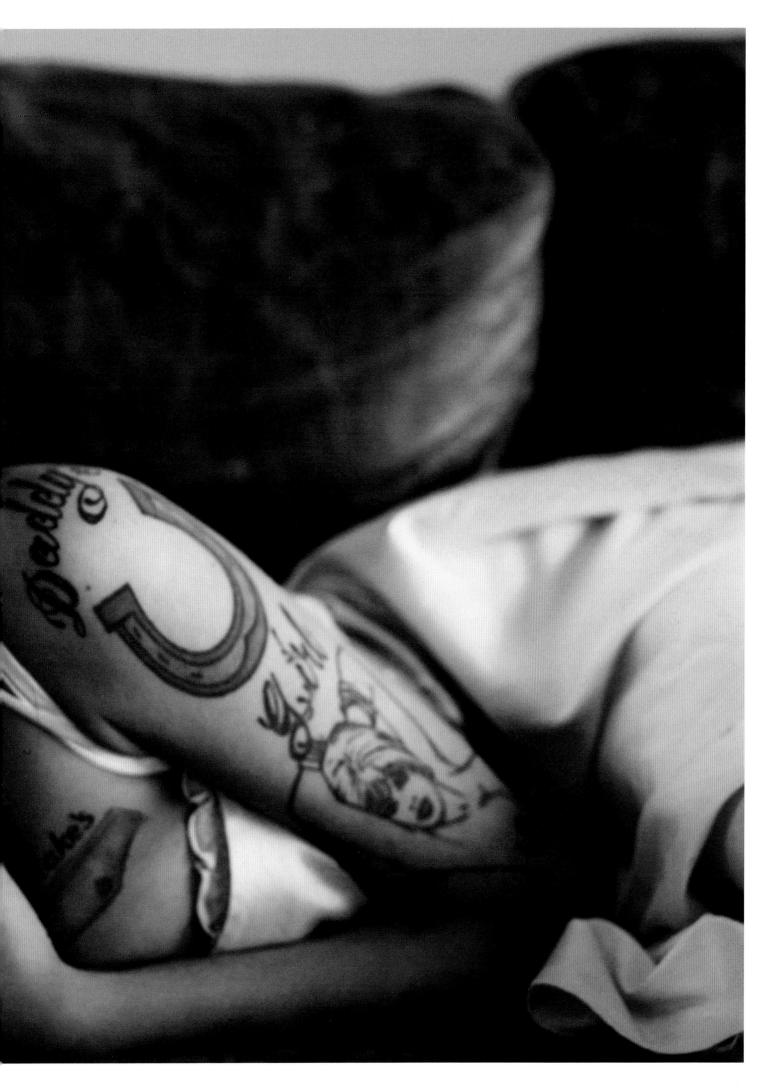

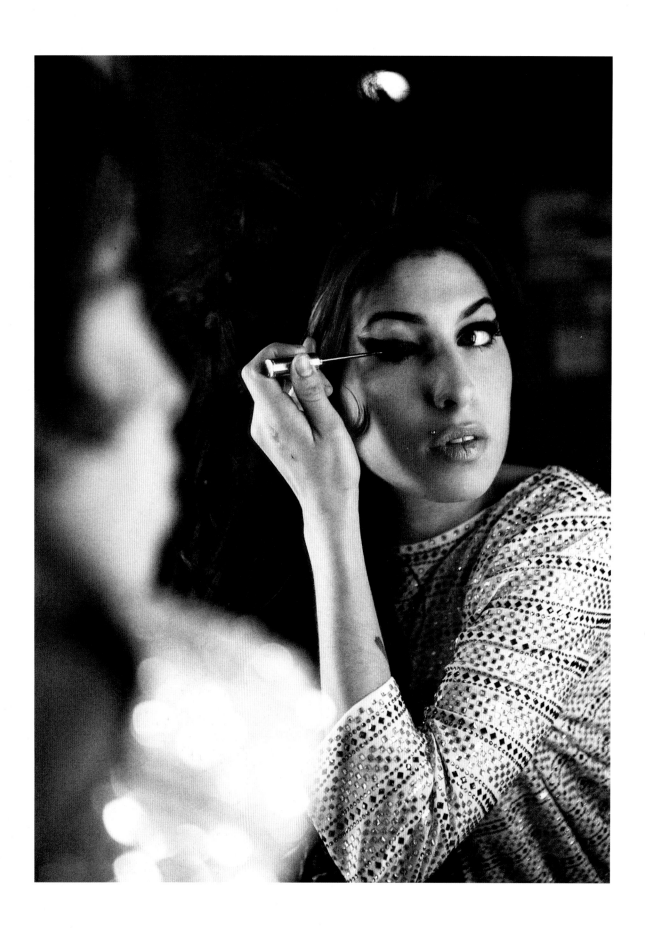

←

Zoo magazine 1
INTERIOR SHOT, ZOO MAGAZINE #15
APRIL 2007
PHOTO Bryan Adams

↑

Zoo magazine 2
INTERIOR SHOT, ZOO MAGAZINE #15
APRIL 2007
PHOTO Bryan Adams

"I didn't know that it was going to be that big. I knew it felt special and that she was in the zone, but I didn't know that it was gonna be that impactful for everyone ... I knew it was good, but I didn't know it was going to sell whatever 20 million plus."

Salaam Remi Producer

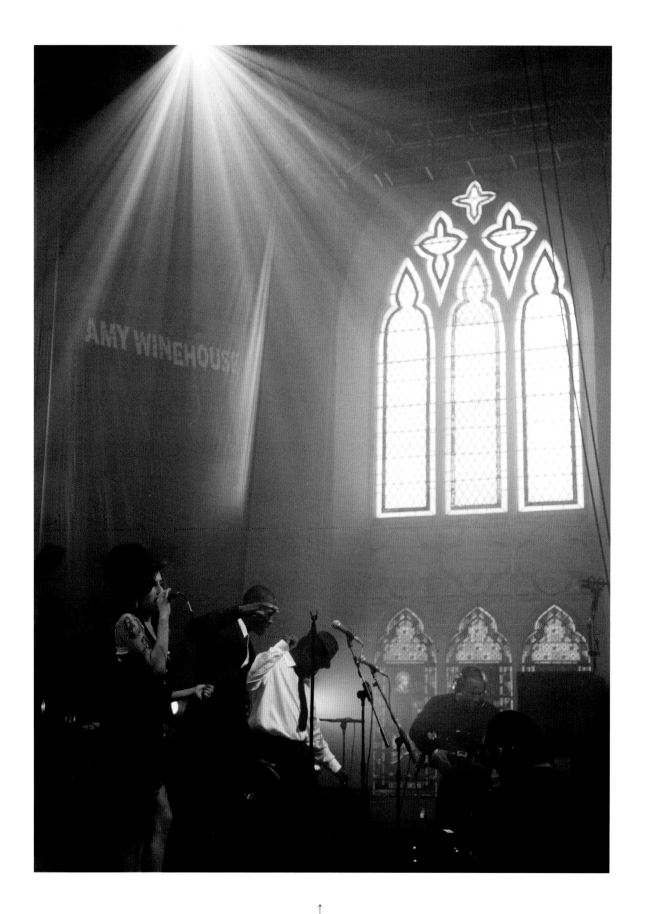

↑
Swoop!
Vodafone TBA Concert Rehearsals
AMY WITH BACKING SINGERS ZALON AND ADE,
CIRCOMEDIA, PORTLAND SQUARE,
BRISTOL, 19 APRIL 2007
PHOTO Yui Mok

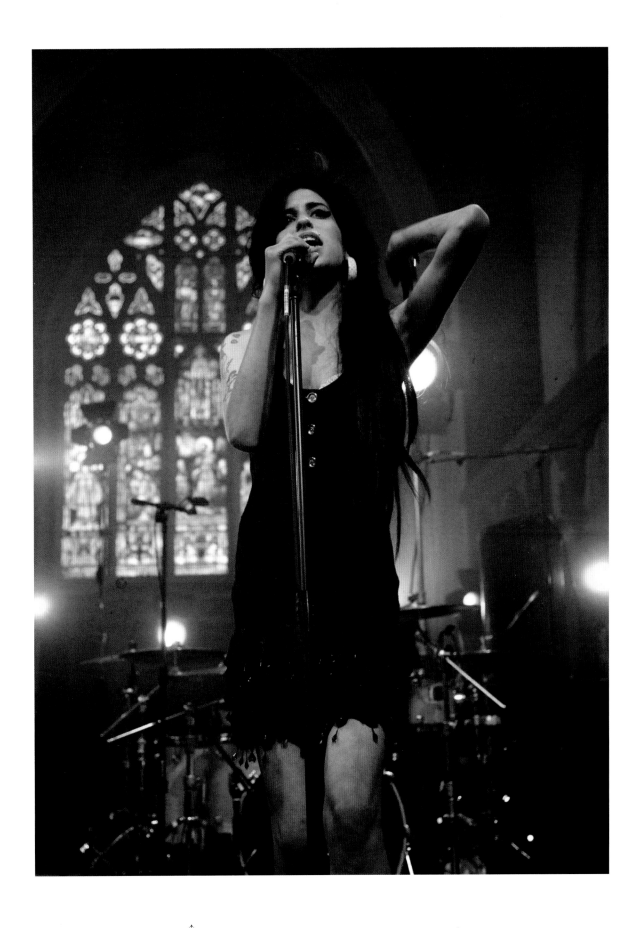

↑
At the Altar
Vodafone TBA Concert Rehearsals
CIRCOMEDIA, PORTLAND SQUARE,
BRISTOL, 19 APRIL 2007
PHOTO Yui Mok

→
Coachella Trailer with Blake
COACHELLA VALLEY MUSIC AND ARTS
FESTIVAL, INDIO, CALIFORNIA
27 APRIL 2007
PHOTO Jennifer Rocholl

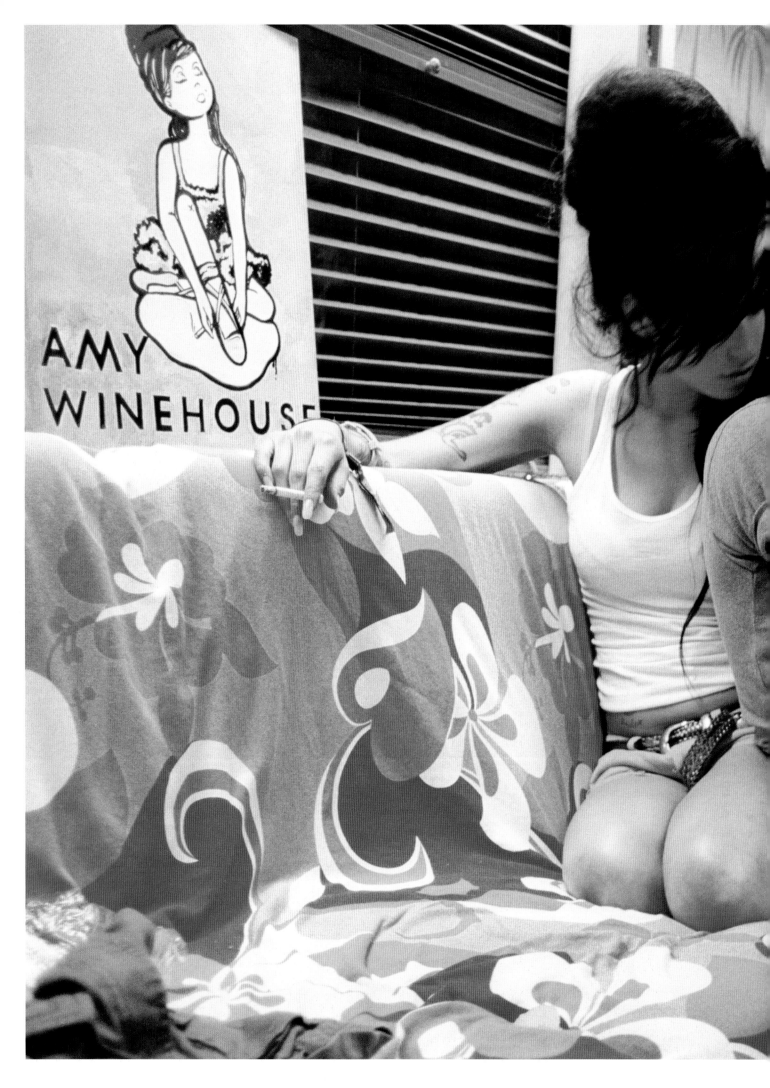

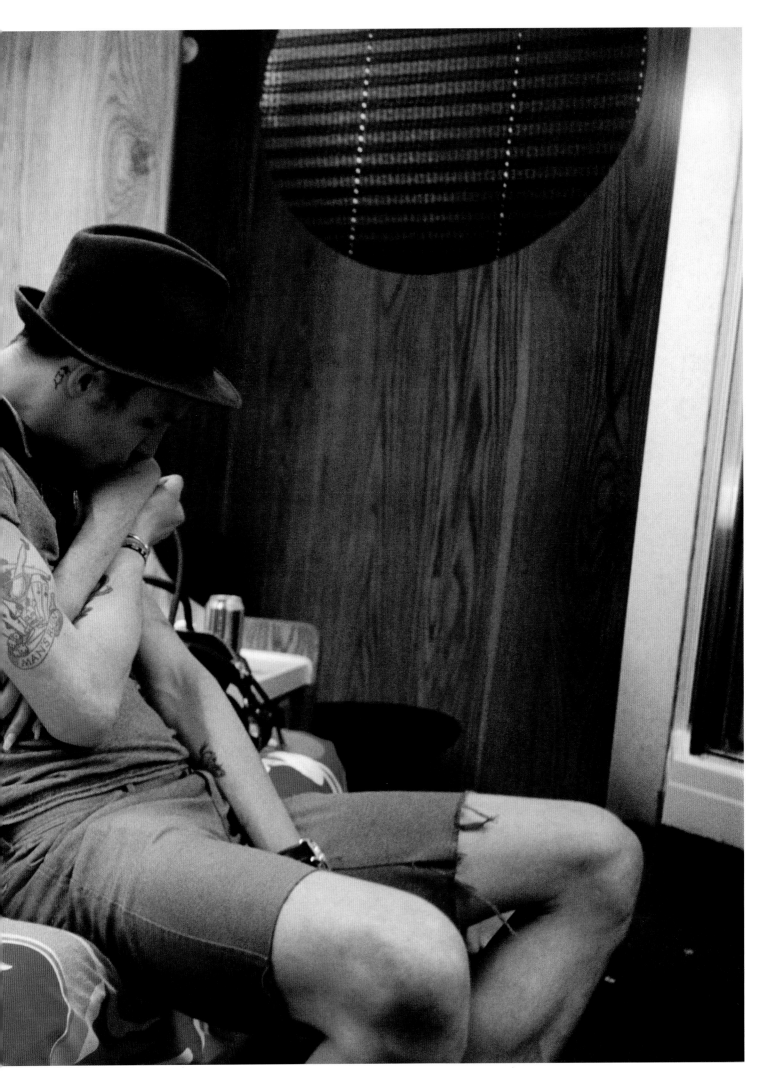

BOOTS RILEY

CSS WITH PARIS HILTON

SHINGAI SHONIWA

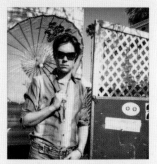

RUFUS WAINWRIGHT

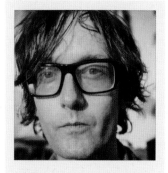

JARVIS COCKER

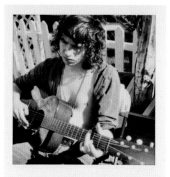

LUKE PRITCHARD

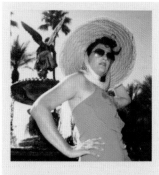

PEACHES

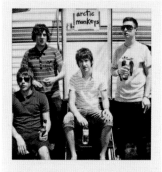

ARCTIC MONKEYS

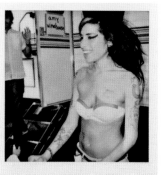

AMY WINEHOUSE

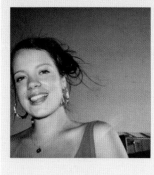

LILY ALLEN

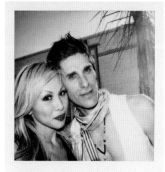

PERRY & ETTY LAU FARRELL

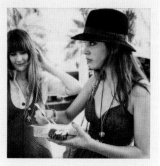

ALEXA CHUNG &
TENNESSEE THOMAS

"Coachella was a Venn diagram of hipster culture and
mainstream pop in 2007. Amy Winehouse may not have
headlined, but she was the axis of the cultural elite
and messy starlets that defined the era."

MITCHELL SUNDERLAND *VICE* MAGAZINE

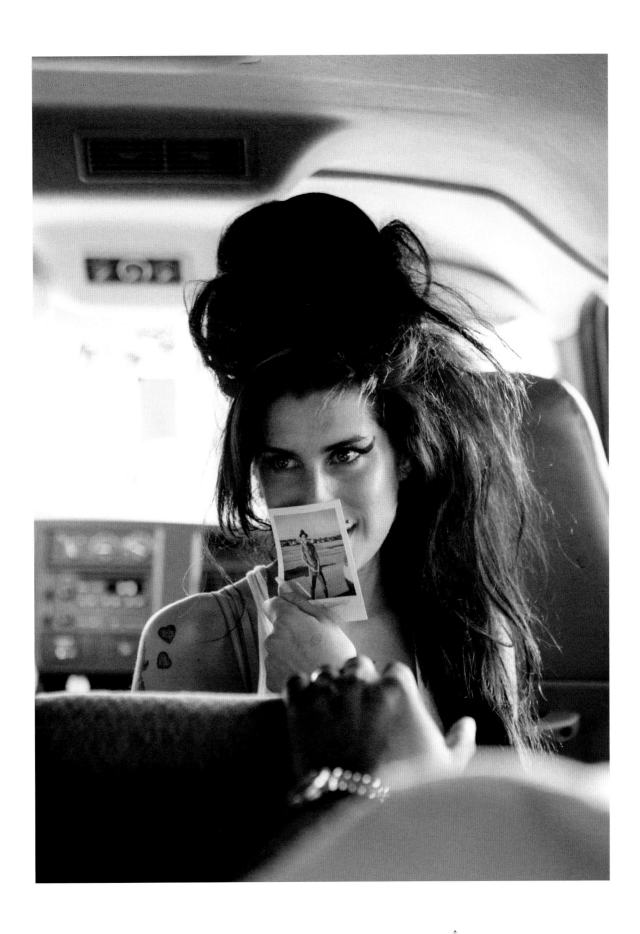

←
Backstage Gentry Polaroids
COACHELLA VALLEY MUSIC AND ARTS
FESTIVAL, INDIO, CALIFORNIA,
27 APRIL 2007
PHOTOS Christy Bush

↑
Amy With Blake Polaroid
COACHELLA VALLEY MUSIC AND ARTS
FESTIVAL, INDIO, CALIFORNIA,
27 APRIL 2007
PHOTO Jennifer Rocholl

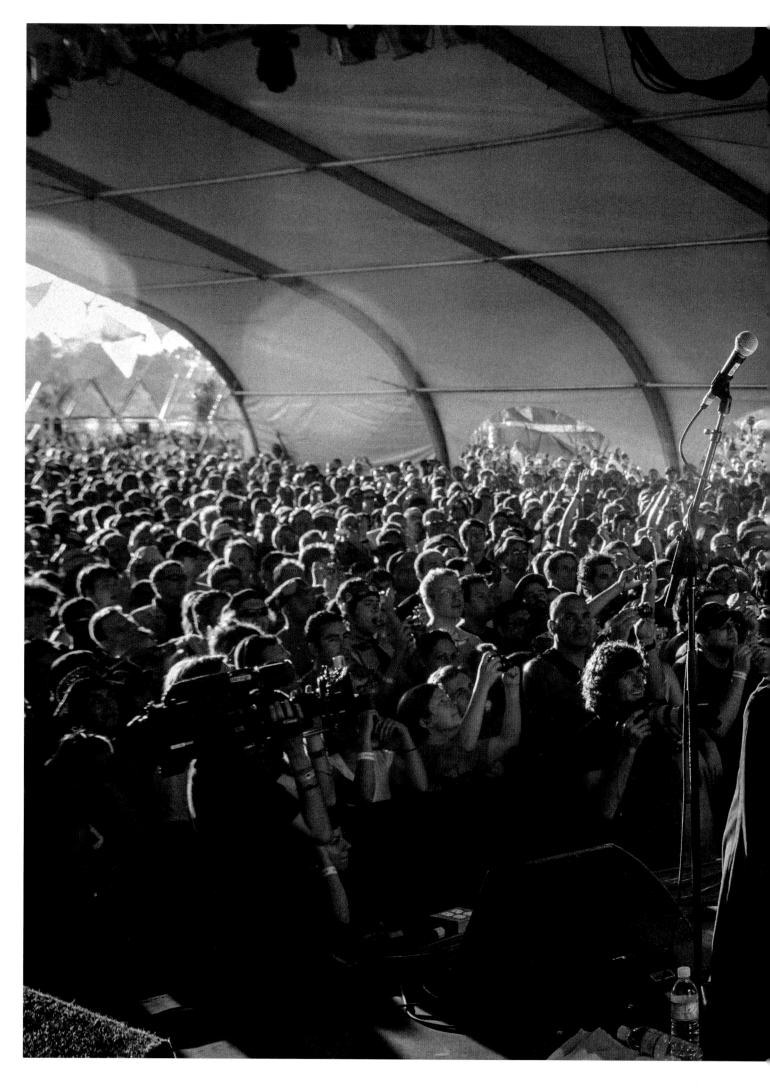

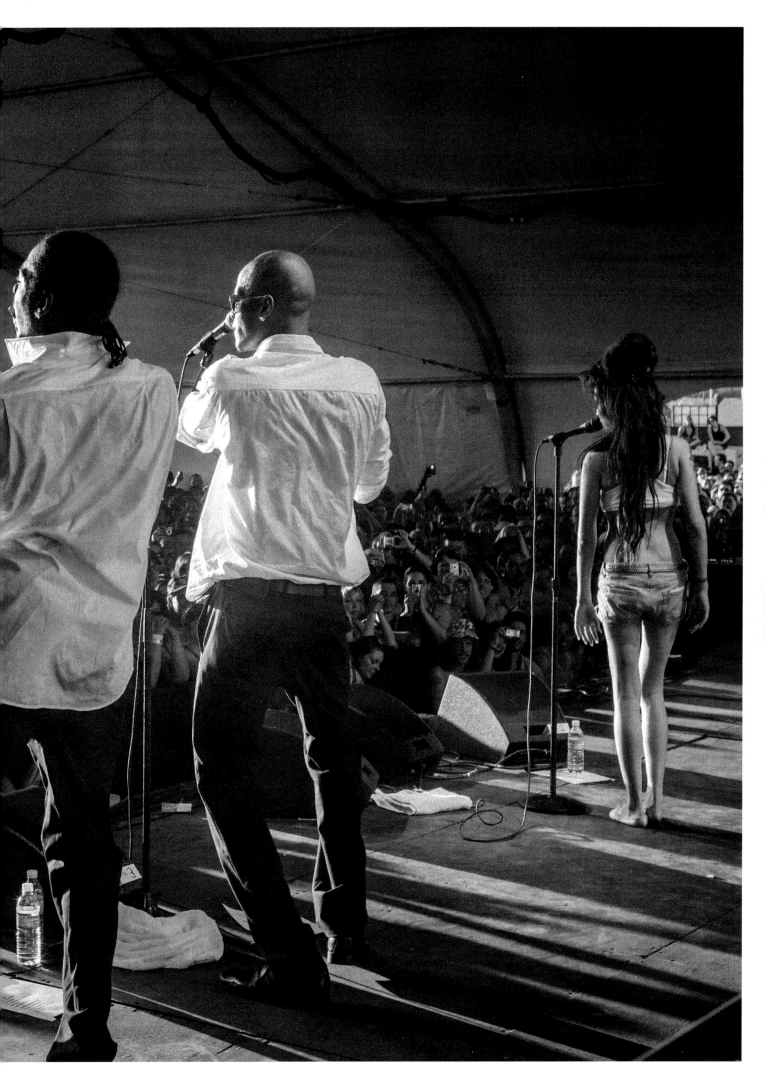

"There's a strong push coming out of London right now which is great. It's been coming ever since, I guess, Amy Winehouse. I mean always, but I think Amy, this resurgence was ushered in by Amy, that's how I see it. I'm just praying she doesn't turn into Lauryn Hill and we never get another album."

Jay-Z Artist

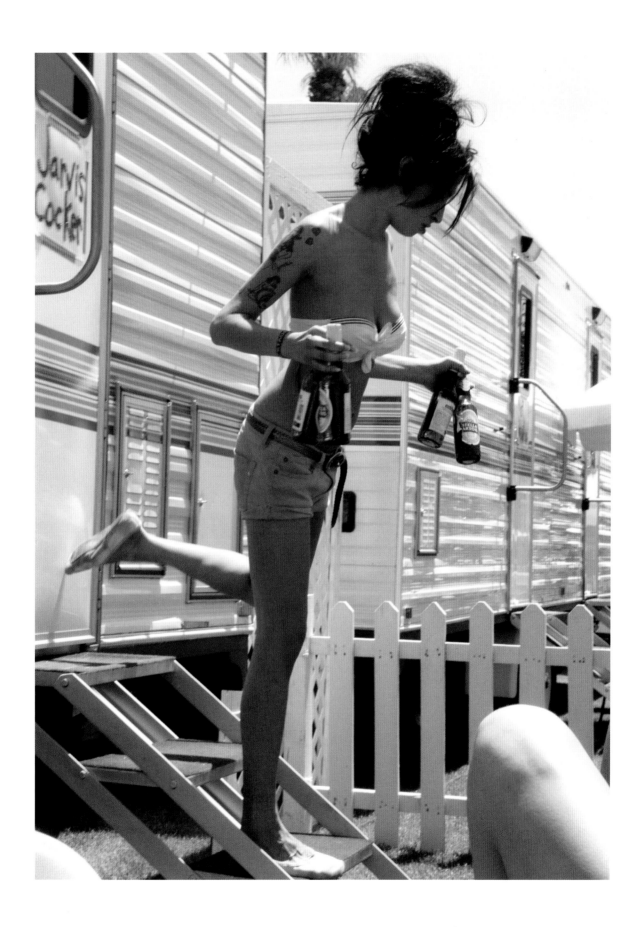

← ↑

Onstage with Dancers *Jarvis Cocker Fridge Raid*

COACHELLA VALLEY MUSIC AND ARTS COACHELLA VALLEY MUSIC AND ARTS
FESTIVAL, INDIO, CALIFORNIA, FESTIVAL, INDIO, CALIFORNIA,
27 APRIL 2007 27 APRIL 2007
PHOTO Jennifer Rocholl PHOTO Jennifer Rocholl

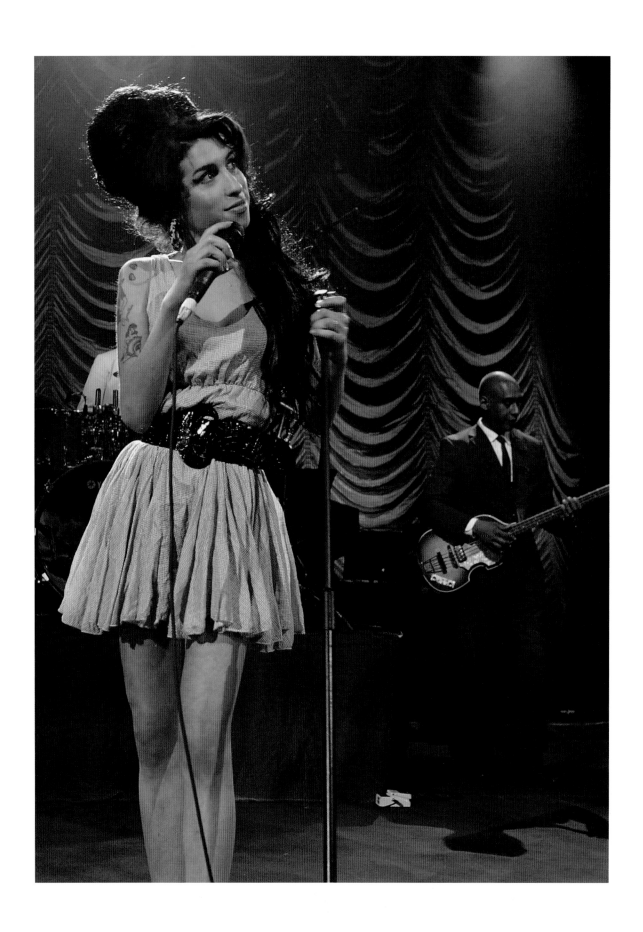

Searching for Blake
AMY AND DALE, SHEPHERD'S BUSH EMPIRE, LONDON,
DRESS BY ARROGANT CAT,
28 MAY 2007
PHOTO Jo Hale

"Because of her, I picked up a guitar, and because of her, I write my own songs. The songs that I got signed with are the songs I wrote completely on my own. If it wasn't for her, that wouldn't have happened. I owe 90 per cent of my career to her."

Adele Artist

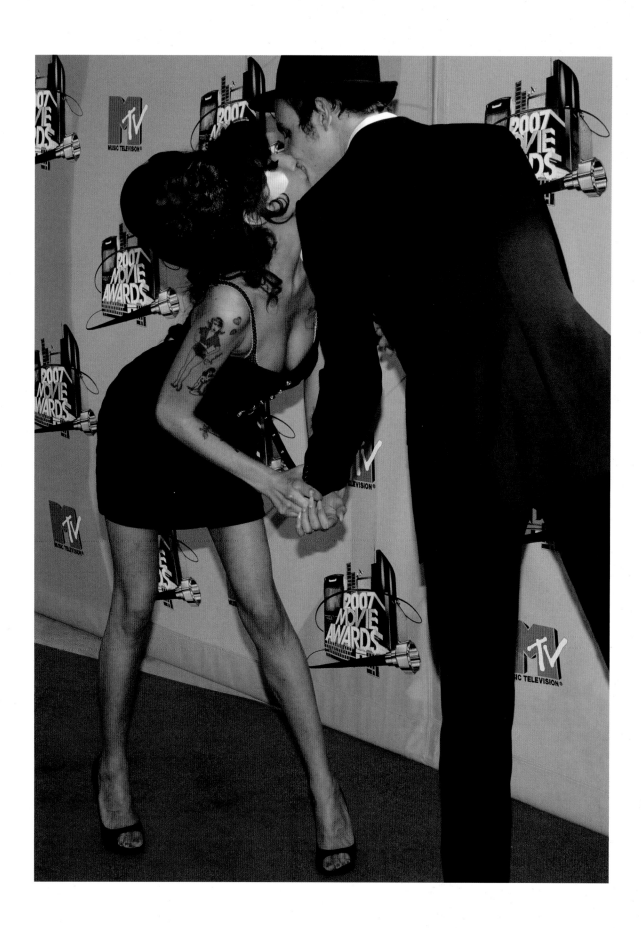

↑
2007 MTV Movie Awards
(Amy kisses husband, Blake Fielder-Civil)
UNIVERSAL AMPHITHEATRE,
LOS ANGELES, 3 JUNE 2007
PHOTO Paul Smith

→
The Kiss (2008)
GERALD LAING (1936–2011),
OIL ON CANVAS,
81.3 × 94.0 CM / 37 × 32 IN.
COURTESY The Estate of Gerald Laing

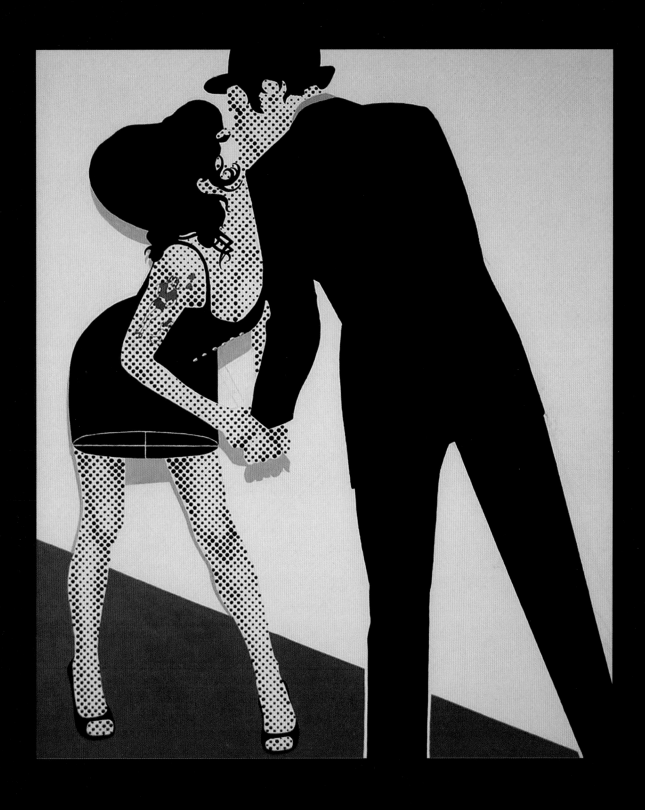

"My work is concerned with the myth, and portrays her as she appeared to us, the public, via the media. Now that the drama has ended, and all is quiet, I hope it will be seen as a tribute from one artist to another."

GERALD LAING, ARTIST

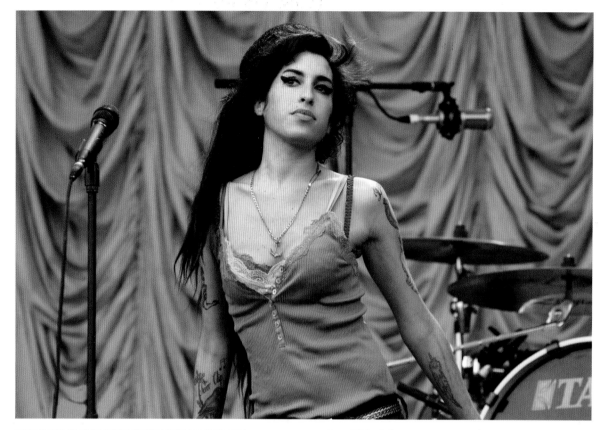

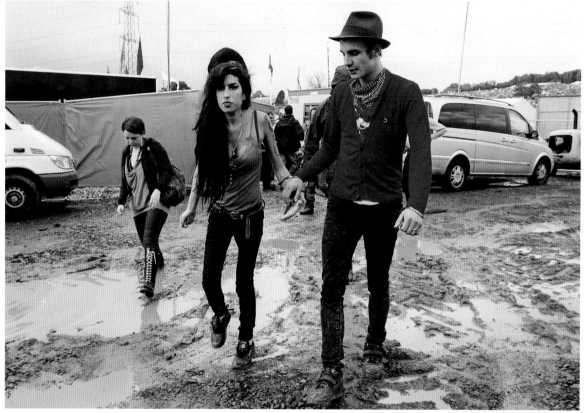

←

MTV Performance of 'Rehab'
GIBSON AMPHITHEATRE,
UNIVERSAL CITY,
LOS ANGELES, 3 JUNE 2007
PHOTO John Shearer

↑

Glastonbury in Mud
GLASTONBURY FESTIVAL, SOMERSET, UK,
22 JUNE 2007
PHOTOS (TOP) Edd Westmacott,
(BOTTOM) Carl de Souza

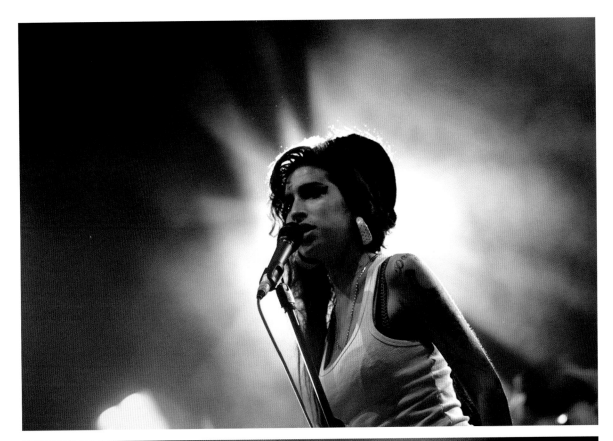

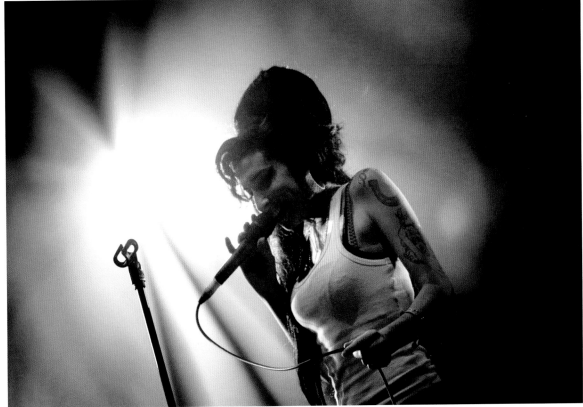

↑
Les Eurokéennes
LAKE MALSAUCY, BELFORT, FRANCE,
29 JUNE 2007
PHOTOS Jeff Pachoud

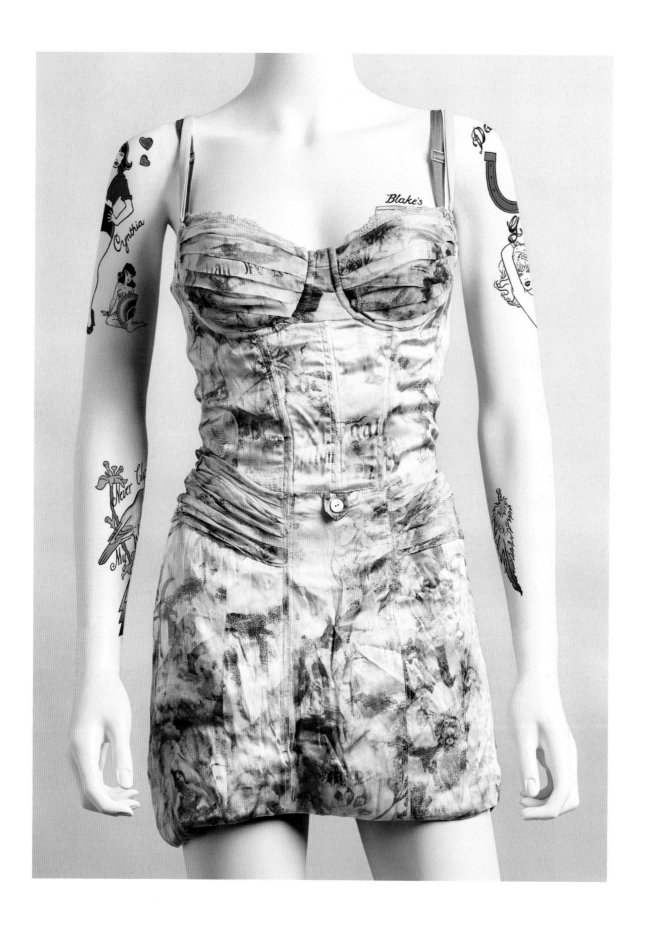

"Double denim is like a crime against humanity. When it comes to fashion, I'm a bitch. You know what's attractive on a girl? A girl being herself. Don't be one of the crowd.... Be different."

AMY WINEHOUSE

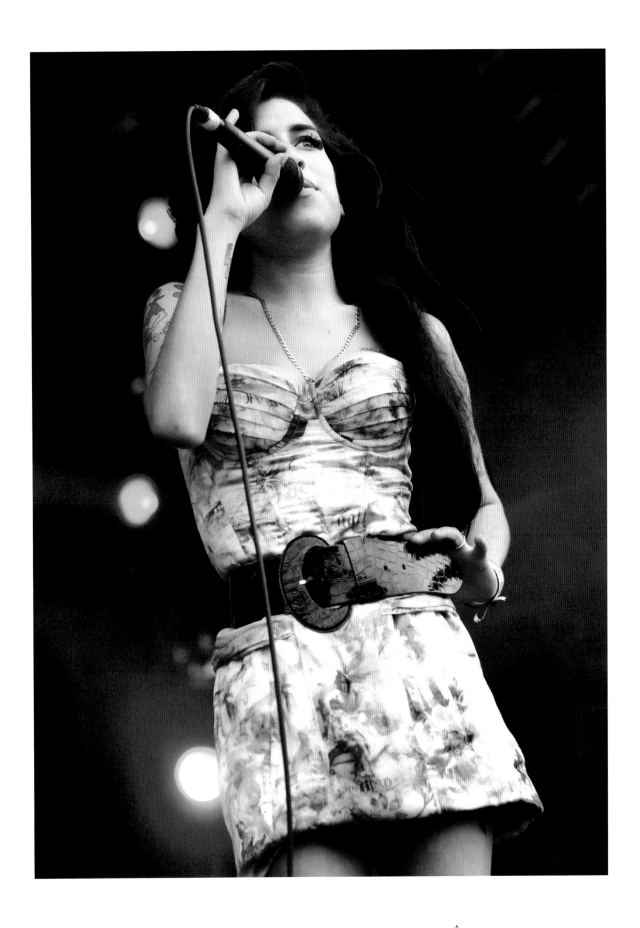

AMY WINEHOUSE \ *BACK TO BLACK* \ 2005–2008

←
Photoprinted Silk Mini Dress
BY JEAN PAUL GAULTIER
WORN AT ROCK WERCHTER FESTIVAL,
BELGIUM & BOBIN'O CABARET CLUB, PARIS,
28 JUNE 2007

↑
Rock Werchter Festival
MAIN STAGE, FESTIVALPARK,
WERCHTER, BELGIUM,
30 JUNE 2007
PHOTO Gie Knaeps

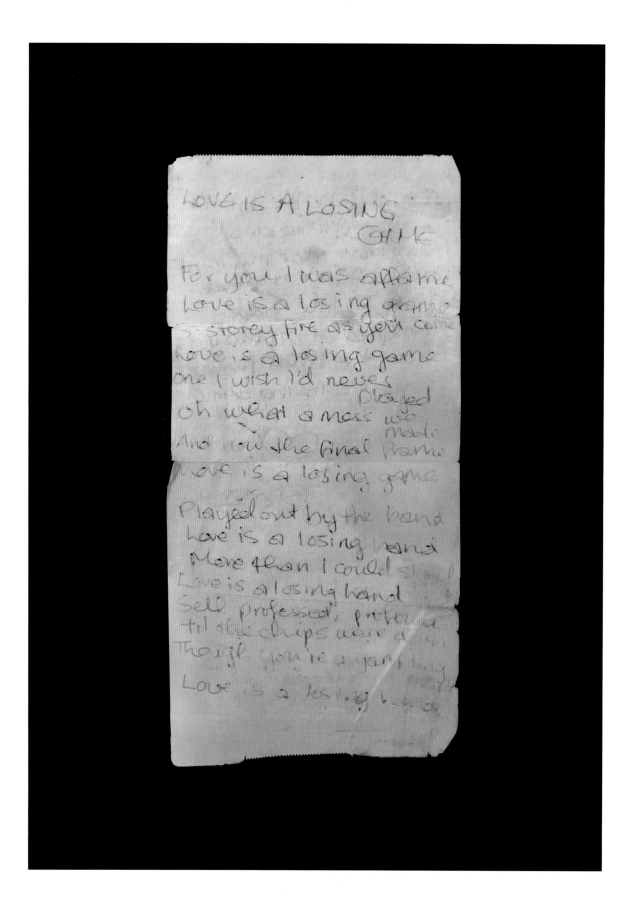

"I love Amy's track 'Love Is A Losing Game'. We play that a lot. I'm a big fan. We're still sorting out the support acts but if I saw her on stage I would absolutely ask her to join me."

PRINCE ARTIST

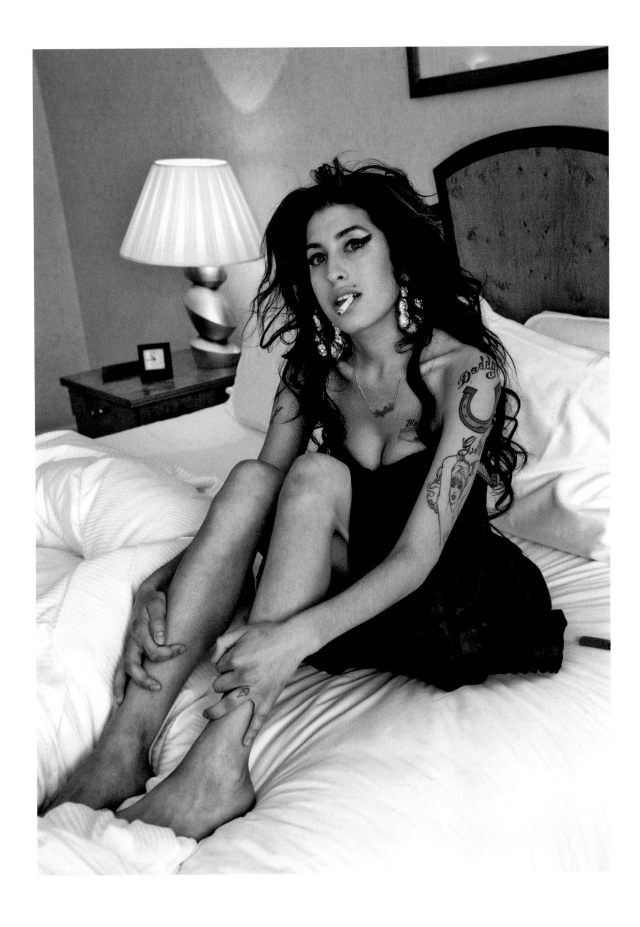

←

'Love Is A Losing Game'
WORKING LYRIC SHEET
(TILL RECEIPT), 2006
COURTESY Sony Music Publishing Ltd

↑

Hotel Room, Savoy
SAVOY HOTEL, LONDON,
10 AUGUST 2007
PHOTO Harry Benson

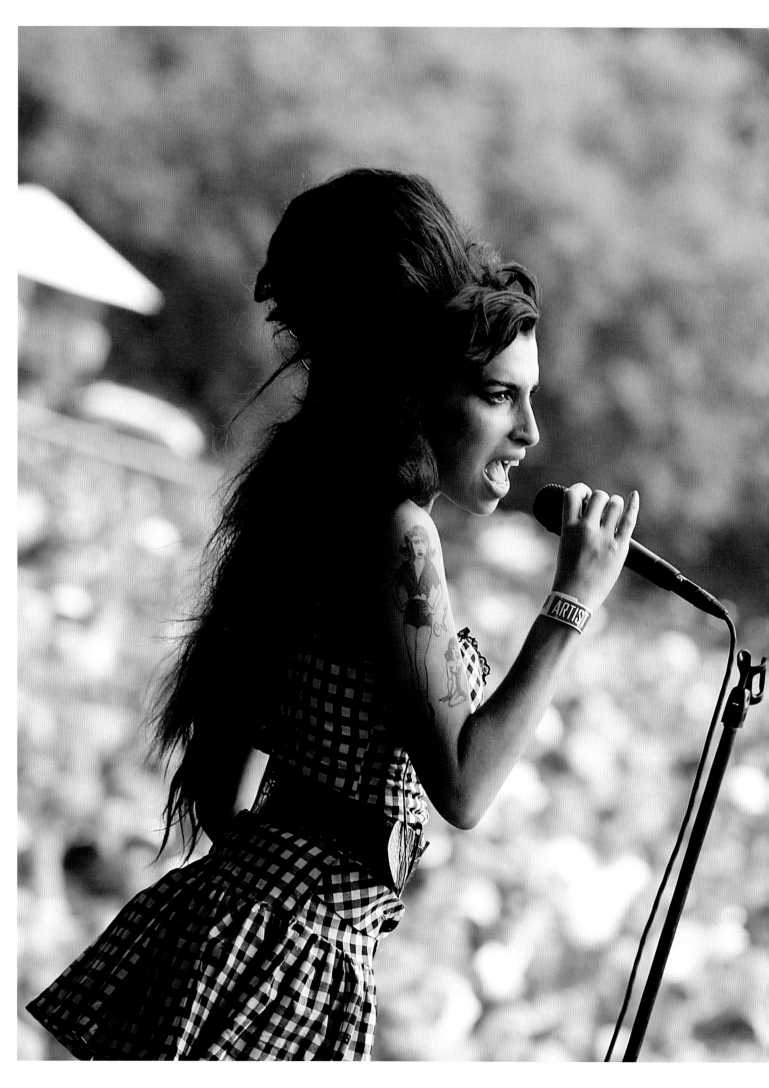

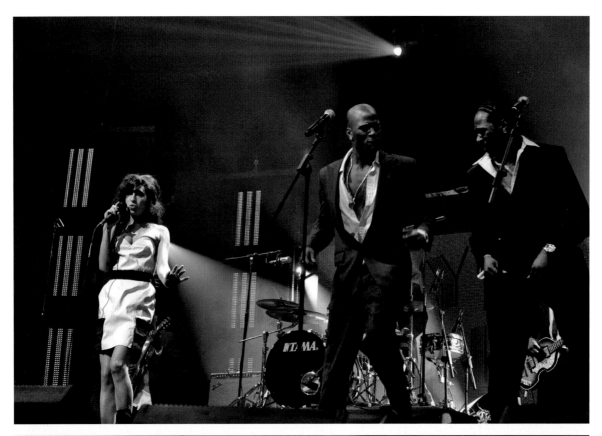

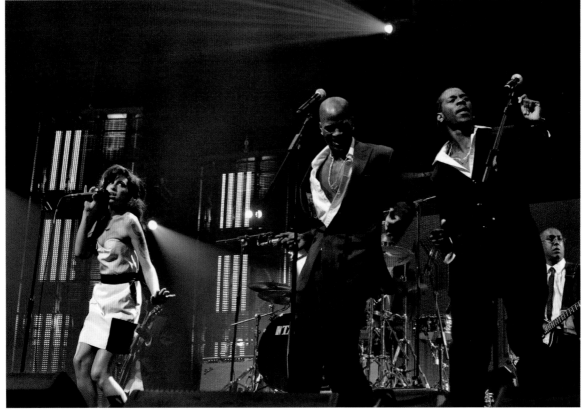

←

Lollapalooza
BUD LIGHT STAGE, GRANT PARK,
CHICAGO, 5 AUGUST 2007 (DAY 3);
CHECK DRESS AND BELT BY
ARROGANT CAT
PHOTO Jason Squires

↑ / →

2007 MOBO Awards
(Winner: Best UK Female)
AMY, HESHIMA AND ZALON, DRESS BY LUELLA,
O2 ARENA, LONDON, 19 SEPTEMBER 2007
PHOTOS (ABOVE) Jo Hale,
(OPPOSITE) Dave Hogan

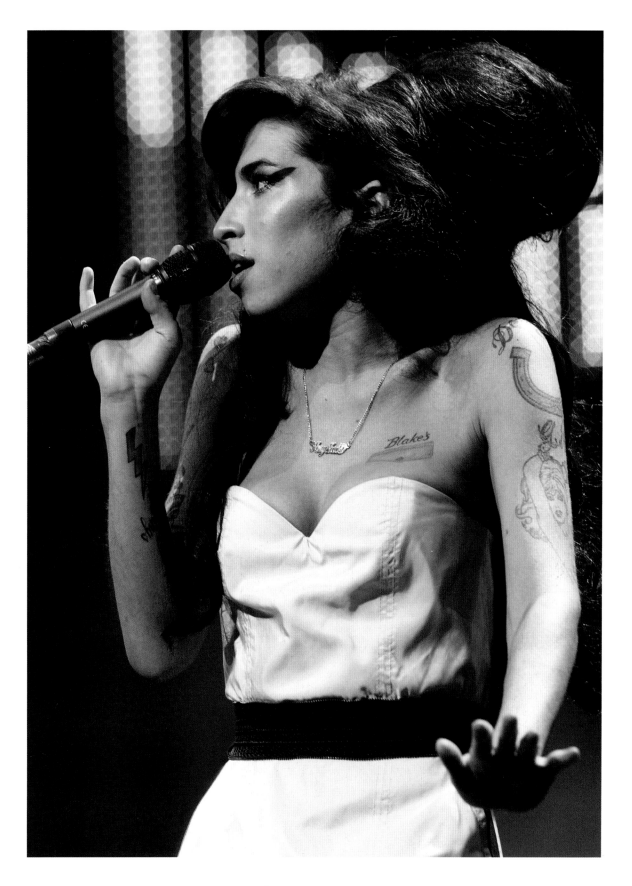

"I felt that her whole life became a performance once she adopted the beehive and winged eyeliner in her regular appearances, not only on stage. I felt it was a barrier to keep the real Amy tightly under wraps and away from the limelight."

JANIS WINEHOUSE MOTHER

"I first heard Amy at a time in my life when I needed inspiration. All artists have a lull at some point. My son brought the *Back To Black* album home, and the first track I heard was 'Rehab'. That just killed me! To me it was a combination of ingredients that made Amy a once-in-a-lifetime artist; the voice, lyrics, style and

that attitude. Was she jazz? Soul? Blues? No she's just Amy, unlike anyone else. Although I was from the sixties I saw myself in her, and she inspired me to continue. As I say at every show I've performed since she left us, Amy gave me a wonderful gift, she made me feel that what I did mattered."

Ronnie Spector Artist

Little Simz
Artist

I was put onto her music by a friend; he played some songs for me from her album *Frank* and I just remember thinking, wow, her voice is so infectious. At the time I was quite young, and I don't think I understood the depths of her writing until I got a bit older. Then I started looking up her lyrics and just resonated with her story, what she was writing about.

She struck me as a very confident woman, in terms of like, she knew she had a gift - she knew she had a pen, an incredible voice - and she just always sang from the heart. I feel like with Amy, it was always about the music. I felt her love for music come through for anything she did. And she was so effortless with it, you know? I do think we've come a long way in a sense, but people like Amy Winehouse definitely laid the foundation and did the groundwork for other women like myself to come through.

I think about how honest and open she was and how her words - as much as it's music you can read her words like a book - were so visual. She had the gift of making the listener feel what she was talking about, be it her pain, be it times of happiness, of joy, whatever it was - it came through in a really honest way. I think there's strength in vulnerability and that's something she did very, very well. It made me wanna be open and honest in my music and write from a reflective standpoint, which I think is a special thing.

I loved her rawness. I love how she was just herself - she brought Amy wherever she went. From videos I've seen and interviews I've watched, she just seemed very London, you know what I'm saying? She weren't switching it up for no one and I love that. She was very musically intelligent and, yeah man, she was so, so raw. I love that. •

Heineken Festival
HEINEKEN MUSIC HALL, AMSTERDAM,
22 OCTOBER 2007
PHOTO Loe Beerens

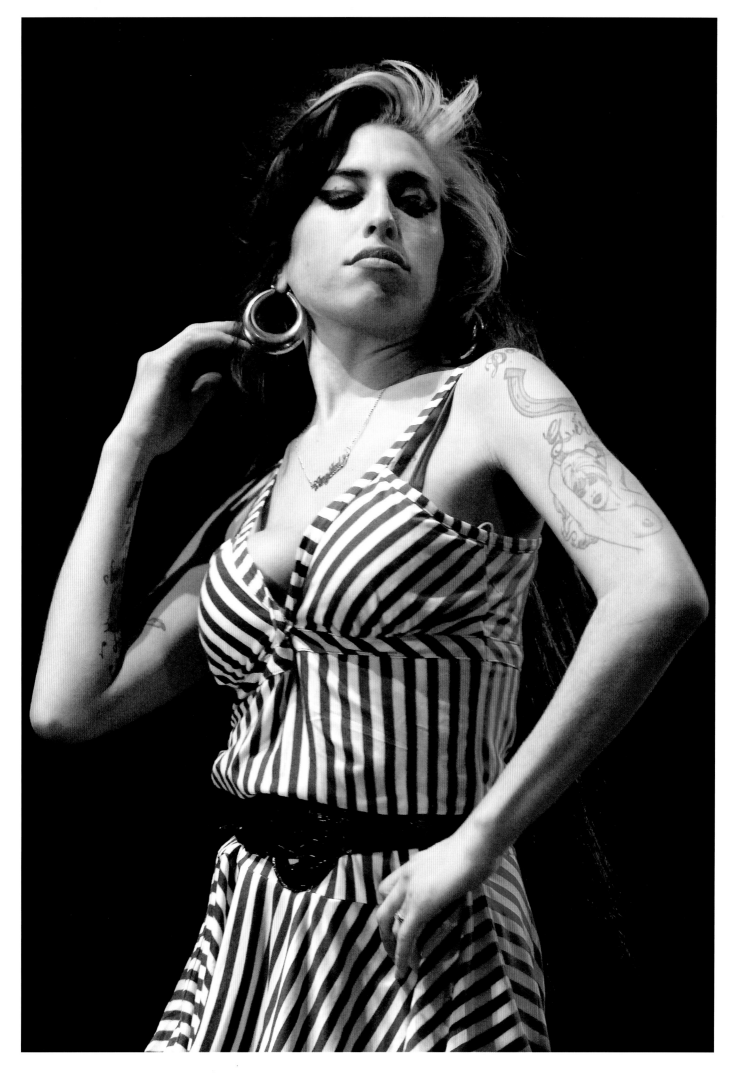

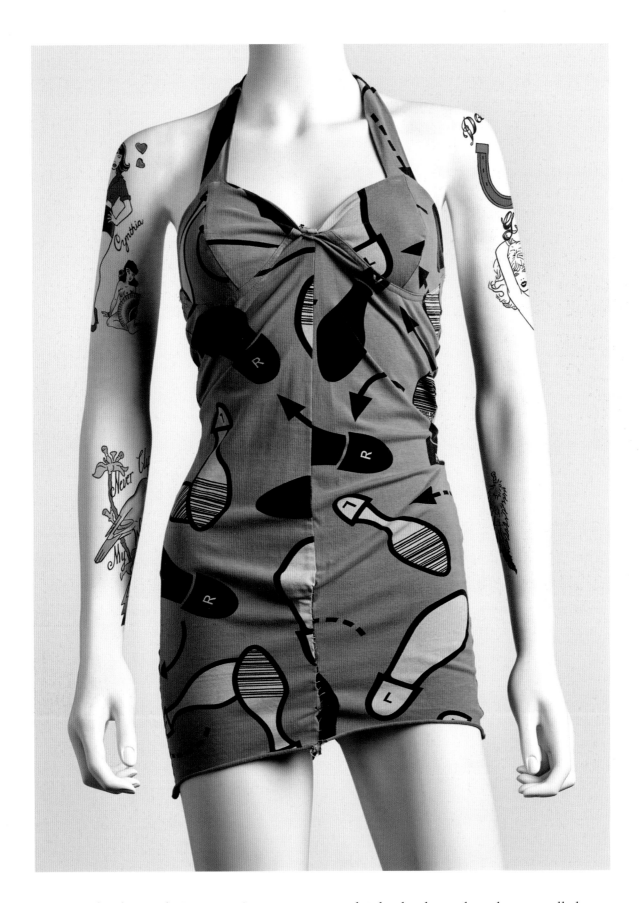

"Amy had a pink Jeremy Scott catsuit, which she loved and wore all the time on the tour bus. Less than an hour before the Paris show, she insisted that I remodel it into a dress so that she could wear it onstage that night. I set about it with scissors – there wasn't even time to sew a hem!"

NAOMI PARRY STYLIST

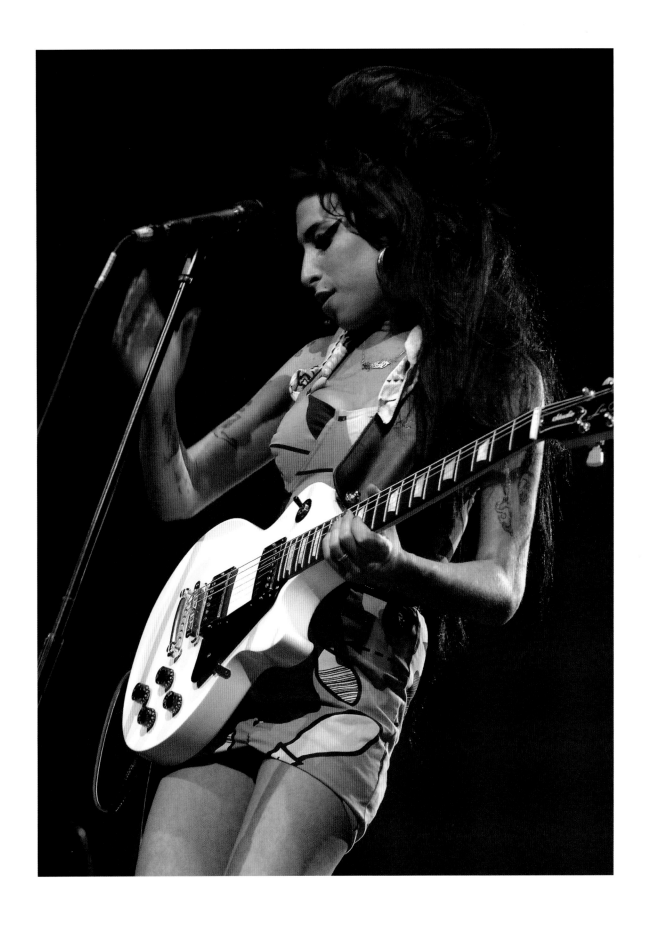

←
Customized Catsuit
UPCYCLED CATSUIT / MINI DRESS
BY JEREMY SCOTT, CUSTOMIZED
BY NAOMI PARRY

↑
Amy in Paris
WITH GIBSON LES PAUL STUDIO GUITAR
LE ZÉNITH, PARIS, 29 OCTOBER 2007
PHOTO Agency

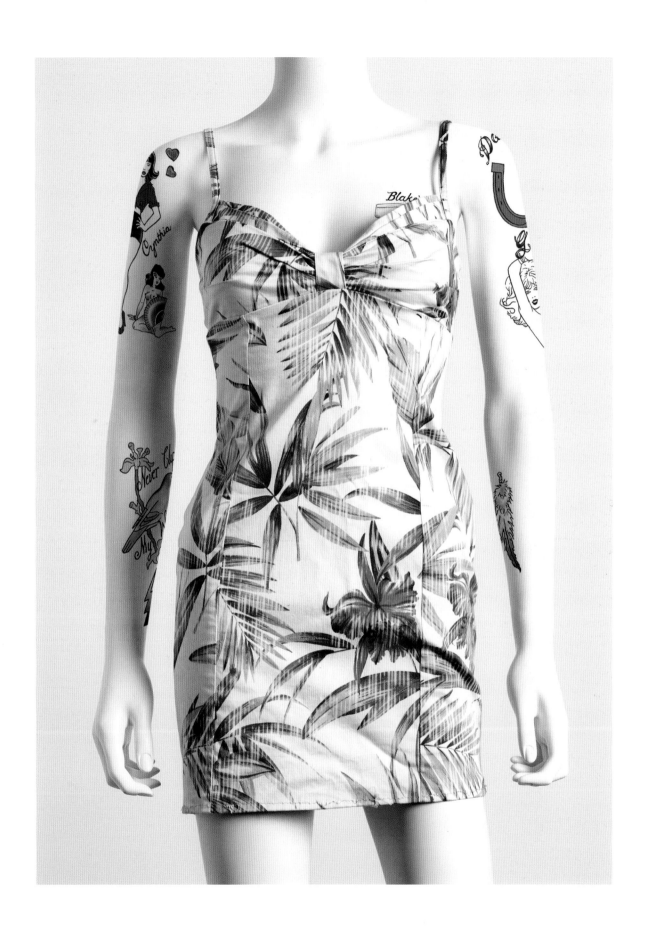

↑
Floral Dress
BY KAREN MILLEN
FLORAL VINTAGE DRESS WORN
ON THE 2007 EUROPEAN TOUR

→
Live at the Apollo
APOLLO, HAMMERSMITH, LONDON,
24 NOVEMBER 2007
PHOTO Agency

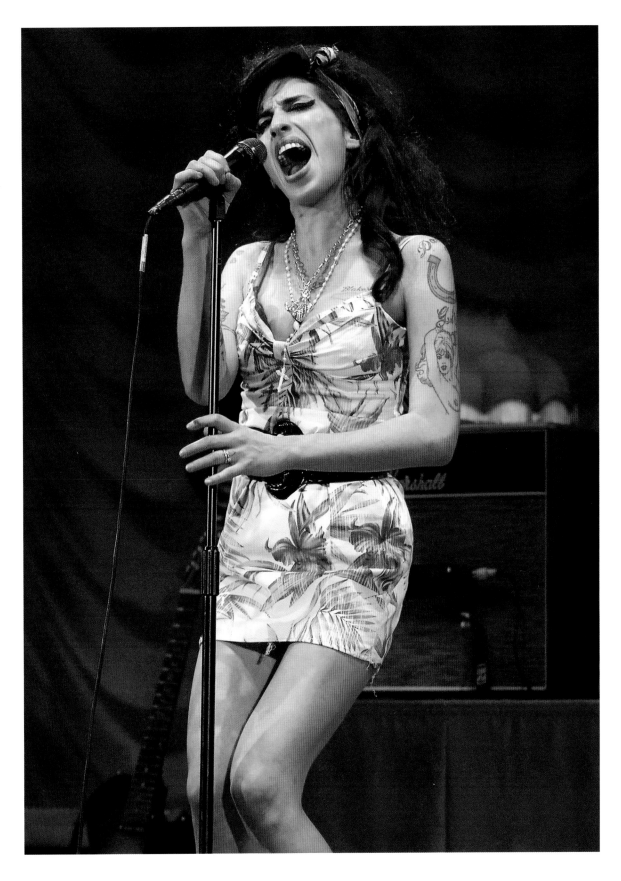

"She did the hard work that when *Back To Black* blew up there was a room for an Adele, for other singer songwriters of that generation. Somebody has to break the ground and take the beating. Somebody has to go out and be that trailblazer, put the railroad where there was just dirt."

SALAAM REMI PRODUCER

"She asked me if I would teach her how to drive. I said I would be happy to. The next day she asked again, so I got the Landrover and explained the basics of the clutch and brake, and she asked to have a go. The moment she got in the driver's seat she pushed down on the gas pedal and headed

AMY WINEHOUSE \ BACK TO BLACK \ 2005–2008

196

down the road with me in the passenger's seat. I told her to ease off the gas pedal as we hurtled towards a corner, but she didn't slow down. So I had to grab the handbrake and stop the car. Perhaps that moment sums up Amy's short, brilliant life more than any other: full speed, straight ahead, no brakes."

Bryan Adams Artist & Photographer

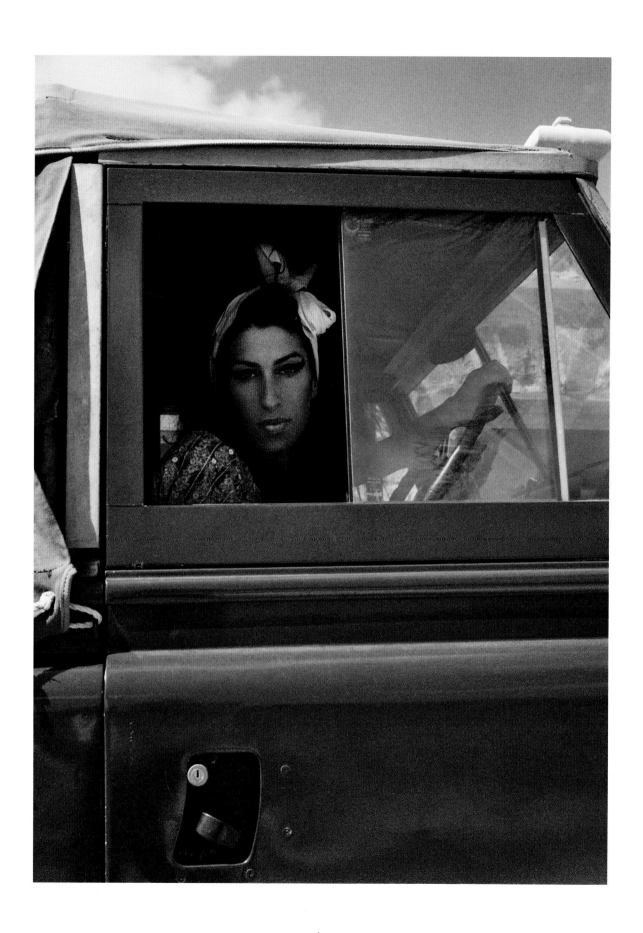

↑
Driving Lesson
MUSTIQUE, GRENADINES,
WEST INDIES,
DECEMBER 2007
PHOTO Bryan Adams

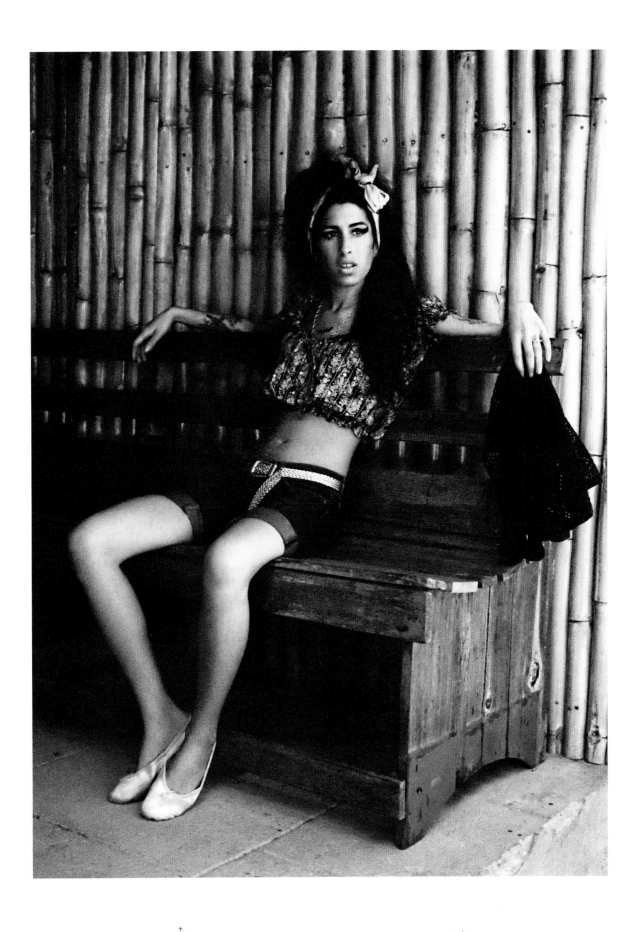

↑
Christmas in Mustique
MUSTIQUE, GRENADINES,
WEST INDIES,
DECEMBER 2007
PHOTO Bryan Adams

→
50th Annual Grammy Awards
(Winner: 5 Grammys)
VIA SATELLITE FROM RIVERSIDE STUDIOS,
HAMMERSMITH, LONDON, 10 FEBRUARY 2008
PHOTO Peter Macdiarmid

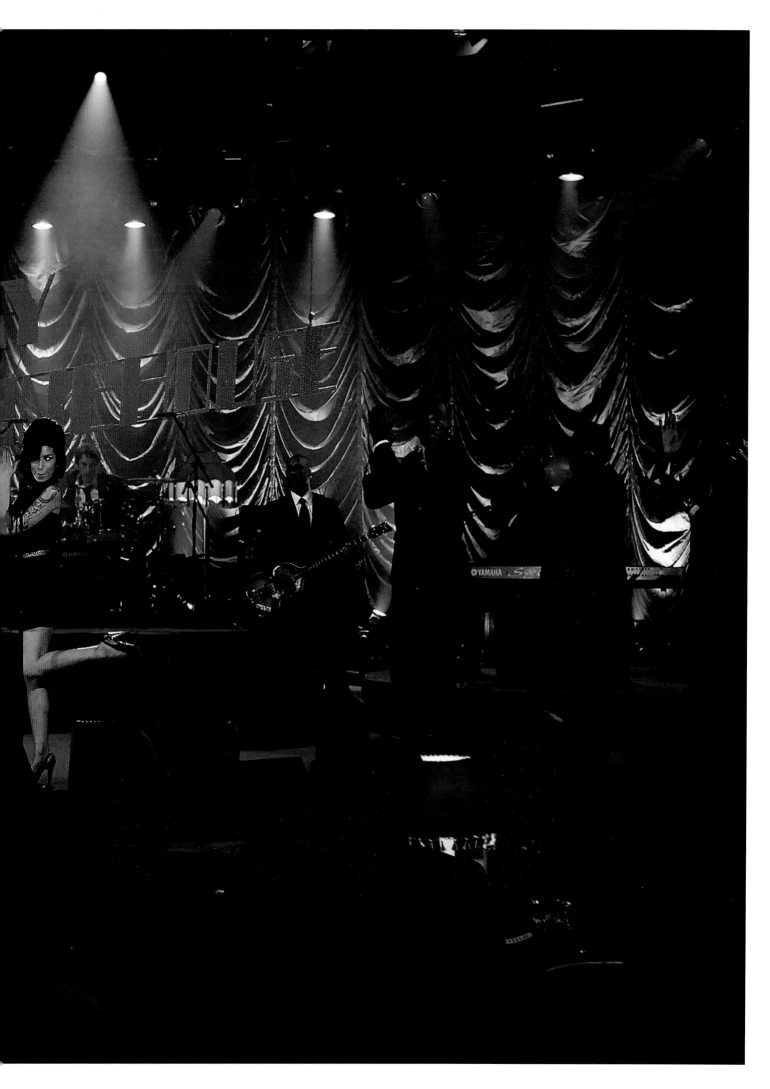

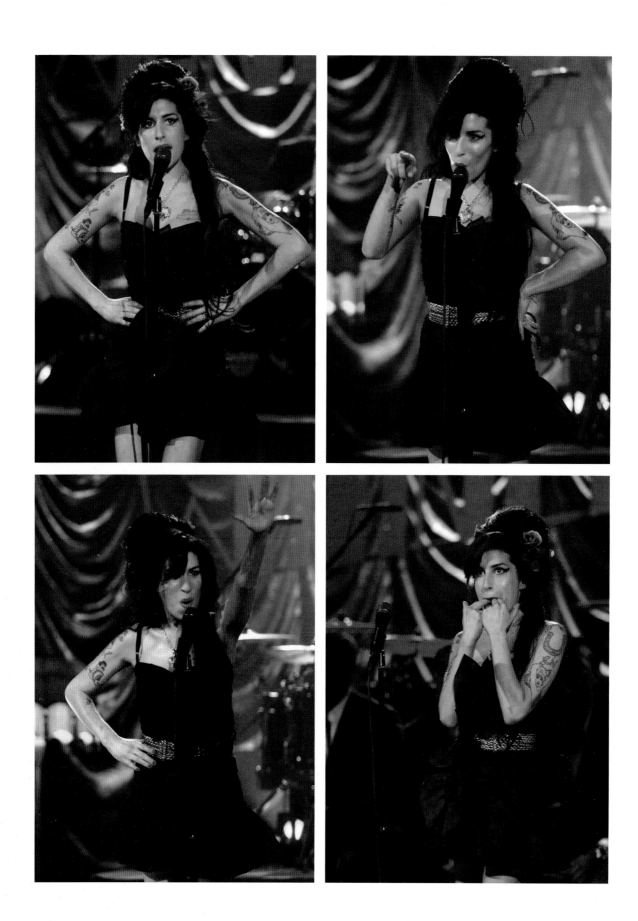

AMY WINEHOUSE \ *BACK TO BLACK* \ 2005–2008

↑
Grammy Awards Performance
VIA SATELLITE FROM RIVERSIDE STUDIOS,
HAMMERSMITH, LONDON, DRESS BY D&G,
10 FEBRUARY 2008
PHOTOS Richard Young

→
Record of the Year Speech
HAMMERSMITH, LONDON,
10 FEBRUARY 2008
PHOTOS (TOP) Mike Blake,
(BOTTOM) Robyn Beck

"Thank you to everyone at Island records, everyone at EMI Music Publishing. To Raye Raye... and Jo – ten years this year, Raye Raye and Jo – To Mark Ronson and Salaam Remi, To my mum and dad. For my Blake, my Blake incarcerated. And for London, this is for London, 'cause Camden Town ain't burnin' down."

AMY WINEHOUSE GRAMMY AWARD SPEECH

Five Grammys
50th Annual Grammy Awards 2007
(IN AWARDS ORDER, BOTTOM LEFT TO TOP RIGHT)

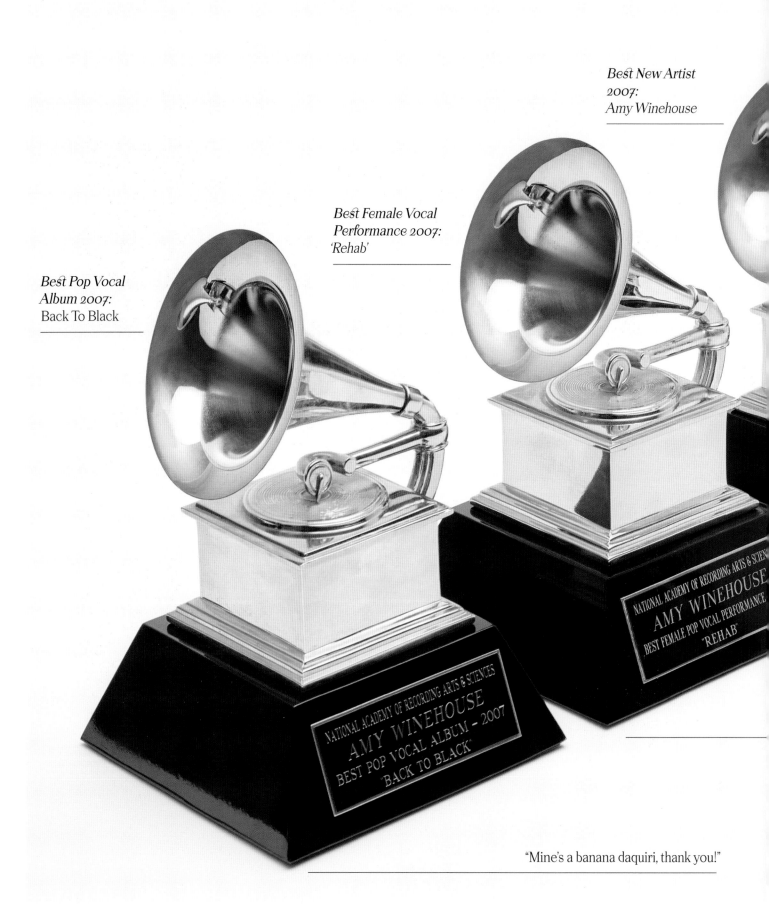

*Best New Artist
2007:*
Amy Winehouse

*Best Female Vocal
Performance 2007:*
'Rehab'

*Best Pop Vocal
Album 2007:*
Back To Black

"Mine's a banana daquiri, thank you!"

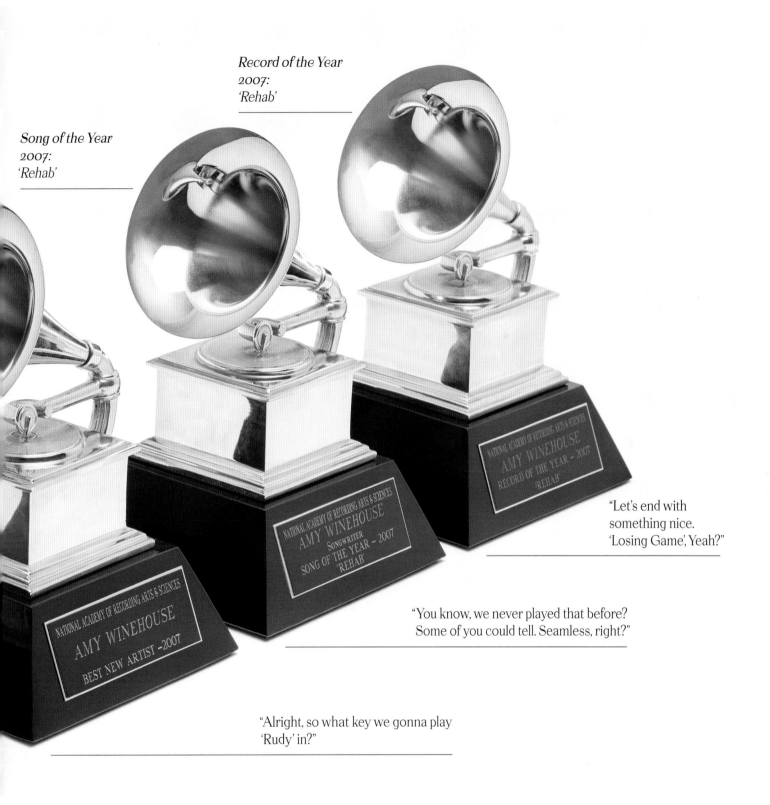

Song of the Year
2007:
'Rehab'

Record of the Year
2007:
'Rehab'

"Let's end with
something nice.
'Losing Game', Yeah?"

"You know, we never played that before?
Some of you could tell. Seamless, right?"

"Alright, so what key we gonna play
'Rudy' in?"

"I'm serious. Anyone whose not busy at
the minute.... Alright, let's move on...
'Back To Black', yeah?"

AMY WINEHOUSE BEST POP VOCAL ALBUM 2007 **Back To Black**
AMY WINEHOUSE BEST FEMALE VOCAL PERFORMANCE 2007 'Rehab'
AMY WINEHOUSE BEST NEW ARTIST 2007
AMY WINEHOUSE SONG OF THE YEAR 2007 'Rehab'
AMY WINEHOUSE RECORD OF THE YEAR 2007 'Rehab'

"She changed a whole generation of music, and every artist who is asked about their inspiration, Amy Winehouse is always on that list. Everything about her... she mixed a bunch of stuff together and created the most beautiful things. She was incredible."

Billie Eilish Artist

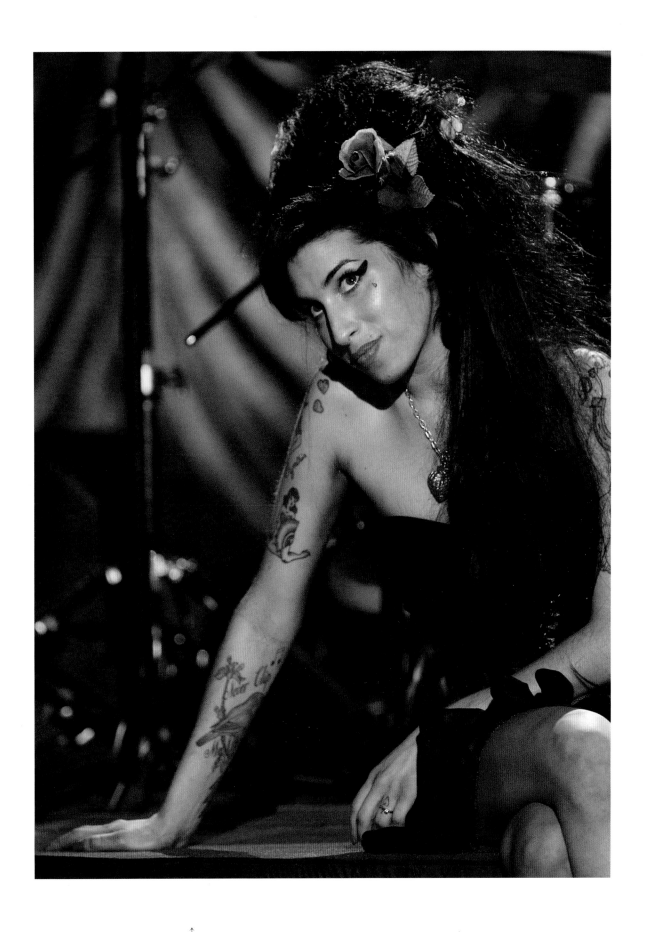

↑
After the Win
RIVERSIDE STUDIOS, HAMMERSMITH,
LONDON, DRESS BY TINA KALIVAS,
10 FEBRUARY 2008
PHOTO Peter Macdiarmid

→
2008 BRIT Awards with Mark Ronson
EARL'S COURT, LONDON,
20 FEBRUARY 2008,
OUTFIT BY D&G
PHOTO Agency

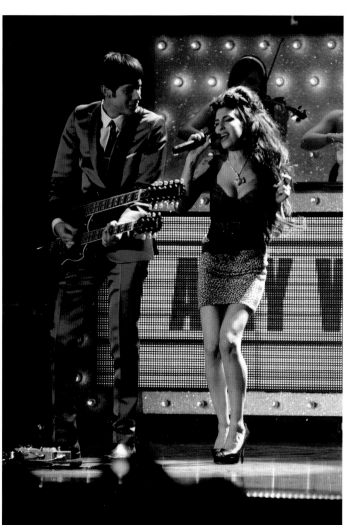
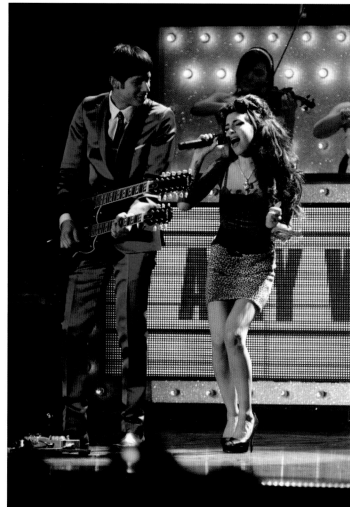
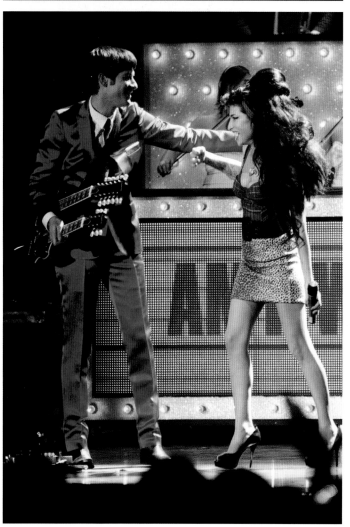
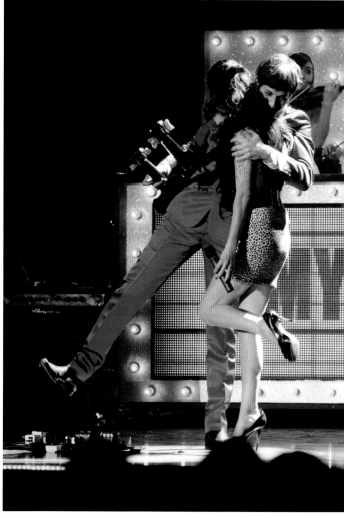

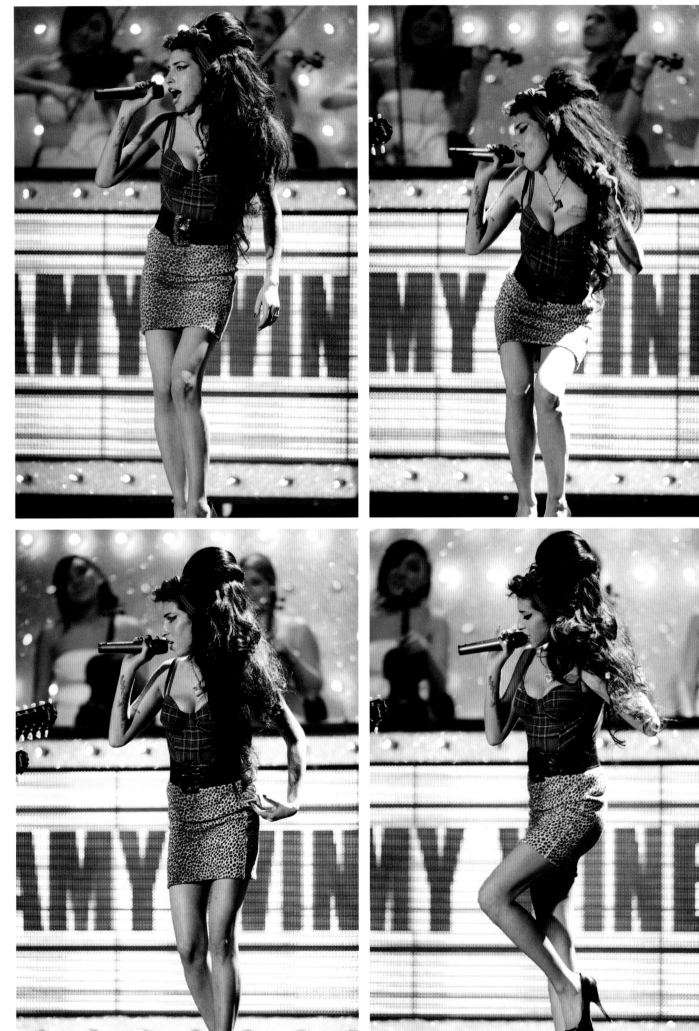

"I'm a girly girl. It's just my music. It's the only thing I have real dignity in in my life. That's the one area in my life where I can hold my head up and say 'No one can touch me.' 'Cos no one can touch me!"

Amy Winehouse

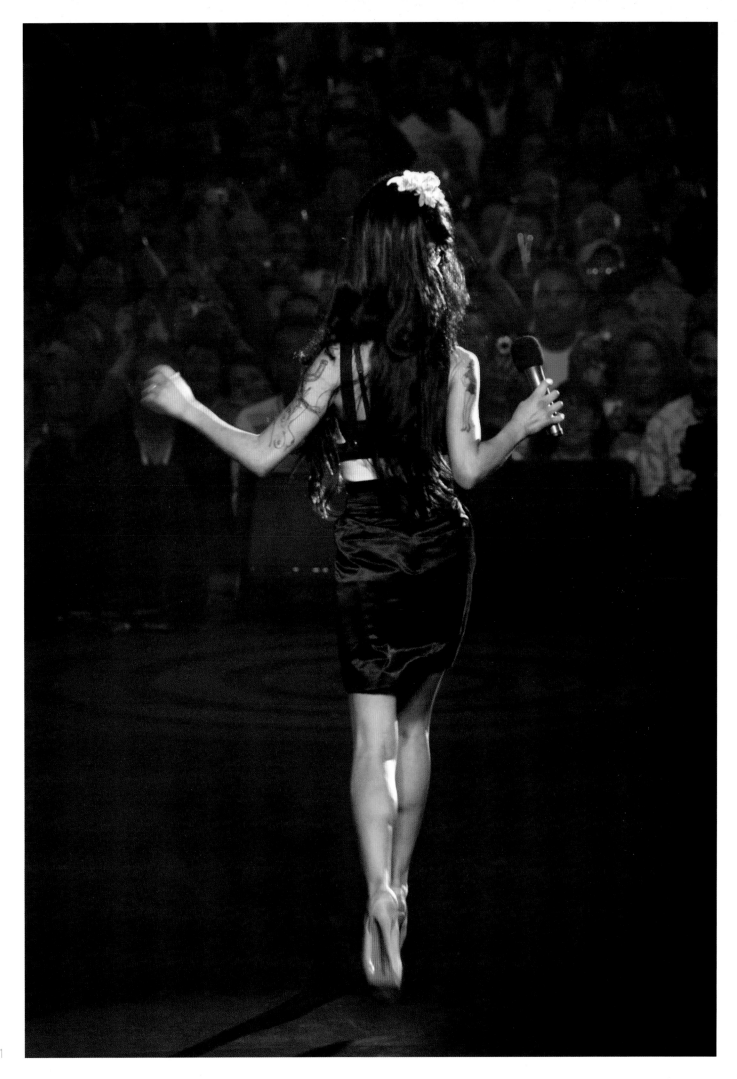

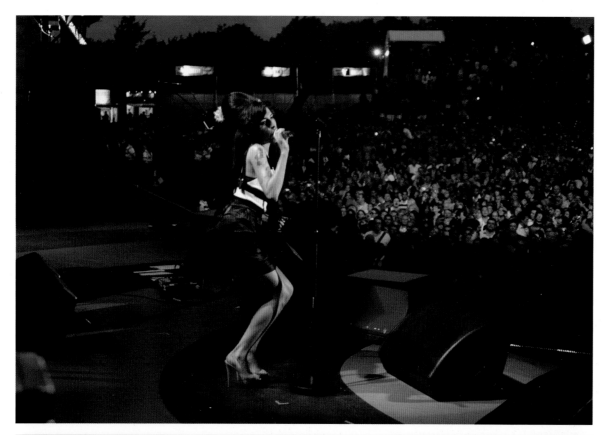

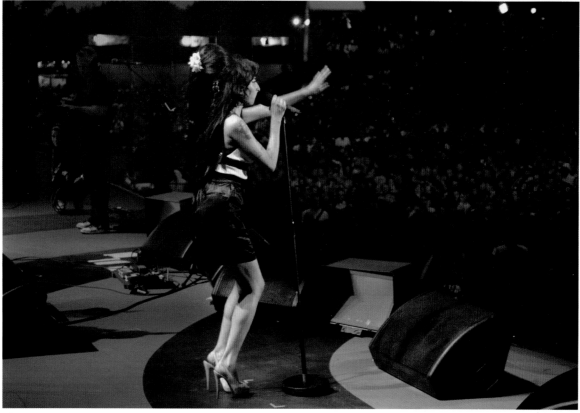

←/↑
Nelson Mandela 90th Birthday Tribute
HYDE PARK, LONDON, 27 JUNE 2008,
DRESS BY TEMPERLEY, SHOES BY LOUBOUTIN
PHOTOS (PREVIOUS) Richard Young,
(ABOVE) Dave Benett

→
Blake Hair Clip
NELSON MANDELA 90TH BIRTHDAY TRIBUTE,
HYDE PARK, LONDON,
27 JUNE 2008
PHOTOS Dan Kitwood

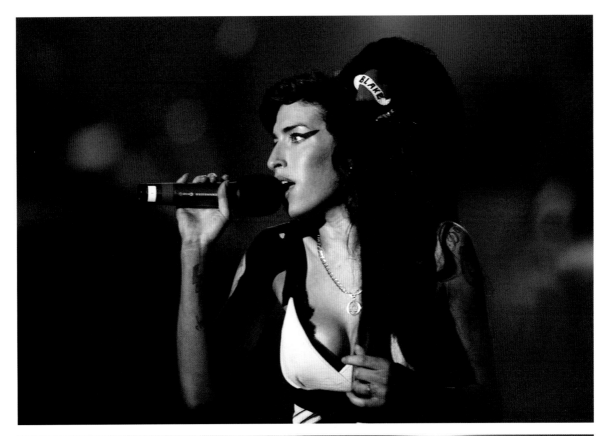

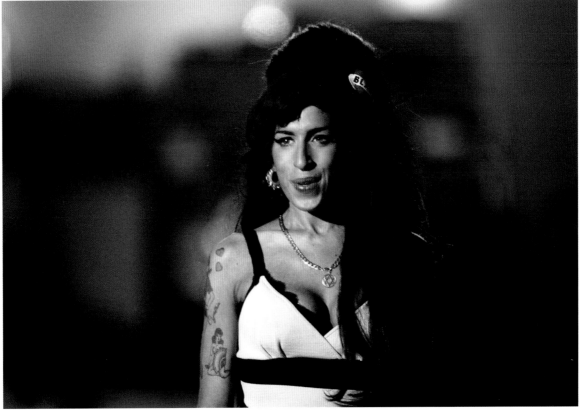

"She's an artist I relate to so much. I could cry every time
I speak about her. I feel her just going: 'Tell the fucking truth.'
Just tell the truth because right now there's a lack of it."

YUNGBLUD ARTIST

"I came backstage and a man came over and said would you mind saying hello to my daughter. I had no idea who he was and this little girl got on her knees and kissed me on the wrist and said I have loved your music ever since, all the way back to *The Swinging Miss 'D'* when

you were my age — 24. I was shocked that she was that smart. We sat and talked for a while, we had our arms around each other. I saw the good in her and I saw her brains. She went out and sang her song and punched some chick out in the audience. But she was a sweetheart."

Quincy Jones Producer

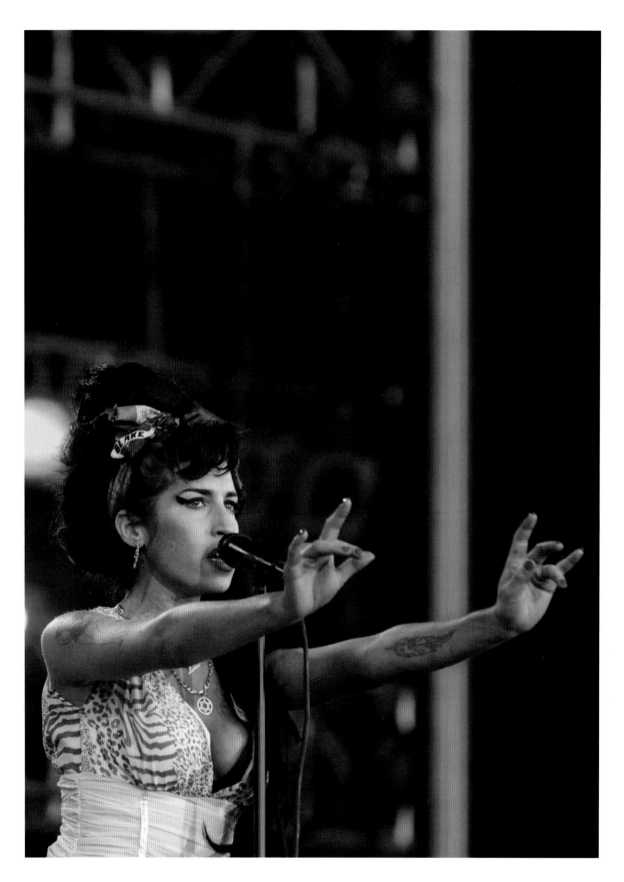

↑ / →
Rock In Rio
CIUDAD DEL ROCK, ARGANDA DEL REY, SPAIN,
4 JULY 2008 (DAY 3),
DRESS BY ARROGANT CAT
PHOTOS (ABOVE) Jack Abuin,
(OPPOSITE) Carlos Alvarez

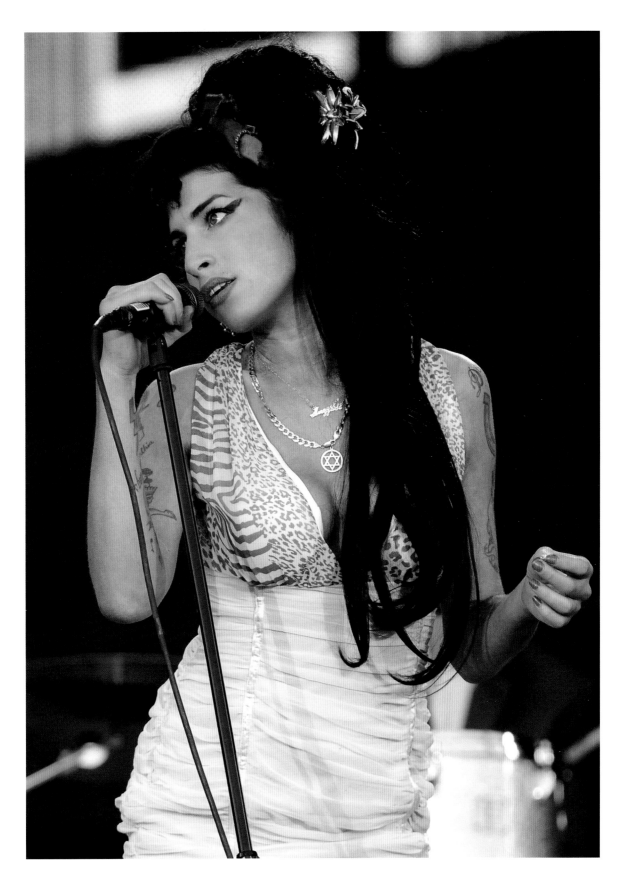

"Amy is everything to me. She made me realize the power of what a voice can achieve. It was like looking deep into the soul of someone just through the tenor and pitch of their voice. She is someone I sadly never met yet is one of my closest allies on my journey so far. I carry her forever."

TOM GRENNAN ARTIST

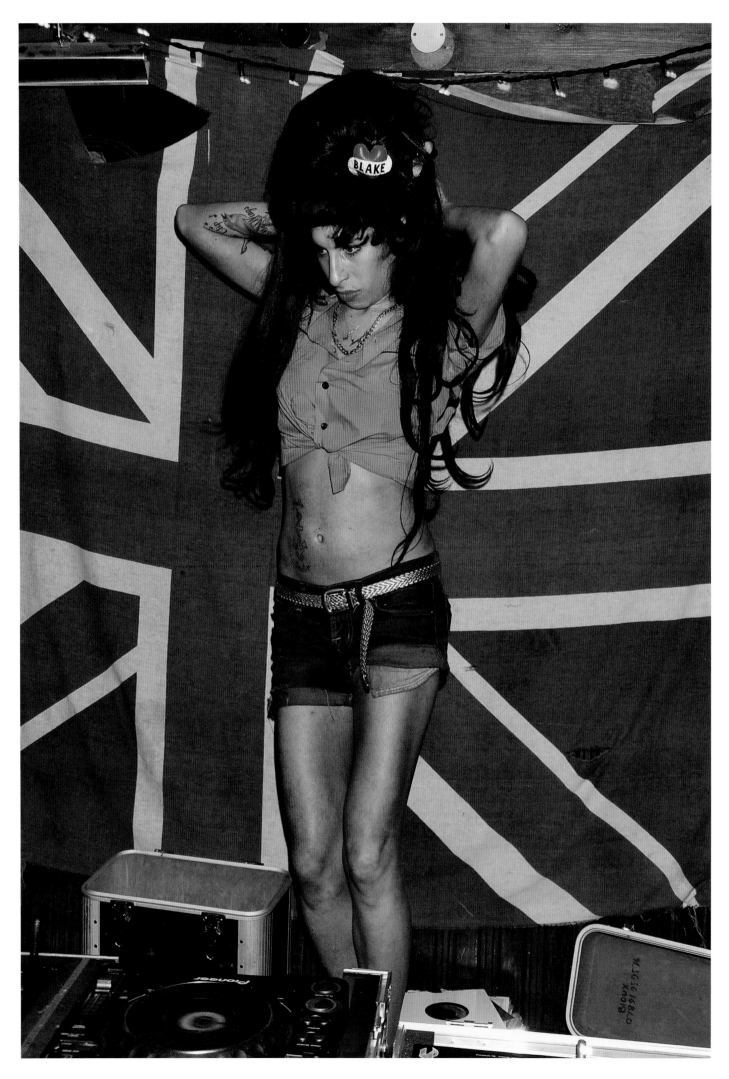

DJ Bioux
Musician & DJ

I first met Amy, playing pool in The Good Mixer in Camden in 2003. I DJ-ed around Camden for years and she had seen me play records out. At first I was pretty cold towards her. She was larger than life even then and I thought people sucked up to her because of *Frank*. After we were friends she often used to say, 'Remember when we met and you were a prick to me?' It didn't take me long to realize I was completely wrong about her. She was an ace person to be friends with. She had a generosity of spirit and a deep capacity for love that she showed to all those who were close to her. She would do silly but kind things like turning up unannounced at my flat accompanied by four security guards all carrying food shopping. Without a word she would fill up the cupboards with food, kiss me on the cheek and leave, waving goodbye. And the people who knew her, which was everyone it seemed, really did love her. She was also very loyal and would defend her friends with a pool cue if required.

I play a lot of sixties soul, girl group stuff, early sixties ska and late sixties / early seventies roots. Soon after becoming friends with Amy she started turning up whenever I played out, sometimes several times a week. It wasn't long before she was planting herself behind the barriers at gigs and rooting through my 45s. Anyone else would have got a quick kick up the arse, but Amy was quite a special person, charismatic and charming, and got away with more than most. I'd turn my back and before I knew it, she'd have pulled a record off that I had lined up and replaced it with one she wanted to play. Then she'd poke me in the side and, giggling, say, 'Check it's cued up properly.' I'd just laugh at the cheek of her. She was a great laugh and she shone a really bright light. She got into the girl group stuff really quickly and soon knew more than I did. I had the records though!

I'm a guitar player by trade but I have an upright piano at home. Amy and I had been out somewhere and left early on to drink vodka at mine. Neither of us were piano players, but Amy had a natural ear for music and was picking chords out over melodies as we tried to work out songs we knew. Eventually, after dawn, Amy got up and said, 'Right, I'm off home.' Later she called me to say she 'needed' my piano. Now, this piano is a white, shabby-looking thing but it does have a lovely action. It's from the period when keyboard makers were trying to develop an electric piano that felt like a real piano, so they removed some strings. That is what gives it such a light feel when you

Snakehips at The Monarch
THE MONARCH (PUB), CAMDEN, LONDON,
10 JULY 2008
PHOTO Dave Benett

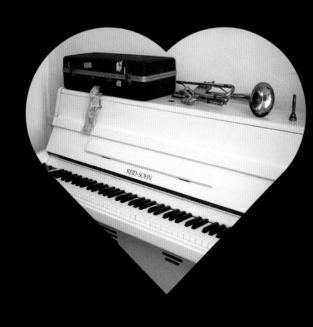

play it. Even though I couldn't really play it, I liked my piano because it's a funny piano and I didn't want to part with it. 'You can play it whenever you like, but you can't take it away,' I said firmly. She offered me thousands of pounds for it; she tried to swap it for a Wurlitzer keyboard and a Hammond organ. I refused to budge. A few days later Amy turned up at my house with a holdall bag and said she was moving in! In fact, she stayed for 24 hours and then went home. It's a really nice piano to play!

Weeks later Amy sent me a text asking me to meet her at Jazz After Dark in Soho. She was with some people she wanted me to meet. I found her in a curtained-off booth to the left of the stage. The house band of hot jazz musicians were playing. In between songs the guy with the mic announced that Amy was in the room and the audience immediately started chanting Amy's name. Eventually she emerged and announced to the packed house that she was going to do something special with her friend. I was horrified to discover that she meant me! She told the amazing jazz pianist to step aside

and got everyone to chant my name. I have played thousands of shows in my life but always with a guitar. I don't really play piano and, despite the hours we had spent messing around singing songs to each other, I was very much not ready and completely unwilling. She pulled me onto the stage and there I sat at the piano with the excellent pianist glaring at me from the side. We tried to play 'Remember' by the Shangri-Las, as we had for literally hours at my flat. We started and stopped, then argued for five minutes about whether it started with a major chord or a minor chord. We couldn't complete the song and eventually I escaped the stage. I have never been so embarrassed before or since. Even now I sometimes get a sickening pang when I remember that night.

When I arrived back in the booth, I discovered a new arrival sitting there. I'd never met Mark Ronson and didn't know who he was. The first thing he said to me was 'YOU'RE WITH US? The awful guy who can't play piano.' I replied, 'OH, GO FUCK YOURSELF.'

I still have my piano and I can still just about play some chords on it. •

Musical Instruments
TRUMPET LESSON (TOP LEFT)
REID-SOHN WHITE UPRIGHT PIANO (BOTTOM LEFT)
TRUMPET WITH INADVERTENT SELF-PORTRAIT (RIGHT)
PHOTOS Digby Oldridge

Customized Snare Drum:
"'Rattle Those Pots & Pans" Cheers Mate!!'
PREMIER ARTIST MAPLE

Amy's Gear
MINI KEYBOARD, FARFISA F324 (TOP);
ACOUSTIC GUITAR, MARTIN & CO. FELIX THE CAT II
DON ORIOLO LIMITED EDITION (CENTRE);
KALIMBA, HUGH TRACEY TREBLE (BOTTOM LEFT);
DRUMSTICKS, VIC FIRTH AMERICAN CUSTOM SD10
SWINGER WOOD TIP (BOTTOM RIGHT)

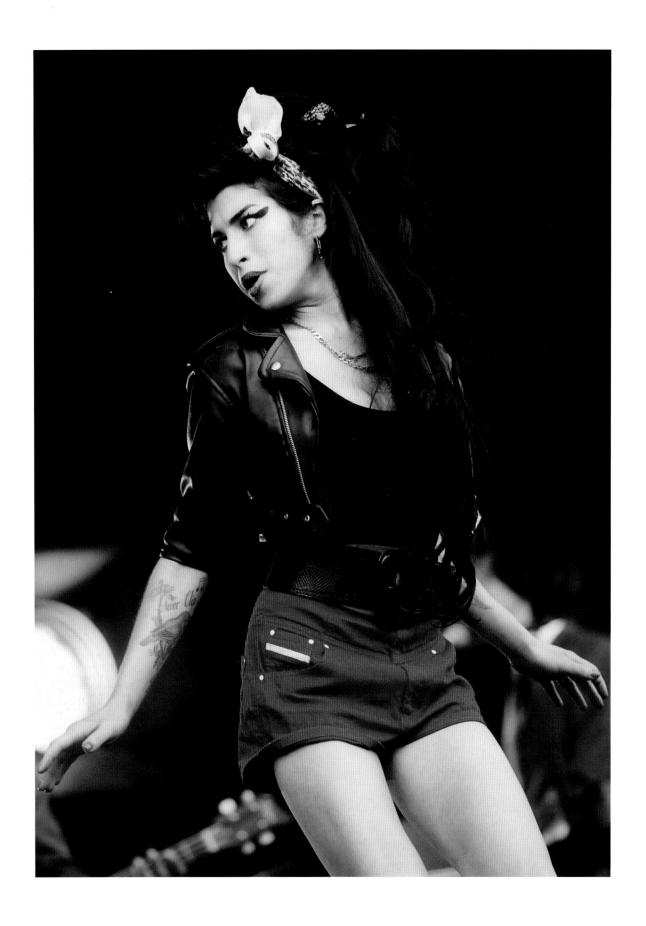

Onstage at T In The Park 2008
BALADO AIRFIELD, KINROSS-SHIRE, SCOTLAND,
13 JULY 2008 (DAY 3);
DIESEL JEANS RED SHORTS AND JACKET
PHOTO Ross Gilmore

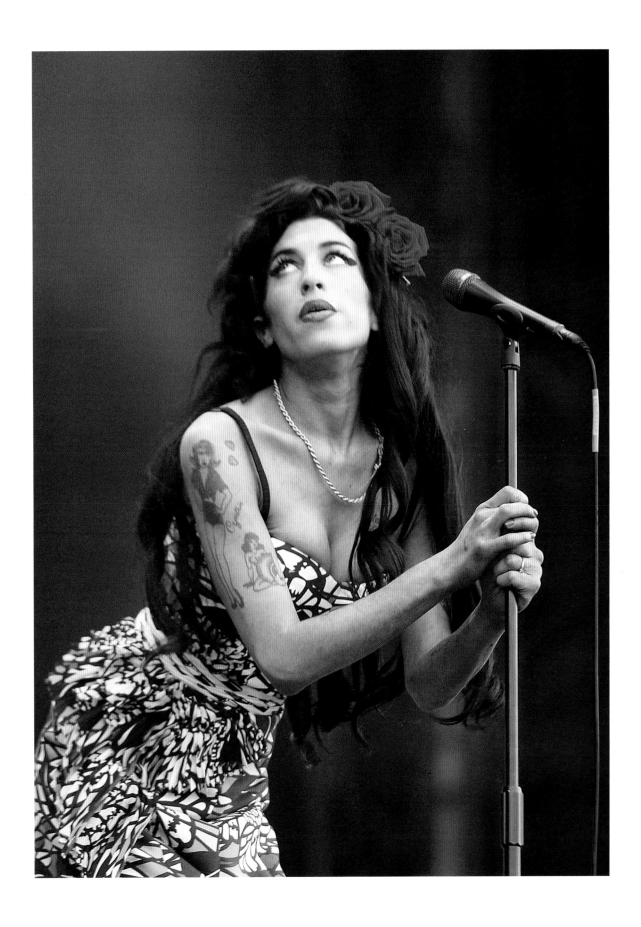

Onstage at V Festival 2008
HYLANDS PARK, CHELMSFORD, ESSEX,
17 AUGUST 2008 (DAY 2),
DRESS BY MATTHEW WILLIAMSON
PHOTO Danny Martindale

"She had a ridiculous amount of underwear and always insisted on wearing frilly French knickers under everything, no matter how snug her dresses were."

NAOMI PARRY STYLIST

←/↑
Lingerie
BRAS, CAMISOLES AND STOCKINGS
BELONGING TO AMY

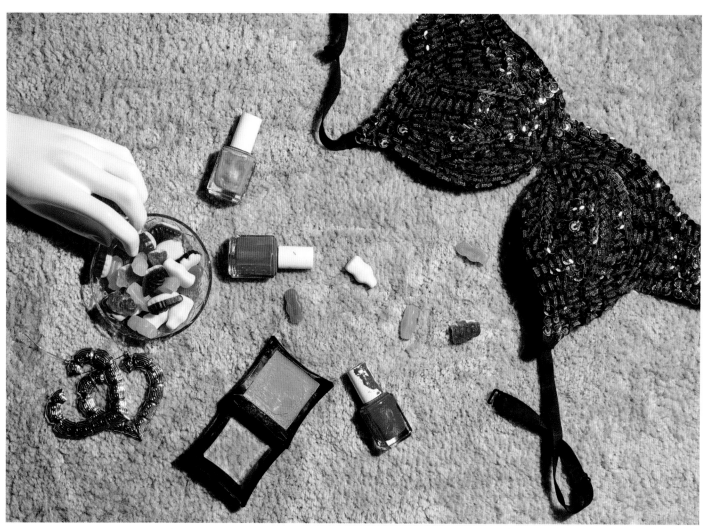

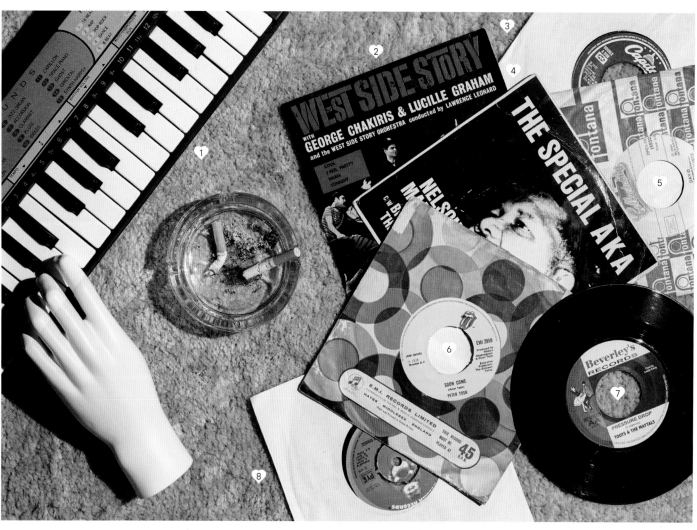

Styling Amy
By Naomi Parry

We're all crammed in Amy's tiny hallway, preparing ourselves for the onslaught that awaits us outside. I counted eight paparazzi when I arrived, possibly nine but one could have been a passer-by; it's hard to see when you are desperately trying to scuttle in laden with bags. As usual, one was sitting quite casually on the bonnet of my car. They shouted, 'Mary, Mary!' I am unsure whether they were trying to get a rise out of me for fun or if they genuinely thought that was my name.

There are seven of us – two quite sizeable security men, her tour manager, her make-up artist and hairdresser, myself and of course Amy. Leaving her home, which opened up directly onto the street, was always quite the operation. The press always knew when something was bubbling as there was no way for us, her quite modest entourage, to sneak in the back of the house, and there were at least four paps out front at any one time –

they seemed to take shifts camping there day and night waiting for 'that' shot.

The house was dark as a result of having to keep the shutters semi closed to stop prying eyes. In hindsight, it was perhaps not the best idea for her to have moved here, but it was in her beloved Camden Town and she had it in her head that it was owned by The Specials' frontman, Terry Hall, so there was no chance of persuading her otherwise. (Later discussions with Terry revealed that he had actually owned the house next door.)

Amy, her hair as close to God as gravitationally possible, and wearing heels to match, is sandwiched between her two security guards. Her tour manager is standing to the side of them, squashed against the wall and ready to usher everyone out as quickly as possible into their respective cars. I stand behind with no real instruction other than to get into the six-seater Mercedes

Amy's Things #6

❶ MINI KEYBOARD, FARFISA F324 / ❷ *WEST SIDE STORY* EP: 'COOL', 'I FEEL PRETTY', 'WANTED', 'TONIGHT' / ❸ PAUL MCCARTNEY 'MULL OF KINTYRE' / ❹ THE SPECIAL AKA 'NELSON MANDELA' / ❺ HARRY BELAFONTE 'DAY-O' / ❻ PETER TOSH 'SOON COME' / ❼ TOOTS & THE MAYTALS 'PRESSURE DROP' / ❽ GLADYS KNIGHT & THE PIPS 'DON'T BURN DOWN THE BRIDGE'

people carrier as quickly as possible. The door opens and sunlight floods the dingy hallway. A wall of photographers lunges forwards and blinding flashes from the cameras go off like fireworks in your face. They are right there, right on our toes immediately and there is no time to strategize any further; it's very disorienting but it's do or die. The TM is shouting for us to keep moving and stay close as he hustles us through – it's his responsibility to make sure that we all make it to the car safely and that Amy's house is fully secure on leaving, so he hangs back.

I am following close behind Amy as security is battling with the press to create a clear pathway for her and prevent her stacking it in her heels. Security is shouting at the press, the press are shouting at Amy, the camera lights are strobing, someone stands on my foot and elbows me in the boob. This is all taking place within a 2-metre gap between the front door and the car. My car is parked to the left of the Mercedes and there's a wall to the right – so we are boxed in. An arm breaks through the blockade of men with cameras, grabs my shoulder and launches me into the car where I land with a thud, wide eyed and full of adrenalin, clutching my bag. In the safety of the blacked-out car, and away from the bloodthirsty mob, Amy relaxes. She puts her hand on my shoulder and says, 'They are such bastards; are you OK?'

I met Amy in the summer of 2004; I was 19 and she 21. My first impression of her was that she was unlike anyone I had ever met before. She was casually cool, with a north London accent and heaps of confidence. We met in a bar in the West End and ended up gallivanting round Soho – the Raymond Revuebar for 'Gay Bingo' followed by too many drinks at the Shadow Lounge where she was politely asked to leave for being too rowdy. Our friendship developed from there and there was mutual respect from the get-go. I can't stress enough how normal we were as a group of young adults living in London, although perhaps looking back on it that was just our normal. I suppose it was a bit strange that one of us had a team of people working for them and would be whisked away for weeks at a time to write and record. I remember the first time I met her manager: Amy, Catriona Gourlay and I were playing pool in The Good Mixer at too early o'clock in the middle of the week and he'd tracked us down. He strode in and just stood sternly, arms crossed, in the doorway. A man of few words, he was also quite a big guy, which exacerbated the feeling of panic that Catriona and I felt – it was as though we had been caught red-handed 'bunking off' school. We lowered our eyes to the ground. Amy, however, was totally unfazed. 'Raye Raye!' she called and gave him a big hug; his demeanour softened instantly. She finished her game of pool and then went off to do whatever it was that she had been late for. Her irreverent attitude to being a musical artist not only made her intriguing but also normalized

Amy's Things #7
❤1 EMBOSSED PURPLE SNAKESKIN-EFFECT BAG / ❤2 MAC LIP PENCIL, REDD, WITH CHANEL SHARPENER / ❤3 BOB DYLAN WORLD TOUR 1978 PROGRAMME / ❤4 TORTOISESHELL-EFFECT HAIRCLIPS

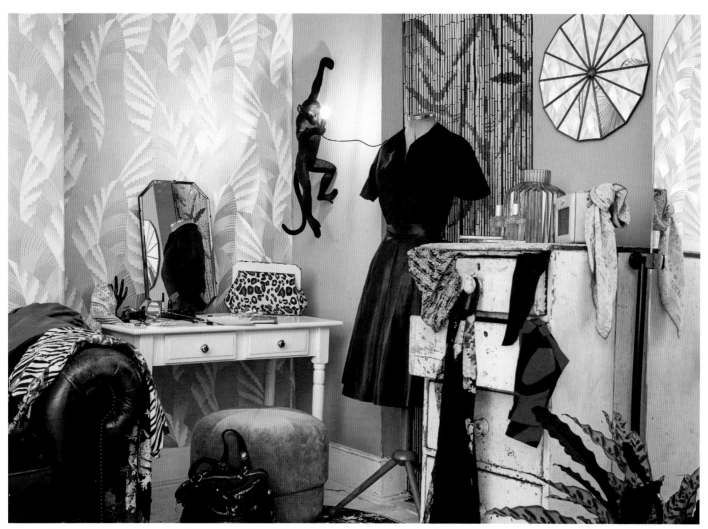

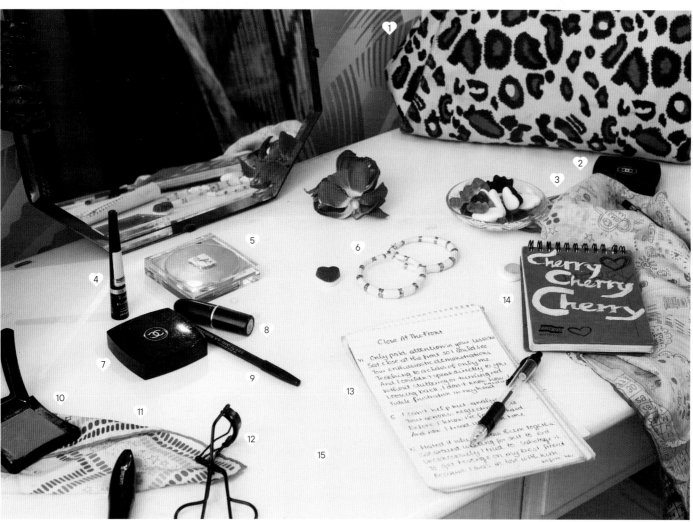

the situation. In the early days, we were totally unaffected by her success – she just happened to be an award-winning artist. She was so genuine in her nonchalance about her fame that I think it made her ever more refreshing and accessible to her fans.

I had worked in the industry since I was 16, when I assisted a fashion designer in my hometown of Fairford, Gloucestershire. By the time I met Amy I had assisted two stylists and had started to work on my own projects with some of the local bands in Camden. It was towards the end of 2006, while on a bizarre photo library job, that Amy asked me to work with her as her stylist, something we had never discussed nor had I ever expected. It was typical of Amy to want to create a family within her working environment and I knew that I had been chosen perhaps more for my loyalty than my talent. I had a slightly bumpy start in the role at Jools Holland's *Hootenanny* show where Amy's self-described 'Shirley Bassey' dress slipped down as the tit tape came unstuck, unable to resist the weight of the double dose of 'chicken fillets' that she'd stuffed into the strapless M&S bra. The audience got a little more than they or Paul Weller, who she was duetting with, had bargained for, to the horror of her team and to my intense dismay. Amy took it all in her stride. She shimmied about a bit while rearranging her bosom like an absolute pro. Fortunately for me, the show was pre-recorded.

Although her look had started to develop during her early years in Camden, largely influenced by the characters living there - the rockabillies, punks, ska and indie kids - it was in 2007 at the BRIT Awards when she made her debut as the Amy Winehouse that is so recognizable today. It was one of the few times she had allowed some time prior to the event to do a fitting. Even then Amy had insisted on cooking first, something that with her was always quite an event, and involved a fair amount of red wine - terrifying when in the same vicinity as a fitting full of loaned designer pieces. I am greeted with a 'hello mamma' before she plants a wet, sloppy kiss on my mouth, like my mother, and legs it up the stairs into the kitchen. Two hours after my arrival, and some rather flavourless meatballs later, I finally managed to get her to pay attention for 15 minutes to the clothes I'd brought, and in that time she whipped a few outfits on and off and made her decision. We had dresses from Preen, Moschino and Armani, which she planned to change into before, during and after her performance. This was an exciting prospect as it would score us some much needed brownie points with the designers whom I was desperately trying to persuade to move us up the hierarchical list of loanees. The acid yellow Preen dress was pulled in as a wild card, which was something I always did, something that pushed Amy slightly out of her comfort zone but that was still in keeping with her general vibe. I wanted to steer her away from a

Amy's Things #8

❤1 REISS LEOPARD PRINT BAG / ❤2 CHANEL BLUSH TWEED AMBRE / ❤3 FENDI SCARF / ❤4 RIMMEL EXAGGERATE EYELINE 100 BLACK / ❤5 BRONZY BABE SOFT SHEER BRONZER / ❤6 HOOP EARRINGS / ❤7 CHANEL JOUES CONTRASTE POWDER BLUSH FANDANGO / ❤8 MAC COSTA CHIC LIPSTICK/ ❤9 MAC PINKIE PENCIL CRAYON DE COULEUR / ❤10 MASQUA CREAM BLUSHER / ❤11 FENDI SCARF / ❤12 EYELASH CURLERS / ❤13 'CLOSE AT THE FRONT' LYRICS / ❤14 'CHERRY' NOTEPAD / ❤15 DRESSING TABLE

carbon copy rockabilly look and encourage her to modernize it slightly, drawing inspiration from her multitude of musical references. Of course, no matter what I put her in Amy was very much the architect of her ultimate appearance. It didn't matter how armed I was with the correct underwear, tit tape, sewing kit, safety pins etc, she would always add the Amy edge, the imperfection of the look that ultimately was the ingredient that made her unique.

The Jeffrey's Place I knew had a stained ceiling that always looked like it was threatening to cave in at any moment. It was constantly being redecorated as Amy would often change her mind about a wall colour or discover some new kitsch vintage wallpaper she liked. Action Man wallpaper adorned the stairwell, while the spare room was covered in a repeating pattern of creepy Thunderbird puppets and the living room featured bamboo paper not dissimilar to the paper decorating Del Boy's council flat in *Only Fools and Horses*. The furniture was all mismatched but the whole place had a retro feel to it and, as with every house she owned, it contained a Smeg fridge to which she would fix notes and pictures. When Amy was tidy she was a 'take polaroids of your shoes and stick them on the front of their box' kind of girl but more often than not she was incredibly messy, never unclean, just very untidy. She was a bit of a hoarder, too, so there was always a lot to make a mess with. Clothes were often strewn all over the place and hung on door frames.

Whatever activity she was engaged in, perhaps listening to records or writing notes, she left the objects exactly where they were when she moved on to the next one.

The year 2007 was a significant one for Amy. She had become internationally recognized which, for any musician, is the ultimate achievement but ironically it was also a contributing factor to her decline. She'd scooped up various awards and accolades; we'd shot the 'Back To Black' music video in March and worked with David LaChapelle on the 'Tears Dry On Their Own' video in May. It was at about this time they decided that Amy might benefit from having a PA, an idea she wasn't keen on. On first introduction Amy sat her down and offered to make her a cup of tea while insisting on packing her own suitcase just to prove a point. I had gone from working with her here and there to working with her every week and was booked to work with her on the European tour towards the end of the year. Amy was also seeing Blake Fielder-Civil again and, knowing how toxic this pairing had the potential to become, everyone in her inner circle was nervous and the atmosphere changed quite noticeably. Now, I'm going to keep this brief and be as diplomatic as I can: Amy was no angel and with a multitude of different issues brewing, she teetered on the edge of delinquency and frequently pushed the boundaries as far she could. Blake, on the other hand, brazenly pole vaulted over them and due to the type of person Amy was – 'I don't

Amy's Things #9

❤1 MIU MIU BAG / ❤2 *HEAVEN TO HELL* BY DAVID LACHAPELLE / ❤3 KAREN GILSON NÉGLIGÉE / ❤4 KALIMBA, HUGH TRACEY TREBLE / ❤5 FRANK SINATRA & COUNT BASIE & HIS ORCHESTRA *IT MIGHT AS WELL BE SWING* / ❤6 CHRISTIAN LOUBOUTIN SHOES / ❤7 MIU MIU SHOES / ❤8 CHANEL FOUNDATION / ❤9 GENE VINCENT & HIS BLUE CAPS *HEY MAMA* 10-INCH LP / ❤10 HOOP HEART EARRINGS / ❤11 GIBSON LES PAUL STUDIO GUITAR / ❤12 AGENT PROVOCATEUR BRA / ❤13 CHANEL ORANGE FIZZ 307 NAIL VARNISH

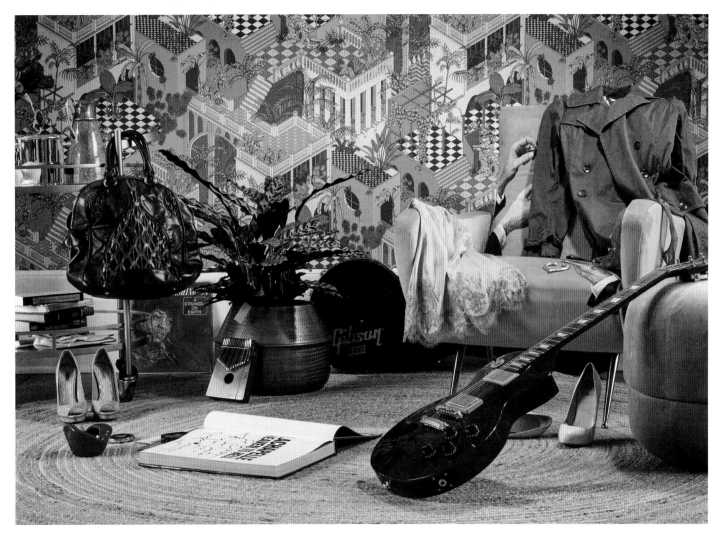

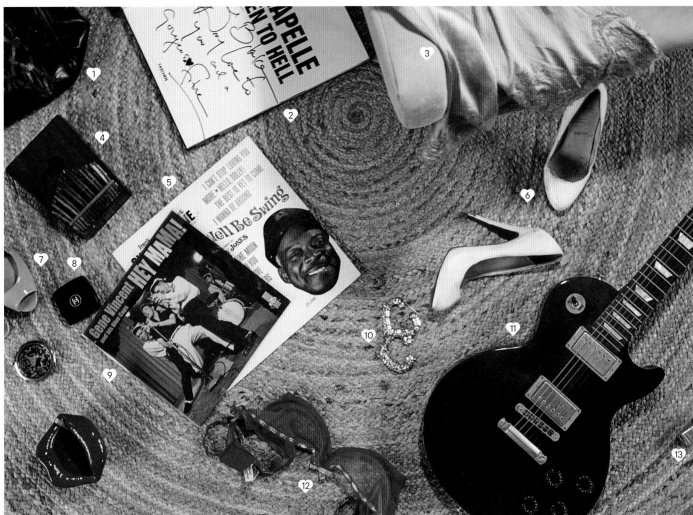

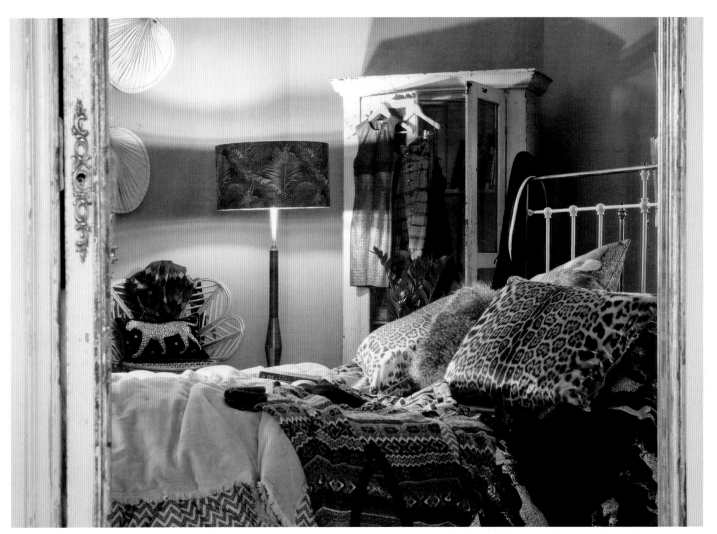

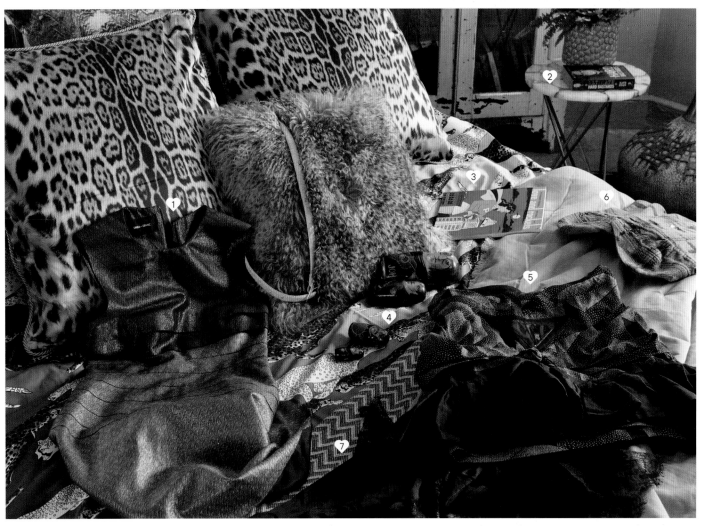

care if you don't love me, I will lie down in the road, pull my heart out and show it to you' - she had already shackled herself to his ankles before anyone knew what was going on. It was around this time that I met Mitch Winehouse, who like any father would, became more hands on as Amy's life started to look like it might be spiralling downwards. One particular memory is of the time he flew directly to Bergen after Amy had been arrested for possession of cannabis there and insisted on sleeping in a bunk on the tour bus with us despite our protests that it would be too cramped. I was struck by how similar they were: they sounded the same, looked the same and even had the same sense of humour; they were both larger-than-life characters with little filter. Having relinquished my middle bunk to Mitch, I slept on the one nearest to the ground which, unknown to me at the time, is the most uncomfortable. The following day I woke with pain in my upper back, something Amy insisted she could fix by walking on it. In retrospect, it was a terrible idea and I have had a recurring pain in that shoulder ever since.

As Amy's personal life became more chaotic she became far more appealing to the paparazzi. By no means is this an attack on the press, although I do take issue with individuals who sensationalize, misrepresent and harass people. I actually think there is a deeper, societal issue – like causing delays on the motorway because of our inability to drive past a car crash without slowing to take a look. In the early days Amy would occasionally get photographed walking to pick up the papers, she now had several photographers permanently camped outside her house. After a pretty diabolical European tour gets pulled and after Blake's arrest in November and subsequent imprisonment, the several turn into upwards of ten sometimes. Being the 'Wear your heart on your sleeve. Who cares what anyone thinks of me? I am going to do it my way' person that Amy was so inclined to be, this was disastrous and became a vicious circle. Amy was struggling, the press would capture it; Amy would read it and struggle some more and so on. As far as she is concerned, at this point, the love of her life has been taken away from her and she has been left with an impossible addiction while all the shady people that embrace this lifestyle are now friends, and she is stuck in a house that opens out onto the street where the paparazzi await her every move and peep through the blinds. At this time, despite being her neighbour, I only saw her a few times a week briefly and rarely for work. By July 2008 we'd haphazardly made it through a BRIT Awards performance in February at which she held my hand right up until the last minute; this was possibly the performance that broke the camel's back as far as her make-up artist, Talia Shobrook, was concerned. In June she performed at Glastonbury but in all honesty I don't remember much about the performance. She'd been buoyantly bouncing around backstage, chatting to Jay-Z, Beyoncé and Jack White while

Amy's Things #10

❶ SINHA-STANIC METALLIC TWO-TONE DRESS / ❷ *ULTIMATE HARD BASTARDS* BY KATE KRAY / ❸ *LOVE AND ROCKETS* COMICBOOK BY THE HERNANDEZ BROTHERS / ❹ THE BEATLES MATRYOSHKA DOLLS / ❺ TINA KALIVAS SKIRT / ❻ PETER JENSEN DRESS / ❼ AGENT PROVOCATEUR NÉGLIGÉE

I had practically gone purple with exasperation trying to get her into her dress with only a few minutes remaining before she was due onstage. It took three of us to hoist her into the corseted, beaded Luella dress, which I sewed her into. Topped off with some cocktail umbrellas in her hair, she tottered off to give the band the usual hugs, kisses and words of encouragement. Sadly, what started reasonably well ended with a member of the audience grabbing her hair and receiving a thump in the face in return, which became the main focus of the performance afterwards. Amy's violence towards others became a running theme in the press for a while as people tried to taunt her to get a reaction.

When you are a kid and you become aware of drugs you never imagine yourself becoming friends with an addict, let alone working with them, but I did. It has given me a much deeper understanding of addiction and the link to mental health. Fortunately, as a society, we are now starting to talk more openly about mental health and its effects on our behaviours, including addiction and eating disorders. Back then, it was still a fairly taboo subject and certainly not something you willingly offered up to anyone without feeling that you would be written off and locked up. Addiction starts as a coping mechanism and progresses to alienation from loved ones, isolation from reality and then to self-destruction, which serves to deepen the initial wound that started you off in the first place. It is deeply misunderstood

by those that haven't experienced it as I witnessed so often when dealing with Amy.

Miraculously and against all odds, In January 2008 Amy had decided to get clean - thanks to the determination of her security team, her parents, her inner circle of loyal friends, including an incredibly understanding Bryan Adams and, mainly, herself. However, making the decision did not mean all her troubles were suddenly in the past; getting clean was a long and gruelling process with several heartbreaking relapses.

The night of the Grammy Awards in February 2008, Amy had just completed a reassuring stint of sobriety in hospital. That night was one of the most special and unforgettable nights we got to share with her and something that those who love her will treasure forever. It was such a comfort that we got to see her reach such a monumental point in her career, while apparently healthy and happy. She was on top form. I had pulled in a D&G dress that now resides in the Grammy Museum and a Tina Kalivas skirt, which we teamed with a basic bandeau top, which was very in keeping with Amy's MO. I remember being asked to paint a bra on her topless shoulder tattoo, which depicted a pair of bare breasts. This I did using her Rimmel eyeliner, and we laughed backstage about how ridiculous it was. It was an easy but naive mistake to presume we were over the worst and it would be plain sailing from here on in.

However, Amy's fame had become something that was increasingly hard

Amy's Things #11

❤1 PREEN DRESS / ❤2 ESSIE BRIGHT TIGHTS NAIL VARNISH / ❤3 FREED OF LONDON BALLET PUMPS / ❤4 ESSIE WHO'S SHE RED NAIL VARNISH / ❤5 PATRICIA FIELD DRESS / ❤6 DEADLY DAMES KISS ME DEADLY DRESS / ❤7 TROPICAL KAREN MILLEN DRESS / ❤8 *MARLON BRANDO* BY PATRICIA BOSWORTH / ❤9 BAM BAM GOLD EARRINGS / ❤10 CALVIN KLEIN PINK SCARF / ❤11 ARROGANT CAT BELT

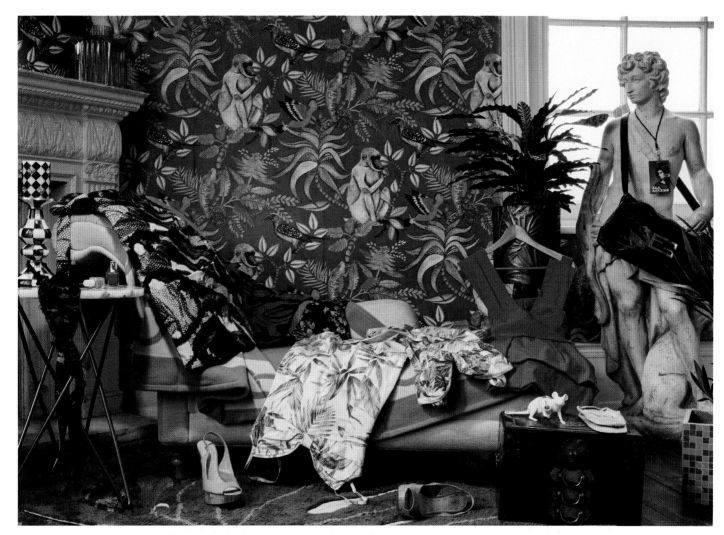

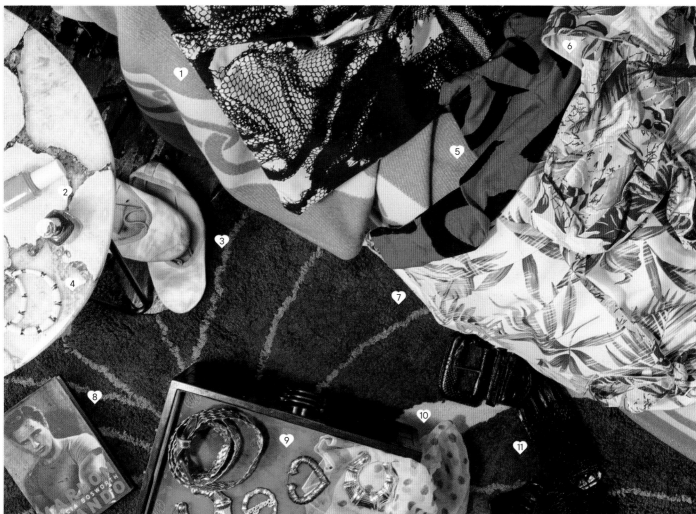

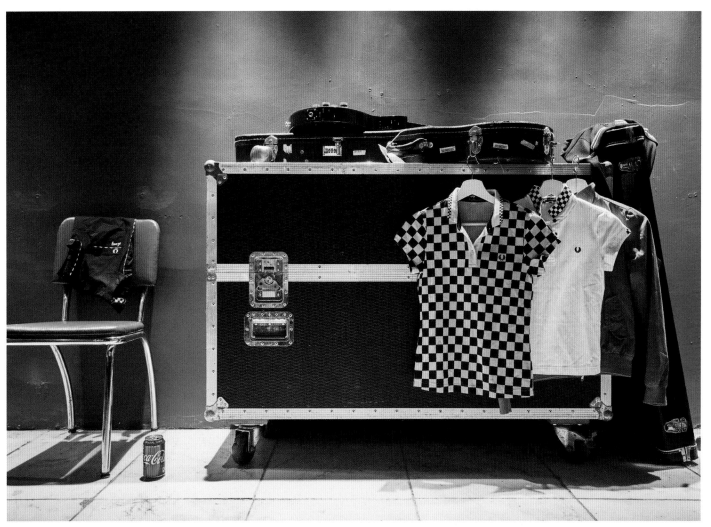

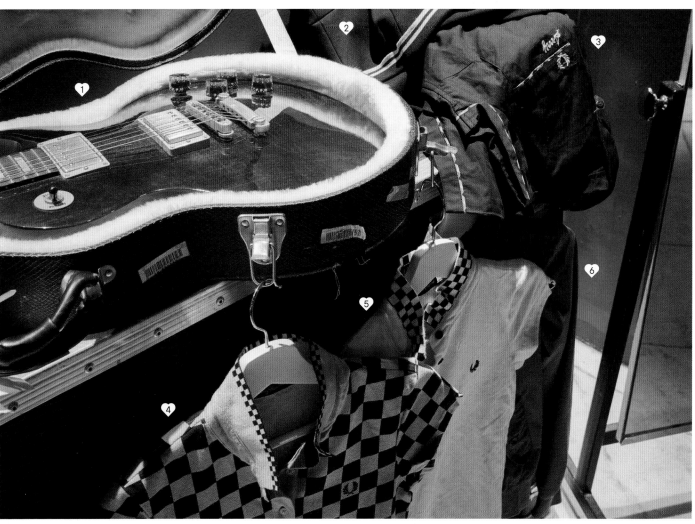

for everyone to navigate. The days of bowling about Camden without recognition or retribution were long gone. An already quite small inner circle had dwindled owing to people's understandable inability to cope with the situation, while her workforce had increased, with four new security guards working in shifts to ensure there was always one there 24 hours a day, seven days a week. For a remarkable girl with a fundamentally ordinary background nothing about this was normal. It became harder and harder for people to be around her and she became more isolated through circumstance, not choice. Without the anaesthetising self-medication of narcotics, the new reality of a heavily restricted life lived in the glare of publicity was starkly clear to Amy. Alcohol abuse continued to be a problem for her.

In 2010 I encouraged her to consider a Fred Perry collaboration that I had been discussing with their head of PR, Natalia Damm. It was something that might get the creative juices flowing again without the pressure of writing another album to follow on from *Back To Black*. This collaboration was something she was immeasurably excited about on first introduction and she immediately started making notes of what she wanted – linen mac coat, cashmere socks, Fred Perry wreath gold earrings. It was truly a beautiful thing to see her so engaged in something creative after such a prolonged state of apathy.

It was just after the Brazilian tour In 2011 that I moved in with her, partly because I thought I could provide some company and be a good influence and partly because she had insisted. We had travelled to Brazil in the first week of January. I feel incredibly lucky to have had this time with her as we had some brief moments of normality despite the daily chanting of 'Rehab' outside the hotel gates. The fences were high and the hotel was in a remote part of the city. Ronnie Wood was in town for some reason and popped over to see her; I had a couple of friends in town too and her beloved band members popped in at every opportunity. It was a rare and welcome sight to see her chatting away so comfortably; it was something I had missed.

Brazil had its ups and downs but there were some really positive performances and Amy was far more enthusiastic about getting her life in order than I'd seen her recently. The first show she performed was nothing short of electric. When she sang the opening lines of 'Boulevard Of Broken Dreams' the hairs on my arms stood up and I really felt that we had started to get Amy back. This was when we discussed the tour wardrobe for what would be her final tour that ended before it had begun. The conversation started with: 'Nai Nai, the boys need new suits.' Then she described how she wanted her band in coral pink prom suits with black frilly shirts. I used this as an opportunity to suggest that she allow me to create something more bespoke for her given

Amy's Things #12

❶ GIBSON LES PAUL GUITAR / ❷ AMY WINEHOUSE FRED PERRY COLLECTION BLACK & GOLD-TIPPED SHIRT / ❸ EMBROIDERED AMY FRED PERRY COLLECTION SHIRT / ❹ AMY FRED PERRY COLLECTION CHEQUERED SHIRT / ❺ AMY FRED PERRY COLLECTION CHEQUERED SHIRT / ❻ AMY WINEHOUSE FRED PERRY COLLECTION BEIGE HARRINGTON JACKET

that the boys were going to be such an illuminating backdrop.

Between being made aware of the 2011 summer dates in Europe and the first show we had about eight weeks to design and complete 11 dresses. And while I love them, as they are a culmination of five years of working together, I am at the same time reviled by them as they represent so much loss. During the months after the Brazilian tour and particularly the eight weeks leading up to the show in Belgrade, Amy had been quite volatile. Weeks of sobriety and hope were interspersed with relapses of binge drinking and despair. Her mental health had taken a nosedive and she was struggling. I wrote her reassuring letters, bought her books she might find interesting and tried to make her healthy food to eat, such as scrambled eggs and avocado for breakfast, which she loved. When she was doing well she could be found cycling on her exercise bike while eating haribo, down in her studio bashing away at her drums or chatting away on the phone to friends. While the good days gave me hope of a more positive trajectory, the bad days were difficult.

The Belgrade show in June was the last time I worked with her. By this time I had moved out and lived in a house around the corner. The lack of sleep caused by her nocturnal behaviour was impacting on my mental health and I felt like I wasn't particularly useful in that state. The moment I told her she cried and I have felt dreadful about

my decision ever since, even though I popped in most days to see her. Clearly, she felt I was abandoning her; it was awful. The day of the show she was in her hotel room, which we often used as a dressing room if she didn't want to go to the venue too early. When I arrived, she was chatting away to various band members and appeared in good spirits. I noticed that she had been drinking but I had no idea how much at that point. The problem with drinking on an empty stomach and at a rapid pace is that there is no real measure of how inebriated you are until it is too late. I don't think she had intended to get so drunk, but by the time everyone had left, she was not in a good way and it was just her and me alone in the room a mere 30 minutes before she was due onstage. As I gave her water to drink, begged her tour manager not to put her on stage and wiped off the smeared make-up she'd applied, she managed to sober up marginally. She shoved some clothes on and charged out to meet her management who were standing in the lobby. Once at the venue, she put on her dress and proceeded to drink another glass of wine. I have no idea why. What I do know is that it was at that moment I knew it was all over. That show should not have happened.

A month later, on 22nd July, I was about to head to the Secret Garden Party festival to meet a group of friends. Before I left I popped over to Amy's to drop off several possible outfits for her to wear to Nick Shymansky's wedding, which she was due to attend the following day.

Amy's Things #13
❤1 PALM TREE DRESS, 2011 TOUR / ❤2 FLAMINGO DRESS, 2011 TOUR / ❤3 FOLIAGE DRESS, 2011 TOUR / ❤4 WAVES DRESS, 2011 TOUR / ❤5 EXOTIC BIRD DRESS, 2011 TOUR

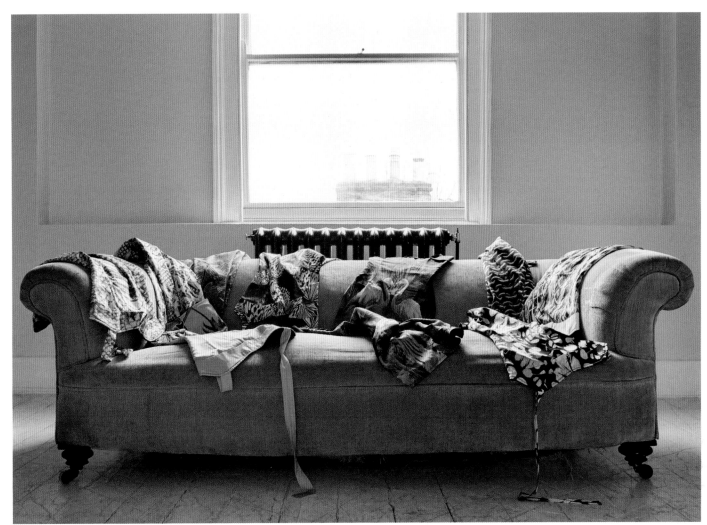

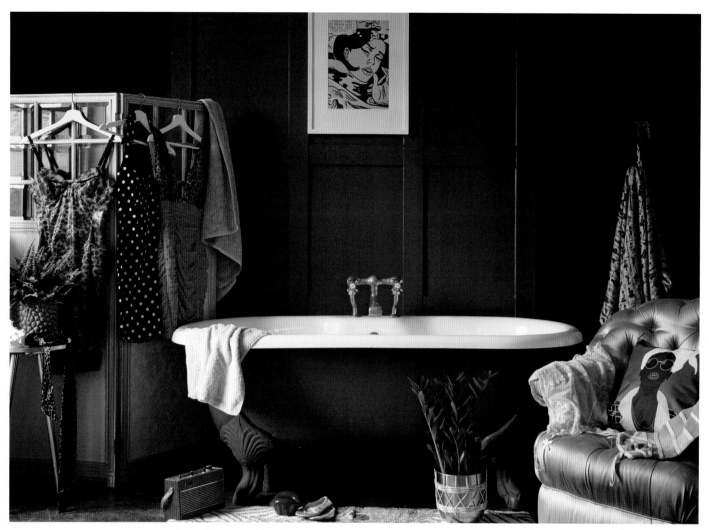

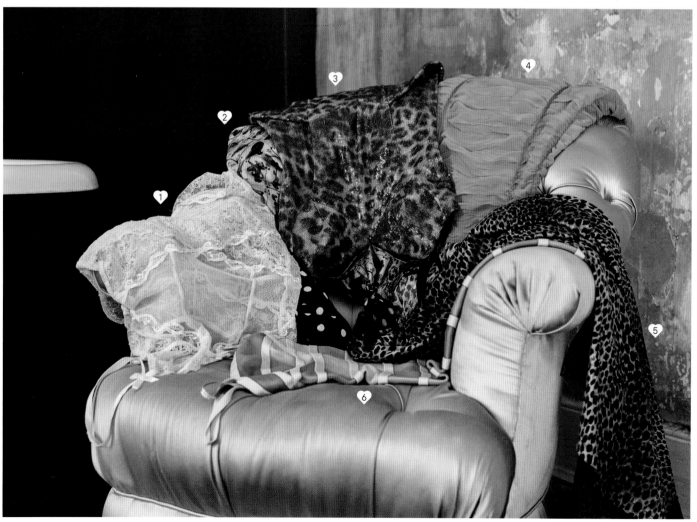

When I arrived, she was sound asleep, so I laid out the dresses on the sofa with shoes and accessories alongside, together with a note explaining the choice of outfits, where I was off to and that I'd see her when I got back on Sunday. When I arrived at the festival Amy called me and we chatted briefly but, although she sounded in good spirits, she had clearly been drinking. We parted with the usual 'love you mamma'; it was the last time I spoke to her. The following day I had an anxiety attack and told my boyfriend I wanted to go home – something didn't feel right. An hour later a friend took me aside and said, 'Amy Winehouse is dead.' The words made no sense to me; I simply could not accept them. I travelled home completely numbed. During aninut we were taken to her home on Camden Square one last time to be around her. The outfits I had left for her to wear to the wedding were completely untouched. I wondered if she had even seen my note. I coped by detaching myself from the situation and went onto autopilot helping prepare for the funeral, calling in suits for people to wear and even a dress for Amy. It was not how I'd ever imagined our last show would be. I settled on a leopard print Dolce & Gabbana dress, which I hope did her proud.

When I think again about sitting in that cab with Amy at my side asking me if *I was OK* after *she'd* survived the mass of men twice her size abusively thrusting cameras in her face, I think how incredibly fortunate I was to have known such an enigmatic small creature and how much I owe to her. It's hard to comprehend how I feel about having 10 years pass without Amy. There is so much that I have learnt over the years that I wish I could have shared with her, that may have even helped her. I often think about what else she might have achieved – would she have had children? Would she have grown out of Camden and moved somewhere quieter like the rest of us? I think about the sloppy kisses, the bummed cigarettes and the mouthful of hair I'd get when she hugged me; the nasally sound of her voice as she called my name and the saccharine smell of her perfume. She has left behind a big beehive-embellished hole in my heart and a legacy that will outlive us all. •

Amy's Things #14

❤1 AGENT PROVOCATEUR LINGERIE / ❤2 AGENT PROVOCATEUR PIN-UP ROBE / ❤3 VIVIENNE WESTWOOD GOLD LEOPARD PRINT DRESS / ❤4 ARROGANT CAT PINK LEOPARD DRESS / ❤5 DOLCE & GABBANA LEOPARD PRINT ROBE / ❤6 HERVÉ LÉGER MULTICOLOURED BANDAGE DRESS

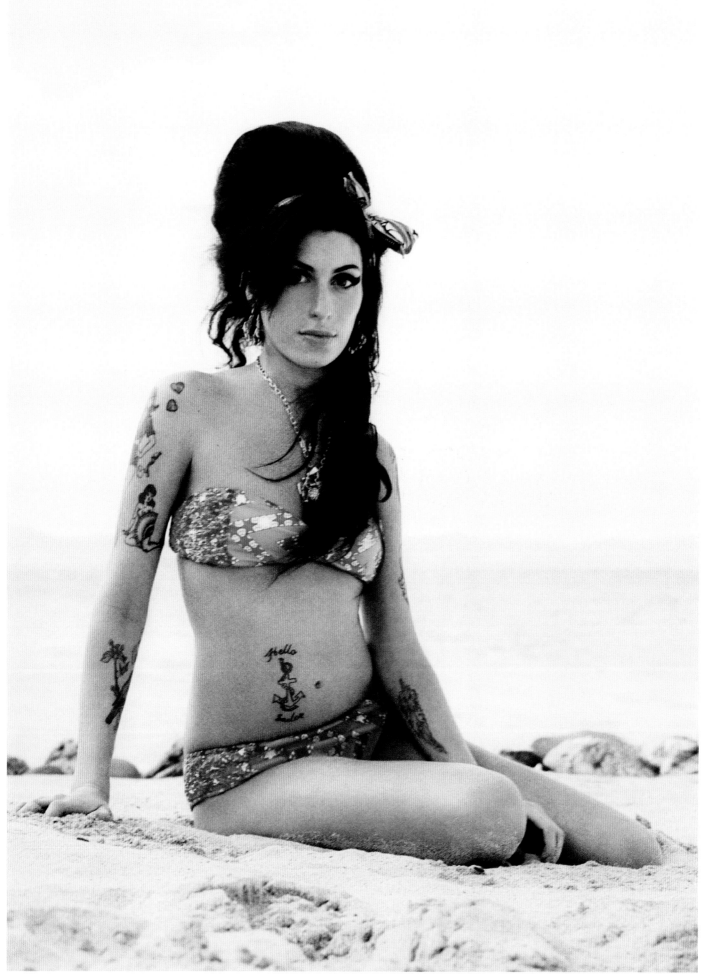

3

Lioness

2009–2011

In January 2009, Amy announced that she was launching her own label: Lioness Records. The decision was inspired by Motown and 2 Tone Records, founded by Berry Gordy and Jerry Dammers of The Specials respectively, with the name referencing a lioness pendant necklace given to Amy by her grandmother, Cynthia. The website at the time stated that 'Lioness symbolizes strength, pride and confidence, and will be a place where the artist is given the time, space and the opportunity to develop and flourish.'

The first act signed to Lioness was 13-year-old Dionne Bromfield, Amy's goddaughter, whose debut album *Introducing Dionne Bromfield* was released on 12 October 2009. Speaking at the time, Amy said: 'The first time I heard Dionne sing, I couldn't believe what I was hearing... such an amazing voice from such a young girl. I'm just so proud of her. I'm very lucky to have a record label. I've got all these people that I love, that are really talented – and Dionne is my number one.'

It was followed by two solo EPs by soul singer-songwriter Liam Bailey, and - on 4 July 2011 - Bromfield's second album *Good For The Soul*. Bailey's prospective debut, *Out Of The Shadows* (recorded and produced by Salaam Remi), was scheduled to be released in September 2011. However, Bailey unexpectedly pulled it. There have been no releases through Lioness since Amy's death on 23 July 2011, although Mitchell Winehouse remains an active director.

The name 'Lioness' was later used as the title for the posthumous compilation album, *Lioness: Hidden Treasures*. Released through Island Records on 5 December 2011, the 12-track collection featured previously unreleased songs, covers and demos compiled by Salaam Remi, Mark Ronson and the Winehouse family. Speaking ahead of its release, Remi said that Amy was 'at the top of what she did' when she was writing these songs, and that it made 'no sense' for them to be 'sitting on a hard drive withering away'.

While it was notoriously difficult to get Amy into the studio after *Back To Black*, two songs emerged from the sessions she had done for her unfinished third album, both carrying a heavy doo-wop influence. There's 'Like Smoke', whose despondent chorus ('*I never wanted you to be my man / I just needed company*') and ascending 'Oohs' are bridged by dexterous verses from American rapper Nas. And there's 'Between The Cheats', whose unsettling lyrics ('*I would die before I divorce ya / I'd take a thousand thumps*') feel like the spiritual equivalent to The Crystals' 1962 single 'He Hit Me (And It Felt Like A Kiss)'.

Elsewhere, there's a reggae cover of Ruby & the Romantics' 'Our Day Will Come', 'Half Time' - a 2002 outtake from her sessions with Salaam Remi in Miami - fleshed out with the help of ?uestlove of the Roots, and 'Will You Still Love Me Tomorrow?' by The Shirelles is given the *Back To Black* treatment. 'Body And Soul' - a duet with the legendary Tony

←
On the Beach
MUSTIQUE, GRENADINES, WEST INDIES, DECEMBER 2007
PHOTO Bryan Adams

→
Amy & Tony
ABBEY ROAD STUDIOS, LONDON, 23 MARCH 2011
PHOTO Kelsey Bennett

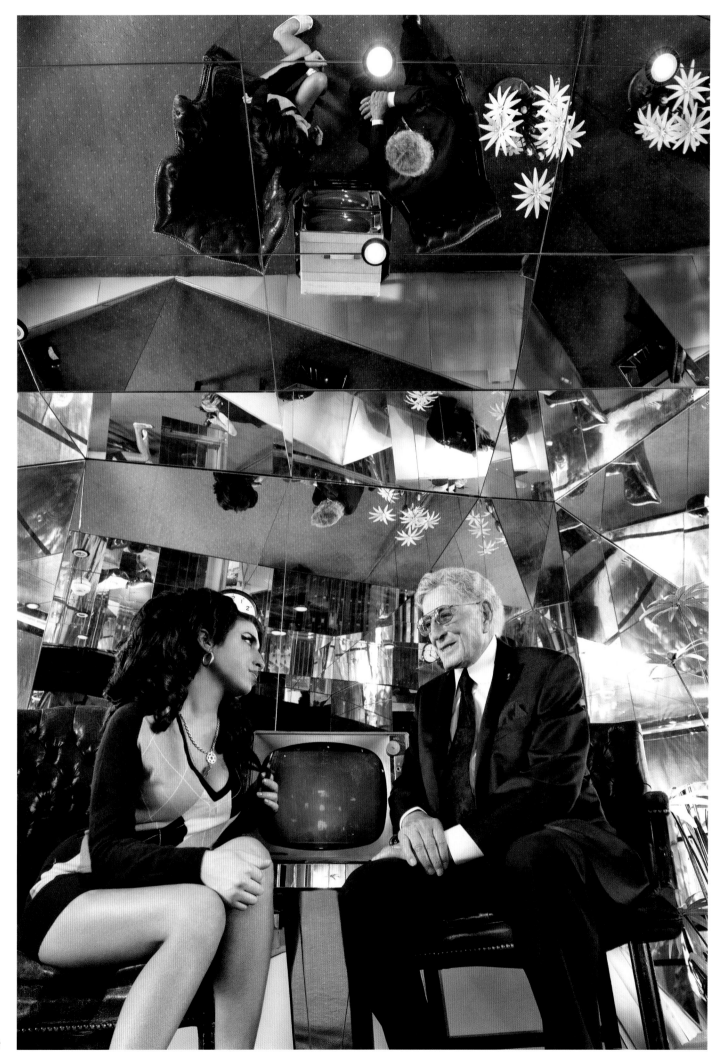

Bennett, and Winehouse's final studio recording – was released as the lead single on what would have been her 28th birthday. The profits were donated to the Amy Winehouse Foundation, a charity set up by her family to provide support for disadvantaged young artists and those at risk of drug and alcohol misuse.

Lioness was met with mixed reviews, with *Q* magazine calling it 'an admirable tribute' while *The Guardian* said it felt cobbled together. *Rolling Stone* was more generous, writing that the songs 'remind you, first and foremost, of that voice – one of pop music's most instantly recognizable vocal imprints, a sound that leapt out of your speakers and seized you by the ears.' Even so, *Lioness* received the biggest first-week sales of Winehouse's career, debuting at No. 1 on the UK Albums Chart and finishing 2011 as one of the best-selling albums of the year.

Above all else, *Lioness* is both a reminder of Amy Winehouse's once-in-a-generation talent, and a projection of what she could have gone on to produce, given the time. It's hard to conceive of *Back To Black* as the work of an artist in formation, but with two albums under her belt by the age of 24, Amy really was just at the beginning of her career – and, indeed, of her life. As *Rolling Stone* noted, 'She was still finding her feet as a singer and a songwriter when she died.' With the exception of Nick Drake, you'd be hard pressed to find another UK singer-songwriter whose comparatively short time on Earth would leave such a long-lasting imprint.

Amy Winehouse has inspired countless artists, from Adele to Future to Lana Del Rey to those whose names we have yet to hear, but her significance is felt just as keenly by those who came before her. In a 2015 interview with *MOJO* magazine, Ronnie Spector said, 'Amy Winehouse was so great for me because she made me feel like what I did mattered.' It's a testament to Amy's sincerity as an artist and her ability to sing truthfully about pain, just as The Ronettes did; staring down feelings that most people would hesitate to glance at sideways.

Like all the greats, Amy Winehouse's music will stand the test of time because it is honest. While there is no question that *Back To Black* is her most celebrated body of work, it's hard not to believe that she would have gone on to redefine the parameters of pop music over and over again. •

"Just as sorrow crept in to her best songs... it's here in spades. But no one ever expected 'Walking on Sunshine' from a woman who battled through troubled relationships and addictions so publicly."

LOU THOMAS BBC

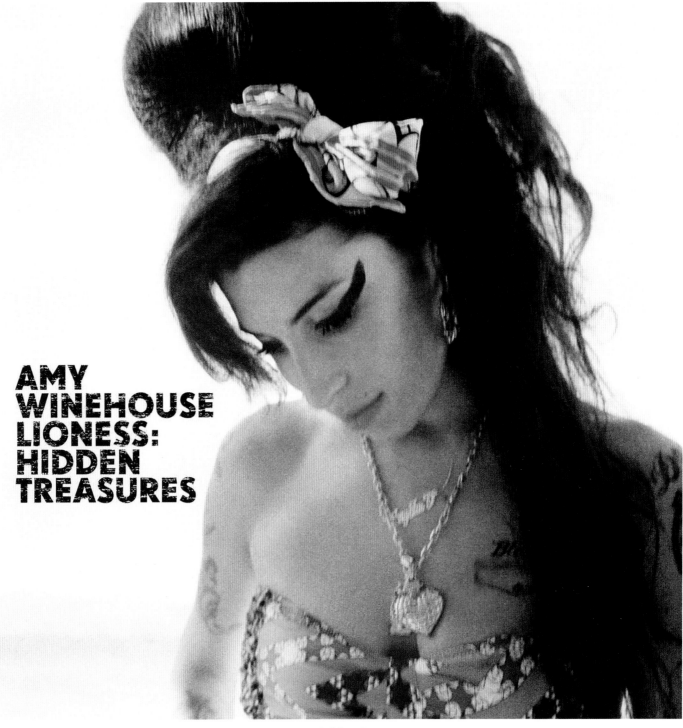

AMY WINEHOUSE LIONESS: HIDDEN TREASURES

Lioness: Hidden Treasures.
ISLAND RECORDS, 2 DECEMBER 2011

'Body And Soul'
ISLAND RECORDS,
14 SEPTEMBER 2011

'Our Day Will Come'
ISLAND RECORDS,
2 NOVEMBER 2011

Lioness:
Hidden Treasures

Jody Rosen,
Rolling Stone, 2011

This is a sad record. A grab bag of outtakes, unreleased tracks, demos, covers and song sketches, these recordings feel like a gut punch. They remind you, first and foremost, of that voice – one of pop music's most instantly recognizable vocal imprints, a sound that leapt out of your speakers and seized you by the ears. Here, as always, Winehouse's singing is both raggedy and dramatic, winking and insouciant, full of high drama and a breezy sense of play – sometimes all those things at the same time.

Listen to the deliciously easeful crooning in 'Our Day Will Come', a reggae-fied reworking of a doo-wop chestnut, recorded in 2002. Or listen to 'Half Time', also from 2002, a sultry ode to the pleasure of sultry music – '*When the beat kicks in / Everything falls into place*' – with Winehouse conjuring a Sunday-noontime-light-slanting-through-the-blinds vibe over a luscious seventies jazz-soul groove. Then there's 'Between The Cheats', from Winehouse's aborted attempts at recording a third album with producer Salaam Remi in 2008. An old-fashioned 6/8 R&B ballad, it perfectly distils Winehouse's marriage of classic soul style and goth-barfly smuttiness.

Sadder still, what's not here. Winehouse was a talent in formation. Her debut album, the jazzy retro-soul *Frank* (2003), was promising but flawed: her appealing mix of London homegirl brassiness and classic-pop chops was undermined by her overly mannered singing and an unsure songwriting touch. On *Back To Black* (2006), she turned from sass to melodrama – with help from producer Mark Ronson and a pile of old Shangri-Las 45s – and recorded wrenchingly beautiful (and funny, and potty-mouthed) songs about love and addiction. But she was still finding her feet as a singer and a songwriter when she died. On *Lioness*, there are charming reminders of what was: the stirringly stately 'Will You Still Love Me Tomorrow?' cover, an alternate version of 'Tears Dry'. But it's hard not to believe that Winehouse died with her best work in front of her. We'll never hear those records, and the silence is deafening. •

Harper's Bazaar
'AMY WINEHOUSE: UNPLUGGED',
NOVEMBER 2010 ISSUE
PHOTO Bryan Adams

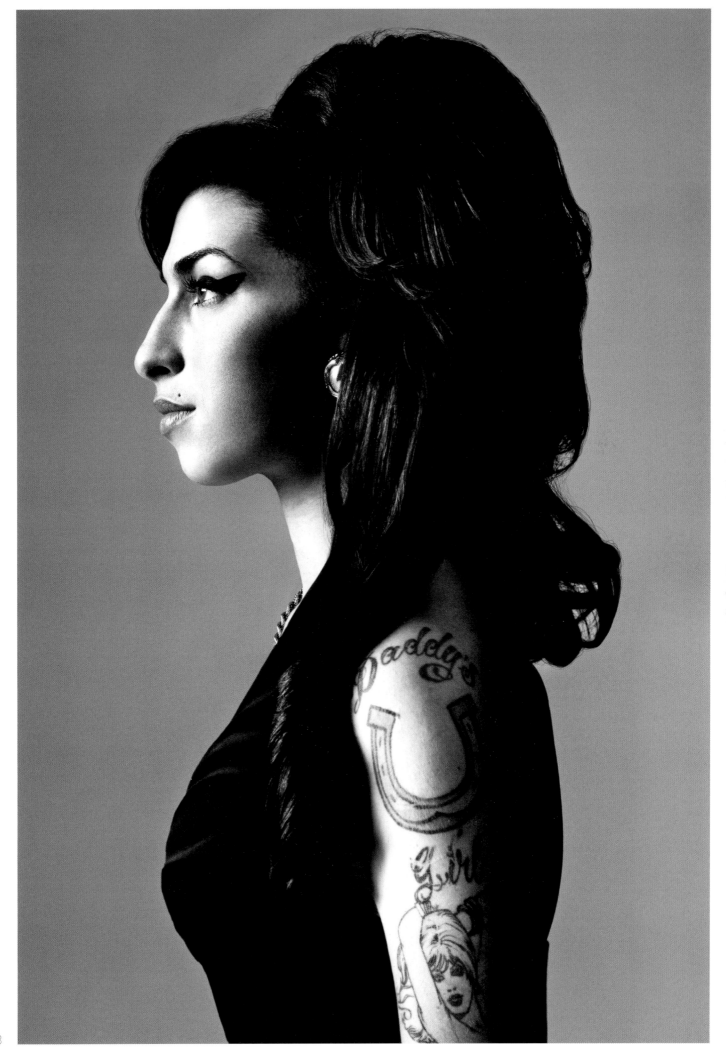

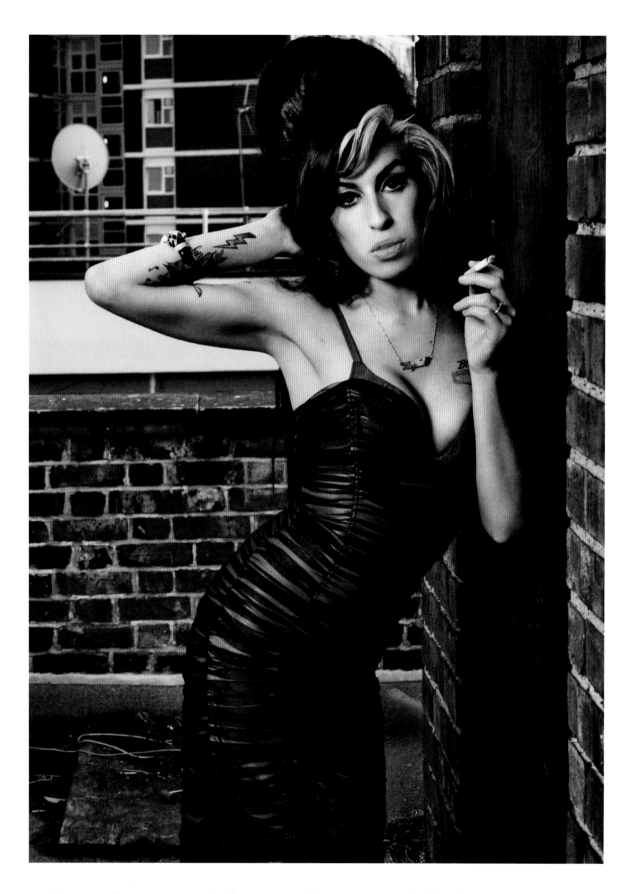

"It was a late summer's day in London's east end. The door opened and in came Amy with her gang. She looked incredibly beautiful – strong and fragile at the same time. I started shooting inside but we decided to move to the roof of the building, where everything seemed less claustrophobic."

MARC HOM PHOTOGRAPHER

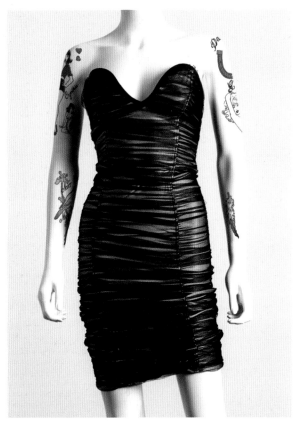

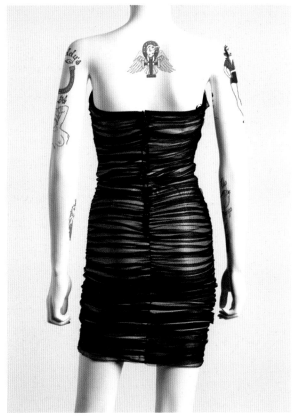
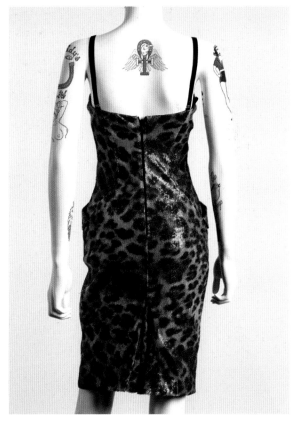

← / ↑
Ruched Tulle Dress
BY WHEELS & DOLLBABY
WORN FOR PHOTOSHOOT FOR JANUARY 2008
ISSUE OF *BLENDER* MAGAZINE

↑
Leopard Print Dress
BY VIVIENNE WESTWOOD
WORN FOR PROMO SHOOT FOR
2011 BRAZILIAN TOUR

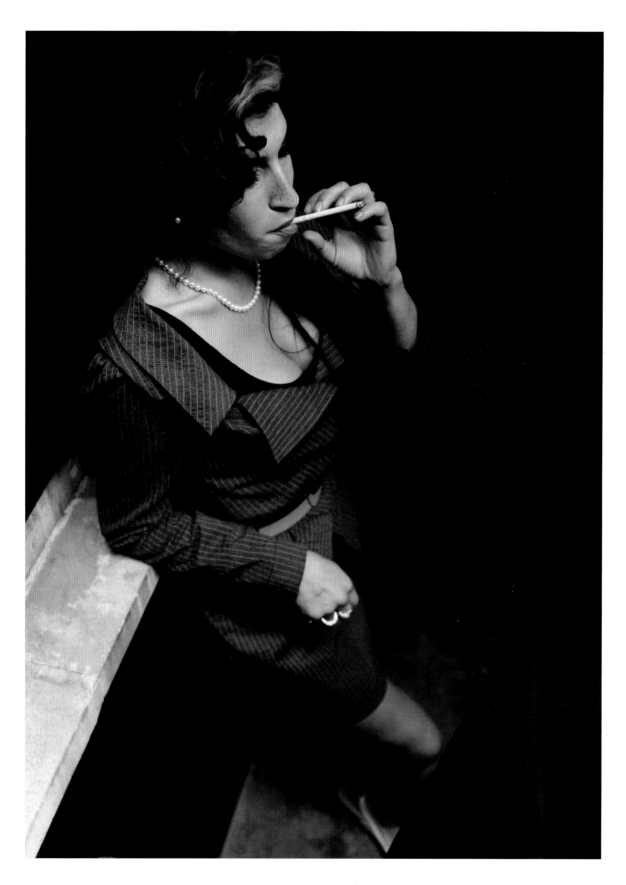

"It is unbelievable how much one refers to her still, and rightly so! She was an amazing force and talent. Vivienne and I loved the way she looked – and more and more so as she grew into herself. She really found her style, and she would often wear our clothes. She always looked so great!"

ANDREAS KRONTHALER & VIVIENNE WESTWOOD FASHION DESIGNERS

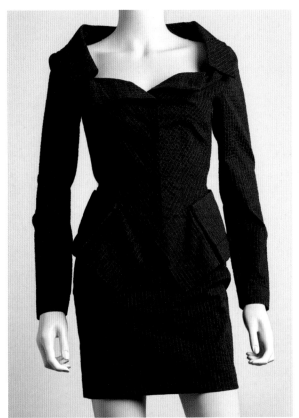

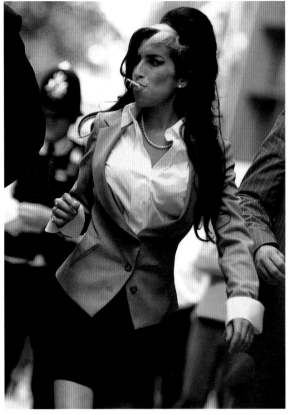

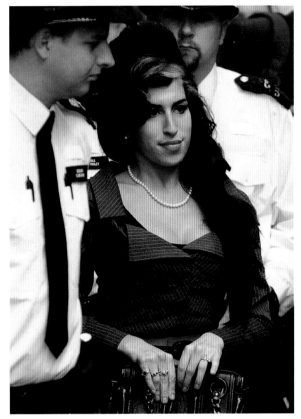

←/↑
Westwood 1
OUTSIDE WESTMINSTER MAGISTRATES
COURT, LONDON, 23 JULY 2009
PHOTO (OPPOSITE) Marc Hom,
(BOTTOM) Toby Melville

↑
Westwood 2
ARRIVING AT WESTMINSTER
MAGISTRATES COURT, LONDON,
24 JULY 2009
PHOTO (TOP) Andy Rain

"Of course she was a *Grease* fan! When Amy was 11 she
played Rizzo in a school version and the footage is out there
of her singing 'Look at me, I'm Sandra Dee' in a huge wig."

NAOMI PARRY STYLIST

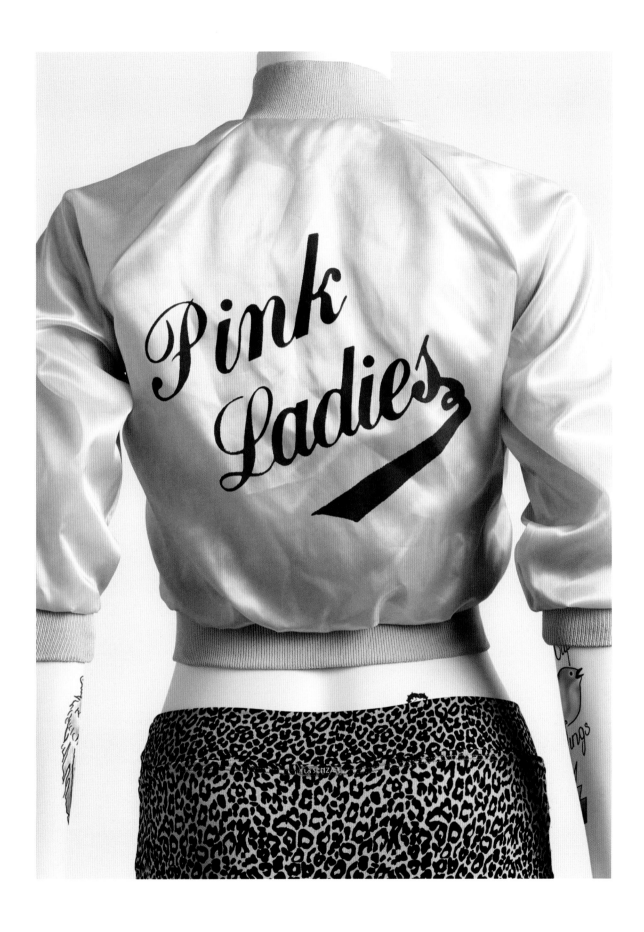

Greased Lightning!
CUSTOMIZED PINK LADIES
SATIN BOWLING JACKET WITH
LEOPARD PRINT HIPSTER BRIEFS
BY LA SENZA

"It was an amazing experience to have worked alongside Amy. She did nothing by halves and put her whole self into everything she did. A line from *Blade Runner* sums her up best for me: 'The light that burns twice as bright burns for half as long, and you have burned so very, very brightly.'"

DAMIEN WILSON FASHION DESIGNER

Natalia Damm
Fred Perry

Amy was already big fan of Fred Perry, and we had a great relationship with her stylist Naomi Parry, so when she suggested that we work with Amy on a collection it made total sense.

Amy was incredibly headstrong when it came to designing the collection for Fred Perry. She knew exactly what she wanted to create, but she was always respectful of the brand's design codes and what she thought her fans would want too. It was an easy collaboration and one that she took very seriously: she would arrive with books tabbed up, pictures and reference points. The collaboration was so successful that it continued beyond the first collection and still exists to this day in honour of her for the Amy Winehouse Foundation.

Shooting the first collection on her with Bryan Adams at his studio was also great fun. They shared a close bond and she would bring her record player and a ton of records to play throughout the day. Although she was incredibly guarded in a room full of people she didn't know, the music always made her relax and she would dance in front of the camera and sing along with Bryan - they were such special moments.

One memory that has always stayed with me was when I accompanied her to the Fred Perry store at Seven Dials, Covent Garden, for a styling appointment, and to get inspiration for her first collection. The paparazzi caught wind of her being in the store, which was effectively a glass box, and within minutes we were surrounded; we were locked in. The paps were shouting horrible things and doing anything to try to get a reaction from Amy, including slamming their cameras against the glass. I was so scared and didn't know how the two of us were going to get out but she didn't bat an eyelid. She turned to me, put her arm around me and told me that we were going to be OK and not to react to the provocation of these people - don't give them what they want. Her security team arrived shortly after and we were whisked out of the store. She turned and gave me a big comforting smile. She was a caring soul with a good heart. •

←
Early Designs
AMY'S PINK AND BLACK CHEQUERED
COLLECTION FOR FRED PERRY
BY DAMIEN WILSON,
OCTOBER 2010

→
Amy & Fred
AMY MODELLING POLO SHIRTS, MINI SKIRT
& BELTS FROM THE AMY WINEHOUSE
FRED PERRY COLLABORATION,
OCTOBER 2010

"As she started singing you could hear a pin drop. Her unique voice filled the airwaves. She was growing in confidence by the minute. She was absolutely lost in the music and avoided much eye contact, but it was a classy and magical performance. One knew one had been in the presence of greatness."

Alan Edwards Publicist

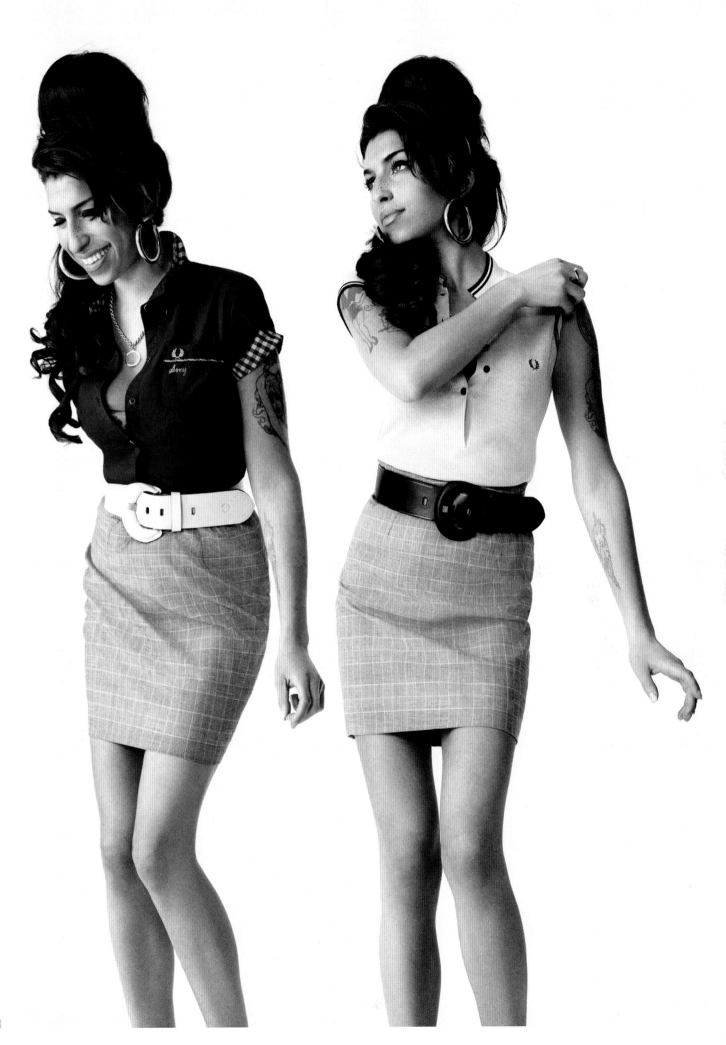

"People would say not very nice things to her to get a reaction so they could get a picture to sell to the photo agency for a lot of money. And some of the stuff they used to say was savage. And that made me so protective of her because I didn't want her to have to deal with that on a daily basis."

Catriona Gourlay Friend

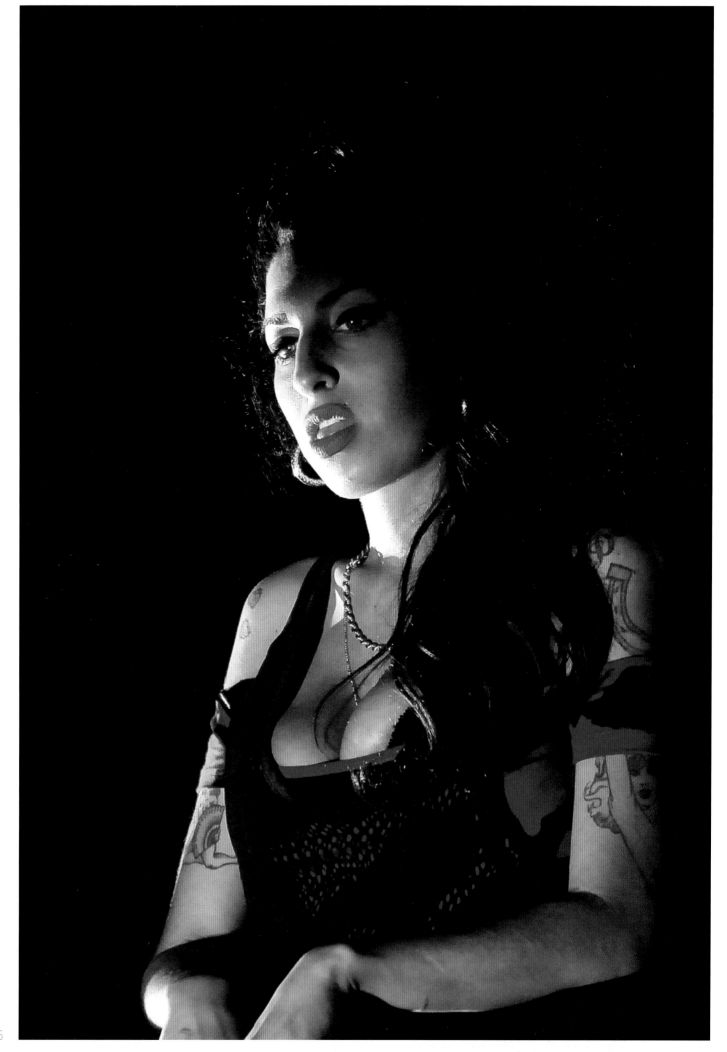

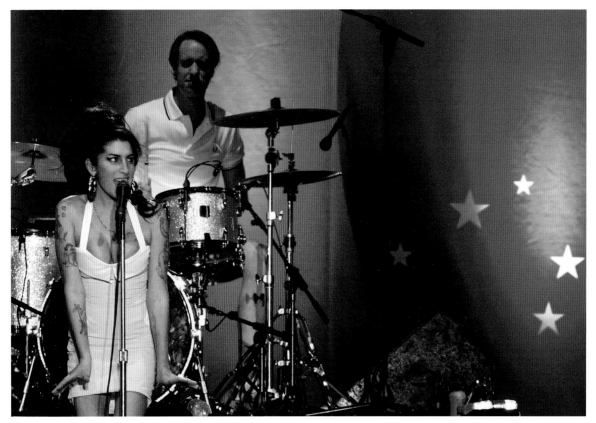

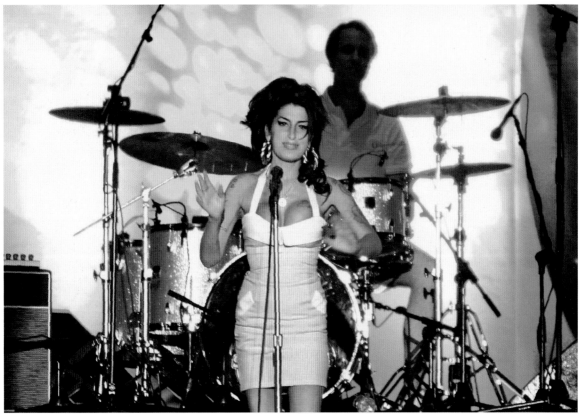

←
Watching the Libertines
IN THE AUDIENCE AT THE FORUM,
KENTISH TOWN, LONDON,
25 AUGUST 2010
PHOTO **Toby Hancock**

↑
Summer Soul Festival 2011
AMY AND TROY, IL DIVINO, FLORIANÓPOLIS,
BRAZIL, 8 JANUARY 2011,
DRESS BY DEADLY DAMES
PHOTOS **Nabor Goulart**

↑

Brazil Tour Dress 1
WORN AT THE HSBC ARENA, RIO,
10 JANUARY 2011

Brazil Tour Dress 3
WORN AT CONVENTION CENTER
RECIFE, 13 JANUARY 2011

↑

Brazil Tour Dress 2
WORN AT THE HSBC ARENA, RIO,
11 JANUARY 2011

Brazil Dress 4
WORN OUT IN SÃO PAULO,
16 JANUARY 2011

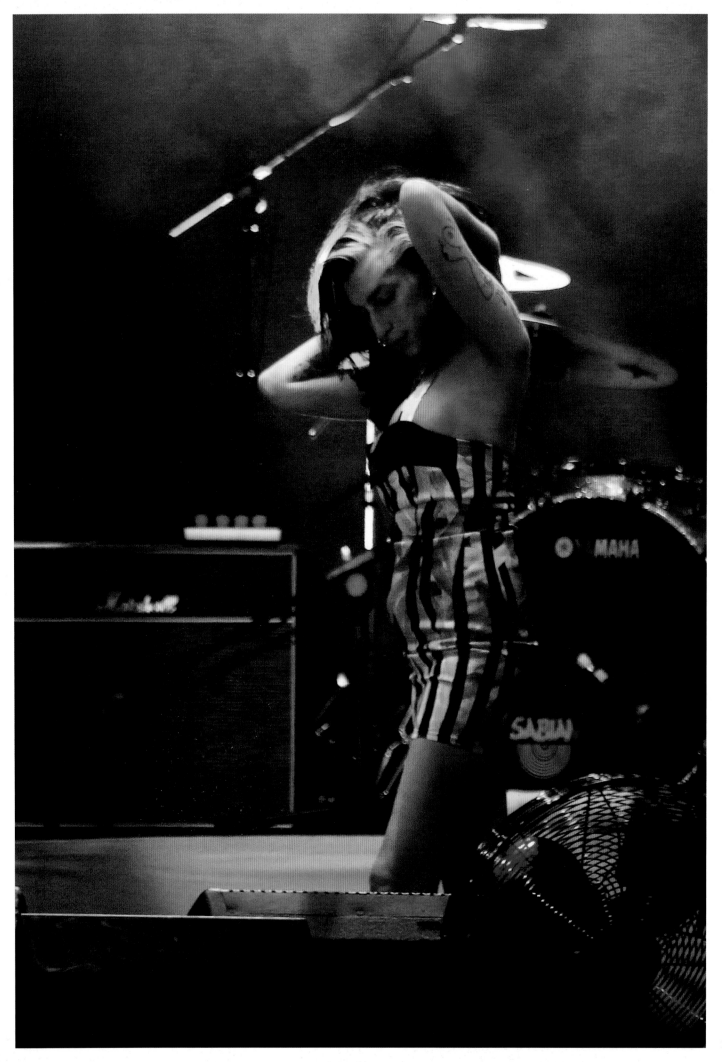

"She's really special. She just gave me a lot of hope and she deserved a lot better than what people gave her. And I hope that the world learns a lesson from this. I really hope they do. Because it's not her lesson to learn — it's the world's."

Lady Gaga Artist

Last Concert
KALEMEGDAN PARK, BELGRADE,
18 JUNE 2011
PHOTO **Srdjan Stevanović**

Tour Dress 1
BY NAOMI PARRY,
WORN KALEMEGDAN PARK, BELGRADE,
18 JUNE 2011

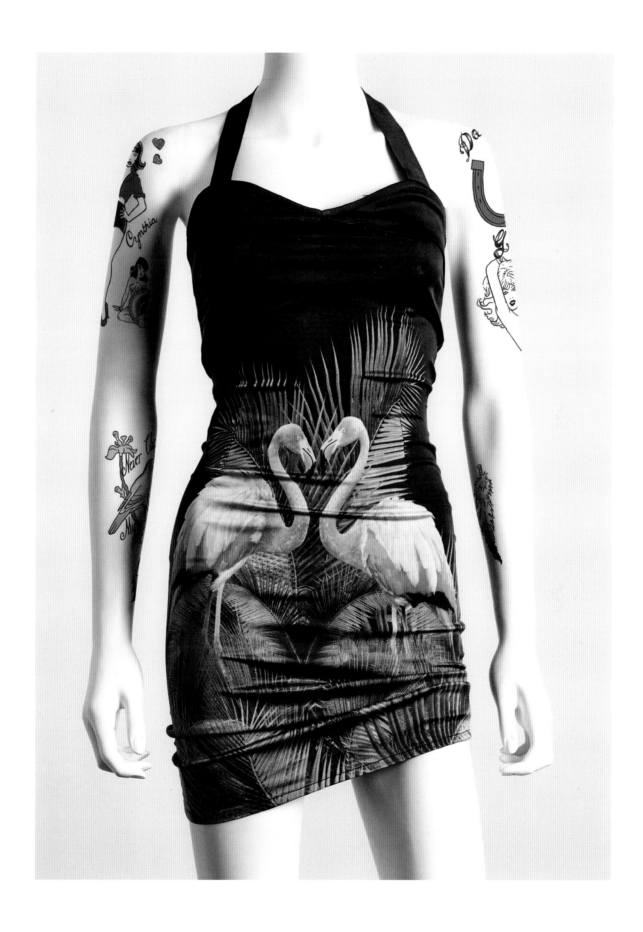

↑ / →
Unworn Tour Dresses
BY NAOMI PARRY,
DESIGNED SPECIALLY FOR THE
2011 EUROPEAN TOUR

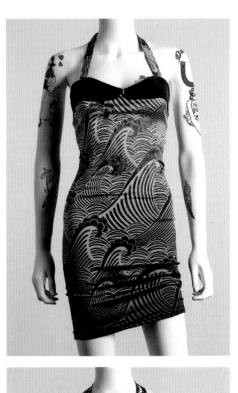
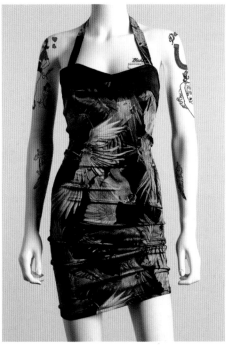
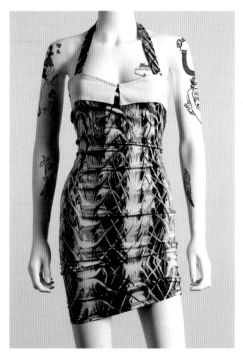
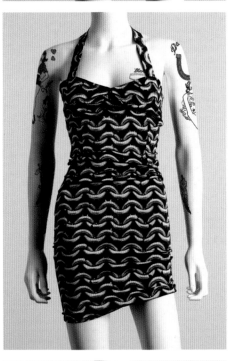
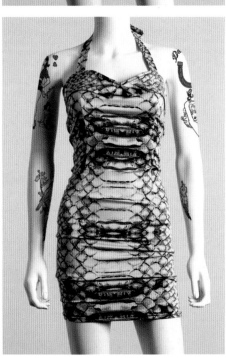
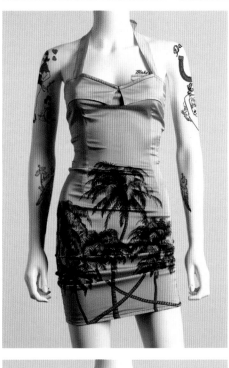
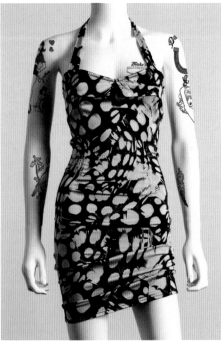
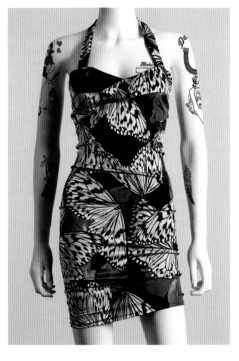
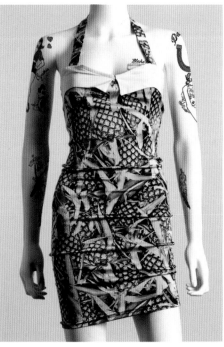

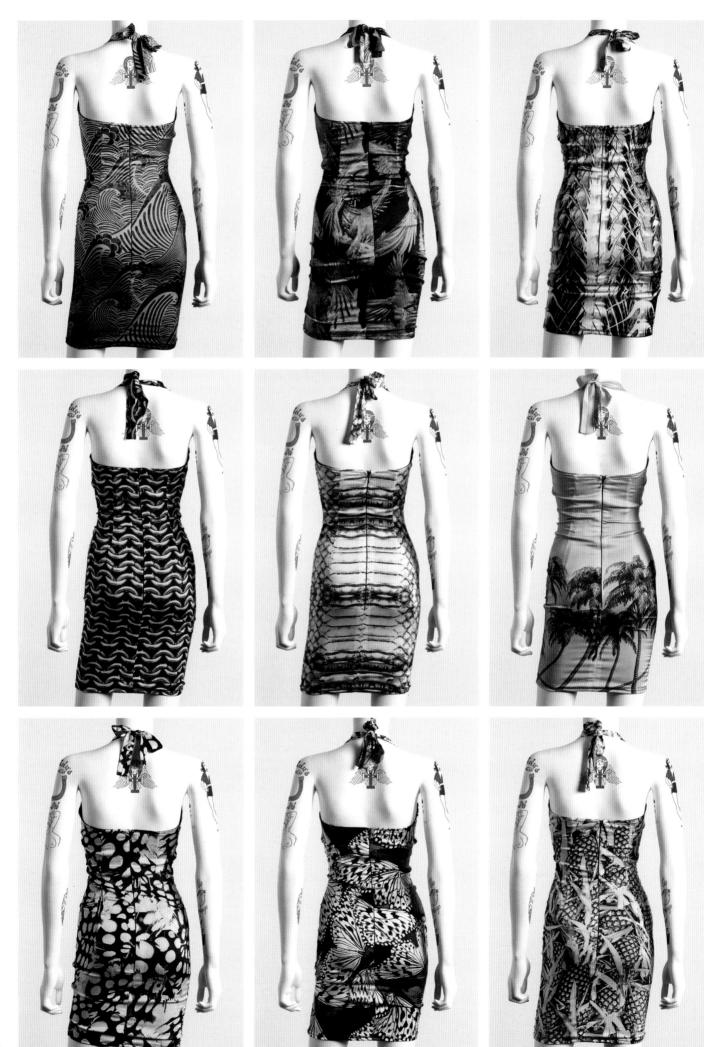

Dionne Bromfield
Goddaughter

Where do I even begin! One thing about knowing Amy is that you will have beautiful memories for life. One particular memory I have is especially strong and means so much to me.

20th July 2011, Camden Roundhouse:

It was a Wednesday and I was performing at the iTunes Festival. I remember people telling me that they had heard that Amy was coming down to watch but I thought, 'Nah, she isn't gonna turn up, even if she lives around the corner.' Fast forward two hours. I'm onstage and I notice a figure standing in the wings, calling me to come over. I rush to the side of the stage and there's Amy, who tells me, 'I wanna come on for 'Mama Said' [my song] but I don't wanna sing. I just wanna dance!' 'OK!' I said, slightly nervous about what she intended to do!

But I shouldn't have worried. She came onto the stage happy at the start of 'Mama Said'. She danced to the song and had a short spell singing the backing vocals on the mic. Once the song had finished, she ran up and hugged me, whispering with a little smirk, 'I knew you were gonna out the mic on me.' After I had come off stage, we went back to my dressing room where everyone was coming down off an adrenaline rush from having done a great gig.

There was another tiny room attached to my dressing room and Amy pulled me into it so we could be away from everyone else and have a private chat. She told me how proud she was of me and how excited she was to be recording again soon. And we had a good old chit chat about silly girl stuff! I hadn't seen her so happy or healthy looking for years. That evening she was beaming with happiness and looked shit hot - quite frankly, she was glowing!

Although I have many musical and non-musical memories of times spent with Amy that I cherish deeply, that half hour, just us two In the tiny dressing room, was the first time everything felt so still. So clear, so normal. Even if it was for only a couple of hours.

I had never thanked Amy for everything she had done for me - I thought she just knew how grateful I was. But for some reason It just felt like the right time to tell her. Afterwards we hugged tightly, then carried on laughing and having fun with our friends and family. I'll never forget the last words we exchanged: 'Love ya so much Didi!' 'Love ya loads Mama.'

Amy & Dionne
AFTER PRESENTING AT THE Q AWARDS 2009,
GROSVENOR HOUSE, LONDON,
26 OCTOBER 2009
PHOTO Agency

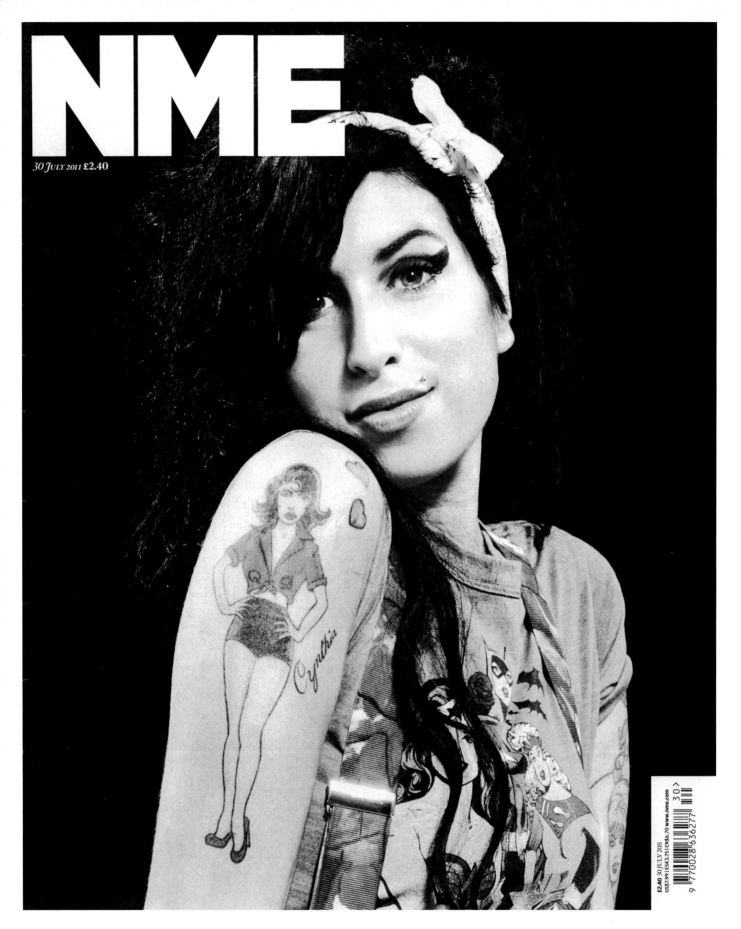

NME

30 July 2011 £2.40

NME *Cover*
30 JULY 2011 ISSUE
COVER PHOTO Dean Chalkley

276

"This photograph of Amy has a rare and magnetic force. Amy's gaze holds you... connects with you. There was passionate and heated discussion at *NME* about how to demonstrate the respect Amy deserved. What resulted was one of their most striking covers. Words seemed irrelevant — the picture said it all."

Dean Chalkley Photographer

"Amy Winehouse was my favourite to perform with on the whole album. Every great artist I ever met... have the butterflies... And Amy was just like that... I said to Amy, you know you sound like one of the great jazz singers, Dinah Washington. From that moment on the record came out just beautiful."

Tony Bennett Artist

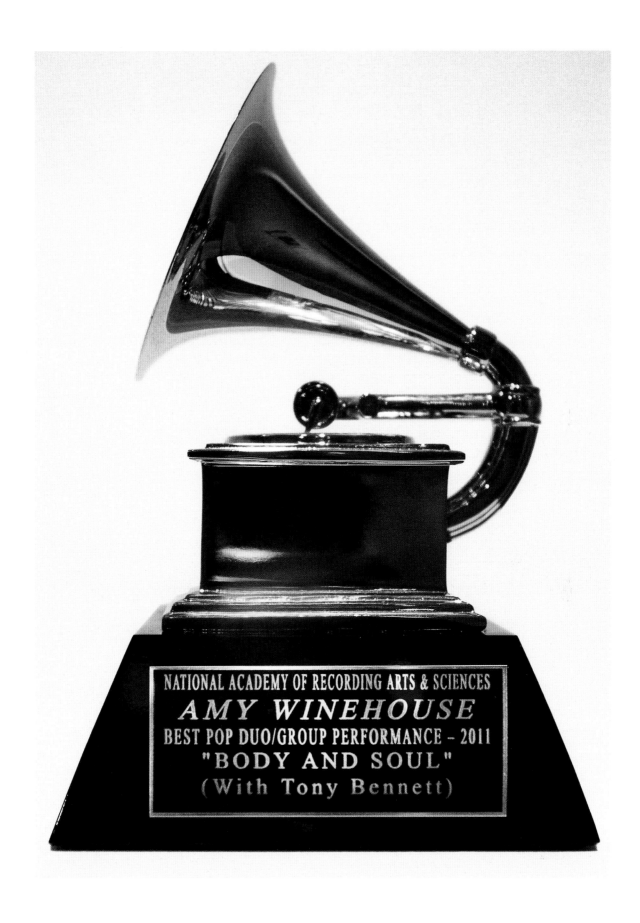

NATIONAL ACADEMY OF RECORDING ARTS & SCIENCES
AMY WINEHOUSE
BEST POP DUO/GROUP PERFORMANCE – 2011
"BODY AND SOUL"
(With Tony Bennett)

↑
Posthumous Grammy
(Best Pop Duo/Group Performance 2011
'Body And Soul')
AMY WINEHOUSE (WITH TONY BENNETT),
12 FEBRUARY 2012

→
Amy's Camden Hangouts
FAVOURITE STREETS, SHOPS, PUBS,
CLUBS, PLACES & SPACES IN & AROUND
CAMDEN TOWN, LONDON
(PHOTOGRAPHED IN 2021)

1 - 4

5 - 8

9 - 12

13 - 16

17 - 20

21 - 24

❶ ROKIT FITTING ROOMS / ❷ COTTONS RESTAURANT MURAL / ❸ VIEW FROM THE GOOD MIXER PUB / ❹ ROKIT VINTAGE SHOP / ❺ PAINTED RAIL BRIDGE, CAMDEN LOCK / ❻ POOL TABLE / ❼ THE OLD EAGLE PUB / ❽ CAMDEN SQUARE / ❾ THE GOOD MIXER PUB / ❿ STAINED GLASS IN THE OLD EAGLE PUB / ⓫ PLAQUE ON THE ROUNDHOUSE, COMMEMORATING ITS ORIGINAL USE AS AN ENGINE SHED / ⓬ PRIVATE BAR, THE GOOD MIXER PUB / ⓭ KEBAB SHOP, CAMDEN HIGH STREET / ⓮ STAGE AREA, THE DUBLIN CASTLE PUB / ⓯ ORNATE CAMDEN TOWN LAMPOST DETAIL / ⓰ PUB BENCHES / ⓱ PROWSE PLACE TUNNEL / ⓲ THE CORNER OF JEFFREY'S PLACE & PROWSE PLACE / ⓳ MAIN BAR, THE DUBLIN CASTLE PUB / ⓴ KOKO MUSIC VENUE / ㉑ PIANO, THE GOOD MIXER PUB / ㉒ COBBLESTONES IN PROWSE PLACE / ㉓ THE HAWLEY ARMS PUB / ㉔ COTTONS RESTAURANT WALL COLLAGE

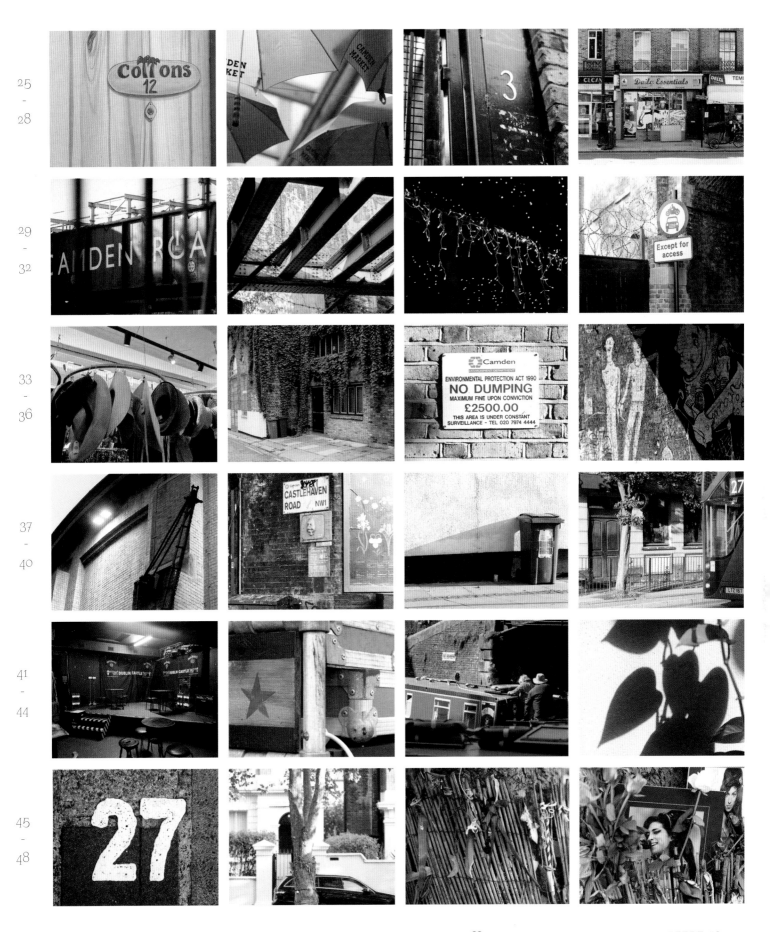

25 – 28

29 – 32

33 – 36

37 – 40

41 – 44

45 – 48

❤25 COTTONS RESTAURANT / ❤26 UMBRELLAS AT CAMDEN MARKET / ❤27 GATEWAY TO AMY'S HOME AT JEFFREY'S PLACE / ❤28 DAILY ESSENTIALS, MURRAY STREET / ❤29 CAMDEN ROAD RAILWAY BRIDGE / ❤30 CAMDEN LOCK RAIL BRIDGE / ❤31 PUB DECORATIONS, THE OLD EAGLE PUB / ❤32 CAMDEN ROAD STREET SIGN / ❤33 ROKIT CLOTHES RAIL / ❤34 AMY'S PROWSE PLACE HOME / ❤35 LOCAL COUNCIL NOTICE / ❤36 CASTLEHAVEN ROAD GRAFFITI / ❤37 THE ROUNDHOUSE / ❤38 CASTLEHAVEN ROAD STREET SIGN / ❤39 CAMDEN WHEELIE BIN / ❤40 QUINN'S PUB / ❤41 MAIN STAGE, DUBLIN CASTLE PUB / ❤42 FLIGHT CASES INSIDE THE ROUNDHOUSE / ❤43 BARGES AT CAMDEN LOCK / ❤44 LEAF SHADOWS AT JAMON JAMON, PARKWAY / ❤45 STALL NUMBER AT CAMDEN MARKET / ❤46 AMY'S CAMDEN SQUARE HOUSE / ❤47 REMEMBRANCES TO AMY TIED TO BAMBOO CANES OUTSIDE AMY'S FINAL HOME / ❤48 SHRINE TO AMY

References

20-21 Lyrics: 'Dolly's Diner' Words and Music by Amy Winehouse © 2001. Reproduced by permission of EMI Music Publishing Ltd / Sony Music Publishing Ltd, London W1T 3LP

22 Lyrics: 'Close To The Front' Words and Music by Amy Winehouse, Felix Howard and Paul Simm © 2001. Reproduced by permission of EMI Music Publishing Ltd / Sony Music Publishing Ltd, London W1T 3LP

24 Print interview: Nick Shymansky interviewed by Kathryn Bromwich, *The Guardian*, 14 June 2015. Courtesy of Guardian News & Media Ltd.

45 Print interview: *The Observer*, February 2004. Courtesy of Guardian News & Media Ltd.

46-47 Video interview: VladTV, 10 January 2017

48 Lyrics: 'Cherry' Words and Music by Amy Winehouse and Salaam Remi © 2002. Reproduced by permission of Salaam Remi Music Inc / EMI Music Publishing Ltd/ Sony Music Publishing Ltd, London W1T 3LP

51 *Frank* review: Greg Boraman, BBC Music 2003, https://www.bbc.co.uk/music/reviews/gh9x/

57 Adele at Boston gig, 2016

74-75 Lyrics: 'You Sent Me Flying' Words and Music by Amy Winehouse and Felix Howard © 2002. Reproduced by permission of EMI Music Publishing Ltd / Sony Music Publishing Ltd, London W1T 3LP

74 Print interview: *Q* magazine, June 2004

91 Print interview: *Rolling Stone*, 2 August 2011

92 Print interview: *Independent*, 22 October 2011

114 Online article: *Mirror*, 5 July 2015

115 Online interview: *Fader*, 8 October 2015

116 *Back To Black* review: John Murphy, musicOMH

140 *The Ronnie Wood Show*, 13 August 2013

143 Online interview: *Missbish*

149 Print interview: *Independent*, 22 October 2011

156 Online interview: MTV News, 7 January 2019

161 Video interview: VladTV, 10 January 2017

166 Online article: By Mitchell Sunderland, *VICE* magazine, 18 April 2017

170 Online article: Natalie Jamieson, BBC News, 18 February 2010

173 Adele at Boston gig, 2016

175 Online article: *Artlyst*, 11 October 2011

180 Print interview: *Elle* magazine, June 2004

182 Lyrics: 'Love Is A Losing Game' Words and Music by Amy Winehouse © 2006. Reproduced by permission of EMI Music Publishing Ltd / Sony Music Publishing Ltd, London W1T 3LP

182 Online article: *Digital Spy*, 8 November 2011

195 Video interview: VladTV, 10 January 2017

210 Print interview: Amy Winehouse interviewed by Garry Mulholland, *The Observer*, 1 February 2004. Courtesy of Guardian News & Media Ltd.

213 Print interview: Yungblud interviewed by Michael Cragg, *The Guardian*, 21 November 2020. Courtesy of Guardian News & Media Ltd.

214-215 Video interview: VEVO News, 19 April 2011

250 Review extract: Lioness: Hidden Treasures, Lou Thomas, BBC Music 2011, https://www.bbc.co.uk/music/reviews/zr28/

252 Print and online review: By Jody Rosen for *Rolling Stone*, Copyright © 2011 and Trademark ® Rolling Stone LLC. All rights reserved. Used by permission.

269 Print interview: *Rolling Stone*, 2 August 2011

278 Video interview: *The Guardian*, 11 July 2011. Courtesy of Guardian News & Media Ltd.

Sources of Illustrations

a=above / b=below / l=left / r=right / c=centre

All studio, set and street photography by Andrew Hobbs

1 Private Collection

2 Photograph by Bryan Adams, Camera Press London

4-5 © Jennifer Rocholl

8 EDB Image Archive/Alamy Stock Photo

12 Charles Moriarty/Iconic Images

17a © Janis Winehouse

17b AF archive/Alamy Stock Photo

18 Courtesy Amy Winehouse Foundation

20-22 Courtesy Amy Winehouse Foundation/Sony Music Publishing Ltd

25 David Butler/Shutterstock

26 John Alex Maguire/Shutterstock

31 Samir Hussein/Getty Images

32a Getty Images for MTV

32b Sean Gallup/Getty Images for MTV

34-35 Photographs by Jimmy James, Camera Press London

38-41 Charles Moriarty/Iconic Images

42-43 Courtesy Amy Winehouse Foundation

44 Courtesy Island Records, a division of Universal Operations Ltd

48 Courtesy Amy Winehouse Foundation/Sony Music Publishing Ltd

49 Rick Smee/Redferns

50 © Picture Alliance/photoshot/Bridgeman Images

52-55 Charles Moriarty/Iconic Images

56-57 Ian Dickson/Redferns

59 Photograph by Phil Knott, Camera Press London

60-61 © Karen Robinson

63 Brian Rašić/Getty Images

64-65 Photography by Diane Patrice

67 Rob Watkins/Pymca/Shutterstock

68-73 © Jake Chessum/Supervision

74-75 Courtesy Amy Winehouse Foundation/Sony Music Publishing Ltd

76-78 © Roger Sargent

80al Richard Young/Shutterstock

80br C Brandon/Redferns

81 MediaPunch Inc/Alamy Stock Photo

83 Rob Verhorst/Redferns

86-87 Photograph by Mark Okoh, Camera Press London

91 David Lodge/FilmMagic

92-94 © Ram Shergill

106 Grenville Charles/Alamy Stock Photo

109 Photograph by Jay Brooks, Camera Press London

110-111 Courtesy Island Records, a division of Universal Operations Ltd

112 © Jennifer Rocholl

117 Kevin Winter/Getty Images

120 © Henry Hate

121 Photograph by Bryan Adams, Camera Press London

122-123 © Mischa Richter

127 © Phil Griffin

128 Photograph by Scarlet Page, Camera Press London

130-131 Photograph by Dean Chalkley/*NME*/Camera Press London

133 © Kristian Marr

135 Simone Joyner/Getty Images

136 © Roger Sargent

138-139 FIG Fotos/Alamy Stock Photo

141 Photograph by James Veysey, Camera Press London

142-143 FIG Fotos/Alamy Stock Photo

148-149 Daniel Stier/Contour by Getty Images

150ar PA Images/Alamy Stock Photo

150bl Radharc Images/Alamy Stock Photo

151 FIG Fotos Alamy Stock Photo

153 David Fisher/Shutterstock

154 Dave Hogan/Getty Images

157 Matt Dunham/AP/Shutterstock

158-160 Photograph by Bryan Adams, Camera Press London

162-163 PA Images/Alamy Stock Photo

164-165 © Jennifer Rocholl

166 © Christy Bush

167-171 © Jennifer Rocholl

172 Jo Hale/Getty Images

174 Featureflash Archive/Alamy Stock Photo

175 Courtesy of the Estate of Gerald Laing, photography by Ewen Weatherspoon

176-177 John Shearer/WireImage

178a Edd Westmacott/Photoshot/Getty Images

178b Carl De Souza/AFP via Getty Images

179 Jeff Pachoud/AFP via Getty Images

181 Gie Knaeps/Getty Images

182 Courtesy Sony Music Publishing Ltd/Jim Payton

183 Harry Benson/Contour by Getty Images

184-185 Jason Squires/WireImage

186 Jo Hale/Getty Images

187 Dave Hogan/Getty Images

191 Photograph By Loe Beerens/Sunshine, Camera Press London

193 Sipa/Shutterstock

195 WENN Rights Ltd/Alamy Stock Photo

198-199 Photograph by Bryan Adams, Camera Press London

200-201 Peter Macdiarmid/Getty Images for NARAS

202 Richard Young/Shutterstock

203a Reuters/Alamy Stock Photo

203b Robyn Beck/AFP via Getty Images

207 Peter Macdiarmid/Getty Images for NARAS

208-209 WENN Rights Ltd/Alamy Stock Photo

211 Richard Young/Shutterstock

212 Dave M. Benett/Getty Images

213 Dan Kitwood/Getty Images

216 Zuma Press, Inc./Alamy Stock Photo

217 Carlos Alvarez/Getty Images

218 Dave M. Benett/Getty Images

220 Courtesy DJ Bioux, photography by PR Eye Ltd

224 Ross Gilmore/Redferns

225 Danny Martindale/WireImage

246 Photograph by Bryan Adams, Camera Press London

249 Photographer: Kelsey Bennett. Courtesy of Sony Music Archives

251 Courtesy Island Records, a division of Universal Operations Ltd

253 Photograph by Bryan Adams, Camera Press London

254 © Marc Hom

256 PA Images/Alamy Stock Photo

257ar Andy Rain/EPA/Shutterstock

257bl Reuters/Alamy Stock Photo

260 Courtesy Damien Wilson and Fred Perry

263 EDB Image Archive/Alamy Stock Photo

265 Toby Hancock/Shutterstock

266a Nabor Goulart/AP/Shutterstock

266b BDG/Shutterstock

268 Srdjan Stevanovic/WireImage

275 Wenn Rights Ltd/Alamy Stock Photo

276 Dean Chalkley/NME/Camera Press

279 PA Images/Alamy Stock Photo

Index

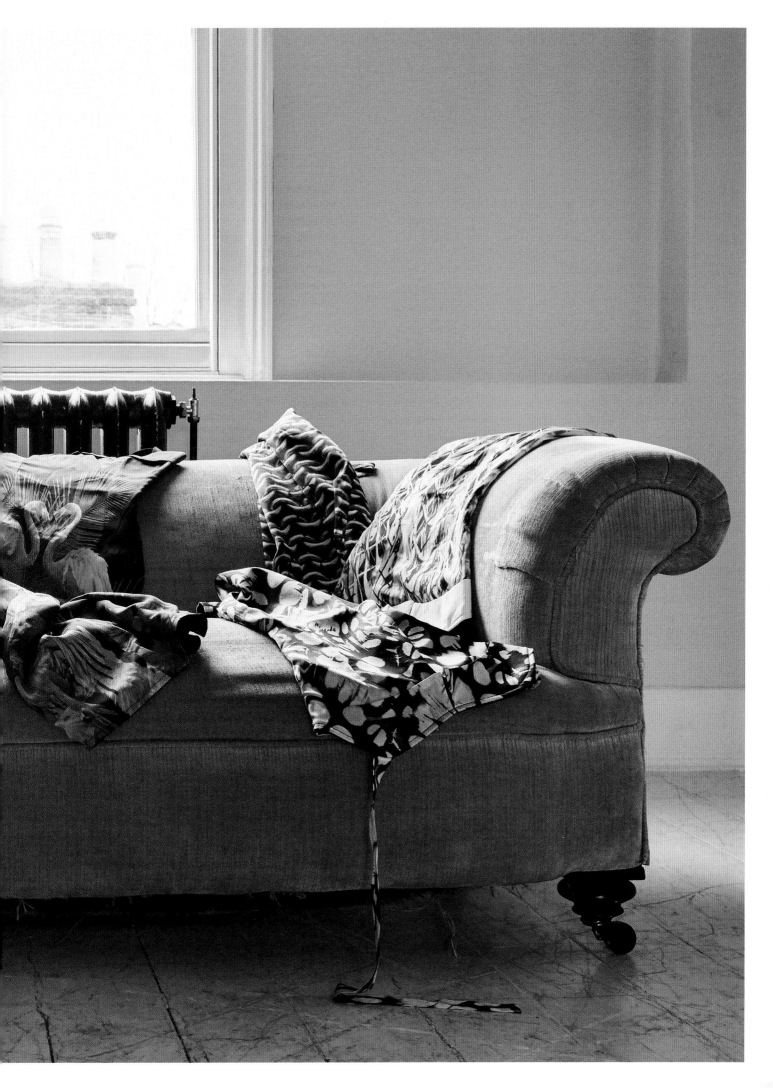

Acknowledgments

First and foremost, I would like to thank Simon Moore whose tireless support, advice and work behind the scenes has been instrumental in my creating a book I am so very proud of. You really are the best. Without you I wouldn't have met Andrew Hobbs who has done such a smashing job of interpreting my stream of consciousness and messy moodboards. I am so unbelievably proud of the images of the sets we created; they have really captured Amy and you went absolutely above and beyond to ensure that you got each one right. Thank you from the bottom of my heart.

To the Winehouse family - Mitch & Jane, Janis & Richard - thank you for your trust in me. This book is as much for you as it is for Amy. You are all very much loved.

A huge thank you to Emma Garland for writing the best piece of writing I've read on Amy ever. Your narrative holds the book together and you've brought a fresh approach to a story that has been told many times before, handling the tricky areas with delicacy and sensitivity. You have done Amy proud.

My darling Catriona Gourlay, thank you for your beautiful contribution, both in your lovely words and your incredible archive. This book would not have been as special without you and I look forward to all we will do together in the future.

Thank you so much to Matt Smith for his help with the licensing of the archive materials.

Karen Waddilove at AMARA who loaned us an astronomical amount of goods for our shoot - thank you, thank you, thank you. Without all of your beautiful homewares we would have just had the 'old' and not the 'new'.

A special thank you to all of the contributors who took the time and emotional energy to write such insightful and deeply felt contributions. You have really made this book. Your pieces are brimming with love and humour - just like her.

Thanks too to all the photographers who allowed us to reproduce their images - you have captured so many beautiful moments and characterful images of Amy.

The most enormous thanks to Tristan de Lancey, Jane Laing, Phoebe Lindsley and Sadie Butler at Thames & Hudson, who have worked with me night and day on this book through one of the most difficult times we have ever experienced in our lives. You have all been absolutely wonderful and I hope you are as proud of this book as I am. A special thanks to Tristan who stood outside in the cold for half a day waiting for the Smeg fridge to be collected - way below your paygrade!

Finally - thank you Mum for your unwavering support over the last 10 years. Your love and belief in me has allowed me to heal and to produce a book that honours the person I knew and provides a fitting tribute to her talents and achievements.

Also, thanks Kate.

With kind support from the Winehouse family.

About the author

I'm a creative director and curator based in London but raised in the country. Whilst studying at the London College of Fashion I began my career as Amy Winehouse's stylist. Over the subsequent 15 years, I've also worked with a variety of music artists and been involved in a wide range of projects in fashion, TV and film. More recently, I founded my own company, Future Archive, to help brands and individuals connect with more people through creative applications of their archive of work.

Page 1:	Temporary Tattoo Set, Amy Winehouse edition.
Page 2:	'Hear The World' campaign portrait by Bryan Adams, 2007
Pages 4-5:	Amy in her trailer at Coachella by Jennifer Rocholl, 2007
Page 6:	Amy's trademark pink ballet flats, photographed by Andrew Hobbs.
Pages 286-87:	Amy's last tour dresses, designed by Naomi Parry, photographed by Andrew Hobbs.

Front cover: Photograph by Jason Bell, Camera Press London
Back cover: Grenville Charles/Alamy Stock Photo

Published in 2021 by Abrams, an imprint of ABRAMS.

First published in the United Kingdom in 2021 by Thames & Hudson Ltd, 181A High Holborn, London WC1V 7QX

Amy Winehouse: Beyond Black © 2021
Thames & Hudson Ltd, London

Introduction and Chapter Introductions © Emma Garland
'Styling Amy' © Naomi Parry
'Knowing Amy' by Catriona Gourlay

For image copyright information see pp. 283.

Designed by Anıl Aykan at Barnbrook

Library of Congress Control Number: 2021932414

ISBN: 978-1-4197-5768-6

Printed and bound in Italy
10 9 8 7 6 5 4 3 2 1

Abrams books are available at special discounts when purchased in quantity for premiums and promotions as well as fundraising or educational use. Special editions can also be created to specification. For details, contact specialsales@abramsbooks.com or the address below.

Abrams® is a registered trademark of Harry N. Abrams, Inc.

ABRAMS The Art of Books
195 Broadway, New York, NY 10007
abramsbooks.com

MIX
Paper from responsible sources
FSC® C015829